MONUMENTS OF
ROMANESQUE ART

IN MEMORIAM

ADOLPH GOLDSCHMIDT
KINGSLEY PORTER
FRITZ SAXL

MONUMENTS OF ROMANESQUE ART

The Art of Church Treasures
in North-Western Europe

by

HANNS SWARZENSKI

SECOND EDITION

FABER AND FABER
24 Russell Square
London

First published in mcmliv
by Faber and Faber Limited
24 Russell Square London W.C.1
Second edition mcmlxvii
Printed in Great Britain by
John Dickens & Co Ltd Northampton
Published in the United States of America by
The University of Chicago Press

CONTENTS

ILLUSTRATIONS IN THE TEXT

PREFACE

This publication grew out of two seminar courses I gave in 1940 and 1942 at Princeton University while I was a member of the Institute for Advanced Study. The dislocation of works of art after the war and other obstacles considerably delayed its completion. However, this inevitable delay had one advantage: it enabled me to include in the bibliographical notes a large number of studies published after my first draft was written, and especially to profit from the writings of T. D. Kendrick and Francis Wormald in which I found valuable inspiration. That the book could appear in its present form is chiefly due to the critical and indefatigable co-operation of Gertrud Bing, of the Warburg Institute, University of London, who assisted me in reading the typescript and the proofs. To her as well as to Dr. Richard B. K. McLanathan, of the Museum of Fine Arts, Boston, Mass., I must express my warmest gratitude for undertaking the arduous task of correcting my English. Special thanks are due to Professor Frankfort, Director of the Warburg Institute, who recommended the book to Faber and Faber; to Erich Meyer, Director of the Museum für Kunst und Gewerbe, Hamburg; Otto Pächt, Oxford; Jean Porcher, of the Bibliothèque Nationale; Hermann Schnitzler, Director of the Schnütgen Museum, Cologne; and to all other friends and colleagues who gave me most valuable information and provided me, often under difficult circumstances, with photographs.

I am greatly indebted for all their kindness to the officials of the Church Treasures, Museums and Libraries, who freely gave me access to the works I wished to study and to reproduce.

Acknowledgements are due to the following institutions and persons who generously granted me permission to reproduce their photographs:—

In Austria: The Bundesamt für Denkmalpflege, Vienna. In Belgium: The Service Photographique, Brussels; Mme. Suzanne Gevaert, Liége. In Denmark: The Royal Library and the National Museum, Copenhagen. In England: The Midland Institute, Birmingham; the Colleges of Corpus Christi, St. John's, Pembroke, Trinity, and the University Library, Cambridge; the Trustees of the Chatsworth Settlement; the Cathedral Library, Durham; the British Museum, the Guildhall Museum, Lambeth Palace Library, the Victoria and Albert Museum, the Warburg Institute, Mr. C. R. Dodwell and Mr. O. Fein, London; the

Preface

Ashmolean Museum and the Bodleian Library, Oxford; Mr. Walter Oakeshott and the Chapter Library of Winchester Cathedral. In France: The Bibliothèque Nationale; the Louvre; the Musée Cluny; the Archives Photographiques and Mlle. Denise Fourmont. In Germany: The Museums of Berlin, Bonn, Braunschweig, Darmstadt, Frankfurt a.M., Hannover, Mainz, Munich; the Rheinische Bildarchiv, Cologne; the Bildarchiv Marburg; the Library of Count Schönborn, Pommersfelden; the Württembergische Bildstelle, Stuttgart; Director Alfred Hentzen, Hannover; E. Krüger, Schwäbisch-Hall; Professor Hans Wentzel, Stuttgart. In Holland: The Rijksmuseum, Amsterdam. In Italy: The Biblioteca Laurenziana and the National Museum, Florence. In Sweden: Dr. Carl Nordenfalk, Stockholm. In Switzerland: The National Museum, Zürich; Robert von Hirsch, Basel; Director Max Huggler, Bern. In the United States: Photographic Collection of Kingsley Porter, Harvard University, Cambridge, Mass.; the Art Insitute, Chicago; the Cleveland Museum; the Frick Art Reference Library, the Metropolitan Museum, the Pierpont Morgan Library, New York; Professor Frederick Stohlman, Princeton, N.J.

Hanns Swarzenski
Boston, Mass., June 1953

INTRODUCTION

The main reason and also, I hope, the justification for presenting as an artistic whole the chief monuments in ivory, gold, bronze and enamel, as well as of the manuscript painting of north-western Europe during the period from 800 to 1200, is the fact that no such book exists. There are facsimile editions of certain illuminated manuscripts, and monographs of individual schools of illumination; we have a corpus of the ivory carvings, the first volume of a corpus of the Romanesque objects cast in bronze, three volumes of a corpus of the Romanesque bronze doors, a corpus of the croziers made in Limoges; and we are eagerly looking forward to the publication of many other equally impressive tomes of the same type. The need for such volumes and their value for the advancement of our knowledge in this field cannot be sufficiently emphasized. Thanks to them we have gained a deeper insight into the complex organism and the artistic development of various schools and workshops, and the benefit gained is especially noticeable in the field of iconographic research. Nevertheless, it is doubtful whether these publications have greatly helped to stimulate the aesthetic experience of these arts. On the contrary, in general the works published in these large and heavy tomes are regarded mainly as material admittedly full of interest for the Christian archaeologist and the historian of liturgy or mediaeval techniques but essentially unconnected with the main stream of artistic production. Marc Rosenberg's comprehensive publication on the art of precious metals has, for instance, the title: *History of the Goldsmith's Art on a Technical Basis*. In the general books on art history, this material is mostly dealt with, under the label 'Minor Arts', in a separate chapter following like an appendix on what appears as the more important section on the 'great' arts of the respective periods. In Morey's recent survey of mediaeval art, the names even of such leading artistic personalities as Rainer of Huy, Godefroid of Huy, later called Godefroid de Claire, and Nicholas of Verdun are barely mentioned.

Nothing is more revealing of this approach than the fact that our vocabulary has no other name for those works than 'Minor Arts', 'Decorative Arts', 'Industrial Arts', or 'Applied Arts', and that the expression 'Arts and Crafts' has a similar connotation. This classification is a typical idea of the later part of the nineteenth century, which is responsible for the final deplorable alienation between artist and artisan; and it is no accident that during that period of historical materialism the great museums of Applied Arts were established with the aim

of showing true examples of all the various historical styles and in the belief that the craftsman, the artisan and the designer would use them in order to improve their own work. For this purpose those new museums of Decorative or Applied Arts acquired, wholesale or piecemeal, the vast number of liturgical objects which the dissolution of the Church treasures had made available and which the antiquaries of the Romantic movement, with their deep interest in the Middle Ages, had eagerly collected. Thus, a 'period' watering-can would, for example, be produced after the design of a dragon found in a small twelfth-century initial, or a 'Romanesque' chair designed after the throne on which King David is seated in a Carolingian psalter. Today, of course, we laugh condescendingly at such naïve attempts of recreating historical models, but we should not forget that they are the forefathers of the period rooms and cloisters of our museums. Besides, the precious materials and remarkable technical workmanship increased the demand for these isolated objects as items of *haute curiosité* among the rich collectors, the Soltikoffs, Basilewskys, Rothschilds, Spitzers, Hoentschels, Morgans, Martin-Le-Roys, in whose homes they were almost as much appreciated and as pretentiously exhibited as the bronzes of the Italian Renaissance or even as Meissen or Sèvres porcelain. It is one of those amusing, ironical incidents in the story of human ambitions that this age, whose craving for archaeological correctness had made it so history-conscious, entirely lost sight of the true meaning of these so-called minor arts of the early Middle Ages. For they represent the great arts of their period and should have to be classified as such, if the distinction between 'major' and 'minor' arts had existed at all at the time when they were made.

The separation of monumental art—architecture, sculpture and painting—from the humbler and minor crafts is entirely a modern idea. It is no mere chance that the artistic aims of Romanesque sculpture and painting found their purest expression in these small works in metal, ivory, enamel and miniature painting which often surpass the official formal achievements of the monumental arts, and it is here that the evolution of the monumental style of the Romanesque period can best be followed. Small bronzes and miniatures foreshadow the great Crucifixes of Werden and Minden (Pls. 94–5, 104–5), initials and aquamanilia prepare the way for the Lion Monument of Henry the Lion (Pls. 204–5), and the gilded statuettes on a book-cover from Trèves (Pl. 224) are the ancestors of the more than life-size statues of Reims Cathedral.

It is therefore a mistake to see in these productions mere substitutes or reflections of lost or damaged works on a grand scale, as is often done. Just as there is no distinction to be drawn between 'minor' and 'major' arts, thus the terms 'monumental' and 'small' cannot be applied to these works; the monumental quality of the art of this period is in no sense determined by size. There are frescoes and stone reliefs that have the minute subtlety and precision of miniatures, ivory carvings, and metal engravings; and there are book paintings, silver-gilt

Introduction

statuettes, ivories, and metal engravings which show the broad summary handling of wall-paintings and stone sculptures. Of course, it is only in the true size of the original in which the artist expressed himself that the suggestive power of the whole design of these works can be fully experienced. But the point is that even so these works, no matter how tiny they may be, stand enlargement to many times their size without distortion. In fact, it is often only through such enlargements that their whole hidden artistic richness and the fullness of their imaginative world can be revealed.

In a certain sense it is the heritage of the Barbarians, the Northern tribes, that this art, at least in its beginnings, consists almost exclusively of small movable objects of precious materials. But it would be a mistake to approach merely as *objets d'art* these works executed in the most refined techniques of gold, filigree, jewels, gems, pearls, enamel and niello. Their material extravagance was not the result of the mere love of powerful ecclesiastical and secular lords for display and ostentation: *Ars auro gemmisque prior* reads the inscription on the fragment of an enamelled shrine commissioned by Henry of Blois, Bishop of Winchester (Pl. 195, fig. 446). In all young cultures gold and jewels embody and convey a magical or symbolical force, a supernatural and impersonal power. And it is due to this quality that they were used in Christian art to enshrine and emphasize the transcendental revelations of the mystery of the liturgy and of the relics. This is the reason why the mediaeval craftsman and his patron found and experienced in those precious materials the appropriate medium for the artistic realization of their purpose. Both were aware that it was an offering pleasing to God, and consequently the artist gave his best to the delicate work—the *opus subtile*, as it was called. For the purer and more precious the material in which he worked, the closer he came to the fulfilment of his consecrated purpose. The very preciousness of the material acquired the value of symbolic significance: crystal and ivory became attributes of the Virgin; the chalice-shaped mounts of the gems on the cover of the Codex Aureus of St. Emmeram (Pl. 10) were associated with the blood of the martyrs, and its precious stones with the Heavenly Jerusalem. Because of this approach, a Romanesque reliquary in the shape of a church, however profuse its ornamental and sculptural decoration, conveys an impression of finality and, in contrast to the toy character often inherent in a reliquary of the Gothic period (Illustration no. 1), always retains its symbolic monumental structure (Pl. 213).

The initials, the first letters or words of the Gospels and the liturgical texts, become sacred signs of gold and purple. Separated from the text, they appropriate the space of an entire page and are framed like full-size panels which may, for instance, show a presentation of Christ on the Cross (Pl. 94, fig. 217). The letter and the word as such become a picture. The lavishly illustrated bibles, psalters, sacramentaries, missals, antiphonaries, gospel-books and lectionaries are not intended merely for the personal use and the aesthetic delight of those who commissioned them, or for the gratification of a sophisticated taste such as, for instance,

Introduction

the prayer books of the Duc de Berry or, later, the *éditions de luxe* of an Ambrose Vollard: they were made solely *In Majorem Gloriam Dei*. However great the importance of the book as the chief vehicle and agent of literary, artistic and iconographical traditions may have been for the Middle Ages, its evaluation and its unique position lie in its consecrated character. It elucidates the Christian myth that Christ is represented with a book in His hands; no other religion has given any of its gods this attribute.

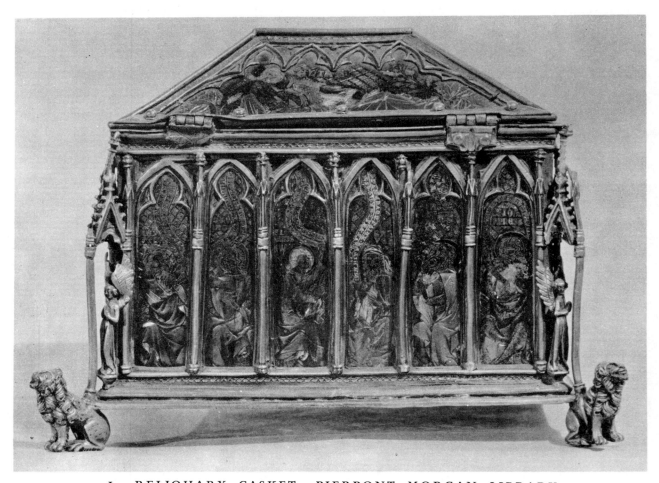

I. RELIQUARY CASKET, PIERPONT MORGAN LIBRARY

The suggestive force of this art and its power of communication lie largely in the fact that the unifying symbols of spiritual and secular life, of *Sacerdotium* and *Imperium,* had not yet lost their meaning. Symbols of Cross and Crown (Pls. 31–33) are combined for this one common objective in the Church Treasure—that curious and enigmatic invention of the mediaeval mind in which both the political and the spiritual ideals of the period are clearly mirrored and in which donors and patrons, secular and ecclesiastical lords alike, were able to combine

14

Introduction

in a lasting monument their artistic tastes with their religious devotion. The insignia of the Holy Roman Empire and of the French kings formed part of the Treasures of the Cathedrals of Aachen and St. Denis (Pls. 31–33, 152–3). The Hand of Justice of the Kings of France (Pl. 153, fig. 338) recalls an arm reliquary (Pl. 27, fig. 66). The Treasure of the Guelphs (Pls. 27, 36, 206, 212, 213) was also the Treasure of St. Blasius, Braunschweig. A more appropriate designation for this art than is implied by the name 'Minor Arts' or 'Applied Arts' would therefore be the 'Art of Church Treasures'.

The great bulk of this art, in which the sacred and symbolic character naturally predominates, actually comes from Church Treasures and was made for liturgical use. It is church ornament not intended for private or domestic use. This does not imply, however, that vernacular art (*ars profana*) did not exist, or that it was dominated or suppressed by liturgical art (*ars sacra*). Profane contents and objects of secular use are not simply by-products. They are permeated with Christian thought and Christian themes to such an extent that the distinction between secular and ecclesiastical art is blurred. The frequent use of classical objects and the admission of survivals of classical mythology and similar subjects should not be interpreted as the sign of a concession to worldly mentality but signify their acceptance and inclusion in the theocratic programme of the cosmic order. An artistic awareness of the harmony between the transcendental and the mundane seems to have preceded its theological and philosophical formulation. In this connection it should also be remembered that the dioceses and the monastic institutions belonged, as powerful landowners, to the same feudal system and consequently were bound to operate under the same social and economic conditions as the secular lords of the period—a fact which made it necessary for the Church to accept the secular world as a reality and to submit to its humanizing influences.

Of course, as in all civilizations there were influential voices and tendencies of a purist and anti-artistic nature which severely criticized the lavishness of the artistic production and especially condemned its ambiguity and irrational fantasies as vain, useless, non-functional, economically wasteful and even dangerous for the beholder. 'Those beauties and worldly graces quickly enervate the man and render the masculine heart effeminate', says the Carthusian Guigo*. Attacking the art of the sumptuously sculptured capitals of the cloisters, St. Bernard writes scornfully: 'What business has there that ridiculous monstrosity, that wondrous and deformed beauty, that beautiful deformity? . . . So rich and so amazing are the varieties of shapes that we are more delighted to read in the marble than in our books, and to spend the whole day wondering at these things piece by piece, rather than meditating on the Divine Law. For God's sake, if men are not ashamed of these follies, why at least do they not shrink from the expense?' This famous quotation from a letter is often tendentiously cited to show St. Bernard's and the Cistercians' hostility to art and his blindness to the beauty of the visible

* See Meyer Schapiro, *On the aesthetic attitude in Romanesque art*, in *Art and Thought* (1948), pp. 130 ff.

Introduction

world. Yet the fact that he chose to use such words as 'wondrous (or amazing, or marvellous) beauty' for these works and the way how, in the same letter, he describes, disdainfully yet so minutely and with such rare visual susceptibility, 'those fierce lions, those unclean monkeys, those monstrous centaurs', or 'a quadruped with the tail of a serpent, a fish with the head of a quadruped', in short the whole imaginary world of the *drôlerie* (Pl. 189) reveals his awareness of their beauty and his aesthetic appreciation and experience. In the book by Bernard's contemporary Suger, Abbot of Saint-Denis, *On the Work Done under his Administration*, are passages which almost sound like a provocative answer to Bernard's remarks, if not like a positive interpretation of Bernard's deprecating comments. Suger writes about the gilt bronze reliefs of his Cathedral: 'Whoever thou art . . . Marvel not at the gold and the expense but at the craftsmanship of the work. Bright is the noble work, but, being nobly bright, the work should brighten the minds . . .' And in contemplating the precious stones that glowed on the Carolingian golden altar and cross, he confesses in another passage: 'The many-coloured gems called me away from external cares, and worthy meditation has induced me to reflect, transferring that which is material to that which immaterial, on the diversity of the sacred virtues; then it seems to me that I see myself dwelling, as it were, in some strange region of the universe which neither exists entirely in the slime of the earth, nor entirely in the purity of Heaven; and that, by the grace of God, I can be transported from this inferior to that higher world in an analogical manner.'*

Apart from this theological argument the didactic value of secular, especially classical, content has always been recognized, and pagan myths and figures were thus invested with a new content, expounded as moral allegories, and charged with Christian meaning. But this classical content was soon divorced from its classical form. For example, a classical gem representing Venus was actually used without hesitation in the twelfth century for the head on a Cologne crucifix embossed in silver (Illustration no. 2). Both form and content became more and more absorbed by the system of mediaeval thought and style and adapted for mediaeval use. The Cross of Lothair has as its centre a precious cameo of Augustus, and on the front of the foot reliquary of St. Andrew (Pls. 27–8) a Justinian gold coin is surrounded by the Apocalyptic Beasts; these are indications that the majesty of a secular ruler could deputize for the majesty of Christ, the *Majestas Domini*. Mythological pictures in astronomical treatises and other illustrations of purely secular content, for instance scenes from Roman plays, are copied with an extraordinary faithfulness to the style of their classical prototypes in the same workshops and by the same artists who painted pictures of Christian subject matter (Pls. 13, 68).

The title-page of a Reims pontifical depicts the Harmony of the Spheres, symbolized by the figures of Air and of Arion sitting on his dolphin, surrounded by busts of the Muses in the

* Quoted from E. Panofsky, *Abbot Suger* (1946), pp. 61 ff.

16

order described by Martianus Capella (Pl. 210). Cosmological personifications like the Sun and Moon and the Four Elements are resuscitated and survive in more or less truly classical attire in representations of the Crucifixion (Pl. 5). Nude classical figures, for instance those of Atlas or the Spinario, appear on altar-crosses and candlesticks (Pl. 91, fig. 211) as well as on the columns of canon-tables and initials. A flabellum (an instrument to chase away flies during the celebration of Holy Mass and processions) can be decorated with scenes from

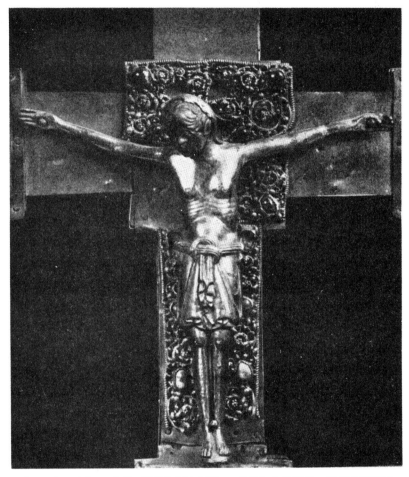

2. CROSS OF HERIMAN, COLOGNE MUSEUM

Virgil's *Bucolica* as well as from John the Baptist's life.* Water-basins, so-called Hansa-bowls and gemellions, are engraved with stories of the life of Achilles (Pl. 189), St. Ursula or Samson; and aquamanilia, vessels for pouring out wine or water, represent groups of Samson wrestling with the Lion (Pl. 203) as well as centaurs and secular knights on horseback, no matter whether they were intended for secular or liturgical use. A ciborium (container for

* See L. E. A. Eitner, *Flabellum of Tournus* (1944) and R. B. Green, *Flabellum of Hohenburg*, in Art Bulletin (1951), pp. 153 ff.

Introduction

the Holy Wafer) in the Treasure of St. Maurice, called *Coupe de Charlemagne*, is adorned with medallions representing scenes from the life of Christ and has a lid surmounted by a group of the centaur Chiron and Achilles (Pl. 217, figs. 511–2). Wearing apparel, such as buckles, and containers for cosmetics are decorated with scenes which often leave one in doubt as to whether they represent biblical subjects like David and Abisaig, or Solomon and the Queen of Sheba, or secular love-scenes such as that of Tristan and Iseult (Pls. 202, 225).

The distinction between patron and artist, between intellectual concept and manual execution, is not yet strictly drawn. Donor and craftsman often appear as one and the same person and are recorded as *Auctor* as well as *Autor*, a fact which indicates the impersonal and superpersonal character of this art. When a work is inscribed with the name of an historical personality it means more than an artist's signature in the modern sense. If, for instance, Bernward of Hildesheim is recorded as goldsmith, sculptor and miniature painter it does not necessarily imply that he actually had a share in the manual execution of his donations (Pls. 28, 50); it mainly indicates the enigmatic unity and universality of the various arts and crafts. Their collective character can perhaps best be compared with the relation between the composer and conductor of a symphony and their use of the various instruments.

The restriction of this selection to monuments of north-western Europe—Lorraine, the valleys of the Meuse and of the Lower and Middle Rhine, the Artois, the Ile-de-France, England, Westphalia, and Lower Saxony—is not arbitrary. It is based on the fact that the great artistic problems of the Romanesque style were here tackled at an earlier date and more thoroughly comprehended and developed than anywhere else in the West. Certainly, South Germany—especially Reichenau, Ratisbon, and Salzburg—, Central and Southern France—especially Cluny and Cîteaux—, Italy and Spain have also produced works of an astonishing originality and extraordinary beauty. But except in works bearing signs of direct contact with north-western art they remain more or less outside the general development. Almost untouched and undisturbed by the adventures and revelations of the so-called Renaissance of the Carolingian and Ottonian dynasties, Italy, Spain and part of Southern France created their individual local styles by continuing the tradition of the decaying Mediterranean art of Late Antiquity which had already undergone Oriental, specifically Coptic, Syrian, and Arabic influences. Until the twelfth century these countries were too deeply involved in this process of absorbing form and content of the ancient world to feel the new liberating and refreshing forces which were the result, in the north, of the wholesome emotional tension existing between the old heritage of a purely abstract form of artistic expression and the new experience of the naturalistic narrative art of the Mediterranean. Certainly, those countries had access to the same sort of Late Antique and classical models on which, for instance, the Gospels of Ebbo of Reims (Pl. 6, fig. 10), the Utrecht Psalter (Pl. 2, fig. 2, Pl. 4, fig. 6), the Bible of San Callisto (Pl. 58), the Terence illustrations of Corvey (Pl. 13, fig. 31), and the

Introduction

constellations in Aratus' astronomical treatise in a Leiden manuscript (Pl. 68, fig. 156) are based. But it is significant that all these outstanding works of Carolingian art are products of the North. It was only here that the Late Antique models were able to kindle a spark of the classical spirit. Only here were they grasped with such passionate sincerity, with such youthful freshness, and with such true understanding of their style and technique that at first sight it may often be doubtful whether they were Carolingian works or Late Antique originals. However, the historical success and the artistic achievement of these works do not lie only in this extraordinary capacity for the faithful reproduction and reinterpretation of classical form and content. Copy work as such, no matter how true to the original, never has the power to create a new style. And the new contribution of north-western European art in the eleventh century is that it brought about a unique transformation of the Mediterranean models; they became dynamic and charged with emotion through the rhythmical distribution of lines and patterns counteracting or reinforcing one another. As an historical achievement this transformation means nothing less than the junction and reconciliation of Mediterranean and Northern artistic expression.

These works and the great number of related miniatures, rock-crystals, and reliefs in gold and ivory (Pls. 1–18) originating in Aachen and Reims and spreading all over Northern France and Lower Lorraine, chiefly to Metz, Corbie and St. Denis, are distinguished by a highly impressionist and nervously sensitive style which, however, is not the only one of Carolingian art. Diametrically opposite styles of equal artistic merit, but based on entirely different models, were developed at the same time in Tours, Fulda, St. Gall and in the so-called Ada School which is now localized in Aachen. In the last quarter of the tenth century, almost a hundred years after the collapse of the Carolingian empire, a cultural reorganization, hitherto unexampled in its proportions and expansion, started under the protection of the Ottonian and Anglo-Saxon rulers and through the agency of the monastic reforms headed on the Continent by Odo of Cluny and in the British Isles by St. Dunstan, Archbishop of Canterbury (957–988). And the remaining works of all these various Carolingian styles came to serve as the chief source and the point of departure for a new artistic activity. They were copied whole or in parts wherever they happened to be preserved.

Thus we now meet, for example, miniatures copied in Trèves from books written in Reims and Tours, because a Bible of Tours and a Gospel-Book from Reims happened to be preserved there. But, however accidental the possession of imported Carolingian works in a new artistic centre might have been, the constructive influence of these works upon the succeeding development seems in each case to have been controlled by the degree of inner affinity and susceptibility to the qualities of the specific Carolingian monument.

This statement may at first sound like a modern interpretation which should not be applied to mediaeval art. However, this is the period when the various European countries were

Introduction

beginning to adopt and to develop their own distinctive national and regional features; and after the definite end of the Carolingian centralization there emerged a rising number of artistic styles of individual local and regional character, especially in the newly-founded dioceses in the North and the East. And it cannot be denied that these various new local styles, concentrated in the artistic output of their respective dioceses, betray from the start certain predilections and different degrees of susceptibility in their reaction to the available Carolin-

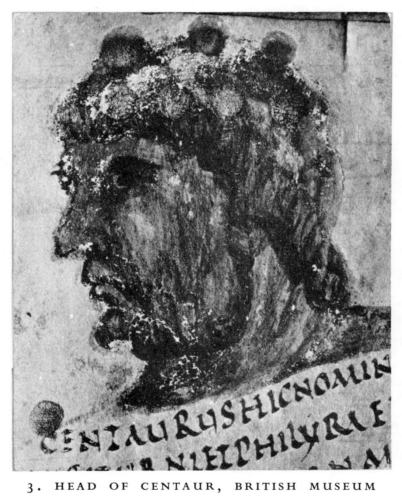

3. HEAD OF CENTAUR, BRITISH MUSEUM

gian monuments. Certain productive artistic centres in Italy as well as in southern Germany possessed outstanding monuments in the Reims tradition (Pls. 4, 8–12) which, even when they were successfully copied, never occasioned a profound change of style or were of any vital consequence in the local artistic development; while in the same places works of the Ada School had a highly effective formative influence. On the other hand, the entire production of Lower Lorraine, Cologne, Northern France and England is based on the Reims

20

tradition, while the monuments of the Ada style which seem to have been available (Pl. 56, fig. 127) contributed but little to the artistic formation.

It is the genius of the art of north-western Europe that in the patrimony of Byzantine art it discovered and revealed the living Greek element, the organic conception of the human body. Nowhere else in Europe was the impressionistic, sketchy manner of the narrative style in the Reims tradition caught with so much eagerness and appreciation. And only here did it remain alive and creative through the whole of the eleventh and twelfth centuries.

Thus, the significance of the Reims school lies not only in its own great artistic achievements, exemplified by the drawings of the Utrecht Psalter and the paintings of the Gospels of Bishop Ebbo of Reims (810–833), but also in that it remained strong enough as a force to be instrumental in shaping the Romanesque and the Gothic styles. The historical contribution of the Reims tradition is that its liberating influence prevented both the laboured classicism and solemn monumentality of the Ada School and the rigid discipline and hieratic order of Byzantine art from making the Romanesque style a mere sterile formalism; its continuity signifies the victory of Hellenic classical humanism over the abstract and anti-naturalistic form of artistic expression of the North and over the hieratic formalism of the East.

Ebbo of Reims, who was also for a time Bishop of Hildesheim in Lower Saxony and an exile in Fleury on the Loire, must have had a personal share in the propagation of the Reims manner. The Evangelist portraits of his famous Gospel-Book were copied in Liége and other places, and we have also reason to assume that under his guidance and initiative the Reims style was introduced into Fleury and Hildesheim, whence it was imported into England a century and a half later. There is indeed enough documentary evidence to advance such a theory. At least three ninth-century books with pictures in the Reims style possibly came from Fleury: the Physiologus in Bern, the Aratea in Paris, MS. lat. 5543, and the British Museum MS. Harley 647. A late tenth-century copy of a lost Reims Gospel-Book of the Ebbo type at Le Puy (Pl. 6, fig. 11) may also have been written at Fleury.

St. Ethelwold, Bishop of Winchester, and Oswald of Worcester were acquainted with the scriptorium of Fleury and through such men as Abbo of Fleury, who taught at Ramsey (c. 986–8), the Harley manuscript containing the most classical of all Carolingian astronomical illustrations in the Reims manner (Illustration no. 3) was brought to Canterbury where it was copied several times in the best Winchester manner. It may not even be too bold to raise the question whether it was perhaps through the same channels that the Utrecht Psalter reached the British Isles since, as will be seen later, it was also copied in Canterbury; and at least one of its copies had an enormous influence on the Winchester style (Pl. 2, fig. 3). In addition, Aelfric's Anglo-Saxon translation of the Pentateuch, from Canterbury, has a picture of the Death of Moses which also presupposes a Reims prototype in the manner of the Bible of San Callisto (Pls. 58–9).

Introduction

This Carolingian Bible, the Aelfric Pentateuch and the only other known Anglo-Saxon picture book, Caedmon's poem of the Fall of Man, reflect in style as well as in iconography a cycle of illustrations to the Book of Genesis which also served as a model for the story of Adam and Eve on one of the greatest monuments of eleventh-century sculpture, the bronze doors which Bishop Bernward of Hildesheim caused to be cast for St. Michael's Church in 1006 (Pls. 46–8). Bernward, whose many-sided artistic tastes can be judged from the various miniatures and works of art which were ordered by him and bear his name, might well, of course, have become acquainted with the Carolingian model of the Adam and Eve story on one of his visits to France and, since the iconography of this story appears also on the Carolingian Bibles of Tours, it is generally assumed that it was a Touraine manuscript which served as a model for Bernward's doors. However, Ebbo was one of Bernward's predecessors on the See of Hildesheim, and the style of drapery on the reliefs of the door and their composition reveal also a knowledge of other Carolingian works in the Reims manner. The theory cannot therefore be quite discarded that it was Ebbo himself who imported the Reims tradition into Hildesheim and that Carolingian works were available there when Bernward's revival of the Reims style began. At least, a Gospel-Book illuminated in the Reims style, now in Hanover, belonged to the Guelph Treasure of Lüneburg and might thus be regarded as a monument of Ebbo's activity in Lower Saxony. Furthermore, the extraordinary sense of drama in the rendering of the story that distinguishes the reliefs of the Hildesheim doors prevail also in another monument of the Reims tradition, originally preserved in this region, the illustrations of Terence's Comedies, from Corvey Abbey, now in the Vatican Library (see also fig. 31). The same excessively dramatic style of the narrative links the Hildesheim doors with the two Anglo-Saxon Genesis cycles (Pls. 46–8), and betrays an affinity between them which makes a common descent from Carolingian Reims prototypes appear very likely. Other tangible evidence of the connection between the Reims traditions in Hildesheim and in England is provided by Bernward's two silver candlesticks and his crozier (Pls. 50–1), whose lively climbing figures survive and re-appear one hundred years later in the magnificently exuberant gilt candlestick of Abbot Peter of Gloucester (1107) (Pls. 89, 90). At any rate Lower Saxony, with Hildesheim as its artistic centre, now became the chief place for the production of bronze casting, and the export of German metalwork to England during the later part of the eleventh century is recorded in contemporary sources: a pulpit and a bronze and silver-gilt crucifix in Beverly Minster are described as *Opus Teutonicum*.

It is, however, the three copies of the Utrecht Psalter which remain the most important records of the Reims tradition. This Psalter, a unique and most miraculous and personal product of the Carolingian 'Renaissance', is illustrated with no less than a hundred and eighty drawings which in their nervous spontaneity, in the dynamic directness and intensity of their message, rival and challenge the sketches of Leonardo, Rembrandt and van Gogh as well as the

best of Chinese painting, and thus have their place among the few genuinely original productions in the history of art. Brought to Canterbury, perhaps from Fleury, as suggested, shortly before the year 1000, this sumptuous manuscript was of so much consequence and exercised such an active spell that it was copied there three times, first in the eleventh

century, then around 1140, and finally about 1200 (Pls. 2, 3). However, it would be an injustice to the artistic quality of these works to label them mere copies of the Utrecht Psalter. They are creative copies, in the same sense as Michelangelo's copies after Giotto and Quercia, Rubens' copies after Piero di Cosimo, Poussin's after Bellini, or those of Delacroix, Manet, Cézanne, Degas, Matisse and Picasso after the Old Masters. The Utrecht Psalter and its copies, of which the illustration to Psalm 43 is reproduced here on the first two opposite plates, provide the successful solution of the outstanding stylistic problems of north-western Europe. They express better and define more clearly than any abstract terminology framed in the language of art history the artistic aims and the stylistic change of the period from 800 to 1200, the period covered in this book.

The first copy is the manuscript Harley 603 in the British Museum. The great bulk of its drawings, done in the best Winchester style, betray such an amazing understanding of the qualities of the model that it has often been suggested that the creation and the flowering of the so-called Winchester Style in England were brought about only by the migration of the Utrecht Psalter from Reims (or, more correctly, from Hautvilliers) to the British Isles. However, the Anglo-Saxon artists would hardly have been able to render and recreate so convincingly the impressionistic narrative style of the Utrecht Psalter if they had not had an inborn taste and an inner affinity for its specific linear qualities, its independent freshness, its highly sophisticated sensitivity and its 'chromatic phantasies'. Further, they could not have imitated and mastered their

4. THE PROPHET AMOS, DURHAM CATHEDRAL

Carolingian models so easily had they not already been initiated to the inspired classicism of the Reims tradition, long before the Utrecht Psalter came to the British Isles.

The earliest anticipations of the Winchester spirit are the beautiful, freely moving figures and leaves embroidered in coloured silk on the stole and maniple of Bishop Frithestan of

23

Introduction

Winchester (*c.* 910), found in the tomb of St. Cuthbert (Illustration no. 4). The Winchester framework with its accentuated corner pieces, which is fully developed in the Benedictional of St. Aethelwold written between 975 and 980 (Pl. 55, fig. 124), is derived from the Franco-Saxon schools (Pl. 18, fig. 42); and the luxurious and almost exotic exuberance of the acanthus leaf that covers this framework originates in the scriptorium of Metz (Pls. 1, 16). The iconography, too, of some of the pictures of the Benedictional suggests continental Carolingian models. The Baptism of Christ with the personification of the river Jordan and the Dove holding in its beak the ampulla with the oil of the chrism is taken from a relief on an ivory reliquary casket of the 'Metz School' which was probably among the gifts of Otto the Great to his brother-in-law, King Aethelstan (Pl. 54–5). Although the figures in the Benedictional and in the few other surviving Anglo-Saxon miniatures of the earlier tenth century do not conceal the influence of the ponderous and solemn solidity of the Ada School (Pls. 54, 56), the massively conceived bodies are animated by a buoyant lightness which betrays the assimilation of the Reims style. This balance between the Ada and the Reims traditions is perhaps most successfully achieved in the miniatures of the Gospels of York Minster (Illustration no. 5). In this manuscript the Evangelists are set against a spacious and airy landscape, after the fashion current in the 'Palace School of Aachen' and in Reims (Pl. 6) and continued in the so-called Coronation Gospels of the Anglo-Saxon Kings (Pl. 7). This tenth-century book illuminated for the Abbey of Lobbes in Lorraine, near Liége, was a little later brought to England, probably also as a present from Otto the Great, and here its Evangelists were copied in a manuscript now at St. John's College, Oxford. The copies are timid, sober, and unpretentious outline drawings, but they prove the Anglo-Saxon readiness to accept the Carolingian models of the Reims tradition; and one might with reason venture the opinion that other more elaborate and inspired copies were made of the Coronation Gospels, and that another manuscript in the Reims style was imported into England which may have served as a model for the York Evangelists.

The drawings of the Harley copy of the Utrecht Psalter are more than just a brilliant English essay in the Reims manner. Done by different artists, the youngest of whom already belongs to the time of the Norman Conquest of 1066, they offer a unique opportunity for closely watching two generations at work. Comparing each drawing with its original, one discovers one draughtsman whose artistic temperament made faithful copying in the long run tiresome and unbearable to him. The nervous turbulence and restless vivacity of the original which he had to copy inspired him into taking liberties and with a courage quite his own he embarked on a personal interpretation of the text of the Psalter. All the artists in the Harley MS. have two things in common that make their work so progressive. They render the narrative of the original with an even greater dynamic vivacity, and they copy the drawings not in their monochrome colour but in plain strokes of red, green, blue, amber and lilac.

Introduction

This change proves to have been of revolutionary stylistic consequences, for not only does it produce a new polychromatic effect but it also signifies a fundamentally new aesthetic direction. It marks the disintegration of the impressionist tradition of classical art and its Carolingian revival, and announces the dawn of the Romanesque style. The monochrome lines and contours in Carolingian art, which in spite of their expressive emphasis had yet created a certain naturalistic illusion and, by means of light and shade, had suggested a visual

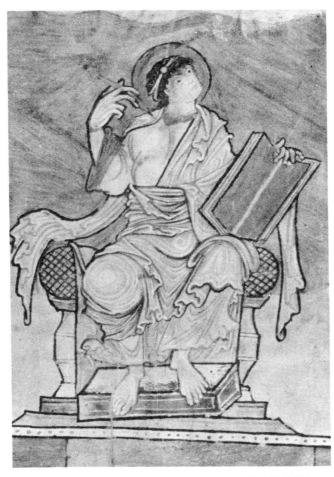

5. ST. MATTHEW, YORK MINSTER

pictorial unity of object and space, became increasingly abstract and hardened, and were more and more used as ornamental patterns. But what is lost in optical function and naturalistic illusion is gained in linear definition of form and rhythmical structure. Especially revealing of this transformation is the change in material and in the enamel technique of the metal-work which takes place at the same time: the embossed reliefs in thin, shimmering gold and the translucent *cloisonné* enamels of Carolingian and Ottonian art (Pls. 26–7) are gradually being

replaced by line-determined, solid bronze casts or copper engravings and by opaque copper *champlevé* enamels. With the help of this abstract linear system there developed a new style which possessed a block-like three-dimensionality and a concentrated weight but was void of all optical experience of light and space.

This change of stress from fluidity to solidity which separates the art of the ninth and tenth centuries from Romanesque art originated in Lorraine. Under the influence of the Ottonian schools of Western Germany, which about the year 1000 produced some of the greatest and most ambitious works of mediaeval art—for instance, the Golden Altars of the Minsters of Bâle and Aachen, the manuscripts and reliquaries of Egbert of Trèves, some goldsmith works of the Treasure of the Holy Roman Empire and of that of the Essen Minster (Pls. 19, 23, 26–33, 37, 39–42, 44, 45)—there developed, in Stavelot and Liége, a metallic style whose sombre monumentality and ponderous rigidity counteracted and curbed the lightness and extravagances of the Reims-Winchester manner. The sobering effect of this style can indeed be followed wherever the production of the Continent had felt the grip of Anglo-Saxon art or the Reims manner had survived. We see it in St. Bertin of St. Omer and in St. Vaast of Arras, in St. Amand and Marchiennes, in Normandy, Chartres, and St. Denis (Pls. 67–78, 81, 84, 85). In the magnificent Bible of St. Vaast's there are miniatures in the heavy, sombre body-colour of the Liége style side by side with drawings which retain all the sensitivity and lightness of the Reims tradition (Pls. 73, 74). A Sacramentary from Liége which, significantly, borrows from the Utrecht Psalter for one of its miniatures the rare illustration of Psalm 84, Verse 11: 'Truth shall spring out of the Earth and Righteousness shall look down from Heaven' was used in the Diocese of St. Omer (Pl. 83), where the closest relations with Anglo-Saxon art and culture had been entertained a generation before under Abbot Odbert of St. Bertin. Stylistically, the Life of St. Omer (Pl. 83) illustrated in the last quarter of the eleventh century depends on Liége work; and so do a number of miniatures in the Encyclopaedia by the monk Lambert of St. Bertin, about 1120, which is known as the *Liber Floridus* (Pl. 114). A comparison of the ivory statuettes from that abbey (Pls. 63, 67) shows most clearly how the sketchy, airy Anglo-Saxon manner has been superseded by a solid block-like style under the influence of such Liége work.

It is generally thought that the intrusion of this heavy Liége style into Anglo-Saxon art was the result of the Norman conquest. But the gold cover of one of the Gospel-Books of Judith Guelph (Pl. 64) and some of the miniatures in the Troper of Hereford, done about 1040 (Pl. 66), already possess the airlessness and frozen animation of these continental works. During his exile in Flanders Leofric of Exeter (1050–72) had miniatures painted in the Liége manner inserted into his Gospel-Book, which is a ninth-century manuscript, and it is probably such work that turned the trembling lightness of the Winchester tradition into a hard Romanesque style. At the same time, works like the celebrated gilt Gloucester candlestick of 1104 (Pls.

89, 90), the miniatures of the St. Augustine codex in the Laurentiana (Pl. 87), or the ivory crozier in the Victoria and Albert Museum (Pl. 88), reveal in the luxuriant growth of their scroll-work and the vigorous turbulence of their figures the extraordinary tenacity of the Anglo-Saxon tradition and secure its survival in its struggle against the superimposed continental style.

On the Continent, however, the metallic, hard, massive, and ponderous style continued during the greater part of the twelfth century under Byzantine influence. It is no mere chance that here the abstract patterns of Oriental textiles with their recurring circles and other geometrical motifs, strictly subordinated to an ornamental design, played a decisive part in shaping the architectonic structure of Romanesque art. They take the place of the illusionistic background and the unreal gold-ground of the preceding periods and thus produce a virtual interweaving of ornament and figure, a complete fusion of pattern and subject matter (Pl. 83, fig. 193). Each part of a figure or an object now becomes firmly defined and isolated by sharp lines, and all are welded together into a purely abstract geometrical unity. By these means, the whole picture surface is being related and subjected to a new, well-regulated system, a sort of groundplan design with many subdivisions in which forms of various sizes, even the framework and the inscriptions, become part and parcel of the whole. The logic and clarity of this sytem, already anticipated in the book-covers of Bouvières-aux-Dames and Echternach (Pl. 23), provided a perfect vehicle to depict the methodical, comprehensive themes of the new scholastic world order, the *Summa Theologica*, and of the typological cycles, i.e. the many parallels between the Old and the New Testament through which Christian iconography then became so immensely enriched (Pls. 144, 145, 206–7). At the same time, figures and objects, reduced to their cubic elements by this principle of dividing the surface into firmly outlined geometrical shapes, are built up into block-like masses; and by means of a concentration of weight they eventually give forth a sense of three-dimensional reality of form not dependent on the natural appearance of what they are supposed to represent. This process explains the close similarity that now exists between the shape and pattern of an initial and an aquamanile (Pls. 114, 115). What makes us so fully aware of the qualities inherent in this style, and so susceptible to them, is perhaps our modern consciousness of the function of geometric structure in organic forms.

It is chiefly in the work of a great influential goldsmith, Roger of Helmarshausen, an abbey on the Weser, and in the output of his school that we are able to follow this slow process of gradual three-dimensional realization of form through abstract design. The niello-engraved Apostles on his silver altar in Paderborn of 1100 (Pl. 102) contain the full power of sculptural expression and could thus be transformed into actual three-dimensional sculptures on the shrine of St. Godehard in Hildesheim with as much exactness as if they had been the actual sculptor's drawings for them. Another work of the school of Roger, revealing the same con-

struction in three-dimensional space, is the silver-plated and nielloed Christ in Minden (Pl. 104). It has the same grandeur, nobility and austerity as the life-size Werden Crucifix (Pls. 94–95) which, though stilled and hardened, preserves in its floating contours and quivering surface quality the visual continuity between object and space, and thus adheres to the 'Ottonian' tradition of the Cross of Lothair, the Essen Crosses, and the Christ in the Abding-hof Missal. But a comparison of these two tremendously monumental Crosses of Werden and Minden reveals most clearly the advance in sculptural power gained in the course of a single generation through the neglect of optical and spatial illusion and through the reduction of the 'natural' forms of the human figure to its essential cubic elements. That this metallic, hard and rigid, tectonic style succeeded in conquering and pervading all Northern and Eastern Europe as far as Poland and the Scandinavian countries is chiefly due to the powerful influence and the expansive connections of dioceses, monastic orders and confraternities. The Western style of the bronze doors of Gnesen is the result of the colonization of Poland, largely carried out by monks of Liége and other monastic establishments of Lorraine and Flanders (Pls. 116–117). Werden stood in confraternity with Helmstedt and the Werden Christ was probably cast for that Lower-Saxon abbey. That the elements of the Roger style are apparent in paintings of Lund as well as in metalwork of Denmark, Scandinavia, and Komburg in Swabia (Pls. 107–109) is easily explained if one remembers that ties of confraternity connected Corvey, near Helmarshausen, with Lund and Komburg. That is the reason why this book on the art of North-West Europe includes the Golden Altar and the magnificent candelabrum of Komburg, in which all the known techniques of Lorraine and Lower Saxon metalcraft, niello, *email brun*, *champlevé*, *cloisonné* and open-work were most sumptuously applied.

However, this style, capable of suggesting three-dimensionality merely by combining and adding varied forms and shapes of pure ornamental design, and also of producing naturalistic details amazingly carefully observed, would never have had this success if the Reims tradition had not continued to survive. This force alone enabled it to overcome its apparent incapacity for coherent articulation and for the integration of observed details into an organic whole. This does not mean, however, that the importance of the Byzantine tradition, the other style-forming force of Romanesque art, can safely be underrated. But that the superior qualities of Byzantine art—the idea of human dignity, formal order and discipline, the concept of the organic representation of bodies, the preservation of classical types and conventions, the established canons of iconography—became more than merely a chilling and chastening revelation to the emotional drive inherent in Northern art, more than a laboured classicism or a wearisome standardization and dull repetition of the same lifeless cliché, is chiefly due to the inspiring perseverance of the Reims tradition in north-western Europe. It is almost a symbol of the artistic situation that about 1140 when, as a result of the Crusades and the close economic, political and cultural ties with the East, Byzantine influence upon European art

was at its height and created a truly international style, the Utrecht Psalter should have been copied a second time. But the monk Eadwine of Christ Church, Canterbury, who undertook this tremendous labour, was no longer so wholly carried away by the charm and the tremulous lightness of the drawings of the original as were the copyists in the Harley manuscript (Pl. 2, fig. 3; Pl. 3, fig. 4). He renders the original with sober correctness, and with a solid and heavy stroke which recognizes the decisive function of the drapery to outline the structure of the body; and it is characteristic that he encloses each drawing like a panel within a simple frame. These miniatures represent the English version of the new Byzantine manner—also found in the Albani Psalter, the illustrated Life of St. Edmund, the Gospel cycle in Pembroke College, Cambridge, and in contemporary carvings (Pls. 118–123)—at the moment when it was seeking a synthesis with the native Winchester-Reims manner. In some of the succeeding works which belong to the mature international style of Byzantine inspiration, such as the Psalter of Henry of Blois and the Lambeth Bible (Pls. 133, 145, 146), it even seems as if England, having exhausted the formal lessons of Byzantine art, returned to the mannerisms of old Anglo-Celtic design.

On the Continent, Roger of Helmarshausen's work already shows the new life and the new vitality which the Reims tradition was able to extract from these geometrical patterns and these forms suggesting solid mass and concentrated weight. On his portable altar at Abdinghof Abbey, Paderborn, of about the year 1100 (Pl. 101, fig. 232), the martyrdom of St. Blaise is rendered with such vivacity and sensitivity of line and the open-work technique gives the story such an airy, floating spaciousness that it almost suggests Winchester or St. Bertin inspiration. But it is chiefly to Lorraine work, based on Reims as well as on Byzantium, that we have to look for the sources of Roger's style. The Liége (?) ivory plaque with the Marys at the Tomb (Pl. 103, fig. 235) has all the nobility of a work of Byzantine art, like for instance the gilded plaque with the same scene from the Treasure of St. Denis in the Louvre (Illustration no. 6); yet the garments are organized by the same system of folds that is characteristic of Roger's work (Pl. 102). Furthermore, as has been rightly suggested, Roger's drapery style is already evident in the miniatures painted by one of the three chief masters of the great Stavelot Bible of 1096, which amalgamates so many elements of Reims and Byzantine art.

The history of the art of Lorraine in the twelfth century bears the imprint of three of the greatest artist personalities of the Romanesque period: Rainer of Huy, who cast in bronze the baptismal font of St. Barthélemy's, Liége, between 1107 and 1118 (Pls. 110–113); Godefroid de Claire, also a native of the city of Huy on the Meuse, who had an active part in the production of the goldsmiths' work commissioned by his friend and patron, Wibald of Stavelot (1130–58) (Pls. 163–4, 166–9); and Nicholas of Verdun, who completed in 1181 the enamelled plaques of the altar in Klosterneuburg and in 1205 the shrine of the Virgin in Tournai Cathedral (Pls. 218–20). The mere fact that three such distinct artists existed is in

itself significant in a period in which the individual production remains on the whole anony-mous. But what strikes one most in these monuments is a highly developed sense of artistic tradition and continuity and a deliberate attempt at mastering organic plasticity and at pro-ducing with all possible devices three-dimensional space. Their principal elements are already apparent in the Stavelot Bible of 1096 (Pls. 97, 98, 110, 150, 162, 184). Heads, whole

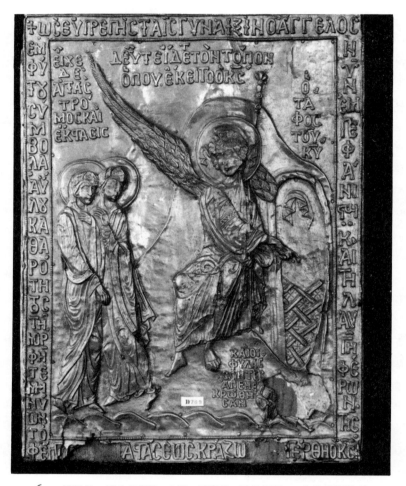

6. THE MARYS AT THE TOMB, LOUVRE

figures, and the inhabited scrolls of the initials in the Bible can be convincingly compared with Mosan bronze sculptures and enamels of the period of Godefroid de Claire. And in the same book Nicholas of Verdun could have found models and sources of inspiration to satisfy his predilection for foreshortening, moving contrapostos, back views and other means of emphasizing movement in space and of creating three-dimensionality. Liége ivory carvings and the miniatures of the Stavelot Bible, both reflecting the Reims tradition, form the basis of Rainer's thoroughly organic and monumental style which is indeed the first expression of

Introduction

a mediaeval humanism achieving the calm but always living harmony of the classical ideal. The fact that contemporary monks call Liége 'the Athens of the North' and compare its school with the Academy of Plato is in keeping with the classical spirit inherent in this art. Rainer's font, resting on a base from which protrude twelve oxen (symbolizing the twelve Apostles), depicts the Molten Sea which, according to the first Book of Kings, Solomon erected in the Temple of Jerusalem. It is a further indication both of the amazingly close artistic tradition existing between the Lorraine workshops and of the striving after three-dimensional illusion which is common to them that Nicholas of Verdun, in need of a representation of the Molten Sea on his Klosterneuburg Altar, went back to the ancient monument and rendered Rainer's font in bird's-eye view on one of his plaques (Pls. 110, fig. 253; 218, fig. 515).

It is another manifestation of this sense of continuity as well as of the vital consequence of Rainer's font for the subsequent Mosan production that its four reliefs are reproduced in a Liége picture-book of c. 1160 (Pl. 113, fig. 259). This book is preserved only in a fragmentary state; yet from its content we can conclude that in its entirety it must have been one of the most complete Bible cycles of the West preserving parts of an Early Christian narrative not depicted on any other known monument. The various problems posed by this picture cycle, especially the question of whether it is copied from an earlier Liége book or compiled in the twelfth century, cannot be discussed in this short survey. However this may be, the pictures of this cycle represent the Mosan, or more precisely the Liége, version of the international style of Byzantine inspiration and iconography; and they are so closely related to the sculptures and enamels of the shrines and crosses commonly labelled Godefroid de Claire that one might almost be tempted to identify them as parts of a goldsmith's pattern-book used in his workshop (Pls. 166–7).

The first of the great Mosan and Rhenish shrines, that of St. Hadelin in Visé, has its historical place between the work of Rainer and that of Godefroid, and its reliefs depend in style on Mosan miniatures. In comparing them with the pictures in a typical Liége manuscript (Pls. 158, 159) we observe in the two works the same characteristic criteria of the Mosan style of 1140–1150: parts of the garments of the figures, especially those covering thigh and calf, are pulled tight, almost as if they were damp and clinging to the skin, in order to emphasize the form of the body underneath, while the mass of the drapery, bulging between the raised parts of the bodies, creates a system of sharply drawn folds radiating from one centre. The bodies thus become more and more articulated and gain in power to suggest sculptural roundness. Yet, like the figures of Roger's style, they are still constructed of separate parts and layers which are added rather than organically united. In the following phase of the development, exemplified by the miniatures of this Liége Bible cycle and the work attributed to Godefroid and his school, these various parts and layers are joined together into an organic reality by the

31

greater plastic value given to the contour and the radiating lines. They are now drawn with a metallic precision, often even in gold, in double strokes, throughout the whole garment and treated as undulating, deeply cut furrows and tubular folds. The two Crucifixions of St. Amand and Maroilles, made at almost the same date, clearly show the difference between the two stages (Pls. 140–1). The new system of 'folds with sculptural value', as it might be called for brevity's sake, quickly infiltrated the figure style of the Rhineland, Westphalia, and Lower Saxony, as well as of the regions on both sides of the Channel (Pls. 160–197, 206–16). We see it in the drawings of a Bible from Malines, in the metal engravings by Wibertus (active *c.* 1165), on Frederick Barbarossa's candelabrum and his Baptismal bowl, and in the enamels of Cologne and Lower Saxony (Pls. 184, 185, 188). That the drawings of a medical treatise, done in the workshop of the Liége Bible cycle (Pl. 208, fig. 483; Pl. 210, fig. 493), were actually copied several times in England is ample proof of the great influential power of this new Mosan style. A few years earlier the situation was the reverse: the English mannerisms of the style of the Canterbury Bible in Lambeth Palace influenced the production of St. Amand and Cambrai, as can be seen in the miniatures of the Gospels of Wedricus, Abbot of Lessies in the Diocese of Cambrai, done in 1147 (Pls. 132–3).

This new style had its origin in metalwork, in copper engraving, niello, and embossed relief sculpture. And it is metalwork that from now on takes the lead and influences the art of painting. On the enamel plaques the figures are no longer painted in coloured pastes of varying patterns, but are modelled by sharp outlines engraved in the gilt copper which emphasize the organic structure. The beginnings of this process can be followed in the miniatures of the story of Job in a codex of St. Omer (Pl. 211) and in the enamelled discs of the magnificent shrine of St. Heribert in Deutz of *c.* 1174 (Pls. 182–4) where suddenly, next to figures filled with body colour, we see figures drawn and modelled most plastically in pure line engraving. Seven years later, in Nicholas of Verdun's altar-piece of 1181, in Klosterneuburg, the greatest enamel work ever done, the possibilities of creating effects of greater plasticity by organic outline drawing rather than by painting in body colour are fully recognized; all its figures are copper gilt, engraved in pure blue outline drawing, and enamel colour is used exclusively for the background (Pls. 218–9).

It is a revealing sign of this new interest in the sculptural and organic appearance of the body that liturgical objects such as portable altars, for instance that of Wibald of Stavelot, or altar crosses and candlesticks, like those of Hildesheim and St. Omer, rest no longer on the ground or on lion's paws, as is usual in the first half of the century, but on three-dimensionally conceived statuettes of human figures (Pls. 169, 175, 177–9). And as all innovations of Romanesque art betray their first timid beginnings in the more subordinate parts of a whole, for instance in the initials of an illuminated manuscript, it is here that we see the first attempt at integrating the articulated, organic structure of the physical body with the spiritually and

Introduction

psychologically animated expression of the human face. It is certainly no mere chance that the same Abbot Wibald, the great patron and personal friend of the goldsmith Godefroid de Claire with whom he exchanged letters themselves remarkable for classical knowledge and humanist wit, commissioned for Stavelot not only the portable altar resting on statues of the Four Evangelists but also the reliquary head of Pope Alexander (Pls. 163–4) of 1145; for this is perhaps the first Romanesque head sculptured in the round that is not a mere cult image

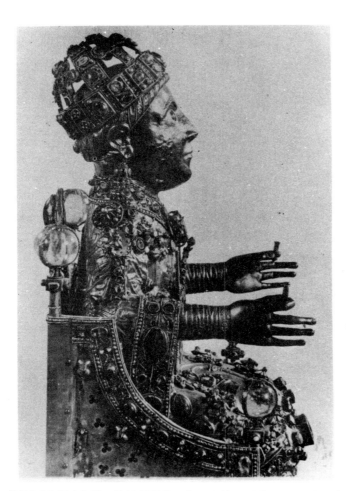

7. RELIQUARY STATUE OF ST. FOY, CONQUES

like the Essen Madonna (Pls. 39, 40) or the reliquary bust of St. Foy in Conques (Illustration no. 7), but a human head in which the physical structure of the face is integrated with its spiritual expression. Though the peculiar stylization of the hair betrays the convention of Mosan art, as indicated for instance in the miniatures of the Bible of Park's Abbey, Louvain, of 1148 (Pl. 162, fig. 357), the head as a whole almost suggests that the metal was hammered around the head of a Roman Imperial statue of Agrippa, whose effigies as the ruler of Belgium

could then be seen in this region as they can be seen today (Illustration no. 8). Moreover, these reliquary heads, as well as the related head-aquamanilia, are derived as a type from provincial Roman water-jars. The so-called Bacchus aquamanile (Pls. 163, fig. 358) in the Aachen Minster betrays the same classicizing spirit; and the reliquary head in Kappenberg (Pl. 165, fig. 363) which actually dares to give the container of the relics the features of the Emperor Barbarossa is a significant symbol of this new interest in the human face.

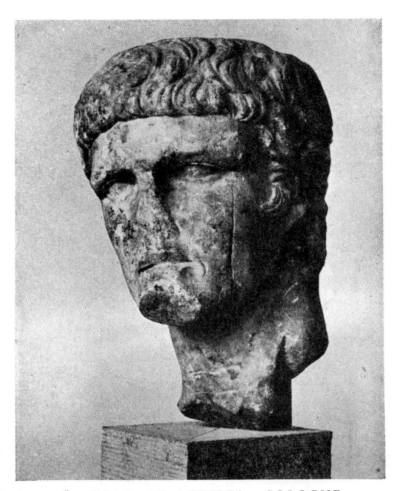

8. HEAD OF AGRIPPA, COLOGNE

The gradual physical and spiritual integration of the human figure can be followed in the great Mosan and Rhenish shrines of St. Servatius in Maestricht, St. Heribert in Deutz, St. Anno in Siegburg (Pls. 171, 182–4, 223), in the work of Nicholas of Verdun and his school (Pls. 218–22), in the contemporary painting of St. Amand, Anchin and Tournai, and in the art on both sides of the Channel (Pls. 142–3, 196–7, 208–12, 228–33). Yet it is once again the liberating power of the Reims tradition, wedded to the Byzantine heritage, that informed

34

this organic sculptural art and turned the frozen animation of the human face into spiritual life. It is at this time that artists of Canterbury or St. Bertin undertook the tremendous job of copying the Utrecht Psalter for the third time (Pl. 3, fig. 5). But now they did it with the full knowledge of sculptural modelling by pictorial means. Just as in the Mosan shrines, structural frames or arcades separate and enclose the scenes; the figures are painted in body colours which most subtly define the functional parts; and they are set against a gold ground which emphasizes their organic life. The same is true of the gold reliefs and bronze statues by Nicholas of Verdun and his school (Pls. 219–21, 224–8). The stormy violence of the seated Apostles and Prophets on the shrines of the Virgin in Tournai and of the Three Kings in Cologne is undoubtedly inspired by contemporary Evangelist portraits like those in the Gospel-Books of St. Amand (in the diocese of Tournai) which are copied from Reims manuscripts of the Ebbo type. * Even the inhabitants of the scrolls in the borders and initials now no longer move in ornamental space, but in the real space of organic life (Pls. 215–6, 222–3). The tendrils of the initials and the thin wires of the filigree no longer form an intricate abstract design. They are twisted, gain more body and evolve finally into organic branches with naturalistic leaves and fruit of such a strong independent existence that it was possible for them to enter into the literary phantasy of a Godfrey of Strassburg who, in his Parsifal and Titurel, speaks of enamelled leaves in natural colours of delicate goldsmiths' work. The chasm between the physical and spiritual worlds which pervaded the thought and art of the Romanesque period is bridged, and their differences are reconciled. The Gothic era had started.

Those who look at the extract of Romanesque art shown on the following plates may reasonably ask on what principle the selection was made. It is not possible to present the whole richness and variety of the period in a book of this size, nor in a much larger one. To include, for instance, the whole world of textiles would have altered the purpose of the book and upset the proportions that had to be observed. The decorative pages of the Codex Aureus of Echternach, inspired by Byzantine silks, which are reproduced on the end papers of the present publication must suffice to give an idea of their importance and the influence which they exercised on Romanesque art. The illustrated cycles depicted in illuminated manuscripts, too, depend so much upon collective effort and cumulative effect that one has to look at the existing separate monographs and facsimile editions to obtain a more comprehensive picture of their achievements. But it is hoped that the restriction to a few examples will stimulate the reader's curiosity to turn to these publications which, for this reason, are mentioned in the notes.

I hesitated long over the choice to be made from these works; and the task of selection and

* A. Boutémy, *Les Evangiles du Musée Mayer van den Bergh*, in Revue Belge d'Archéologie et d'Histoire de l'Art XVIII (1949), pp. 27 ff.

Introduction

sequence proved most difficult. If a strict arrangement by techniques and schools had been followed, the stylistic development and its continuity might have become more illuminating to those who already know the material; but it could hardly have been of help to the unprepared. Above all, it was my intention to choose those monuments which seemed to me the easiest to be grasped in isolation, and at the same time to make the reader aware of the continuity of development by showing representations of related subjects, no matter in what materials they are executed and to what local school they belong. I hope he will find that the plates follow each other in such a way that the transition from one material to another, and from one style to another, presents no difficulty. Of course, all selections of works of art of the past are bound to reflect the tastes of the period in which they are chosen; and the works selected on these plates will disclose their beauty and eloquence only as long as the spectator will see them in relation to the artistic aims of his own time.

9. INHABITED SCROLL ON A RELIQUARY CASKET (See Pl. 154, Figs. 341/2)

NOTES ON THE PLATES

CATALOGUE

1. Fig. 1: Initial "L" as Angel of Matthew. 105 mm. Enlarged detail. METZ, c. 850. *Paris, Bibliothèque Nationale, MS. lat. 9388, fol. 17ᵛ.*

2/3. Illustrations to Psalm 43 in the Utrecht Psalter and its copies. Fig. 2: *Utrecht, MS. 32, fol. 25.* 110 × 230 mm. REIMS, c. 832. Fig. 3: *British Museum, MS. Harley 603, fol. 25.* 95 × 230 mm. CANTERBURY, early XI cent. Fig. 4: *Cambridge, Trinity College, MS. R. 17. 1, fol. 76.* 109 × 180 mm. Written by Eadwine. CANTERBURY, c. 1150. Fig. 5: *Paris, Bibl. Nat. MS. lat. 8846, fol. 57.* W. 290 mm. SAINT-BERTIN or CANTERBURY, c. 1200.

4. Illustrations to Psalm 26. Fig. 6: *Utrecht, MS. 32, fol. 15.* 120 × 235 mm. REIMS, c. 832. Fig. 7: Copy in ivory of Fig. 6. Originally perhaps on the cover of the Psalter of Charles the Bald (846–869) in Munich, Reiche Kapelle. 112 × 88 mm. REIMS (?), c. 860. *Zurich, Landesmuseum.*

5. Fig. 8: Resurrection of the Dead. Personifications of Roma, Sea and Earth. Enlarged detail of a Crucifixion. Ivory. 281 × 128 mm. REIMS (?), c. 860. Possibly by the artist of Fig. 7; originally perhaps on the back cover of the Codex Aureus (see Pl. 10). *Munich, MS. lat. 4452.* Fig. 9: The Earth. Enlarged detail of the miniature of Christ in Majesty. Sacramentary of St. Denis. REIMS (?), c. 870. *Paris, Bibl. Nat. MS. lat. 1141. fol. 3.*

BIBLIOGRAPHY*

1. W. Koehler, *Karolingische Miniaturen III* (1960).

2. E. de Wald, *The Illustrations of the Utrecht Psalter* (1933). F. Wormald, *The Utrecht Psalter.* Utrecht (1953).

3. F. Wormald, *English Drawings of the Xth and XIth centuries* (1952), no. 34.

4. M. R. James, *Canterbury Psalter* (1935).

5. H. Omont, *Psautier illustré, XIIIᵉ–siecle.*—E. G. Millar, *English Illuminated MSS* (1926), pp. 46, 92, Pl. 67.

6/7. A Goldschmidt, *Elfenbeinsculpturen*, I (1914), 42, 43. P. E. Schramm and F. Mütherich, *Denkmale der Deutschen Könige* (1962), 43.

8/9. Schramm-Mütherich (7), 51, 110.

9. A. M. Friend, in *Speculum*, I (1926), pp. 59 ff. W. Koehler, *Karolingische Miniaturen IV (Hofschule Karls des Kahlen).* In the process of publication.

*Numbers in brackets after authors' names refer to the numbers where the full titles are quoted. To avoid unnecessary repetition of titles, preference is given to works containing a full bibliography. For the same reason the following general works published after the first edition of this book in 1954, are listed below:

A. Grabar, C. Nordenfalk, *Early Medieval Painting* (1957) and *Romanesque Painting* (1958).
J. Porcher, *Medieval French Miniatures* (1959).
S. Collon-Gevaert, J. Lejeune, J. Stiennon, *Kunst van Het Maasland* (1961).
T. S. R. Boase, *English Art 1100-1216* (1953).
H. Schnitzler, *Rheinische Schatzkammer* (1957, 1959).

Notes on the Plates

CATALOGUE

6. Mark and his Lion. Fig. 10: Gospels of Ebbo of REIMS (816–835). 190 × 148 mm. *Epernay, MS. 1, fol. 64ᵛ*. Fig. 11: end X century copy of fig. 10; 259 × 199 mm. LIÉGE (?) or FLEURY (?) *Le Puy, MS. 2, fol. 55ᵛ*.

7. Fig. 12: John and his Eagle. 172 × 172 mm. So-called Coronation Gospels of the Saxon Kings. Given by Otto I to Aethelstan. LOBBES (Belgium), *c.* 950. *British Museum, M.S. Cotton Tib. A II, fol. 164ᵛ*. Fig. 13: Luke and his Ox. 232 × 200 mm. LIÉGE, X cent. *New York, Morgan Library, MS. 640, fol. 100ᵛ*.

8. Ciborium Itinerarium (Portable Altar). Given by King Arnulf to St. Emmeram's in Ratisbon. 590 × 310 × 240 mm. Perhaps from the Treasure of St. Denis. REIMS (?) *c.* 870. Upper part. On the roof reliefs in bossed gold, with scenes from the Life of Christ. Precious stones, filigree and cloisonné enamels. Partly restored between 975 and 1001. Fig. 14: Christ forebodes the destruction of the Temple of Jerusalem; Lamb of God; Raising of Lazarus. Fig. 15: Christ calling Peter. Fig. 16: Raising of the Youth of Naim. *Munich, Reiche Kapelle*.

9. Fig. 17: Healing of the Leper. 175 × 155 mm. REIMS, *c.* 830. *Düsseldorf, MS. B. 113, fol. 5*. Fig. 18: The Angel of the Lord holding the disk of Heaven. 160 × 96 mm. LORSCH, end of X cent. *Rome, Vatican, MS. Pal. lat. 1719, fol. 8*. Fig. 19: Healing of the Leper. 65 × 85 mm. Detail of Pl. 10.

10. Figs. 20/21: Front cover of the Codex Aureus. Reliefs in bossed gold. Christ in Mandorla. The four Evangelists; the Woman in Adultery; Chasing from the Temple; Healing of the Leper (see fig. 19) and the Blind. Precious stones, mounted on arcades and chalices; filigree, pearls, cloisonné enamels. Executed for Charles the Bald, *c.* 870. Given by Arnulf to St. Emmeram's in Ratisbon, *c.* 893. 420 × 330 mm.

BIBLIOGRAPHY

10. G. Swarzenski, in *Jahrbuch der Preussischen Kunstsammlungen*, 32 (1902), pp. 81 ff.

11. H. Swarzenski, in *Art Bulletin*, 22 (1940), pp. 7 ff. and *The Role of Copies . . .* , in *Acts of the 20th International Congress of the History of Art I* (1963), pp. 7 ff.

12. F. Wormald, *The so-called Coronation Oath-Books of the Kings of England*, in *Beiträge für Georg Swarzenski* (1951), pp. 233 ff., and *English drawings of the Xth and XIth centuries* (1952), Pl. 40.

13. Belle da Costa Greene, M. P. Harrsen, *The Pierpont Morgan Library. Exhibition of the New York Public Library* (1934), p. 73, Pl. 8.

14–16. E. Molinier, *Histoire Générale des Arts Appliqués à l'Industrie*, IV (1901), p. 94 f.—A. Boeckler, in *Ars Sacra*. Exhibition Catalogue, Munich, 1950, No. 71. Schramm-Mütherich (7), 61.

17. *Ars Sacra* (14–16), No. 43.

18. K. Degenhardt, in *Münchener Jahrbuch der bildenden Künste* (1950), p. 100.

19–21. G. Leidinger, *Codex Aureus* (1926), pp. 87, 118 ff. Schramm-Mütherich (7), 52. O. K. Werkmeister, *Deckel des Codex Aureus*, in *Studien zur Deutschen Kunstgeschichte* 332 (1963).

Notes on the Plates

Notes on the Plates

CATALOGUE

16/17. The Massacre of the Innocents. Rachel weep-
ing for her children. Fig. 36: Ivory. Enlarged
detail of plaque in open-work over a ground of
sheet gold. Originally on the front-cover of MS.
lat. 9388 (see fig. 40). H. 58 mm. The whole
plaque H. 185 mm. METZ, c. 850. Paris, Bibl.
Nat., MS. lat. 9393. Fig. 37: Initial D. En-
larged. H. 45 mm. Sacramentary of Drogo of
METZ (826–855). Paris, Bibl. Nat., MS. lat.
4428, fol. 31. Figs. 38/39: Ivory. H. 450 mm.
The whole plaque H. 220 mm. Enlarged, de-
tails. LORRAINE or N.E. FRANCE, second half XI
cent. Victoria and Albert Museum.

18. The Crucifixion. Fig. 40: Ivory. Enlarged detail
of a plaque in open-work, originally over a
ground of sheet gold. H. 64 mm. See fig. 36.
METZ, c. 850, Paris, Bibl. Nat., MS. lat. 9388.
Fig. 41: 205 × 147 mm. Upper part of plaque
on cover of Munich, MS. lat. 3345. By the carver
of fig. 34. Derived stylistically from a miniature
of the FRANCO-SAXON SCHOOL, like fig. 42:
230 × 175 mm. SAINT-AMAND (?), late IX cent.
Paris, Bibl. Nat., MS. lat. 257, fol. 12ᵛ.

19. Fig. 43: The Crucifixion. 170 × 126 mm. Fig.
44: The Virgin of the Annunciation. H. 40 mm.
Marginal Sketch. Enlarged. Sacramentary of
LORSCH-TRÈVES, last quarter of X cent. Chantilly,
MS. 1447, fol. 4ᵛ, 79.

20. Fig. 45: Annunciation, Nativity, Baptism. Fig.
46: Christ and the two Marys leaving the Tomb,
Ascension, Pentecost. Ivory Diptych. Each
plaque 294 × 121 mm. TRÈVES, second half X
cent. Manchester, Rylands Library.

21. Fig. 47: Moses receiving the Law. Fig. 48: In-
credulity of Thomas. Ivory. Each plaque, 240 ×
100 mm. By the artist of the ivory on fig. 50.
TRÈVES, c. 990. Berlin, Museum.

22. Fig. 49: Enlarged detail of fig. 48. Fig. 50:
Golden Cover of the Codex Aureus of Echter-
nach. 46 × 30 cm. Detail. Christ on the Cross

BIBLIOGRAPHY

36. A. Goldschmidt, Elfenbeinsculpturen, I (1914),
72, 73.

37. W. Koehler (1).

38/39. A. Goldschmidt, Elfenbeinsculpturen, II (1918),
65.—A. Heimann, in Het Nederlands Kunsthis-
torisch Jaarboeck (1959), 5-50, suggests an
English origin.

40. As 36.

41. A. Goldschmidt, Elfenbeinsculpturen, I (1914),
130. A. Boeckler, in Phoebus, IV (1949), p.
145 ff.

42. C. Niver, A study of MSS. of the Franco-Saxon
School. Harvard University, Summary of Theses
(1941).

43/44. C. Nordenfalk, in Münchner Jahrbuch (1950),
pp. 61 ff.

45/46. A. Goldschmidt, Elfenbeinsculpturen, I (1914),

47–50. A. Goldschmidt, Elfenbeinsculpturen, II
(1918), 23 24. C. Nordenfalk, in Zeitschrift für
Kunstgeschichte, I (1932), pp. 153 ff. K.
Oettinger, in Jahrbuch Berliner Museen II (1960),
39 ff. advances without convincing reasons the
date of these ivories in the period of Henry III.

50. One of the decorated pages of the MS. imitating
Byzantine textiles is reproduced on the end
papers. Schramm-Mütherich (7), 85.

Notes on the Plates

with personification of Earth. H. 205 mm. Ivory by the artist of Pl. 21. Gold-cloisonné enamel, glasspaste, precious stones, pearls, filigree. Ordered by Empress Theophanu in the workshop of Egbert of Trèves (985–91). TREVES, *c.* 990. *Nürnberg, Germanisches Nat. Mus.*

23. Fig. 51: Christ on the Cross. H. 165 mm. Ivory. Gold-cloisonné enamel, precious stones. MAAS-TRICHT (?), late X cent. *Maastricht, Cathedral.* Fig. 52: Golden cover of the Gospels of Gauze-lin of TOUL (922–962). The Evangelists engraved (*opus punctile*). Bust of the Virgin in cloisonné and champlevé enamel. Plaques with filigree, precious stones, pearls and cloisonné enamels (one plaque added in XIII cent.). 305 × 220 mm. From the Abbey Bouvières-aux-Dames. LORRAINE, end X cent. *Nancy, Cathedral.*

24. Figs. 53/54: Chalice with Paten. Gold, filigree, precious stones, cloisonné enamel. 132 × 134 mm. Paten 150 mm. As Pl. 23, fig. 52.

25. Fig. 55: Head of Pastoral Staff. Gold, filigree. Presented in 999 by Otto III to Abbess Adelheid I of Quedlinburg. H. 131·5 cm. SAXONY (?), end X cent. *Quedlinburg, Servatius Church.* Fig. 56: Eagle Brooch. From the Coronation vestment of the Empress Gisela. Open-work, gold, cloisonné enamels, filigree, precious stones, pearls. 100 × 93 mm. MAINZ, *c.* 1025. *Mainz, Museum.*

26. The Beasts of the Evangelists. Cloisonné enamels. Figs. 57/58: each 67 × 60 mm. Enlarged details. On a bookcover of Saint-Denis. Gift of Beatrix, wife of Count Frédéric I de Bar (954–1011). Gold, filigree, niello engraving. MAASTRICHT (?) or REIMS (?), end X cent. *Paris, Louvre.* Figs. 59/60: Each 50 mm. diam. CHAM-PAGNE (?), end X cent. *Troyes Cathedral.*

27. Fig. 61: Case of a Nail of the True Cross. 68 × 153 × 42 mm. Gold-cloisonné enamel and glass

51. A. Goldschmidt, *Elfenbeinsculpturen,* II (1918), 172.

52–54. M. Digot, in *Bulletin Monumental,* XII (1846), pp. 507 ff.—E. Molinier (14–16), p. 106 f. —J. Seligmann, *L'Orfèvrerie Carolingienne* (1927/ 28), pp. 137 ff.—*Commemorative Catalogue of the Exhibition of French Art, Royal Academy, London* (1932), No. 1031, 1034.

55. E. Molinier (14–16), p. 120 f.—A. Brinck-mann, *Bau-und Kunstdenkmäler der Provinz Sach-sen,* XXIII. Quedlinburg. (1922), p. 133 f.— Schramm-Mütherich (7), 99.

56. O. v. Falke, *Mainzer Goldschmuck der Kaiserin Gisela* (1913), pp. 12 ff.—Schramm-Mütherich (7), 144.

57/58. A. Darcel, *Notice des Emaux* (1891), pp. 5 ff., 458 ff.—E. Molinier (14–16), p. 118.

59/60. A. Gaussen, *Portefeuille Archéologique de la Champagne* (1861), Pl. 3.—Le Brun-d'Albanne, *Recherches sur l'histoire et le symbolisme de quelques émaux du Trésor de Troyes* (1862), pp. 9 ff., Pl. 1.

61–63. N. Irsch, *Dom zu Trier. Kunstdenkmäler der Rheinprovinz,* XIII (1931), pp. 329 ff.—F.

Notes on the Plates

CATALOGUE

paste, precious stones. Workshop of Egbert of TRÈVES (977–93). Figs. 62/63: 20 × 385 mm. Copper gilt, niello. Reliquary Shrine of the Foot of St. Andrew. The Beasts, Lion of Juda. Gold, ivory, gold-cloisonné enamel and glass paste, open-work (*opus interasile*), pearls, precious stones, filigree. Dedicatory inscription in niello. As fig. 61. The lions' feet added later. 310 × 447 × 220 mm. *Trèves Cathedral*. Figs. 64/65: Lion of Mark. Angel of Matthew. c. 60 × 50 mm. Cloisonné enamels. From the 'Third' Cross in the *Minster of Essen*; end X cent. Fig. 66: Arm Reliquary of St. Blase. Given by Countess Gertrud (died 1077) to Braunschweig Cathedral. At the bottom inscribed: *Gertrud hoc fabricari fecit*. Guelph Treasure (see Pl. 36, fig. 85). BRAUNSCHWEIG (?), soon after 1038. Gold, filigree, precious stones. H. 510 mm. *Braunschweig, Museum*.

28. Fig. 67. Cross of Bernward of Hildesheim (993–1032). Silver. 310 × 210 mm. HILDESHEIM (?), c. 1000. *Hildesheim Cathedral*. Fig. 68. Cross of Lothair. Detail. Gold, filigree, precious stones, cloisonné enamel, rock-crystal with bust of Lothair II (?) (855–69). See fig. 71. Fig. 69: Processional Cross of Abbess Mathilda and her brother Otto, Duke of Swabia (†982). The Serpent below Christ. Detail. Precious stones, filigree (restored in the XIIIth century), cloisonné enamel. (see fig. 70).

29. Fig. 70: Reverse of Cross of Mathilda (see fig. 69). Beasts of the Evangelists. Lamb of God. Gold engraved. H. 445 mm. ESSEN (?), c. 980. *Essen, Minster*. Fig. 71: Reverse of Cross of Lothair. (see fig. 68). Christ on the Cross; Sun and Moon; Hand of God holding a laurel wreath with the Dove of the Holy Ghost; the Serpent. Gold engraved. H. 500 mm. AACHEN, end X cent. *Aachen Minster*.

30. Fig. 72: Christ on the Cross. Silver, niello en-

BIBLIOGRAPHY

Witte, *Tausend Jahre Deutscher Kunst am Rhein*, (1932), pp. 19 ff.—F. Rademacher, in *Trierer Zeitschrift*, XI (1936), pp. 146 ff.

64/65. G. Humann, *Kunstwerke der Münsterkirche zu Essen* (1904).—K. Wilhelm Kästner, *Münster in Essen* (1930).—F. Witte (61–63).—H. Köhn, *Essener Münsterschatz* (1950).

66. O. v. Falke (as 32, 33), p. 20.

67. E. Panofsky, *Deutsche Plastik des XI.–XIII. Jahrhundert* (1924), p. 73 f.—F. J. Tschan, *St. Bernward of Hildesheim*, III (1951), pp. 98 ff., Pls. 91, 92.

68. H. Schnitzler, *Dom zu Aachen* (1950), p. XIX, Pls. 46–49.—Schramm-Mütherich (7), 30, 106.

69. As 64/65.

70. As 64/65.

71. As 68.

Notes on the Plates

CATALOGUE	BIBLIOGRAPHY

graved. On a book cover. 148 × 113 mm. MAINZ, early XI century. *Mainz Cathedral, MS. 1.* Fig. 73: Cross of the Crown of the Holy Roman Empire (see fig. 75). Reverse. Silver, niello engraved. Added to the Crown for Emperor Konrad II (1024–1039). Imperial Workshop, MAINZ (?). *Vienna, Schatzkammer.* Fig. 74: Last Supper. Reliquary casket. Silver, niello engraved. Copper enamel. H. 150 × 260 × 200 mm. HILDESHEIM (?), c. 1000. *Hildesheim Cathedral.*

31. Fig. 75: Crown of the Holy Roman Empire. Gold, pearls, precious stones, plaques in cloisonné enamel. Christ between two Cherubs. LORRAINE (?), end X cent. 240 mm., diameter 21 mm. Arc and Cross (see fig. 73) added for Konrad II. On the arc in pearls the inscription: CHUONRADUS DEI GRATIA ROMANORUM IMPERATOR AUGUSTUS. Probably given to the Emperor in 1032 after the death of Conrad III of Burgundy. Imperial Workshop, LORRAINE and MAINZ (?). *Vienna, Schatzkammer.*

32. Figs. 76–78: Cross of the Holy Roman Empire (see fig. 79). Reverse. Silver, niello engraved with the Beasts of the Evangelists and portraits of the Apostles. Details. Lion of Mark, Thadaeus, Lamb of God, Angel of Matthew.

33. Fig. 79: Cross of the Holy Roman Empire. Front. Gold, pearls, precious stones mounted on arcades, rock-crystal, filigree. 78 × 71 cm. Detail. Imperial Workshop, MAINZ (?), c. 1030. *Vienna, Schatzkammer.* Fig. 80: 'Fourth' Processional Cross of Essen. Gold, precious stones and pearls mounted on arcades, filigree, rock-crystal; cloisonné enamels from a work of the period of Abbess Mathilda (see Pl. 28, fig. 69). Gift of Abbess Theophanu (1039–56). H. 450 mm. Detail. (see Pl. 36, fig. 84 and Pl. 100, fig. 230). ESSEN, c. 1050. *Essen, Minster.*

34. Figs. 81/82: So-called Reliquary Cross of Bernward. Gold, filigree, precious stones,

73, 75–79. F. Bock, *Kleinodien d. Römischen Reichs Deutscher Nation* (1864).—J. v. Schlosser. *Schatzkammer des Allerhöchsten Kaiserhauses* (1918). —A. Weixlgärtner, in *Jahrbuch der Kunsthistorischen Sammlungen in Wien* (1926), pp. 15 ff.— A. Weixlgärtner, *Geschichte im Wiederschein der Reichskleinodien* (1938).—E. Meyer, in *Zeitschrift für Kunstgeschichte*, X (1943), p. 193 f.— H. Fillitz, in *Jahrbuch der Kunsthistorischen Sammlungen in Wien* 50 (1953), pp. 23 ff. and *Katalog der Schatzkammer* (1961). Schramm-Mütherich (7), 67, 145-47.

74. V. H. Elbern, in *Das erste Jahrtausend* II, 1080 ff.

80. As 64/65.

81/82. F. J. Tschan (67), pp. 91 ff., Pls. 82–88.— H. Schnitzler, in *Karolingische und Ottonische*

Notes on the Plates

CATALOGUE

pearls, rock-crystal, one an intaglio with Christ
on the Cross, the other containing a Relic of
the Holy Cross, a present to Bernward by Otto
III. Reverse: Christ on the Cross. Silver
engraved. H. 475 mm. HILDESHEIM (?), *c.* 1100.
Hildesheim, Magdalen Church.

35. Fig. 83: Reliquary Cross of Bertha of Borghorst
(†988). Gold, filigree, precious stones, pearls,
rock-crystal. Embossed plaques with the Cruci-
fixion, SS. Cosmas, Peter, Paul, Damian, por-
trait of Henry II received by two Angels; prob-
ably later additions from another object. Re-
verse engraved with portrait of Abbess Bertha.
410 × 280 mm. LIESBORN or ESSEN (?), soon
after 1024. *Borghorst (Westphalia) Church.*

36. Fig. 84: Book-cover of Abbess Theophanu.
350 × 260 mm. Christ in Mandorla held by two
Angels, SS. Peter Paul, Cosmas, Damian, Vir-
gin with Child, Pinnosa, Waldpurgis. Donor's
portrait of Theophanu (1039–56). Embossed
gold, filigree, precious stones, pearls. ESSEN,
c. 1050. Ivory: Crucifixion with Church and
Synagogue, Ascension, Resurrection of the
Dead, Nativity, Evangelists writing on the back
of their Beasts. Copy of an XI century ivory of
Liége in Brussels. COLOGNE, *c.* 1050. *Essen,
Minster.* Fig. 85: Portable Altar. Sigismund,
Adelheit, Constantine and Helena adoring the
Holy Cross. Embossed gold, cloisonné enamel,
niello, filigree, semiprecious stones, pearls.
207 × 103 mm. Given by Gertrud (†1077) to
Braunschweig Cathedral. Guelph Treasure.
BRAUNSCHWEIG, *c.* 1038. (see Pl. 27, fig.
66). *Cleveland, Ohio, Museum.*

37. Fig. 86: Entry into Jerusalem. Detail. One
of the unrestored parts of the plaques of the
Golden Altar of Aachen. Probably a gift of
Otto III. H. 230 mm. AACHEN (?), *c.* 1000.
Aachen Minster.

38. Figs. 87/88; Virgin and Child. Ivory. 220 ×

BIBLIOGRAPHY

Kunst (1957), pp. 382 ff.

83. S. H. Steinberg, C. Steinberg-v. Pape, *Bildnisse
Geistlicher und Weltlicher Fürsten*, I (1931), p.
116, No. 5.—*Westfalia Sacra.* Exhibition Cata-
logue, Münster, 1951/52, No. 3.

84. As 64/65.—A. Goldschmidt, *Elfenbeinsculpturen*,
II (1918), 58.

85. Von Falke (32/33), pp. 20, 41 ff., No. 5; Pls.
11–13.

86. H. Schnitzler, *Dom zu Aachen* (1950), p. XX f.,
Pls. 62-65. *Fulda oder Reichenau*, in *Wallraf-
Richartz Jahrbuch XIX* (1957) pp. 39–132;
Goldaltar von Aachen (1965).

87/88. A. Goldschmidt, *Elfenbeinsculpturen*, II

Notes on the Plates

CATALOGUE

100 × 55 mm. MAINZ (?), c. 1000. *Mainz, Museum.*

39. Figs. 89/90: Virgin and Child. Embossed gold, filigree, precious stones, the eyes in enamel, throne in gilded copper. Gold cloisonné enamels, Probably a donation of Abbess Mathilda (see Pl. 28, fig. 69). H. 740 mm. ESSEN, or MAINZ, end X cent. The Eagle brooch, c. 1000. *Essen Minster.*

40. Fig. 91: Head of the Virgin. Detail of fig. 90. Fig. 92: Model or impression in wax of the head of Michael (fig. 93) on the Golden Altar of Bâle. H. 100 × 170 mm. *Munich, National Museum.*

41/42. Details from the Golden Altar given for the Dedication of Bâle Minster in 1019 by Emperor Henry II and Kunigunde. Embossed and stencilled gold, precious stones, pearls. 120 × 177 cm. MAINZ (?), between 1002 and 1019. *Paris, Museé Cluny.* Fig. 93: Head of Michael. H. 100 mm. Fig. 94: Empress Kunigunde at the feet of Christ (see Pl. 45, fig. 101). 75 × 100 mm. Fig. 95: Benedict and Michael. H. of figures c. 635 mm.

43. Angels holding panels with the introduction to the Gospels. Fig. 96: H. 300 mm. MAINZ (?), c. 1030. *Fulda, MS. Aa 44, fol. 70.* Fig. 97: H. 350 mm. STAVELOT, c. 1000. *London, Chester Beatty Coll. MS. 17, fol. 118.* Now Brit. Mus.

44. Inhabited scrolls. Fig. 98: Sketch, with Saint, perhaps for work in gold or ivory. Single leaf. 267 × 200 mm. MAINZ (?), end X cent. *Bâle, Collection R. von Hirsch.* Fig. 99. W. 80 mm. Detail of border. Golden Altar of Bâle (see Pls. 41, 42). Fig. 100: Sheaths of the Sword of the Abbesses of Essen. Embossed gold. H. 802 mm. Detail. ESSEN, c. 1000. *Essen Minster.*

45. Fig. 101. Christ holding the globe. H. 670 mm. At His feet Henry II and Kunigunde. Medallions with personifications of Fortitude and Modera-

BIBLIOGRAPHY

(1918), 40.—C. Nordenfalk, in *Münchner Jahrbuch der Bildenden Kunst* (1950), p. 76.

89–91. As 64/65.

92–95. R. F. Burckhardt, *Basler Münsterschatz* (1933), pp. 29 ff.—W. Otto, in *Zeitschrift für Kunstgeschichte* (1950), pp. 39 ff.—T. Buddensieg, in *Wallraf-Richartz Jahrbuch XIX* (1957), pp. 133 ff. Schramm-Mütherich (7), 138.

96. A. Boeckler, in *Ars Sacra*, Exhib. Cat., Munich, 1950, No. 110.—H. Swarzenski, in *Art Bulletin*, 24 (1942), p. 293. H Schnitzler, *Fulda . . .* (86).

97. E. G. Millar, *Catalogue of the Western MSS in the Library of A. Chester Beatty* (1927), MS. 17, pp. 64 ff., Pls. XLIII–XLV.

98. O. Homburger, in *Kunst des frühen Mittelalters*, Exhibition Catalogue, Bern, 1949, No. 69.

99. As 92–95.

100. As 64/65.

101. As 92–95.

Notes on the Plates

CATALOGUE

tion. Centre of the Golden Altar of Bâle (see Pls. 41, 42). Fig. 102: Christ led to Herod. H. 550 mm. Detail. From the Doors of Bishop Bernward of Hildesheim (993–1032). Bronze cast. HILDESHEIM, 1015. *Hildesheim Cathedral.*

46. Fig. 103: Adam and Eve before God. Fig. 104: Expulsion from Paradise (detail). As fig. 102.

47. Fig. 105: The serpent in the Tree of Knowledge inspiring evil desire in Eve and Adam. 110 × 145 mm. Caedmon's Pentateuch. WINCHESTER or CANTERBURY (?), early XI cent. *Oxford, Bodleian, MS. Junius XI, fol. 20.* Fig. 106: Adam and Eve hiding before God. 88 × 178 mm. Aelfric's Anglo-Saxon paraphrase of Pentateuch and Joshua. CANTERBURY (?), c. 1025. *British Museum, Cotton MS. Claud. BIV, fol. 7).*

48. Sacrifice of Cain and Abel. Fig. 107: Bernward's Doors (see Pl. 45, fig. 102). Fig. 108: Cover of a Reliquary Casket. 146 × 227 mm. Copper gilt. Engraved. From the Guelph Treasure of St. Michel's. LÜNEBURG (?), second quarter XI cent. *Hannover, Museum.*

49. Fig. 109: The Three Women at the Tomb. Harrowing of Hell. 245 × 195 mm. Gospels of Abdinghof (Paderborn). WESTPHALIA, end X cent. *Kassel, MS. theol. fol. 60, fol. 2.* Fig. 110: Gideon and the Angel. Scenes from Judges VI, 21. W. 160 mm. Cup from Wloclawik. Silver embossed. BELGIUM, LOWER SAXONY or POLAND, X cent. *Krakowj National Museum.*

50. Figs. 111, 112: Candlesticks of Bernward. One of a pair. Details. Naked men riding dragons; climbing men and beasts in vine. Silver gilt. H. 460 mm. HILDESHEIM, end X cent. *Hildesheim, Magdalen's Church.*

51. Figs. 113/114: Head of Pastoral Staff of Bernward. Creation of Adam, or Adam before God. The Temptation. On the node, the Rivers of Paradise. Silver gilt. H. 110 mm. Signed Erkenbold (Abbot of Fulda, 996–1011).

BIBLIOGRAPHY

102–04. A. Goldschmidt, *Die mittelalterlichen Bronzetüren,* I (1926).—F. J. Tschan, *St. Bernward of Hildesheim,* II (1951), pp. 141 ff., Pls. 115–136.—R. Wesenberg, *Bernwardinische Plastik* (1955).

105–06. I. Gollancz, *The Caedmon MS.* Complete Facsimile (1927).—E. G. Millar, *English Illuminated MSS.* (1926), pp. 18 f., 22, 90. F. Wormald, *English Drawings of the X^{th} and XI^{th} centuries* (1952), No. 28, pp. 39 ff., 67; No. 50, pp. 39 ff., 76.

107. As 102–04.

108. F. Stuttmann, *Reliquienschatz der Goldenen Tafel des St. Michaelklosters in Lüneburg* (1937), p. 62.

109. A. Goldschmidt, *German Illumination,* I (1928), p. 24 f., Pls. 81/82.—H. Deckert, R. Freyhan, K. Steinbart, *Religiöse Kunst aus Hessen und Nassau* (1932), pp. 91 ff., No. 137, Pls. 147–51.

110. W. Gorzynnski, W. Stroner, M. Sokolowski, *Czara Wloclawska* (1911).

111/12. F. J. Tschan (102–104), pp. 129 ff., Pls. 107–13.—Wesenberg (102–4), 21 ff.

113/14. E. Schlee, *Iconographie der Paradiesesflüsse* (1937), p. 16 f. F. J. Tschan (102–04), p. 83 f., Pl. 81.—Wesenberg (102–4), 17 ff.

Notes on the Plates

CATALOGUE

Hildesheim Cathedral. Figs. 115/116: Personifications of Winds. H. *c.* 100 mm. From the edges of the base of the candlestick in the *Essen Minster.* H. 230 cm. Dedicatory inscription of Abbess Mathilda (973–1011). Bronze cast. ESSEN, early XI cent.

52/53. Triumphal Column of Christ. Commissioned by Bishop Godehard (1022–1038). Fig. 117: Lazarus at the table of Dives licked by dogs. Below, Raising of the Youth of Naim. Above, Christ walking on the Water. Fig. 118: Salome's Dance. Fig. 119: Detail of fig. 117. Fig. 120: St. Paul let down by the wall in a basket. Details. Bronze cast. Each relief H. 450 mm. Height of the whole column, 379 cm., diameter 58 cm. HILDESHEIM, *c.* 1030. *Hildesheim Cathedral.*

54. Fig. 121: The Baptism. Ivory casket, originally set with cloisonné enamels and precious stones. 150 × 220 × 110 mm. Perhaps a present from Otto I to the Anglo-Saxon court and later to Gandersheim Abbey. METZ (?) or SAXONY (?), early X cent. *Braunschweig, Museum.* Fig. 122: Christ in Majesty with the Beasts of the four Evangelists. Ivory. Open-work. 110 × 95 mm. On the cover of a Gospelbook of Marchiennes. LOWER LORRAINE, end X cent. *New York, Morgan Library, MS. 319.* Fig. 123: Christ in Majesty surrounded by the Heavenly Choirs. So-called Psalter of King Athelstan (*c.* 925–940). 125 × 86 mm. WINCHESTER (?), X cent. *British Museum, MS. Cotton Galba A XVIII, fol.* 35.

55. The Baptism. Fig. 124: Benedictional of Aethelwold of WINCHESTER, 963–984. Fol. 25. Inscription by Godeman, his chaplain. 243 × 266 mm. Detail. WINCHESTER. British Museum, 49598 formerly *Chatsworth, Duke of Devonshire.* Fig. 125: Gospels of Hitta, Abbess of Meschede (Westphalia). 292 × 221 mm. COLOGNE, early XI cent. *Darmstadt, MS.* 1640, *fol.* 75.

56. Fig. 126: St. Paul and two other Apostles. Four

BIBLIOGRAPHY

115/16. As 64/65.—P. Bloch, in *Wallraf-Richartz Jahrbuch XXIII* (1961), pp. 101 ff.

117–20. F. J. Tchan (102–4), pp. 271 ff., 336 ff., Pls. 147–190.—A. Fink, in *Zeitschrift für Kunstwissenschaft* (1948), pp. 1 ff.—Wesenberg (102–4). .

121. A. Goldschmidt, *Elfenbeinsculpturen,* I (1914), 96.

122. B. Greene (13), No. 10, Pl. 9.

123. E. G. Millar, *English Illuminated MSS.* (1926), pp. 2 f., 70, Pl. 2.

124. G. F. Warner, *The Benedictional of St. Aethelwold.* Complete Facsimile (1910).—E. G. Millar, *English Illuminated MSS.* (1926), p. 7 f. —T. D. Kendrick (136/37), p. 6.—F. Wormald, *Benedictional of St. Aethelwold* (1959).

125. E. Schipperges, *Der Hitda Codex* (1938).

126. As 124.

Notes on the Plates

CATALOGUE

Angels from the Heavenly Choir. Benedictional of Aethelwold, fol. 4. As fig. 124. Fig. 127: Mary and the Apostles watching the Ascension. Fragment. Ivory. 140×93 mm. LORSCH (?), "Ada Group", IX cent. *Darmstadt Museum.* Fig. 128: Two Angels swinging censers. Fragment. Walrus ivory. 75×50 mm. WINCHESTER (?), end X cent. *Winchester Museum.*

57. Fig. 129: Matthew and his Angel blowing horn. God. 386×282 mm. ANGLO-SAXON, end X cent. *Copenhagen, MS. Kongl. Saml. 10, fol. 17ᵛ.* Fig. 130: Luke. 356×254 mm. SAINT-BERTIN (?), end X cent. *New York, Morgan Library, MS. 827, fol. 66.*

58/59. Blessing of the Tribes and Death of Moses. Fig. 131: Bible of San Callisto, fol. 49ᵛ. 401×312 mm. Written by Ingebertus for Charles the Bold. REIMS (?), c. 870. *Rome, St. Paul's without the Walls.* Fig. 132: Aelfric's Pentateuch, etc., fol. 139ᵛ. 280×190 mm. As Pl. 47, fig. 106.

60. Fig. 133: David rescuing the Lamb from the Lion. 200×120 mm. ANGLO-SAXON, second quarter XI cent. *British Museum, MS. Cotton Tib. C VI, fol. 8.* Fig. 134: Samson wrestling with the Lion. H. 135 mm. Marginal drawing in a psalter from BURY ST. EDMUNDS, second quarter XI cent. *Rome, Vatican, MS. Regin. lat. 12, fol. 66ᵛ.* Fig. 135: Lion devouring a Man. 90×47×38 mm. Walrus ivory. From an Abbot's chair. ANGLO-SAXON, early XI cent. *Munich, National Museum.*

61. Marvels of the East. Fig. 136: Mambres at the mouth of Hell. 165×150 mm. Fig. 137: The Huge Monster devouring Men. 118×100 mm. ANGLO-SAXON, c. 1025. *British Museum, Cotton Tib. B V, fol. 81ᵛ, 89ᵛ.*

62. Fig. 138: Christ in Majesty. H. 100 mm. Morse ivory. ANGLO-SAXON, first half XI cent. *Victoria and Albert Museum.* Fig. 139: Virgin and Child. Pendant to fig. 138. Fig. 140: Initial O. The

BIBLIOGRAPHY

127. A. Goldschmidt, *Elfenbeinsculpturen*, I (1914), 20. —Perhaps the lower part of a diptych. H. Fillitz, in *Aachener Kunstblätter* (1966), 20 ff., 36 ff.

128. M. H. Longhurst, *English Ivories* (1926), p. 15, No. XIV.—A. Goldschmidt, *Elfenbeinsculpturen*, IV (1926), 276.

129. F. Mackeprang, *Illuminated MSS. in Danish collections* (1921), pp. 7 ff. E. G. Millar, *English Illuminated MSS.* (1926), p. 16, 107.

130. H. Swarzenski, in *Art Bulletin*, 31 (1949), pp. 77 ff.

131. J. Westwood, *The Bible of St. Paul near Rome* (1876).—A. Venturi, *Storia dell' Arte Italiana*, II (1902), pp. 319 ff.—P. Durrieu, in *Melanges offerts à M. E. Chatelain* (1910), pp. 1 ff.—R. Hinks, *Carolingian art* (1935), pp. 114 f.; 134 ff.—L. Traube, in *MG, Poet. Lat* 3, p. 257 ff.—Schramm-Mütherich (7), 56. J. E. Gaehde, in *Gesta* 5 (1966), 9 ff.

132. As 106.

133/34. F. Wormald, *English Drawings of the Xᵗʰ and XIᵗʰ centuries* (1951), No. 56, pp. 47 f., 64, 68; No. 32, pp. 50 ff., 57, 64, 68, 71 and in *Walpole Society* 38 (1962), 1–13, Pls. 1–30.

135. A. Goldschmidt, *Elfenbeinsculpturen*, IV (1926), 306.

136/37. M. R. James, *Marvels of the East* (1929).—R. Wittkower, in *Journal of the Warburg Institute*, 5 (1942), pp. 159 ff.—T. D. Kendrick, *Late Saxon and Viking Art* (1949), pp. 23, 26, 131.

138/39. M. H. Longhurst, *English Ivories* (1926), p. 17, No. XVIII, and *Victoria and Albert Museum, Catalogue of Carvings in Ivory*, II (1929), p. 131.

140. As 124.

Notes on the Plates

CATALOGUE

Holy Trinity. Benedictional of Aethelwold, fol. 70 Diam. 105 mm. As Pl. 55, fig. 124, Pl. 56, fig. 126. Fig. 141: Virgin and Child in Mandorla carried by Angels. Panel in the framework of the so-called Grimbald Gospels. Twice enlarged. WINCHESTER, early XI cent. *British Museum, MS. Add. 34890, fol. 15.*

63. Fig. 142: Crucifix. Walrus ivory. H. 125 mm. The cross covered with gold and filigree; two plaques with superscription and four medallions with the Beasts in cloisonné enamel. 188 × 148 mm. ANGLO-SAXON, c. 1000. *Victoria and Albert Museum.* Figs. 143/144: Mary and John. From a Crucifixion group. Morse ivory. Eyes inlaid with black beads. H. 115 and 121 mm. ANGLO-SAXON or SAINT-BERTIN, c. 1000. *St. Omer, Museum.*

64. Figs. 145/147: Enlarged details of the cover of the Gospels of Judith Guelph, in 1051 bride of Earl Tostig of Northumbria (died 1066). Christ in Majesty surrounded by Cherubs. Christ on the Cross with Mary and John. Embossed gold, filigree, precious stones, pearls, translucent cloisonné enamel. 300 × 191 mm. ANGLO-SAXON, c. 1050. *New York, Morgan Library, MS. 708.*

65. Fig. 148: Christ in Majesty. Bronze cast. From Sandford, Oxon. H. 71 mm. ANGLO-SAXON, end X cent. *Oxford, Ashmolean Museum.* Fig. 149: Cruet for the chrism (?). Bronze cast, gilt. H. 70 mm. ANGLO-SAXON, early XI cent. *British Museum.* Fig. 150: Christ from a Cross. Enlarged. Bronze cast, engraved. From Old Malton. H. 160 mm. ANGLO-SAXON, c. 1070. *Private Collection.*

66. Fig. 151: The Ascension. Christ in Mandorla surrounded by Angels. Reliquary Casket. Boxwood, 90 × 153 × 70 mm. ANGLO-SAXON, X cent. *Cleveland, Ohio, Museum.* Figs. 152/153: Andrew. Anne with Mary and Joachim. H. 85

BIBLIOGRAPHY

141. E. G. Millar, *English Illuminated MSS.* (1926), pp. 12 f., 74 f., Pls. 16/17.—T. D. Kendrick (136/37), p. 10.

142/44. M. H. Longhurst, *English Ivories* (1926), p. 9, 16, No. X, XV, XVI.—A. Goldschmidt, *Elfenbeinsculpturen,* IV (1926), 3–5.

145–47. M. C. Ross, in *Art Bulletin,* 22 (1940), pp. 83 ff.

149. T. D. Kendrick, in *The Antiquaries Journal,* XVIII (1938), pp. 377 ff.

150. J. Charles Cox, in *Reliquary,* New Series 111, p. 133, Pl. XV.

151. P. Nelson, in *Archaeologia,* LXXXVI (1936), pp. 91 ff.

152/53. E. Millar, *English Illuminated MSS.* (1926), p. 22.—T. D. Kendrick (136/37), pp. 21, 131.

Notes on the Plates

CATALOGUE

mm. Troper. HEREFORD, second quarter XI cent. *British Museum, MS. Cotton Caligula A XIV, fol. 30ᵛ, 31.*

67. Fig. 154: Apocalyptic Elder (David?). Morse ivory. Eyes inlaid with blue beads. H. 111 mm. On the cover of a Psalter of St. Hubert d'Ardennes. SAINT-BERTIN, c. 1050. *British Museum, MS. Add. 37768.* (see Fig. 229.) Fig. 155: Christ in Mandorla carried by four Angels. 280×96 mm. Lid of a Reliquary Casket. Ivory. ARRAS (?), first half XI cent. *Berlin Museum.*

68. Aratus Manuscripts. Fig. 156: Andromeda. H. 175 mm. REIMS or SAINT-OMER, early IX cent. *Leiden, MS. Voss, lat. Q. 79, fol. 30ᵛ.* Fig. 157: Copy of fig. 156. H. 145 mm. SAINT-BERTIN, early XI cent. *Boulogne s. M., MS. 188, fol. 24.* Fig. 158: Luna on chariot. *As fig. 157, fol. 32ᵛ.* Fig. 159: Bust of two Virtues. Naked men climbing in vine. Silver gilt, engraved. Border from cover of a Fulda MS. W. 155 mm. FULDA (?), early XI cent. *Bamberg, MS. Lit. 1.*

69. Fig. 160: Beginning of Gospels of St. John. Ascension, the Four Rivers of Paradise, Harrowing of Hell, the Marys at the Tomb, Earth and Sea, Initial I with Crucifixion, Church and Synagogue. H. 255 mm. Gospelbook of Odbert of SAINT-BERTIN. As Pl. 70, fig. 162. *New York, Morgan Library, MS. 333, fol. 85.* Fig. 161: Inhabited scroll. 35 mm. Detail of border in a Gospelbook of Odbert (986–1008). SAINT-BERTIN, c. 1000. *Saint Omer, MS. 56, fol. 36.*

70. Fig. 162: Abbot Odbert (986–1008) and Dodolinus, his scribe, dedicate their Gospelbook to St. Bertin. 92×100 mm. SAINT-BERTIN, c. 1000. *New York, Morgan Library, MS. 333, fol. 84.* Fig. 163: Milo thanking God after the completion of his poem. 145×111 mm. SAINT-BERTIN, early XI cent. *Leiden, MS. B. P. L. 190, fol. 26ᵛ.* Fig. 164: Philosophy consoling Boethius. 148×115 mm. FLEURY (?), early XI

BIBLIOGRAPHY

154. A. Goldschmidt, *Elfenbeinsculpturen*, IV (1926), 38.

155. A. Goldschmidt, *Elfenbeinsculpturen*, II (1918), 34/35.

156–58. G. Swarzenski (10), p. 88 f.—G. Thiele, *Antike Himmelsbilder* (1898), pp. 77 ff., 90 ff. —A. W. Bijvank, in *Bulletin de la Société Française de Réproduction des MSS.*, XV (1931), pp. 65 ff.—F. Saxl, *Lectures* (1957), 101.

159. W. Messerer, *Bamberger Domschatz* (1952), No. 60.—His attribution to Bamberg is not convincing.—Buddensieg (92–95), 159 ff.

160–63. Dom A. Wilmart, in *Bulletin de la Société des Antiquaires de la Morinié*, 14 (1924), pp. 169 ff.—B. Greene (13), No. 21.—A. Boutémy, in *Scriptorium*, 4 (1950), pp. 101 f., 245 f. and in E. de Moreau, *Histoire de l'Eglise en Belgique*, II, pp. 323 ff.

164. J. Porcher, *Manuscrits en France.* Catalogue of the Bibliothèque National exhibition (1954), 122.

Notes on the Plates

<table>
<tr><td valign="top">

CATALOGUE

cent. *Paris, Bibliothèque Nationale, MS. 6401, fol. 5ᵛ.* Fig. 165: Initial O with Christ calling Peter and Andrew. The Beasts of the Evangelists. 115×80 mm. SAINT-DENIS (?), *c.* 1030. *Paris, Bibliothèque Mazarine, MS. 384, fol. 138.*

71. Fig. 166: The Last Supper. 222×165 mm. SAINT-MAURE-DES-FOSSES, *c.* 1050. *Paris, Bibliothèque Nationale, MS. lat. 12054, fol. 79.*

72. Fig. 167: Mark with his Lion. Juggler (?) spouting fire. 220×123 mm. ARLES (?), first half XI cent. *Reims, MS. 13, fol. 61ᵛ.* Fig. 168: The Earth swallowing the Flood. H. 45 mm. Detail of illustration to Revelation, XII, 16. As Pl. 157, fig. 348. TRÈVES (?), early IX cent. *Trèves, MS. 31, fol. 39.*

73. Bible of St. Vaast's. Fig. 169: Ascension of Elias. Battle with the King of Syria. Illustration to the Fourth Book of Kings. Fig. 170: Initial O to Song of Solomon. Christ and the Church surrounded by the Zodiac. W. 290 mm. ARRAS, *c.* 1030. *Arras, MS. 435, fol. 144ᵛ; vol. 2, fol. 142.*

74. Fig. 171. Vision of Habakkuk. 100×111 mm. As Pl. 73, vol. 3, fol. 108. Fig. 172: Virgin and Child in Mandorla. 207×160 mm. ARRAS (?), *c.* 1030. *Cologne, Cathedral Library, MS. 141, fol. 5.*

75. Ascension of the Virgin. Fig. 173: 175×125 mm. ARRAS, second quarter XI cent. *Arras, MS. 684, fol. 1ᵛ.* Fig. 174: H. 198 mm. MONT-SAINT-MICHEL, soon after 1067. Perhaps written for Fécamp. *New York, Morgan Library, MS. 641, fol. 142ᵛ.* Fig. 175: 95×150 mm. SAINT-DENIS or ARRAS, second quarter XI cent. *Paris, Bibliothèque Nationale, MS. lat. 9436, fol. 129.*

76. Fig. 176: Bishop Fulbert of Chartres (1006–1028) preaching in his Cathedral. Painted by Andreas de Mici. H. 263 mm. CHARTRES, *c.* 1028. *Chartres (formerly St. Etienne, MS. 104), fol. 32.*

</td><td valign="top">

BIBLIOGRAPHY

165. A. Molinier, *Catalogue des MSS. de la Bibliothèque Mazarine*, I (1885), p. 140 f.

166. Cf. C. Niver, in *Speculum*, III (1928), pp. 398 ff.

167. Porcher (164), 298 suggests a Provençal origin.

168. W. Neuss, *Apokalypse des hlg. Johannes* (1931), pp. 247 ff., 286.

169–73. A. Boutémy, in *Scriptorium*, 4 (1950), pp. 67 ff. Pls. 1–8.—J. Porcher, *L'art du moyen âge en Artois. Catalogue. Musée d'Arras* (1951), No. 35–37. S. Schulten, in *Münchner Jahrbuch der Bildenden Kunst* (1956), 49–90.

174. B. Greene (13), No. 22. Cf. P. Gaut, *Le Mont-Saint-Michel*, I (1910).—Written at the time of Maurilius and Philibert of Fécamp.

175. V. Leroquais, *Sacramentaires et Missels des Bibliothèques Publiques de France*, I (1924), No. 60, pp. 142 ff.—S. Schulten (169–73).

176. R. Merlet, Abbé Clerval, *Un MS. Chartrain* (1893).

</td></tr>
</table>

Notes on the Plates

CATALOGUE

77. Fig. 177: Paul blinded, led into Damascus. Paul let down by the wall in a basket. 155 × 210 mm. PRÜM, under Abbot Ruoprecht, 1026–1068. *Manchester, Rylands Library, MS. 7, fol. 133ᵛ, 134.* Figs. 178/179: Life of St. Amand. St. Amand and his companion climbing a mountain. H. 100 mm. St. Amand teaches the prisoners who become his pupils. H. 115 mm. SAINT-AMAND, c. 1025. *Valenciennes, MS. 502, fol. 10ᵛ. 15ᵛ.*

78. Fig. 180: Triumph of Faith and Concord. 140 × 170 mm. Prudentius' Psychomachia. LIÉGE, second quarter XI cent. *Brussels, MS. 1066–77, fol. 135ᵛ.* Fig. 181: Drawing in a Life of St. Livin. GHENT (?), c. 1054. H. 175 mm. *Ghent, MS. 308 (150), fol. 1ᵛ.* Fig. 182: Saint Maurice (?). H. 125 mm. MAGDEBURG (?) or STAVELOT (?), early XI cent. *Brussels, MS. 1814, fol. 23.*

79. Fig. 183: The Women at the Tomb. 196 × 70 mm. Gospels of Gembloux. LIÉGE (?), c. 1025. *Brussels, MS. 5573, fol. 10.* Fig. 184: Saint Maurice. Copper gilt, engraved. H. 275 mm. MAINZ, second quarter XI cent. *Mainz, Gutenberg-Museum, MS. 3.*

80. Fig. 185: Augustine inspired by an Angel. 290 × 205 mm. LIÉGE, XI cent. Copied from sketch of portrait of Matthew in Brussels, MS. 18383. *Brussels, MS. 10791, fol. 2.* Fig. 186: Luke. 227 × 177 mm. LIÉGE, second quarter XI cent. *Brussels, MS. 18383, fol. 84ᵛ.*

81. Fig. 187: Matthew. Fig. 188: Luke. H. 205 mm. Fig. 189: Detail. Lion of Mark. Gospels of CORBIE, second quarter XI cent. *Amiens, MS. 24, fol. 15, 77ᵛ, 53.*

82. Fig. 190: Matthew. H. 280 mm. BELGIAN, second quarter XI cent. *British Museum, MS. Stowe 3, fol. 2ᵛ.* Fig. 191: St. Quentin tortured. Detail. Life of St. Quentin. H. c. 285

BIBLIOGRAPHY

177. A. Goldschmidt, *German Illumination*, II (1928), Pl. 69 ff.

178/79. L. Traube, *Monumenta Germ. Poet. Lat.*, III, p. 557 ff., 819 ff.—*Mon. Germ. Scriptorum Rerum Merovingicarum*, V, pp. 415 f., Pls. 2–18. —A. Boeckler, *Abendländische Miniaturen* (1930), p. 57 ff., 114, Pls. 50, 51.—A. Boutémy, in *Revue belge d'archéologie et d'histoire de l'art*, 10 (1940), pp. 231 ff.—F. Wormald, *Some illustrated MSS. of the Lives of Saints*, in *Bulletin of the John Rylands Library*, 35 (1952), pp. 256 ff.

180. R. Stettiner, *Prudentius-Handschriften* (1895), pp. 61 ff. C. Gaspar, F. Lyna, *Les Principaux MSS. Bibliothèque Royale de Belgique* (1937), pp. 21 ff.

182. Gaspar, Lyna (180), pp. 30 ff.

183. Gaspar, Lyna (180), pp. 49 ff., Pl. IX.

184. The miniatures of the MS. are related to Fulda, MS. Aa 44 (fig. 96).—V. Elbern, *Das I. Jahrtausend* (1962), 446.

185. Gaspar, Lyna (180), pp. 64 ff.—F. Massai, in *Art Mosan et Arts anciens du pays de Liége.* Exhibition Catalogue, Liége, 1951, 390, Pl. XLVIII, 391, Pl. XLIX.

186. Gaspar, Lyna (180), pp. 43 ff.

187–89. A. Haseloff, in A. Michel, *Histoire de l'art*, I, 2 (1905), p. 748 f., fig. 404. J. Porcher, *Medieval French Miniatures* (1959), p. 30, pl. XXII.

191. Porcher (164), 180. The Scribe of the book Raimbert is portrayed on p. 4.

Notes on the Plates

CATALOGUE

mm. SAINT-QUENTIN, c. 1050. *Saint-Quentin, Chapter Library, MS. 1, fol. 43.*

83. Fig. 192: Illustration to Psalm 85, 11. Lamb of God. 'Truth shall spring out of the earth and Righteousness shall look down from heaven.' H. 190 mm. From Bergues-Saint-Vinoc. LIÉGE, after 1025. *Paris, Bibliothèque Nationale, MS. lat. 819, fol. 13.* Fig. 193: St. Bertin crossing the Sea. Life of St. Omer. 163 × 120 mm. SAINT-BERTIN, end XI cent. *Saint-Omer, MS. 698, fol. 34.*

84. Fig. 194: Lion attacking Bear. Detail of border of ivory plaque on Pl. 125, fig. 286. Fig. 195: Lion. Enlarged detail from a Canon Table. JUMIÈGES, c. 1050. *British Museum, MS. Add. 11850, fol. 14ᵛ.* Fig. 196: John sitting on a Bull. Gospels of CYSOING. 310 × 220 mm. FRENCH FLANDERS, c. 1050. *Lille, MS. 33, fol. 87.*

85. Fig. 197: Michael and the Dragon. Fig. 198: Canon Table. Christ in Majesty surrounded by angels imploring Him. Climbing man, angels and dragon in columns. Inhabited scrolls. H. 238 mm. NORMANDY, second half of XI cent. *British Museum, MS. Add. 17739, fol. 17, 2.*

86. Fig. 199: Initial T with musicians, illustrating life of St. Castor. Passionale. H. 80 mm. ST. AUGUSTINE'S, CANTERBURY, c. 1100. *British Museum, MS. Arundel 91, fol. 218ᵛ.* Fig. 200: Initial I with Angel of Matthew. H. 115 mm. Bible of Carileff (1081–95). DURHAM OR NORMANDY. *Durham, MS. A. II, 4, fol. 187ᵛ.*

87. Fig. 201: The Bad and the Good Regiment. St. Augustine's City of God. W. 202 mm. CANTERBURY (?), c. 1125. *Florence, Laurentiana, MS. Plut. XII, 17, fol. 1ᵛ.*

88. Fig. 202: Inhabited scroll. Nude escaping dragon. Enlarged detail of a staff. Ivory. H. 117 cm. Diameter 47 mm. (maximum), 35 mm. (minimum). LORRAINE (?), XI cent. *Victoria and Albert Museum.* Fig. 203: Initial G with men

BIBLIOGRAPHY

192. N. Huygebaert, *Sacramentaire de l'Abbé Manassès de Bergues-Saint-Vinoc*, in *Annales de la Société d'émulation de Bruges*, 84 (1947), pp. 1 ff.

193. M. Schott, *Zwei Lütticher Sacramentare* (1931), pp. 83 ff., 191 f.—A. Boinet, in *Bulletin Archéologique du Comité des travaux historiques* (1904), p. 415.—A. Boutémy, in E. de Moreau, *Histoire de l'Eglise en Belgique*, II, p. 331. Cf. also the stylistically related miniatures in the Life of St. Winnoc in Bergues, MS. 19 (*Annales du Comité Flamand de France'* Lille (1926), and *The Sussex County Magazine* (July 1928).—Porcher (164), 181.

194. As 286.

195. A. Baker, in *Walpole Society*, 31 (1946), p. 31 ff., Pl. VIII.

196. Porcher (164), 182.

197/8. C. R. Dodwell, in *Jumièges. Congrès Scientifique du XIIIᵉ Centenaire* (1955).

199. F. Wormald, *English Drawings of the Xth and XIth centuries* (1952), p. 55 f.—C. R. Dodwell, *The Canterbury School of Illumination* (1954), 26 ff.

200. R. A. B. Mynors, *Durham Cathedral MSS.* (1939), No. 30, pp. 33 f.—O. Paecht, *Hugo Pictor*, in *Bodleian Library Record*, III (1950), p. 102 f.—H. Swarzenski, *Stil der Karilef Bibel*, in *Form und Inhalt, Studien Otto Schmitt dargebracht* (1950), pp. 89 ff.

201. P. de Laborde, *Les MSS à Peintures de la Cité de Dieu* (1909), 217.—*New Palaeographical Society*, I series, Pls. 138/39.—F. Wormald, in *Proceedings British Academy*, XXX (1944), p. II. —Dodwell (199), pp. 28 ff.

202. An English origin has also been suggested.

203. As 201.

Notes on the Plates

CATALOGUE

in scrollwork catching bird and fish. H. 100 mm. As fig. 201, fol. 5. Fig. 204: Man and winged lion in scrollwork. Front and reverse of left side of the head of a Tau-Cross. Enlarged. H. 45 mm. Morse ivory. From Le Mans. ENGLISH or NORMAN, early XII cent. *Victoria and Albert Museum.*

89/90. Figs. 205–208: Gloucester Candlestick. H. 515 mm. Devils. Nudes fighting dragons (symbols of vice) while climbing from Darkness to Light. Beasts of the Evangelists. Enlarged details. Bronze gilt. Eyes inlaid with black beads. Inscriptions. Gift of Abbot Peter of GLOUCESTER (1104–1113). In the XII century given to Le Mans. *Victoria and Albert Museum.*

91. Figs. 209/210: Base of a Cross. 273 × 244 mm. Details. Fig. 209: Evangelist astride a River of Paradise. Fig. 210: Seraphim and Cherubim lifting the column of Christ over Adam rising from the Tomb. Bronze gilt. From the Guelph Treasure of St. Michel, Lüneburg. BRAUNSCHWEIG (?), last quarter XI cent. *Hanover, Museum.* Fig. 211: Foot of a candlestick. Men with falcon and dog. Spinario. 100 × 200 mm. Bronze gilt. ENGLISH (?), end XI cent. *Bâle, Collection R. von Hirsch.*

92. Fig. 212: Reliquary Key of Servatius. H. 290 mm. Open-work. Silver. LORRAINE (?), late IX cent. *Maastricht, Servatius Church.* Fig. 213: Throne of King Dagobert. Armrest. Detail. 115 × 500 mm. Open-work. Bronze cast. SAINT-DENIS (?), late IX cent. (?) or time of Suger (1122–1151). *Paris, Bibliothèque Nationale, Cabinet des Médailles.*

93. Fig. 214: Imperial Throne. Back. 893 × 650 mm. Bronze cast. LOWER SAXONY (GOSLAR?), last quarter XI cent. *Goslar, Kaiserhaus.* Fig. 215: Plaque. H. 260 mm. Open-work. Copper gilt, engraved. FRITZLAR (?), second half XI

BIBLIOGRAPHY

204. M. H. Longhurst, *English Ivories* (1926), p. 27, No. XXVIII.—A. Goldschmidt, *Elfenbeinsculpturen*, IV (1926), 33.—T. D. Kendrick, *Late Saxon and Viking Art* (1949), pp. 133, 136, Pl. LXXXIX.

205–08. O. v. Falke, E. Meyer, *Bronzegeräte de Mittelalters*, 1 (1935), 88.—C. C. Oman, *The Gloucester Candlestick* (1958).

209/10. F. Stuttmann (108), p. 76 ff., Pls. 65/6.—G. Swarzenski, in *Staedeljahrbuch*, VII/VIII (1932), pp. 294 ff.—A closely related foot of a cross in the Treasure of Chur Cathedral mentions in its dedicatory inscription a *Nortpertus Praepositus* and an *Azzo Artifex*. Nortpertus might perhaps be identified with Bishop N. of Chur (1079–88), or with Archbishop of Magdeburg (died 1134).—A third example of a similar foot of a Cross was sold at Christie's, 1855 (Collection Bernal).—A. M. Cetto, in *Kunstchromik* 7 (1954), 281 ff.

211. Falke, Meyer (205–08), 91.

212. H. Leopold, in *Römische Quartalsschrift* (1910), p. 131.—*De Monumenten van Geschiedenis en Kunst in de Provinzie Limburg*, I (1935), p. 408 f.

213. E. Panofsky, *Abbot Suger* (1946), p. 72, 192.—Schramm-Mütherich (7), 57. M. Weinberger, in *Essays in Memory of Karl Lehmann* (1965), 375 ff.

214. E. Meyer, in *Zeitschrift des Deutschen Vereins für Kunstwissenschaft*, X (1943), pp. 183 ff.—Schramm-Mütherich (7), 161.

215. H. Deckert, R. Freyhan, K. Steinbart, *Religiöse Kunst aus Hessen und Nassau* (1932), pp. 144 ff., No. 161, Pls. 257/8.—Buddensieg (159).

Notes on the Plates

CATALOGUE

cent. *Cassel, Museum.* Fig. 216: David rescuing lamb from the lion. Weather-Vane. 225 × 290 mm. Open-work. Copper engraved. NORWAY, second half XI cent. *Tingelstadt.*

94. Fig. 217: Initial T with Christ on the Cross. Canon-page. 220 × 300 mm. COLOGNE, c. 1060. *Freiburg i. B., MS. 360a, fol. 15ᵛ.* Fig. 218: Christ on the Cross. The Arms added later. H. 1085 mm. Bronze cast. From Helmstedt. WERDEN(?) or LOWER SAXONY, last quarter XI cent. *Werden, Church.*

95. Figs. 219/20: Head of fig. 218.

96. Fig. 221. Creation of Eve. 450 × 337 cm. Bible of St. Castor's, Coblenz. TRÈVES or MAINZ (?), 1067–1077. *Pommersfelden, Library Count Schönborn, MS. 2776, fol. 2ᵛ.* Fig. 222: Initial I for Genesis with Adam and Eve before God, the Expulsion, personifications of Earth and Sea. 310 × 55 mm. Written by Goderanus. STAVELOT, end XI cent. *Brussels, MS. II, 1179, fol. 3ᵛ.*

97. Christ in Mandorla. Fig. 223: H. 225 mm. LIÉGE (?), c. 1100. *Darmstadt, MS. 766, fol. 13.* Fig. 224: 438 × 273 mm. Bible of Stavelot. Written by Goderanus and Ernestus. STAVE-LOT, 1097. *British Museum, MS. Add. 28107, fol. 136.*

98. Fig. 225: King Cyrus. H. 145 mm. As fig. 224. *British Museum, MS. Add. 28106, fol. 93ᵛ.* Fig. 226: Christ Triumphant treading on lion and dragon. H. 540 mm. Silver gilt, embossed. Front of shrine of St. Hadelin of Celles. See Plates 158/59. LIÉGE (?), c. 1075. *Visé, Church.*

99. Fig. 227: Tomb of Rudolph of Swabia (†1080). 197 × 68 cm. Bronze cast with silver and niello engraved. LOWER SAXONY, soon after 1080. *Merseburg, Dom.* Fig. 228: St. Pantaleon. H. 179 mm. SIEGBURG, c. 1130. *British Museum, MS. Harley 2889, fol. 66ᵛ.*

BIBLIOGRAPHY

216. A. Bugge, in *Acta Achaeologica*, II (1931), pp. 159 ff., 166 ff.

217–20. F. Rademacher, in *Zeitschrift des Deutschen Vereins für Kunstwissenschaft*, VIII (1941), pp. 141 ff.

221. H. Swarzenski, *Vorgotische Miniaturen* (1927), No. 42.—E. B. Garrison, *Studies in the History of Medieval Italian Painting III* (1958), 179 ff., suggests a somewhat later date.

222. Gaspar, Lyna (180), pp. 66 ff., Pl. XIIIb.

223. A. Boeckler, in *Kunst des frühen Mittelalters*, Exhibition Catalogue, Bern, 1949, No. 316.

224/25. M. Laurent, *Art rhénan, art mosan et art byzantin*, in *Byzantion*, VI (1931), pp. 75 ff.—H. Usener, *L'Art Mosan* (1953), 103-12.

226. J. Borchgrave d'Altena, in *Revue belge d'archéologie et d'histoire de l'art*, XX (1951), pp. 15 ff., figs. 1–10.—S. Collon-Gevaert, *Histoire des arts du Métal en Belgique* (1951), pp. 149 ff., 243, Pls. 18/9, 23.

227. H. Beenken, *Romanische Sculptur in Deutschland* (1924), 24.—E. Panofsky, *Deutsche Plastik* (1924), p. 82, Pl. 13.—Schramm-Mütherich (7), 162.

228. P. Bloch, *Siegburger Lektionar* (1964).

Notes on the Plates

CATALOGUE

100. Fig. 229: Portrait of Lothair I (840–855).
Bookcover of his Psalter. Silver gilt, embossed
and engraved, *opus punctile*. BELGIAN (SAINT
HUBERT?), XI cent. *British Museum, MS. Add.
37768*. Fig. 230: Cross of Theophanu of Essen
(1039–1054). Reverse probably added ca.
1130. Christ and the Beasts. Silver gilt,
engraved, *opus punctile*. See Pl. 33, fig. 80. H.
450 mm. *Essen Minster*.

101. Fig. 231: Christ in Mandorla carried by
Angels holding two crowns; two Evangelists;
the donor of the book, crowned by the Hand
of God. Copper gilt; engraved; *opus punctile*.
Upper part of a bookcover with a Liége ivory
plaque in the centre. 268 × 200 mm. BELGIAN,
first quarter XI cent. *Oxford, Bodleian, MS.
Douce, 292*. Fig. 232: Martyrdom of St.
Blaise. Copper gilt, engraved; *opus punctile*;
open-work. Long side of the portable altar of
Abdinghof Abbey. Perhaps by Rogerus. 118 ×
310 × 185 mm. HELMARSHAUSEN, 1118 (?).
Paderborn, Church of St. Francis.

102. Portable Altar of Liborius and Kilian. Fig.
233: Front. Christ in Majesty. SS. Kilian and
Liborius. Silver embossed. Precious stones,
filigree, pearls. Feet and inscriptions in niello.
Fig. 234: The Apostles Peter, Thomas, Simon.
Detail of long side. Engraved. *Opus punctile*.
165 × 345 × 212 mm. Work of Roger of
Helmarshausen. Commissioned by Bishop
Henry of Werl. HELMARSHAUSEN, 1100.
Paderborn Cathedral.

103. Fig. 235: The Marys at the Tomb. 118 × 112
mm. Ivory. LIÉGE (?), early XII cent. *Florence,
Bargello, Carrand Collection*. Fig. 236: Ewer
for Holy Water. Evangelists with the Beast
heads, Rivers of Paradise, winged sphinxes,
riders, lions. H. 165. Diam. 150 mm.
Bronze cast. The figures separately cast in
copper, gilt. The bands with the inscriptions

BIBLIOGRAPHY

229. P. E. Schramm, *Deutsche Kaiser und Könige in
Bildern ihrer Zeit* (1928), p. 50, 173.—
Schramm-Mütherich (7), 27.

230. As 64/5.

231. A. Goldschmidt, *Elfenbeinsculpturen*, II (1918),
51. Schramm-Mütherich (7), 160.

232–34. K. H. Usener, *Tragaltäre des Roger von
Helmarshausen. Religiöse Kunst aus Hessen und
Nassau* (1932), pp. 1 ff., Pls. 1–12.—E.
Meyer, in *Westfalen*, 25 (1940), pp. 6 ff. A.
Fuchs, in *Verzeichnis der Vorlesungen der erzbi-
schöflichen Philosophisch-Theologischen Akademie
Paderborn* (1940).—P. Metz, in *Thieme-
Becker XXVIII*, p. 512 f.

235. A. Goldschmidt, *Elfenbeinsculpturen*, II (1918),
165.

236. E. Witte, *Tausend Jahre Deutsche Kunst* (1932),
Pl. 22.—F. Back, in *Pfälzisches Museum*, 42
(1925), pp. 1 ff.—*Ars Sacra*, Exhibition Cata-
logue, Munich, 1950, No. 357.

Notes on the Plates

CATALOGUE

silver, gilt. Work of Snello (*auctor*) and Haert-
wich (*factor*). Gift of Abbot Berthold of St.
Alban's, MAINZ (1116–1119). *Speyer Cathedral*.

104. Figs. 237/38: Christ on the Cross. H. 117
cm. Copper and silver plated with niello.
HELMARSHAUSEN (?), early XII cent. *Minden
Cathedral*.

105. Fig. 239: Christ from a Cross. H. 177 mm.
Bronze. HILDESHEIM (?), Workshop of Roger of
Helmarshausen, *c.* 1130. *St. Louis, Missouri,
Museum*. Fig. 240: Adam rising from the Tomb.
The Evangelists. Inscriptions in niello on sil-
ver. Bronze cast. Base of a Cross. W. 120 mm.
LOWER SAXONY, *c.* 1130. *Weimar, Goethe-Haus*.

106. Figs. 241/42. Portable Altar of Eilbert of
Cologne. 130 × 357 × 210 mm. From the
Guelph Treasure, Braunschweig Cathedral.
COLOGNE, second third XII cent. *Berlin,
Museum*. Fig. 241: Altar plaque. In the centre
under a rock-crystal: Christ in Majesty, the
four Beasts. Miniature on vellum. By the
painter of the Gospels of München-Gladbach
(Darmstadt, MS. 680). Cologne, *c.* 1130.
Six plaques in champlevé enamel: The 12
Apostles holding scrolls with the opening
words of the *Credo*, Annunciation, Visitation,
Nativity, Presentation, Crucifixion, The Marys
at the Tomb, Harrowing of Hell, Ascension.
Fig. 242: Long side. Daniel, Ezekiel,
David, Melchisedek, Hosea, Malachi. Cham-
plevé enamel, imitating cloisonné. Borders,
stencilled silver gilt.

107. Fig. 243: Peter. H. 155 mm. Copper gilt,
embossed. From a shrine or altar frontal of
St. Walburg's, Groningen. WESTPHALIAN (?),
c. 1130. *Groningen, Museum*. Figs. 244/45:
Bartholomew, Peter. Details. Altar frontal.
H. 780 mm. Copper gilt, embossed. Copper
cloisonné enamel. Commissioned by Abbot
Hartwig (1103–1139). KOMBURG OR CORVEY,

BIBLIOGRAPHY

237/38. H. Beenken, *Romanische Sculptur* (1924),
21.—G. Swarzenski, in *Staedeljahrbuch*, VII/
VIII (1932), p. 315.—W. Rave, in *Westfalen*,
19 (1934), p. 292.

239. H. Swarzenski, in *Art Bulletin*, 24 (1942), p.
303.—H. Stewart Leonard, in *Bulletin of the
City Art Museum of St. Louis* (1950), p. 7 f.

240. Falke, Meyer (205–08), 188.—G. Swarzenski
(237/38), p. 295.—P. Bloch, in *Anzeiger des
Germ. National Museums Nürnberg* (1964), 7–23.

241/42. O. v. Falke (32, 33), No. 17, pp. 61 f.,
121 ff., Pls. 27–34.—E. Meyer (214), p.
201 f.—The identification of Eilbert of Col-
ogne with the *Eilbertus canonicus de Hildesheim
et frater eius Johannes* (mentioned between 1175
and 1195), put forward by W. Berger and H.
J. Rieckenberg (*Nachrichten der Akademie der
Wissenschaften, Göttingen, Phil. Hist. Klasse,*
1951, pp. 23 ff.) cannot be sustained.

243. *Kunst der Maasvallei*. Exhibition Catalogue,
Rotterdam, 1952, No. 76.

244–48. A. Herrmann, in *Zeitschrift des Deutschen
Vereins für Kunstwissenschaft*, III (1936), pp.
144 ff.—H. Swarzenski, in *Art Bulletin*, 24
(1942), p. 306.—A. Kitt, *Frühromanische
Kronleuchter*. Vienna Dissertation (1944).

Notes on the Plates

c. 1130. *Gross-Komburg, Church.* Fig. 246: Bust of Christ. Inscription: I am the light of the world. Copper engraved. 285 mm. diam. Headpiece of Chandelier symbolizing the Heavenly Jerusalem. See Pl. 108.

108. From the Komburg Chandelier. Fig. 247: Tower. St. Magdalene. H. *c.* 250 mm. Fig. 248: Apostle. H. of circular rim 340 mm. Diam. 5.02 m. Towers 80 × 27 × 20.5 cm. Copper gilt, embossed. Inhabited scrolls in open-work. Email brun. As figs. 244/5.

109. Fig. 249: Head of Crucifix of Tirstrup, Jutland. H. 124 cm. Fig. 250; Virgin Mary. H. 275 mm. Copper gilt, embossed. DENMARK, *c.* 1140. *Copenhagen, Museum.*

110. Fig. 251: Oxen. Detail of Initial F with Elkanah's sacrifice. H. 43 mm. Fig. 252: Initial F with Deborah killing Sisera with the nail. W. 90 mm. Bible of STAVELOT, 1097. *British Museum, MS. Add. 28106, fol. 97, 84.* As Pls. 97, 98. Fig. 253: Oxen carrying the Baptismal Font of Rainer of Huy, in analogy to the Molten Sea in the Temple of Jerusalem (1. Kings, VII, 23ff.). As Pls. 111–113.

111–113. Baptismal Font. H. 635 cm. Diam. 103 cm. Bronze cast by Rainer of Huy. Commissioned by Hellinus (1107–1118) for Notre-Dame-aux-Fonts. HUY or LIÉGE, *c.* 1110. *Liége, St. Barthélemy.* Figs. 254–257: John preaching and baptizing the Publican. Fig. 258: John baptizing Christ. Fig. 259: The reliefs of the Font depicted in a Bible Cycle of LIÉGE, *c.* 1160. H. 250 mm. *Berlin, Print Room, MS. 78A6, fol. 9ᵛ, 10.*

114. Fig. 260: Lion and Porcupine. 120 × 200 mm. Lambert of St. Omer's *Liber Floridus.* SAINT-BERTIN, *c.* 1120. *Ghent, MS. 16, fol. 56ᵛ.* Fig. 261: Dragon Aquamanile. H. 170 mm. Bronze gilt, inlaid with silver, niello. LORRAINE, *c.* 1130. *Vienna Museum.*

249/50. P. Nørlund, *Golden Altars* (1926), pp. 68 f., 99 ff., and *Acta Archaeologica*, I (1930), pp. 107 ff.

251/52. As 224/25.

253–58. K. H. Usener, in *Marburger Jahrbuch für Kunstwissenschaft*, VII (1933), pp. 1 ff.—S. Collon-Gevaert (226), pp. 136 ff.—J. Lejeune, in *Anciens Pays et Assemblées d'Etats.* Etudes publiées par la section belge de la Commission Internationale pour l'histoire . . . III (1952), pp. 3–27.

259. P. Wescher, *Verzeichnis der Miniaturen des Kupferstichkabinetts der staatlichen Museen Berlin* (1931), pp. 18 ff.

260. J. Casier, P. Bergmans, *L'art ancien dans les Flandres*, II (1921), pp. 32 ff., Pls. 129–21.—A. Goldschmidt, in *Vorträge der Bibliothek Warburg 1923–1924* (1926), pp. 220 ff., Pls. IV–VII.—J. Porcher (169–71), No. 18.—F. Saxl, *Lectures* (1957), 228–254.

Notes on the Plates

CATALOGUE

115. Fig. 262: Dragon Aquamanile. H. 183 mm. Bronze gilt; wings inlaid with silver, niello. LORRAINE, *c.* 1130. *Victoria and Albert Museum.* Fig. 263: Griffin. *As fig. 260, fol. 60ᵛ.*

116. Doors of *Gnesen Cathedral.* Probably commissioned by Boleslav III of Polen after the Invention of the Head of Adalbert in 1127. Design and wax model, LIÉGE (?). Cast, GNESEN (?). H. 328 cm. Fig. 264: Christ appearing to Adalbert in his sleep. Fig. 265: The fleeing companions. Detail of Adalbert killed. Figs. 266/67: Inhabited scrolls. Details of border.

117. Fig. 268: Adalbert's Tomb. As Pl. 116. Figs. 269/70: Box. Inhabited scrolls. Ivory. H. 97 mm. 115 mm. diam. Bronze mounts with engraved inscription, XIII cent. LIÉGE (?), first quarter XII cent. *Munich, National Museum.*

118. Fig. 271: Initial V for the book of Job. The soul of Job struggling with Satan. H. 145 mm. WINCHESTER (?), *c.* 1140. *Oxford, Bodleian, M.S. Auct. E infra 1, fol. 304.* Fig. 272. Initial D. Illustration to Psalm 22: The troubled Psalmist threatened by bulls and lions. The rescuing Hand of God. Enlarged. H. 110 mm. Psalter of ST. ALBAN'S, *c.* 1125. 275×190 mm. *Hildesheim, St. Godehard, fol. 112.*

119. Fig. 273: Initial B. Enlarged. Illustration to Psalm 103: The Lord walking upon the Wings of the Wind breathes the Spirit into his Angels. *As fig. 272, fol. 276.* Fig. 274: Philosophy visiting Boethius in Prison. Enlarged. Detail. H. 140 mm. HEREFORD, *c.* 1140. *Oxford, Bodleian, MS. Auct. F. 6. 5, fol. 1ᵛ.*

120. Fig. 275: The Flagellation (*As figs. 272–73*). Fig. 276: Life of St. Edmund. Hanging of the Thieves. 205×134 mm. BURY ST. EDMUNDS, *c.* 1140. *New York, Morgan Library, MS. 736, fol. 19ᵛ.*

BIBLIOGRAPHY

261/62. Falke, Meyer (205–8), 265/6.

263. As 260.

264–68. A. Goldschmidt, *Die frühmittelalterlichen Bronzetüren*, II. *Die Türen von Nowgorod und Gnesen* (1932).—H. Swarzenski, in *Art Bulletin*, 24 (1942), p. 299.—P. Francastel, in *L'Art Mosan* (1953). pp. 203 ff. M. Walicki, M. Morelowski and others, *Drzwi Gnieznienskie* (1956).

269/70. A. Goldschmidt, *Elfenbeinsculpturen*, IV (1926), 74.

271. T. S. R. Boase, *English Romanesque Illumination.* Bodleian picture books (1951), No. 18/9.

272/73. A. Goldschmidt, *Albani-Psalter* (1895).— O. Pächt, C. R. Dodwell, F. Wormald, *The St. Alban's Psalter* (1960). H. Swarzenski, in *Kunstchronik* (1963), pp. 77 ff.

274. M. A. Farley, F. Wormald, in *Art Bulletin*, 22 (1940), pp. 175 ff.

275/76. E. G. Millar, *English illuminated MSS.* (1926), p. 29 f., Pl. 36.—F. Wormald (191), pp. 259 ff.—O. Pächt (272/3), 118, 141 f., 166 f.

Notes on the Plates

CATALOGUE

121. Fig. 277: Two Centaurs. Enlarged detail. Oval Box. 75 × 35 mm. Morse ivory. ENGLISH, c. 1130. *Victoria and Albert Museum*. Fig. 278: Initial M. Two Nudes bitten by Serpents. H. 95 mm. Illustration to Josephus' Antiquities XXII. By the scribe Samuel. CANTERBURY, c. 1150. *Cambridge, St. John's College, MS. A 8, fol. 91*.

122. Fig. 279: The Crucifixion. Mary with the wooden sticks of the Widow of Sarepta. John standing on the Fish. H. 220 mm. WORCESTER (?), c. 1150. *Oxford, Corpus Christi College, MS. 157, fol. 77ᵛ*. Fig. 280: Christ from a Crucifixion. H. 135 mm. Morse ivory, traces of gilding. ENGLISH, c. 1150. *London, Guildhall Museum*.

123. The Stoning of Christ. Fig. 281: Lunette of Canon Table. Single leaf. Fragment from a Bible. 288 × 200 mm. ENGLISH, c. 1140. *Brussels, Musée du Cinquantenaire*. Fig. 282: W. 264 mm. BURY ST. EDMUNDS (?), c. 1140. *Cambridge, Pembroke College, Ms, 120, fol. 2ᵛ*.

124. Fig. 283: Luke riding on his Beast. Overpainted in the XVI cent. H. 116 mm. CANTERBURY (?), c. 1130. *New York, Morgan Library, MS. 777, fol. 37.ᵛ* Fig. 284: Initial Q with Luke as Priest slaughtering his Beast. H. 135 mm. Bible of Dover. CANTERBURY, c. 1150. *Cambridge, Corpus Christi College, MS. 5, fol. 192ᵛ*.

125. Fig. 285: Initial L with Matthew. H. 137 mm. *As fig. 284, fol. 168ᵛ*. Fig. 286: *Adoration of the Magi*. Morse ivory. H. 142 mm. ENGLISH or NORMAN, c. 1140 (?). See Pl. 84, fig. 194. *Victoria and Albert Museum*.

126. Fig. 287: Lions. H. 108 mm. From a Bestiary. ENGLISH, c. 1150. *Oxford, Bodleian, MS. Laud. Misc. 247, fol. 139ᵛ*. Fig. 288: David and his Musicians. Bear beating the drum. H. 255 mm. Psalter Triplex written for St. Remy or English cell of St. Remy. REIMS (?), second

BIBLIOGRAPHY

277. M. H. Longhurst, *English Ivories* (1926), p. 31, No. XXXIII.—A. Goldschmidt, *Elfenbeinsculpturen*, IV (1926), 71.

278/9. Dodwell (199), 37 ff.

280. M. H. Longhurst, *English Ivories* (1926), p. 24, No. XXV.—A. Goldschmidt, *Elfenbeinsculpturen*, IV (1926), 271.

281. M. Laurent, in *Bulletin des Musées Royaux d'Art et d'Histoire*, IV (1934), pp. 74 ff.—H. Swarzenski, in *Gazette des Beaux-Arts* (1963), 71–80.

282. E. G. Millar (275/6), p. 29, Pl. 35.—M. R. James, in *Walpole Society*, 25 (1937), p. 15 f.— Pächt (272/3).

283. D. Tselos, in *Art Bulletin*, 34 (1952), pp. 257 ff.

284/85. As 278/9.

286. M. H. Longhurst, *English Ivories* (1926), p. 23, No. XXII.—A. Goldschmidt, *Elfenbeinsculpturen*, IV (1926), 14.

287. As 271, No. 7.

288. M. R. James, *Descriptive Catalogue of the MSS. in St. John's College* (1913), No. 40, pp. 52 ff.

Notes on the Plates

CATALOGUE

quarter XII cent. *Cambridge, St. John's College, MS. B 18, fol. 1.*

127. Fig. 289: Abbot Lambert (†1125) on his bier; his soul carried to Heaven by Angels; Christ in Majesty. In semicircular medallions: *Elemosina* (Charity); the Virgin carrying the new Church of St. Bertin built by Lambert; Patience; Abbot Martin of St. Bertin. H. 270 mm. SAINT-BERTIN, soon after 1125. *Boulogne, MS. 46, fol. 1ᵛ.* Fig. 290: Initial I. Christ in Majesty; Offerings of Cain and Abel; Death of Abel; Abraham visited by three Angels; Sacrifice of Isaac. In the frame medallions: Sibyls; Virtues; a Prophet; Envy. H. 430 mm. SAINT-BERTIN, second quarter XII cent. *Saint-Omer, MS. 34, fol. 1ᵛ.*

128. Fig. 291: Christ and the Holy Trinity defending the City of God against the Devil's attack. Satan threatening a rescued soul. Adaptation of Revelation XII. W 190 mm. Lower part of title-page of a MS. of St. Augustine's City of God. ENGLAND, c. 1140. *Oxford, Bodleian. MS. Laud. Misc. 469, fol. 1ᵛ.* Fig. 292: Monks dedicating the writings of John Cassianus to St. Amand. Upper part of miniature. W. 257 mm. SAINT-AMAND, c. 1130. *Valenciennes, MS. 169, fol. 2.*

129. Fig. 293: Author's Portrait of Pliny. Pliny dedicating his Natural History to Vespasian. H. 320 mm. LE MANS (?), c. 1150. *Le Mans, MS. 263, fol. 10ᵛ.*

130. Fig. 294: The Donation of Richard II of Normandy to Bishop Manger of Avranches. Abbot Almod presents the Chart to his monks. A man at the door stops the intruders. 300 × 230 mm. Fig. 295: An angel appears to Robert le Diable offering his glove to St. Michael. Detail. Chronicle of Robert de Torrigny (1154–1186). MONT-SAINT-MICHEL, c. 1160. *Avranches, MS. 210, fol. 19ᵛ, 25ᵛ.*

BIBLIOGRAPHY

289/90. *Katzenellenbogen* (454), pp. 34, 40.

290. J. Porcher (169–73), No. 21, Pl. XVII.

291. A. de la Borde (201), p. 103.

292. A. Boutémy (318/19).

293. Porcher (164), 231. Perhaps by an English painter working at Le Mans.

294/95. P. Gaut, *Le Mont-Saint-Michel*, I (1910), pp. 7 f., 95.—Porcher (164), 195.

Notes on the Plates

CATALOGUE

131. Fig. 296: Boethius, Pythagoras, Plato and Nicomachus discussing music. 240 × 195 mm. CANTERBURY, *c.* 1150. *Cambridge, University Library, MS. Ii. 3, 12, fol. 61ᵛ.* Fig. 297: Simon, Davus and Pamphilus. Illustration to Terence's 'Andria', Act 2, Scene 4. H. 85 mm. ENGLISH, *c.* 1150. *Oxford, Bodleian MS. Auct. F2, 13, fol. 16.*

132. Fig. 298: John inspired by the Holy Ghost, held by the Hand of God. In the medallions: John's Eagle, scenes from John's Life, portrait of Abbot Wedricus holding his inkpot. H. 340 mm. Single leaf cut out from Metz, MS. 1151 (fig. 299). *Avesnes, Historical Society.* Fig. 299: Initial I with the Incipit words of the Gospel of John. Christ in Mandorla. In the medallions: Dedicatory portrait of Wedricus, abbot of Liessiés (1127–1147), scenes from the Gospels of John. H. 355 mm. Written by a 'Johannes' in 1147. Perhaps by one of the Illuminators of the Lambeth Bible. CAMBRAI or CANTERBURY (?), 1147. *Metz, MS. 1151, fol. 267* (Destroyed).

133. Fig. 300: Ruth and Boaz. Enlarged detail. Fig. 301: Initial F with Saul's death at the battle of Gilboa. Illustration to Second Book of Kings. H. 270 mm. Lambeth Bible. 387 × 230 mm. CANTERBURY, *c.* 1150. *London, Lambeth Palace, MS. 3, fol. 130, 151.*

134. Fig. 302: Moses addressing the Israelites. Enlarged detail. By Magister Hugo. Bible of BURY ST. EDMUNDS, *c.* 1148. *Cambridge, Corpus Christi College, MS. 2, fol. 94.* Fig. 303: John. H. 175 mm. SHERBOURNE, *c.* 1146. *British Museum, MS. Add. 46487, fol. 86ᵛ.*

135. Fig. 304: Elijah. Enlarged detail of Initial P with the Messengers of Ahaziah. Illustration to Fourth Book of Kings. WINCHESTER BIBLE, *fol. 120ᵛ.* As Pls. 137, 138. Fig. 305: Initial E with God calling Joshua. Illustration to

BIBLIOGRAPHY

296. Dodwell (199), 23, 35 ff.

297. As 31.

298/99. A. Boinet, in *Bulletin de la Société nationale des Antiquaires de France* (1919), pp. 214 ff., and *La Bibliofilia* (1948).
J. Leclercq, in *Scriptorium* (1952), pp. 53 ff., Pls. 4–7.—Dodwell (199), 55. Dodwell, *The Great Lambeth Bible* (1959).

300–02. E. G. Millar, *English Illuminated MSS.* (1926), pp. 30 ff., 83 f., Pls. 37–41.—E. G. Millar, in *Bulletin de la Société Française de Réproduction de MSS.* (1924), Pls. II–XI.—Dodwell (298/99).

304. *Palaeographical Society*, II, Pls. 166/7.—E. G. Millar, *English Illuminated MSS.* (1926), p. 34, 85, Pls. 45–47.—W. Oakeshott, *The Artists of the Winchester Bible* (1945).

Notes on the Plates

CATALOGUE

Joshua. H. 80 mm. Perhaps by one of the Illuminators of the Winchester Bible. FÉCAMP (?) c. 1150. *Rouen, MS. A 5, fol. 72ᵛ.*

136. Figs. 306/7: Michael slaying the Dragon. Christ. Virgin and Child. Man in the jaw of a Dragon. Front and reverse of a Tau Cross. Enlarged details. H. 55 mm. Morse ivory. ENGLISH, c. 1145. *London, Victoria and Albert Museum.*

137. Fig. 308: Initial Q with Doeg slaying the Priests. Illustration to Psalm 52. H. 139 mm. Fig. 309: Initial I with Moses and Aaron; Inhabited scroll. 411 × 82 mm. Illustration to the book of Ezra. Enlarged detail. WINCHESTER BIBLE, c. 1150–1160. *Winchester Cathedral Library, vol. II, fol. 232, 342.*

138. Fig. 310: Burial of Judas Maccabeus. Illustration to the Book of Maccabee. Enlarged detail. *Vol. III, fol. 135.* Fig. 311: Initial P for Epistle to Philemon. W. 72 mm. *Fol. 459.* As Pls. 135, 137.

139. Figs. 312/313: Scenes from the Miraculous Birth of St. Nicholas and the Nativity. Head of Pastoral Staff. 117 × 110 mm. Enlarged details. Ivory. ENGLISH, c. 1150. *London, Victoria and Albert Museum.* Fig. 314: Rest on the Flight into Egypt. H. 81 mm. Ivory. Eyes inlaid with black beads. ENGLISH, c. 1150. *New York, Metropolitan Museum.*

140. Fig. 315: The Crucifixion. Angels swinging Censers. Sun and Moon. Adam rising from the Tomb. H. 250 mm. SAINT-AMAND, c. 1150. *Valenciennes, MS. 108, fol. 58ᵛ.* Fig. 316: Initial M with Stoning of Uriah. Nathan reproaching David and Bathsheba. Illustration to Psalm 50. YORK (?), c. 1170. As Pl. 216, fig. 508. *Copenhagen, MS. Thotts saml. 143, fol. 68.*

141. Fig. 317: The Crucifixion. H. 318 mm. Missal of Maroilles. SAINT-AMAND (?) or ARRAS (?),

BIBLIOGRAPHY

306/07. M. H. Longhurst, *English Ivories* (1926), p. 28, No. XXIX.—A. Goldschmidt, *Elfenbeinsculpturen*, IV (1926), 12.—L. Grodecki *Ivoires Français* (1947), p. 60 f., Pl. XV.

308–11. As 304.

312–13. M. H. Longhurst, *English Ivories* (1926), p. 18, No. XIX.—A. Goldschmidt, *Elfenbeinsculpturen*, IV, 32.—William S. A. Dale, in *Art Bulletin* (1956), 137 ff.

314. A. Goldschmidt, *Elfenbeinsculpturen*, IV, 19.

315. V. Leroquais, *Les Sacramentaires des Bibliothèques de France*, I (1924), p. 269 f.

316. F. Mackeprang, *Greek and Latin MSS. in Danish Collections* (1921), pp. 32 ff., Pl. 59.

317. As 315, p. 306 f.

Notes on the Plates

c. 1160. *Paris, Bibliothèque Mazarine, MS. 341, fol. 125* .

142. Fig. 318: Gregory H. 222 mm. SAINT-AMAND, c. 1160. *Paris, Bibliothèque Nationale, MS. lat. 2287, fol. 1ᵛ.*

143. Fig. 319: Dedication Picture. Gilbert de la Porrée, Bishop of Poitiers (1141–1154) and his Disciples. H. 150 mm. SAINT-AMAND, c. 1170. *Valenciennes, MS. 197, fol. 7.* Fig. 320: Robert le Diable on horseback. Initial C. 85 × 105 mm. BEC, c. 1150. *Leiden, MS. B. P. L. 20, fol. 60.*

144. Fig. 321: The Resurrection and the Three Marys at the Tomb. The Lioness vivifying her whelps with her breath (symbol of the Resurrection). Left side of a Flabellum. 280 mm. diameter. Copper gilt, embossed. Open-work. Perhaps a donation of Henry the Lion. ENGLAND (?), c. 1150. *Kremsmünster Abbey.*

145. Fig. 322: The Lioness vivifying her whelps with her breath (symbol of the Resurrection). Enlarged detail. Gospels of AVERBODEN. H. 60 mm. BELGIAN, c. 1150. *Liége, MS. 363, fol. 57.* Fig. 323: David rescuing Lamb from Lion. Enlarged. W. 228 mm. Psalter of Henry of Blois (1129–1171). WINCHESTER, c. 1150. *British Museum, MS. Cotton Nero C IV, fol. 7*

146. Fig. 324: The Angel closing the Mouth of Hell. As fig. 323, fol. 34ᵛ. Fig. 325: The Last Judgment. 138 × 89 mm. Champlevé enamel. ENGLAND, c. 1150. *London, Victoria and Albert Museum.*

147. Figs. 326/27: Lion as Mouth of Hell. Doorknocker. 550 mm. diam. Ring, 240 mm. Details. Bronze cast. DURHAM (?), c. 1140. *Durham Cathedral.*

148. Fig. 328: Ring of the Durham Doorknocker. Detail. As Pl. 147. Fig. 329: Candle-Bearer. H. 220 mm. Bronze cast. ANGLO-NORWEGIAN, second quarter XII century. *Oslo, Museum.*

BIBLIOGRAPHY

318/19. A. Boutémy, in *Revue belge d'archéologie et d'histoire de l'Art*, XII (1942), pp. 131 ff., 215 ff.

320. G. Delisle, in *Bibliothèque de L'Ecole des Chartes* LXXI, p. 511.—*Codices Manuscripti III. Bibliotheca Universitatis Leidensis* (1912), p. 14 f.

321. G. Swarzenski, in *Staedeljahrbuch*, VII/VIII (1932), p. 351.

322. S. Gevaert, in *Revue belge d'archéologie et d'histoire de l'art*, V (1935), pp. 213 ff.

323/24. E. G. Millar, *English Illuminated MSS.* (1926), pp. 33 f., 84, Pl. 44.—F. Wormald, in *Proceedings of the British Academy*, XXX (1944), p. 14, Pl. 6.

325. M. Chamot, *English Mediaeval Enamels* (1930), p. 25 f., No. 10.

326–28. E. S. Prior, A. Gardener, *An account of medieval figure-sculpture in England* (1912), p. 169 f.—H. Swarzenski (200), p. 95.

329. Falke, Meyer (205–8), 242.

Notes on the Plates

CATALOGUE

149. Figs. 330/31: Priest reading, dragons, scrolls & foliage. H. *c.* 220 mm. Details of base of Candlestick of St. Remy's. Fragment. H. 930 mm. Bronze cast. Rock-crystals. ENGLAND or REIMS, second quarter XII cent. *Reims, Musée.*

150. Fig. 332: Centaurs in scrolls. H. 200 mm. As Pl. 149. Fig. 333: Initial L with inhabited scrolls. Illustration to Matthew. H. 230 mm. Bible of STAVELOT, 1097. As Pls. 97, 98, 110. *Brit. Mus., MS. Add. 28017, fol. 142ᵛ.*

151. Figs. 334/35: Base of Candlestick. (?) Brought to Prague from Milan Cathedral 1143 by Wladimir II of Bohemia or 1162 by Frederick Barbarossa. W. 70 cm. Bronze cast. LORRAINE or MILAN, *c.* 1140. *Prague Cathedral.*

152. Fig. 336: Eagle Vase. Antique porphyry vase, converted by Suger (1122–1151) into shape of Eagle. H. 430 mm. Silver gilt mounts, engr. inscription. SAINT-DENIS, *c.* 1140. *Paris, Louvre.*

153. Fig. 337: From the Shrine of St. Babolin. H. 215 cm. Gilt Bronze. N.W. France, ca. 1140. *Saint-Germer (Oise).*—Fig. 338: From a Cross. Probably made *c.* 1165 for Samson of *Bury St. Edmunds* H. 6 cm. H. of Cross, 57.7 cm. Ivory.—*New York, Metropolitan Mus. of Art.*—Fig. 339: Andrew, James Minor, John. Enlarged detail. Part of casket. H. 46 mm. Ivory open-work, SAINT-DENIS (?), second quarter XII cent. *Paris, Louvre.*

154. The Deposition. Fig. 340: H. 100 mm. Detail. SAINT-TROND (?), *c.* 1140. N.Y., *Morgan Library, Ms. 883, fol. 51ᵛ.* Figs. 341/2: H. 282 mm. Bronze cast. Top of a reliquary casket, probably symbolizing the Holy Sepulchre. The inhabited scrolls, engraved on the casket, reproduced on p. 36. LORRAINE, *c.* 1130. *London, Victoria and Albert Museum.*

155. Figs. 343/44: Censer, symbolizing the Temple

E

BIBLIOGRAPHY

330–32. G. Swarzenski, in *Staedeljahrbuch*, VII–VIII (1932), p. 354 f.—Collon-Gevaert (226), p. 181 f., Pl. 32.—C. C. Oman, in *Apollo* (1952), pp. 53 ff.—Bloch (115–16), 140 ff.

333. As 224.

334/35. Fiorillo, *Geschichte der zeichnerischen Künste*, I (1815), p. 115.—Heider, Eitelberger, *Mittelalterliche Kunstdenkmale des Oestereichischen Kaiserstaates* (1856), p. 197 ff.—Falke, Meyer (205–8), p. 14, fig. 83.—Bloch (115–16), 135 ff.

336. E. Panofsky, *Abbot Suger* (1946), 78 f., 206.—An incense boat from the Treasure of Saint-Denis mounted on a similar base is preserved in a drawing of Peiresc. J. Guibert, *Les Dessins du Cabinet Peiresc au Cabinet des Estampes de la Bibliothéque Nationale* (1910), Pl. X.

337. *Trésors des Eglises de France*. Exhibition Catalogue (1965), 89.

338. T. Hoving, in *The Metropolitan Museum of Art Bulletin* (1964), 318 ff.

339. A. Goldschmidt, *Elfenbeinsculpturen*, III (1926), 61.

340. E. G. Millar, *The St. Trond Lectionary* (1949), pp. 108 ff., coloured frontispiece, Pl. III. Related stylistically is Liége, *MS. 230D.*

341/42. An earlier but similar reliquary with the Holy Sepulchre and the Deposition, probably from Maastricht, in Nürnberg, Germanisches Museum, K. G. 159.—H. Schnitzler, in *Cicerone* (1949), pp. 52 ff.

343/44. M. Creutz, in *Zeitschrift für Christliche*

65

Notes on the Plates

CATALOGUE

of Solomon, according to II Chronicles, 9, 17–19. Types and Antitypes of the Sacrament of the Holy Mass. On top: Solomon on his lion-throne. Lower story: Aaron, Moses, Prophets, Apostles. Upper story: Melchisedek, Abraham's Sacrifice, Isaac's Blessing. The explanatory inscription mentions a Gozbert who might be identified with the Gozbert who signed a fountain in Trèves commissioned by Abbot Folcard of St. Maximim's (990–97). H. 220 mm. Bronze cast, gilt. TRÈVES, *c.* 1000 (?). *Trèves Cathedral.* Fig. 345: Lion's head. Top of handle of a Holy Water sprinkler (?). WERDEN (?), *c.* 1130. *Bonn, Museum.* Fig. 346: Censer. On top, Angel (the wings broken off). The Three Worthies in the fiery furnace. Winged monsters. H. 160 mm., W. 104 mm. Bronze cast. The inscription mentions a 'Reiner' (sometimes erroneously identified with Rainer of Huy). MOSAN, second quarter XII cent. *Lille, Palais des Beaux Arts.*

156. Fig. 347: Aquamanile. Man wrestling with Dragon. L. 300 mm. Bronze cast. LORRAINE, third quarter XIII cent. *Leningrad, Hermitage Museum.*

157. Fig. 348: Illustration to Revelation XII 14, 16. W. 220 mm. Detail: The Woman given wings that she might escape from the Serpent casting water out of his mouth as a flood after her. The Earth swallowing the flood (as Pl. 72, fig. 168). *Liber Floridus* of Lambert of St.-Omer, copied after the original MS. (see Pl. 114), which, however, no longer contains the Apocalyptic cycle. GHENT (?), *c.* 1150. *Wolfenbüttel, MS. Gud. lat. fol. 1, fol. 15ᵛ.*

158/9. Shrine of St. Hadelin with scenes from his life. 54 × 150 cm. See also Pl. 98, fig. 226. Silver gilt, embossed. Email brun. Made for Celles Abbey. LIÉGE (?), *c.* 1140. *Visé, Church.*

BIBLIOGRAPHY

Kunst (1912), p. 37.—N. Irsch, *Dom zu Trier. Kunstdenkmäler der Rheinprovinz* (1931), pp. 342 ff.

345. M. Creutz, in *Zeitschrift für Christliche Kunst* (1912), p. 42.—*Kunst des frühen Mittelalters.* Exhibition Catalogue, Bern, 1949, No. 44.

346. E. Beitz, *Ruppert v. Deutz* (1930), pp. 133 ff. —S. Collon-Gevaert (226), p. 197, Pl. 30.

347. Falke, Meyer (205–8), 284.

348. O. v. Heinemann, *Handschriften der herzoglichen Bibliothek Wolfenbüttel*, IX (1913), 4305.

Notes on the Plates

CATALOGUE

Fig. 349: Miracle of the Spring. Fig. 350:

159. Fig. 351: Hadelin heals a mute woman.
Hadelin receives pupils at his Abbey in Celles.
Fig. 352: Benedict and Maurus taming Devil.
85 × 145 mm. LIÉGE, c. 1150. *Brussels, MS.*
1287, fol. 31.

160. Fig. 353: Job scraping his boils, tried by his
wife and friends. H. 155 mm. Detail.
CHAMPAGNE, c. 1140. *Paris, Bibliothèque*
Nationale, MS. 15307, fol. 1ᵛ. Fig. 354: Job
scraping his boils inflicted by Satan. 130 × 190
mm. In the XIII^th cent. in the Abbey Forest-
les-Bruxelles. FRANCO-FLEMISH, c. 1150. *Paris,*
Bibliothèque Nationale, MS. lat. 15675, fol. 5.

161. Fig. 355: The Fire of Heaven burning up the
sheep and the servants of Job. 130 × 190 mm.
As fig. 354, fol. 4.

162. Fig. 356: Mark. Enlarged detail. BIBLE OF
STAVELOT. 1097. *British Museum, MS. Add.*
28107, fol. 154. As Pls. 97, 98, 110,
150. Fig. 357: Initial V with Amos as Shep-
herd. H. 90 mm. BIBLE OF PARK ABBEY, 1148.
British Museum, MS. 14790, fol. 120.

163. Fig. 358: Bacchus (?). Aquamanile. 183 × 135
mm. Bronze cast. The eyes inlaid with silver.
MOSAN (AACHEN?), second quarter XII cent.
Aachen Minster. Fig. 359: Reliquary Head of
Alexander. H. 445 mm. Depth 225 mm.
Silver gilt, embossed. The eyes inlaid with
enamel. The base: Copper gilt. Precious
stones; rock-crystals; 12 plaques in champ-
levé enamel with portraits of Eventius, Alex-
ander, Theodolus, and personifications of the
Holy Wisdom, Perfection, Humility and the
Gifts of the Holy Spirit. 92 × 282 × 232 mm.
Gift of Wibald (1130–1158) to Stavelot
Abbey. Possibly by Godefroid de Huy. STAVE-
LOT, 1146. *Brussels, Museum.*

164. Figs. 360/61: Side and back view of fig. 359.
H. 305 mm.

BIBLIOGRAPHY

349–51. As 226.

352. Gaspar, Lyna (180), pp. 78 ff., Pl. XVI.—
F. Massai (185), p. 216 f., No. 409.

354/55. F. Massai (185), p. 217, No. 409^bis.—
Gevaert (33), pp. 41 ff., figs. 19–38.

356. As 224.

358. Falke, Meyer (205–8), 328.—H. Schnitzler,
Dom zu Aachen (1950), p. XXVII, Pl. 82.
His attribution to the workshop of the Aachen
Shrine of the Virgin Mary (c. 1215) is not
convincing.

359–61. Collon-Gevaert (226), p. 153 f.—P.
Metz, in Bossert, *Geschichte des Kunstgewerbes,*
V (1932), pp. 259 ff.

Notes on the Plates

CATALOGUE

165. Fig. 362: Head Reliquary. H. 310 mm. Bronze gilt, eyes silver, niello inlaid. From Fischbeck on the Weser. LOWER SAXONY, c. 1150. *Hannover, Kestner Museum.* Fig. 363: Portrait Bust of Frederick Barbarossa, supported by three angels; the fourth supporting figure, now lost, presumably a portrait of Otto of Kappenberg. Bronze, newly gilt; eyes silver inlaid. A gift of the Emperor to Otto of Kappenberg who added the base and gave the head to his church. Used as a container for relics of John the Evangelist. Applied in Kappenberg to Barbarossa's Baptismal Bowl (see Pl. 188). AACHEN and LOWER SAXONY, between 1155 and 1171. *Kappenberg, Church.*

166. Figs. 364/65: Wings of a Triptych with relics of the Holy Cross. 6 Medallions in champlevé enamel, relating the story of the Finding of the True Cross and scenes from the Life of Constantine. (1) Helena summons the Jews. The False Crosses burned. (2) The True Cross dug out. (3) A dead man revived by the True Cross. (4) Constantine's dream. (5) Constantine defeats Maxentius. (6) Constantine baptized by Pope Sylvester. Copper gilt, engraved; precious stones and gems; silver gilt, stencilled; émail brun; embossed silver columns. H. 655 mm. Gift of Abbot Wibald to Stavelot. Possibly by Godefroid de Claire. STAVELOT, c. 1150. *New York, Morgan Library.*

167. Fig. 366: Faith carrying a Baptismal Font. Diam. 145 mm. Champlevé enamel. Fragment of the Retable of Remaclius in Stavelot. Ordered by Abbot Wibald (1130–58) and the Byzantine Empress Irene. Possibly by Godefroid de Claire. STAVELOT, c. 1156. *Frankfurt, Museum.* Fig. 367: The Angel appears to Joseph in a dream. H. 85 mm. LIÉGE, c. 1160. *As Pl. 113, fig. 259, fol. 7.* Fig. 368:

BIBLIOGRAPHY

362. Falke, Meyer (205–8), 345.

363. E. Meyer, *Bildnis und Kronleuchter Barbarossa's.* (Der Kunstbrief, 1946).—H. Fillitz, in *Münchner Jahrbuch der bildenden Kunst* (1963), 39–50. Schramm-Mütherich (7), 173.

364/65. Collon-Gevaert (226), pp. 170 ff., Pl. 28.

366. Collon-Gevaert (226), pp. 158 ff., Pl. 25.—Falke, Frauberger, *Deutsche Schmelzarbeiten des Mittelalters* (1904), pp. 62, 74 ff., colour Pl. XXIV.—The other surviving plaque of the Altar is now in the Collection R. von Hirsch, Bâle.

367. As 259.

368. A plaque depicting Gideon from the same monument in the Museum in Lille. R. Greene.

Notes on the Plates

CATALOGUE

The Angel appears to the Three Worthies in the fiery furnace. W. 229 mm. Champlevé enamel. MAASTRICHT (?), c. 1160. *Boston, Museum of Fine Arts.*

168. Fig. 369: Rivers of Paradise; Geon and Fison. H. 100 mm. Champlevé enamel. Corner pieces of cover of Gospels of Notker of Liége. LIÉGE, c. 1150. *Liége, Museum Curtius.* Figs. 370/71: From a dismantled Portable Altar. Fig. 370: Parable of the Wicked Husbandmen. The beating, stoning and killing of the servants in the vineyard. 50 × 120 mm. Champlevé enamel. Fig. 371: Underside. Email brun. 120 × 220 mm. STAVELOT, c. 1160. *Florence, Bargello.*

169. Figs. 372/73: River of Paradise. H. 130 mm. Bronze cast. MOSAN, c. 1150. *Besançon, Museum.* Fig. 374: Martyrdom of Andrew and Philipp. Small side of Portable Altar of Stavelot. 100 × 150 × 250 mm. Champlevé enamel; borders, silver gilt, stencilled. The statuettes of Matthew and John, bronze cast, gilt. STAVELOT, c. 1150. *Brussels, Museum.*

170. Fig. 375: Triptych with relics of the True Cross. H. 550 mm. Angels (*Veritas* and *Judicium*) as guardians of the Relic (inserted in a golden Cross covered by a plaque of rock-crystal given in 1006 by Emperor Henry II). The Elected. In the lunette, Christ showing His wounds. On the wings, busts of the 12 Apostles. Silver gilt, embossed. Champlevé enamel; Email brun. Borders, copper gilt, engraved and embossed; precious stones; borders stencilled, partly restored. LIÉGE, c. 1160. *Liége, St. Croix.* Fig. 376: Triptych with relics of the True Cross. Centre: Angels (*Veritas* and *Judicium*) holding the relic, covered by a rock-crystal. Justice holding the scales, held by *Misericordia* and *Pietas*. *Elemosina, Oratio.* The Elected (*ommes gentes*). In the

BIBLIOGRAPHY

in *Essays in Honor of E. Panofsky* (1961), 159 ff., suggests that both plaques originally formed parts of the base of Suger's Cross of Saint Denys.

369. Falke, Frauberger (366), pp. 74 ff., fig. 25.—Collon-Gevaert (226), p. 166.

370/71. O. v. Falke, in *Pantheon*, 10 (1932), pp. 279 ff., figs. 2, 3.—Collon-Gevaert (226), p. 177 f.

372/73. H. Swarzenski, in *Burlington Magazine* (1953), p. 157, fig. 4.

374. Collon-Gevaert (226), pp. 157 ff., Pl. 29.—O. v. Falke (370/71).—Usener (253–58), pp. 36 ff.

375. Usener (253–8), pp. 28 ff.—Collon-Gevaert (226), p. 168 f.

376. Falke, Frauberger (366), p. 68.—Collon-Gevaert (226), p. 188.—*Bulletin of the Metropolitan Museum of Art* (1951), p. 253. From the Collection of the Duke of Aremberg.

Notes on the Plates




CATALOGUE

lunette: Christ showing His wounds; Chalice. Champlevé enamel. Borders, silver gilt, embossed and engraved. H. 270 mm. MAASTRICHT (?), *c.* 1160. As fig. 379.

171. Fig. 377: Angel (*Veritas*) holding the Scales. The Resurrected. Angels holding the 'Good Deeds'. Copper and Silver gilt, embossed. Relief on the roof of the Shrine of Servatius. 174×175×49 cm. As Pl. 173. MAASTRICHT, third quarter XII cent. *Maastricht Cathedral.*

172. Fig. 378: Last Judgment. Copper gilt, embossed. Christ in Majesty, the Four Beasts, eight Apostles. Champlevé enamel. Cover of a Lectionary of Saint-Trond. 252×162 mm. MOSAN, *c.* 1160. *Düsseldorf, Arch., MS. A. 4.* Fig. 379: Wings of the Reliquary Triptych, fig. 376. Angels blowing the Trumpet of the Last Judgment. Resurrection of the Dead. On the reverse ornaments in émail brun. *Coll. Bradley Martin, deposited at the Cloisters, New York.*

173. Fig. 380: Resurrection of the Dead. Fig. 381: Angel blowing trumpet. Reliefs of the roof of the Shrine of Servatius. Details. As fig. 377.

174. Fig. 382: Prudence with the Snake. 66×38 mm. Bronze gilt. MOSAN, *c.* 1160. *Paris, Louvre.* Fig. 383: Angel. One of a pair. H. 100 mm. Bronze gilt. MOSAN, *c.* 1170. *Florence, Bargello, Carrand Collection.* Fig. 384: The Three Marys before Christ. W. 136 mm. Enlarged detail. Bible of FLOREFFE, BELGIUM, *c.* 1155. *British Museum, MS. Add. 17738, fol. 179ᵛ.*

175. Figs. 385/86: Luke and John with their Beasts. H. 84 mm. Bronze gilt. MOSAN. *c.* 1170. *Florence, Bargello, Carrand Collection.* Fig. 387: Michael. Foot of a Cross with the three Archangels. H. of figures, vertical 86 mm. Bronze gilt, engraved. The statuettes cast separately. MOSAN, *c.* 1170. *London, Victoria and Albert Museum.* Fig. 388: Africa as the




BIBLIOGRAPHY

377. Falke, Frauberger (366), pp. 64 ff., Pls. 71/2.—Collon-Gevaert (226), p. 188 f.—H. Schnitzler, *Goldschmiedekunst der Aachener Schreinswerkstatt* (1934), pp. 35 ff.—*De Monumenten van Geschiedenis en Kunst in de Provinzie Limburg*, I (1935), pp. 395 ff.

378. A. Boeckler, in *Ars Sacra.* Exhibition Catalogue, Munich, 1951, No. 293.

379. As 376.

380/81. As 377.

382. Usener (253–8), p. 40, reproducing a second cast in the Frankfurt Museum.—Collon-Gevaert (226), p. 180.

383. O. v. Falke, in *Pantheon*, 10 (1932), p. 283, fig. 6.—E. Gosselin, in *Bolletino d'Arte*, 31 (1937/8), pp. 162 ff.

384. G. F. Warner, *British Museum. Reproductions from illuminated MSS.*, III (1910), p. 10, Pl. X.—S. Gevaert (322).—R. Schilling, in *Form und Inhalt. Festschrift für Otto Schmidt* (1951), pp. 73 ff.

385/86. As 383.

387/88. Falke, Meyer (205–8), 47/8.—Collon-Gevaert (226), p. 177 f.




Notes on the Plates

CATALOGUE

BIBLIOGRAPHY

Country of Science. Base of Candlestick with the three Continents. One of a pair. H. 180 mm. Bronze gilt, engraved. The statuettes cast separately. MOSAN, *c. 1170. Hildesheim Cathedral.*

176. The Transfiguration. Fig. 389: H. 235 mm. Enlarged detail. Bible of FLOREFFE, *fol. 4.* As Pl. 174, fig. 384. Fig. 390: H. 170 mm. Ivory on cover of the Gospels of AFFLIGHEM, BELGIUM, *c. 1170. Paris, Bibliothèque de l'Arsénal, MS. 1184.*

389. As 384.

390. A Goldschmidt, *Elfenbeinsculpturen,* III (1923), 28.—S. Gevaert, in *Revue belge d'archéologie et d'histoire de l'art,* VIII (1938), pp. 289 ff.

177. Figs. 391/92: The Earth with the Serpent. Fig. 393: The Fire (the attribute in the hands broken off). Of a series of the Four Elements. 103 × 65 × 57 mm. Copper cast, gilt, engraved. LORRAINE(?),*c. 1180. Munich, National Museum.* Figs. 394/95: The Sea. 90 × 56 × 35 mm. On the base, engraved: *Mare.* Bronze cast, gilt. MOSAN, *c. 1180. London, Victoria and Albert Museum.* Fig. 396: John and his Eagle. H. 120 mm. On the domed base of the Foot of the Cross of St. Bertin (see Pls. 178/79).

391–93. *Ars Sacra.* Exhibition Catalogue, Munich, 1951, No. 296.

394/95. H. P. Mitchell, in *Burlington Magazine,* XXXIII (1918), pp. 59 ff., Pl. 1, 2.

178/79. Foot of the Cross of ST. BERTIN. The four Evangelists with their Beasts.—Capitals with the Elements. Bronze cast, gilt. The domed base and the 4 sides of the pillar covered with plaques in champlevé enamel. Fig. 397: Moses and the Brazen Serpent. Return of the Spies from the Promised Land. Earth with shovel. Fig. 398: A Jew marking the T on a house with the Blood of the Passover Lamb. Aaron marking the Tribe of Levi. Fire with salamander. Fig. 399: Moses striking the Rock. 307 × 295 mm. Perhaps commissioned under Abbot Simon II (1177–86). MOSAN, *c. 1180. Saint-Omer, Museum.*

396–99. H. Garnier, in *Bulletin de la Société d'Etudes de la Province de Cambrai* (1932), pp. 216 ff.—K. H. Usener, in *Festschrift für Richard Hamann* (1939), pp. 163 ff.—Collon-Gevaert (226), p. 162 f., Pl. 26.

180. Figs. 400/01: Plaques from an Altar (?). H. 111 mm. Champlevé enamel. MOSAN, *c. 1160.* Fig. 400: The Ascension. *Goluchow Castle*

400. E. Molinier, *Collection du Château Goluchow* (1903).

Notes on the Plates

CATALOGUE

(*Poland*). Fig. 401: Pentecost. *New York, Metropolitan Museum of Art.*—Fig. 402: Man riding Camel. Fig. 403: Samson (?) wrestling with the Lion H. 100 mm. Champlevë enamel. MOSAN or ENGLAND, *c.* 1160. *London, V. & A. Mus.* Fig. 404: Man riding Camel. Detail of Initial I. Diam. 33 mm. ENGLAND, last quarter XII cent. *Oxford, Bodleian, MS. Laud. Misc. 752, fol. 1.*

181. Pair of Bracelets, perhaps from the Vestment of the Holy Roman Empire. Perhaps given by Emperor Frederick Barbarossa to Prince Andreas Bogoloubski (1157–74). From Wladimir Cathedral. 115 × 130 × 45 mm. MOSAN or COLOGNE, *c.* 1165. Fig. 405: The Crucifixion, *Bâle, Collection R. v. Hirsch.* Fig. 406: The Resurrection. *Paris, Louvre.*

182–184. Shrine of Heribert. 68 × 153 × 42 cm. Copper gilt. Figures silver gilt, embossed. Inhabited scrolls. Champlevé enamel. Email brun, filigree, precious stones, rock-crystals. LIÉGE and COLOGNE, soon after 1165. *Deutz, Heribert Church.* Fig. 407: Long side of the Shrine. Apostles. Fig. 408: Front. Heribert, Chastity, Humility, Christ, Angels. Figs. 409–411. Plaques on the roof. Dream of Heribert and Building of the Abbey. Diam. 173 mm. Angels. Virtues overcoming Vices. H. 46 mm. Figs. 412/13: Ezekiel, Amos. Fig. 414: Initial I as James Major. H. 242 mm. BIBLE OF STAVELOT, *vol. 2, fol. 197ᵛ.* As Pls. 97, 98, 110, 150, 162. Fig. 415: Gabriel. H. 290 mm. Champlevé enamel. From Shrine of Maurinus. COLOGNE, *c.* 1180. *Cologne, St. Pantaleon Church.* Fig. 416: Initial I as Ezekiel. H. 210 mm. Fig. 417: Initial T with inhabited scroll. BIBLE OF MALINES, *c.* 1160. 50 × 37 cm. *Brussels, MS. 9109, fol. 151 and MS. 9110, fol. 11.*

185. Fig. 418: Jacob blessing Joseph's Sons. Prudence with Serpent. Fig. 419: South Wind.

BIBLIOGRAPHY

402/03. H. P. Mitchell, in *Burlington Magazine,* XXXV (1919), pp. 34 ff. (with reproductions of the two corresponding plaques in the Louvre).

404. T. S. R. Boase (27.1), Nos. 19, 20.

405/06. *Mémoires de la Société des Antiquaires de France* (1903), p. 20.—P. B. Jurgenson, in *Zeitschrift für bildende Kunst,* 62 (1928/9), p. 235.—C. Dreyfus, in *Monument Piot,* XXXV (1935/36), pp. 173 ff.—H. Swarzenski, in *Art Bulletin,* 24 (1942), p. 301. Schramm-Mütherich (7), 174, 175. H. Lenzen (418–20).

407–13. Falke, Frauberger (366), pp. 26 ff., 84 ff., Pls. 82–88.—L. Strauss-Ernst, in *Kunstchronik* (1925/26), p. 551 ff.—J. Braun, in *Münchner Jahrbuch der bildenden Kunst,* VI (1929), pp. 109 ff.—E. Beitz, *Rupert von Deutz* (1930), pp. 113 ff., figs. 11, 17.—Collon-Gevaert (226), p. 184 f., Pls. 33/4.—An unpublished miniature of a scene of the Life of Heribert, related to the enamelled disk, is preserved in a Cologne XII century MS. in Sigmaringen.—Mütherich (421), pp. 2 ff.

415. Falke, Frauberger (366), pp. 40 ff., 85 f., 128, Pls. 44–8, colour plates XI, XII.—The plaques with the engraved donor portraits of a *Fredericus* and *Herlivus prior,* mentioned as *frater* of St. Pantaleon (1176–81) are later inserted. See J. Braun, in *Stimmen der Zeit,* 56 (1926), pp. 137 ff., and S. Steinberg, von Pape, *Bildnisse Geistlicher und Weltlicher Fürsten* (1931), pp. 91, 138, Pl. 107.

416/17. Gaspar, Lyna (180), pp. 84 ff., Pl. XVII.

418–20. Perhaps from a Portatile like the one reproduced on Pl. 8. H. Lenzen, in *Vienna*

Notes on the Plates

CATALOGUE

Fig. 420: Return of the Spies from the Promised Land. Temperance. Plaques from a Reliquary. H. 122 mm. and 68 mm. Champlevé enamel. COLOGNE, c. 1170. *Vienna, Cathedral.*—Fig. 421: Zechariah, Haggai, Zephaniah. Detail from a Tower-Reliquary. H. 310 mm. Diam. 300 mm. H. of each plaque 122 mm. Champlevé enamel. COLOGNE, c. 1160, so-called Fredericus Workshop. *Darmstadt, Museum.*

186. Fig. 422: The Rivers of Paradise. Lamb of God. H. 320 mm. Copper gilt, engraved. Openwork. MOSAN (?), c. 1150. *Paris, Musée Cluny.* Fig. 423: Crucifixion with the Four Beasts. Harrowing of Hell. Sea. Earth. Justice. Detail of the Alton Tower Triptych. H. 370 mm. Champlevé enamel. MOSAN (?), c. 1150. *London, Victoria and Albert Museum.*

187. Figs. 424/25: Reliquary Triptych of the True Cross. 29 × 22 cm. Each wing, 17 × 5.4 cm. Copper gilt, engraved. On the closed wings two Angels swinging censers. On the inner wings Helena and the story of the Finding of the True Cross. John and Mary on the sides of the Reliquary Cross. Church and Synagogue, Christ, the Four Beasts. On the frame: Moses marking the T on a house with the Blood of the Passover Lamb; The Tribe of Levi; Moses and the Brazen Serpent as a symbol of Hope; the Selected; Sacrifice of Isaac; The Widow of Sarepta; Elijah. Dream of Constantine; Heraclius beheading Chosroes; Return of the Spies from the Promised Land. 10 plaques in Champlevé enamel with busts of the Bishops of Tongern. Gift of the Chapter of Liége. LIÉGE, c. 1170. *Tongern, Church of St. Mary.*

188. Fig. 426: The Four Cardinal Virtues, Charity, Humility, Faith, Hope; The Four anthropomorphic Beasts holding the Wheel of the Universe. Inscription: *Rota in medio rotae Rota*

BIBLIOGRAPHY

Jahrbuch für Kunstgeschichte XXIV (1966), 21 ff.

421. F. Mütherich, *Ornamentik der rheinischen Goldschmiedekunst* (1941), p. 31 f.—Falke, Frauberger (366), pp. 32, 127, Pl. 35. —Two plaques belonging to the Reliquary, in the Victoria and Albert Museum and in the Kunstgewerbe-Museum Cologne. (M. Creutz, *in Zeitschrift für Christliche Kunst* (1911), pp. 209 ff., fig. 1.—*Victoria and Albert Museum, Picture book of medieval enamels* (1927), Pl. 6.)

422. E. du Sommerard, *Catalogue du Musée Cluny* (1881), No. 4992.—E. Schlee, *Iconographie der Paradiesesflüsse* (1937), p. 161 f.

423. Falke, Frauberger (366), pp. 70, 90, 131, Pl. 79.

424/25. Collon-Gevaert (226), p. 174, note 1.— By M. Creutz, in P. Clemen, *Belgische Kunstdenkmäler*, I (1923), p. 132, fig. 3, erroneously labelled Reliquary of Florennes.

426. P. Verdier, in *La Revue Belge XXX* (1961), 144 ff.

Notes on the Plates

CATALOGUE

una habens IV facies. (On the obverse, virtues and Lamb of God in champlevé enamel.) Diam. *c.* 175 mm. From Waulsort Abbey. Copper gilt, engraved. *Opus Punctile.* Hanging Reliquary (Phylactery). LIÉGE, *c.* 1160. *Namur, Museum.* Fig. 427: The Sermon on the Mount. Beatitude (Blessed are they which do hunger and thirst after Righteousness). 275 × 257 mm. Copper gilt, engraved. Openwork. From the Candelabrum of Frederick Barbarossa, by Wibertus. AACHEN, *c.* 1165.— Fig. 428: Baptism of Frederick Barbarossa in presence of his godfather Otto of Kappenberg. Baptismal Bowl of Frederick Barbarossa, given by the Emperor, together with his Head (see Pl. 165), to Count Otto of Kappenberg. Silver gilt, engraved. Diam. 244 mm. Depth 45 mm. The Bowl, *c.* 1120. Engraved by Wibertus (?) in AACHEN between 1155 and 1171. *Berlin, Museum.*

189. Figs. 429/30. Details from a bowl with scenes from the youth of Achilles (after Statius). Diam. 280 mm. Copper engraved. COLOGNE (?), *c.* 1150. *Paris, Cabinet des Medailles.* Fig. 431: The Monstrous Races of the far ends of the earth (after Solinus Polyhistor). H. 530 mm. ARNSTEIN (Middle Rhine), second half XII cent. *British Museum, MS. Harley 2799, fol. 243.*

190. Figs. 432/33: Chalice. H. 155 mm. Silver gilt, embossed. On the cupa, David crowned by Joab; David crowning Solomon; Elijah revives the Widow's Son. On the base, Samuel anointing David; David and Goliath; Michal deceives Saul by laying an image in David's bed; Abimelech gives David the Showbread and the Sword of Goliath. ARNSTEIN (Middle Rhine) (?), *c.* 1160. *Tremessen (Poland), Abbey Church.*

191. Figs. 434/35: Chalice. H. 170 mm. Silver gilt, engraved; niello. On the cupa, Last

BIBLIOGRAPHY

427. E. Molinier (14–16), p. 154.—E. Meyer (363).—Collon-Gevaert (226), p. 201.— Schramm-Mütherich (7), 177.

428. R. Schmidt, in *Jahrbuch der Preussischen Kunstsammlungen*, 54 (1933), pp. 189 ff.—E. Meyer (363).—Schramm-Mütherich (7), 172.

429/30. E. Molinier (14–16), pp. 172 ff.—Fiedler-Weitzmann, in *Zeitschrift fur Kunstwissenschaft* (1956), 109 ff. (1957), 1 ff.

431. G. C. Druce, in *Archaeological Journal*, 72 (1915), pp. 135 ff.

432/33. J. Kohte, *Kunstdenkmäler Posens*, IV (1896–98), pp. 64 ff.—G. Swarzenski, in *Städeljahrbuch*, VII/VIII (1932), p. 390, fig. 332.—H. Swarzenski, in *Essays in Honor of E. Panofsky* (1961), 437 ff.

Notes on the Plates

Supper; Moses at the Burning Bush; Annunciation; the Four Beasts. On the knob, the Rivers of Paradise (embossed). On the base, the Beatitudes. On the handle, Virtues (Justice, Temperance). Probably a gift of Henry the Lion. LOWER SAXONY, *c.* 1170. *Tremessen (Poland), Abbey Church.*

192. Fig. 436: Paten of the above Chalice. Diam. 199 mm. Niello, engraved. The Crucifixion, Church, Synagogue, Sun and Moon. Sacrifice of Isaac; Abimelech; Jacob's Dream; the Brazen Serpent; Moses striking the Rock; the Spies of the Promised Land; Calling of Gideon; Annunciation of the Birth of Samuel; Elijah and the Widow of Sarepta. Fig. 437: Paten of the Chalice of Berthold of Andechs (1148–1188). Inner side. Silver gilt, embossed and engraved. The Crucifixion with the Four anthropomorphic Beasts; Harrowing of Hell; Cherubim; Seraphim; Angels; Christ leading the Selected to Paradise; the Synagogue leading the Jews to Hell. Diam. 235 mm. Probably connected with Henry the Lion's gifts to Wilten Abbey in 1166. LOWER SAXONY, *c.* 1160–70. *Vienna, Museum.*

193. Fig. 438: Christ in Majesty; the Four Beasts; Christ nailed to the Cross; Sun and Moon mourning; Christ's Mission to Paul and Peter; Nativity; Annunciation to the Shepherds. 150×250 mm. Champlevé enamel. Top of Reliquary Casket of St. Andrew. LOWER SAXONY (?), last quarter XII cent. *Siegburg, Parish Church.* Fig. 439: Noli me tangere. The Crucifixion, Church and Synagogue, Sun and Moon mourning. Detail of a bookcover of a Hildesheim Manuscript. 185×112 mm. Champlevé enamel. Workshop of Welandus. LOWER SAXONY, *c.* 1170. *Trèves Cathedral, MS. 141.*

194. Fig. 440: Hosea. H. 90 mm. Champlevé

BIBLIOGRAPHY

437. H. Klapsia, in *Jahrbuch der Kunsthistorischen Sammlungen Wien* (1938), pp. 7 ff., Pls. I–V.—E. Meyer, in *Zeitschrift für Kunstgeschichte*, X (1943), p. 195 f.—H. Swarzenski, in *Art Bulletin*, 24 (1942), p. 304.

438. *Ars Sacra*, Exhibition Catalogue, Munich, 1950, No. 343.—H. Peters, *Siegburger Servatius-Schatz* (1952), pp. 14 f., Pls. 5, 16, 17. —Stylistically related a plaque with the Crucifixion, signed *Wolpero*, on a Limoges casket in the Berlin Museum.

439. N. Irsch, *Dom zu Trier. Kunstdenkmäler der Rheinprovinz* (1931), p. 349 f., fig. 230.—G. Swarzenski, in *Staedeljahrbuch*, VII/VIII (1932), p. 341 ff.

440. W. M. Milliken, in *Bulletin of the Cleveland*

Notes on the Plates





CATALOGUE

enamel. From a Portable Altar. LOWER SAXONY (?), c. 1170. *Cleveland, Ohio, Museum.* Fig. 441: Sketch for an Apostle (Paul?). H. 113 mm. On the reverse of a plaque from an Altar frontal of Hildesheim Cathedral (see fig. 442). Fig. 442: Pentecost. H. 111 mm. Plaque from an Altar frontal of Hildesheim Cathedral. Champlevé enamel. HILDESHEIM (?) c. 1160. *Hildesheim Cathedral.* Fig. 443: Paul as Author of his Epistles among the Apostles. New York, *Metropolitan Museum.* Fig. 444: Paul disputing with Greeks and Jews. Fig. 445: Paul let down in a basket from the walls of Damaskus. *London, Victoria and Albert Museum.* H. 127 mm. Champlevé enamel. Plaques from an Altar frontal (?). ENGLAND c. 1160.

195. Fig. 446: Portrait of Henry of Blois, Bishop of Winchester (1129–71), offering the Shrine of St. Swithin. Enlarged. H. 179 mm. Champlevé enamel, concave. ENGLAND, c. 1150. *British Museum.* Fig. 447: Christ in Clouds. Inside the lid of the Kennet Ciborium. See figs. 448–50. Twice enlarged. Champlevé enamel. ENGLAND, c. 1175. *London, Victoria and Albert Museum.*

196. Fig. 448: The Circumcision of Isaac. Fig. 449: The Ascension of Elijah. Fig. 450: David rescuing the Lamb from the Bear. Enlarged details of bowl of the Kennet Ciborium. Diam. 155 mm. Champlevé enamel. ENGLAND, c. 1175. *London, Victoria and Albert Museum.* Figs. 451/52: Virtues overcoming Vices. David rescuing the Lamb from the Bear. Details of Crozier, signed *Frater Willelmus.* H. 227 mm. Champlevé enamel. From Chartres. ENGLAND, c. 1175. *Florence, Bargello, Carrand Collection.*

197. Fig. 453: Ciborium with typological scenes. From Malmesbury. Crucifixion, Moses and





BIBLIOGRAPHY

Museum (1951), p. 72 ff.—Other plaques from the same series in the Museums of Dijon, Düsseldorf, Leningrad.

441/42. O. v. Falke, in *Pantheon,* 5 (1930), pp. 266 ff., fig. 4, 5.—G. Swarzenski, in *Staedeljahrbuch,* VII/VIII (1932), p. 340 f., 350.—R. Herzig, *Reste eines Retabels,* in *Unsere Diözese, Zeitschrift des Vereins für Heimatkunde Hildesheim* (1930), pp. 3 ff.

443–53. M. Chamot, *English Mediaeval Enamels* (1930), pp. 6 f., 10, 26 f., 35 f., Pls. 3, 5–13. —G. Swarzenski, in *Staedeljahrbuch,* VII/VIII (1932), pp. 336 ff.





Notes on the Plates

CATALOGUE

the Brazen Serpent. H. 190 mm., diam. 102 mm. Champlevé enamel. ENGLISH, c. 1175. *New York, Morgan Library.* Fig. 454: Virtues overcoming Vices. Champlevé enamel. Niello. H. 50. mm. Casket. ENGLAND, c. 1175. *Troyes Cathedral.*

198. Fig. 455: Precentor's Staff. H. 147 cm. Detail. Diam. 75 mm. Silver gilt, stencilled. Inscriptions in niello. Gift of Hugo, Canon of Cologne Cathedral. ENGLISH, 1178. *Cologne Cathedral.* Fig. 456: Capital. Salamanders and naked man. Ivory. Enlarged Detail. H. 55 mm. Ivory. ENGLISH, c. 1160. *British Museum.* Fig. 457: Bowl of Ciborium (foot lost). H. 82 mm. Diam. 177 mm. Inhabited Scrolls with naked men among dragons. Silver gilt, engraved (*vermiculé*) in Niello. Heads embossed. ENGLISH, c. 1175. *New York, Metropolitan Museum.* Figs. 458/59: Bowl of Ciborium. H. 77 mm. Diam. 115 mm. Inhabited Scrolls with Dragons. Silver gilt, engraved. Niello. Heads embossed. Inside, Lion and Dragon, embossed. Dug out in Dune, Gotland. ENGLISH (?), c. 1175. *Stockholm, National Museum.*

199. Fig. 460: Mirror Case. Dragons among scrolls. Diam. 114 mm. Bronze gilt. ENGLISH, c. 1175. *New York, Metropolitan Museum.* Fig. 461: Dragon, mounted on Ostrich Egg, converted into a Reliquary. H. 120 mm. Detail. Silver gilt. Niello. Set with a precious stone. LOWER SAXONY, c. 1200. *Halberstadt Cathedral.* Figs. 462/63: Naked man with bird's head and winged Dragon. Volutes of Candlestick. Bronze cast. Gift of Henry the Lion. BRAUNSCHWEIG or ENGLAND (?), c. 1170. *Braunschweig Cathedral.*

200. Figs. 464/465: Details of Candlestick. Jesse or Portrait of Wolfram. On the base, Lions and Apes. Inscribed: *Wolframus, Hiltiburc.* H.

BIBLIOGRAPHY

454. E. Le Brun-Dalbanne, *Trésor de la Cathédrale de Troyes* (1864), in *Mémoire lu à la Sorbonne, 9 avril 1863.*—M. Chamot (443–53), p. 33.—A. Katzenellenbogen, *Allegories of the Virtues and Vices in mediaeval Art* (1939), p. 21, fig. 21.

455. G. Swarzenski, in *Staedeljahrbuch*, VII/VIII (1932), p. 384.—P. Clemen, *Dom zu Köln*, in *Kunstdenkmäler der Stadt Köln* (1937), p. 330.

456. A. Goldschmidt, *Elfenbeinsculpturen*, IV (1926), 24.

457. M. Rosenberg, *Niello* (1907), p. 19 f., fig. 26. —J. Rorimer, in *Bulletin Metropolitan Museum of Art* (1948), p. 268 f.

458/59. C. R. af Ugglas, *Gotländska Silverskatter från Valdemarstågets tid* (1936), p. 16, Pl. X.

460. Rorimer (457).—*Art of the Middle Ages.* Exhibition Catalogue, *Museum of Fine Arts, Boston,* 1940, No. 272.

461. O. v. Falke, in *Pantheon*, 18 (1936), p. 269, fig. 6.—E. Meyer (as 534).

462/63. G. Swarzenski, in *Staedeljahrbuch*, VII/VIII (1932), p. 354 f.—H. Graeven, in *Zeitschrift des historischen Vereins für Niedersachsen* (1902), pp. 449 ff.—Bloch (115–16), 145 ff.

464/65. E. Panofsky, *Deutsche Plastik* (1924), p. 95 f., Pls. XI–XIII.—H. Beenken, *Romanische Sculptur in Deutschland* (1924), 58/9.

77

Notes on the Plates

CATALOGUE

180 cm. Bronze cast. Perhaps by the Wolf-
ranus Scultexus, mentioned in ERFURT, 1157.
Erfurt, Dom.

201. Fig. 466: Creation of Eve. Fig. 467: Portrait
of the Caster Abraham. H. *c.* 40 cm. Details
of the Bronze Doors, cast under Bishop Wich-
man of Magdeburg for Plozk Cathedral.
MAGDEBURG, 1152–1154. *Nowgorod Cathedral.*

202. Fig. 468: Key. H. 210 mm. Bronze cast.
MARBURG (?), second quarter XIII century.
Marburg, St. Elisabeths.' Fig. 469: Lovers in
Bed. Lovers embracing (Tristan and Iseult,
or Aeneas and Dido). Handle and mounts of
Mirror. H. 88 mm. Bronze cast, gilt. RHINE-
LAND (?), first half XIII century. *Frankfurt a.
M., Museum.*

203. Fig. 470: Lion Aquamanile. H. 220 mm.
Bronze cast. MAASTRICHT (?) *c.* 1150. *Maas-
tricht Cathedral.* Fig. 471: Samson Aquamanile.
H. 238 mm. Bronze cast. LOWER SAXONY,
second quarter XII century. *Berlin Museum.*

204. Fig. 472: Lion Monument. L. 182 cm.
Bronze cast. Erected by Henry the Lion.
BRAUNSCHWEIG, 1166. *Braunschweig.* Fig. 473:
Lion Aquamanile. 320 × 360 mm. Bronze
cast. BRAUNSCHWEIG or MINDEN, second half
XII century, *Minden Cathedral.*

205. Fig. 474: Initial I with Lion blowing horn.
H. 140 mm. HELMARSHAUSEN, *c.* 1175.
Trier, MS. 64, fol. 91ᵛ. Fig. 475: Initial O with
Lion of Judah. Diam. 100 mm. As Pl. 207.
Fig. 476: Detail of fig. 473. Fig. 477: Lion.
L. 125 mm. Bronze cast, gilt. Foot of a
Shrine (?). MOSAN, second half XII cent.
Amsterdam, Rijks Museum.

206. Fig. 478: The Three Marys at the Tomb. The
Entombment. In the Medallions Phenix, Peli-
can, Lioness vivifying her whelps, Eagle (Sym-
bols of the Resurrection). 235 × 154. Gospels
of Henry the Lion, fol. 74ᵛ. By Heriman.

BIBLIOGRAPHY

466/47. A. Goldschmidt, *Die frühmittelalterlichen
Bronzetüren*, II. *Die Türen von Nowgorod und
Gnesen* (1932).

468. H. Kohlhausen, in *Hessenkunst.*

469. Found at Bussen (Suabia). H. Kohlhausen, in
Festschrift F. Winkler (1959), 29 ff., dates the
mirror ca. 1150 and interprets the scenes as
Sponsus and *Sponsa* and Christ with the
Virginal Soul in Solomon's bed. Mirrors were
called in the middle ages *Specula Solomonis.*

470. Falke, Meyer (205–8), 323, 347.

471. As 470, No. 353.—E. Meyer, in *Festschrift E.
Kühnel* (1957), 317 ff.

472. H. Beenken (464/5), 57.—G. Swarzenski, in
Staedeljahrbuch, VII/VIII (1932), p. 250 f.,
314 ff.

473. Falke, Meyer (205–8), 390.

474. G. Swarzenski, in *Staedeljahrbuch*, VII/VIII
(1932), p. 272 f.

475. S. Beissel, in *Zeitschrift für Christliche Kunst*
(1902), pp. 265 ff., 307 ff.—A. Haseloff, in
O. Döring, G. Voss, *Meisterwerke der Kunst aus
Sachsen und Thüringen* (1905), p. 93.

477. A. Pit, *Catalogus van de Beeldhouwerken in het
Nederlandsch Museum voor Geschiedenis en Kunst te
Amsterdam* (1914), No. 9.

478. F. Jansen, *Helmarshausener Buchmalerei* (1933),
pp. 61 ff.—G. Swarzenski, in *Staedeljahrbuch*,
VII/VIII (1932), pp. 254 ff.

Notes on the Plates

CATALOGUE

HELMARSHAUSEN, *c.* 1171. *Collection Duke of Braunschweig.*

207. Missal of Henry de Midel. 285 × 190 mm. HILDESHEIM, *c.* 1159. *Formerly Collection Count Fürstenberg-Stammheim.* Fig. 479: The Lord surrounded by Cherubim holding the Wheel of the Universe with the six Days of Creation and the Creation of Eve. The Expulsion. Cain kills Abel. David. Fig. 480: Michael and the Battle between Angels and Devils.

208. Fig. 481: Christ. Angels. Cupa of Chalice. H. 64 mm. Diam. 124 mm. Silver gilt. Niello. LORRAINE (?), *c.* 1175. *Cologne, Diocesan Museum.* Fig. 482: Christ showing His Wounds. The Four Beasts. The Four Cardinal Virtues. 'Paten of Bernward of Hildesheim.' Diam. 134 mm. Silver, partly gilt; chiselled. Niello. From the Guelph Treasure of Braunschweig. The plate perhaps contemporary with Bernward, *c.* 1000. The engravings, BRAUNSCHWEIG (?), third quarter XII cent. *Cleveland, Ohio, Museum.* Fig. 483: Portrait of a Physician. H. 114 mm. As Pl. 210, fig. 493. LIÉGE (?), *c.* 1160. *British Museum, MS. Harley 1585, fol. 13.* Fig. 484: St. Sigismund. One of a series of Anglo-Saxon Kings. H. 100 mm. Silver. Niello. On base of the Reliquary Head of St. Oswald. H. 46 cm. BRAUNSCHWEIG or ENGLAND, *c.* 1176. *Hildesheim Cathedral.*

209. Fig. 485: River of Paradise. Niello. As fig. 484. Fig. 486: Creation of Eve. H. 52 mm. Champlevé enamel. TRANSMOSAN (TROYES?), *c.* 1160. *Troyes Cathedral.* Fig. 487: Clasp on the Bible of Hugh du Puiset (1153–95). Twice enlarged. Bronze, inlaid with silver. Niello. DURHAM, end XII century. *Durham, MS. A. II. 1.* Fig. 488: Casket. Medallions with personification of Arithmetic and Geometry, Astronomy (turning her back, looking into stars) and Dialectic (an arrow proceeding out of her

BIBLIOGRAPHY

479/80. As 475.

481. A. Weissgerber, in *Kunstgabe des Vereins für Christliche Kunst in Köln* (1937).

482. G. Swarzenski, in *Staedeljahrbuch*, VII/VIII (1932), p. 371 f.

483. K. Sudhoff, in *Beiträge zur Geschichte der Medizin im Mittelalter*, I (1914).

484/85. G. Swarzenski, in *Staedeljahrbuch*, VII/VIII (1932), pp. 372 ff.—H. Reuther, in *Niedersächsische Beiträge zur Kunstgeschichte IV* (1966).

486. Other plaques of the same dismantled object reproduced in A. Gaussen, *Portefeuille archéologique de la Champagne* (1861), Pl. 19.—E. Le Brun-Dalbanne, *Recherches* (59/60), Pl. IV.

487. R. A. B. Mynors, *Durham Cathedral MSS.* (1939), No. 146, pp. 83 ff.

488. G. Swarzenski, in *Staedeljahrbuch*, VII/VIII (1932), p. 361 f.—M. Chamot (443–53), p. 33 f., No. 16, Pls. 4, 13.

Notes on the Plates

mouth). 61 × 110 × 53 mm. Champlevé enamel. ENGLAND, *c.* 1200. *London, Victoria and Albert Museum.* Fig. 489: Casket. Inhabited scrolls. 43 × 55 × 133 mm. Champlevé enamel. ENGLAND, *c.* 1200, *Florence, Bargello, Carrand Collection.* Fig. 490: Thomas Becket murdered. Angel. Reliquary Casket for the Blood of the Saint. L. 70 mm. Silver. Niello; lid surmounted by a ruby. Perhaps made for John of Salisbury and presented to Chartres Cathedral. ENGLAND, *c.* 1175. *New York, Metropolitan Museum.* Fig. 491: Lid from a Casket. Baptism of Christ with river god. L. 165 mm. Champlevé enamel. ENGLAND, end XII century. *Bâle, Collection Robert von Hirsch.*

210. Fig. 492: The Harmony of the Spheres. Air and the Four Winds. Arion on the Dolphin, Pythagoras, Orpheus. In medallions the Nine Muses (after Martianus Capella). 527 × 377 mm. REIMS (?), *c.* 1170. *Reims, MS. 672, fol. 1.* Fig. 493: Phlebotomy. Curing by bloodletting. H. 118 mm. *As Pl. 208, fig. 483, fol. 7.*

211. Fig. 494: Eliphaz, Job's arrogant friend, as Initial I. H. 280 mm. Fig. 495: Job, smitten by Satan, among his wife and three friends. God. W. 300 mm. SAINT-BERTIN, end XII century. *Saint-Omer, MS. 12, vol. 2, fol. 92ᵛ; vol. 1, fol. 5ᵛ.*

212. Figs. 496–498: Arm Reliquary. Busts of Christ and Apostles. H. 510 mm. Silver gilt; embossed. Champlevé enamel. From the Guelph Treasure. BRAUNSCHWEIG (?), last quarter XII cent. *Cleveland, Ohio, Museum.* Fig. 499: Casket. Angels. Silver embossed. On lid, champlevé enamel. 64 × 116 mm. LORRAINE (?), *c.* 1175. *Oxford, Ashmolean Museum.*

213. Figs. 500/1: Reliquary in form of a church surmounted by a dome. Made for the Head of Gregory, brought by Henry the Lion in 1172 from Constantinople to Braunschweig.

BIBLIOGRAPHY

490. T. Borenius, *St. Thomas Becket in Art* (1932), p. 78 f.

491. O. Homburger, in *Kunst des frühen Mittelalters.* Exhibition Catalogue, Bern, 1949, No. 344.

492. Didron, *Annales Archéologiques* (1844), p. 36 ff.—P. Lacroix, *Sciences et Lettres au Moyen-Age* (1877), p. 435, fig. 319.—O. Schmitt, in *Festschrift H. Schrohe* (1934), pp. 70 ff.

493. As 483.

494/95. J. Porcher, *L'Art du Moyen Age en Artois.* Exhibition Catalogue, Arras, 1951, Nos. 28/9. —Porcher (164), 129, and (187–89), 35.

496–98. G. Swarzenski, in *Staedeljahrbuch*, VII/VIII (1932), pp. 326 ff.—O. v. Falke (32, 33), p. 75, No. 30, Pls. 65/6.

499. O. M. Dalton, *Fitzwilliam Museum, McClean Bequest. Catalogue*, No. 58, Pl. XVII.

500–02. A. Goldschmidt, *Elfenbeinsculpturen*, III (1923), 47.—O. v. Falke (32, 33), pp. 68 f., 136 ff.—E. Meyer, in *Zeitschrift für Kunstgeschichte*, X (1943), p. 199 f.—A closely

Notes on the Plates

CATALOGUE

Guelph Treasure. 455 × 410 mm. Copper gilt. Champlevé enamel. Borders partly silver gilt, stencilled. Figures Morse ivory. Journey of the Magi, Jonah, Zechariah, Obadiah, Zephaniah, Crucifixion. Below the dome, the Apostles. COLOGNE, c. 1180. *Berlin, Museum.*

214. Fig. 502: Journey of the Magi. Detail of Pl. 213. H. 125 mm. Fig. 503: One of the Magi on horseback. H. 160 mm. Knob of the Trivulzio Candlestick. See Pl. 215.

215. Figs. 504/5: Rivers of Paradise. Diam. 20 mm. Volutes of the Trivulzio Candlestick. Perhaps commissioned to replace the older candlestick transferred by Emperor Barbarossa in 1162 to Prague Cathedral (see Pl. 151). Bronze cast. Rock-crystals. H. 182 m. LORRAINE, ENGLAND (?) or MILAN (?), c. 1200, *Milan Cathedral.*

216. Fig. 506: Initial P with Paul preaching. H. 155 mm. Fig. 507: Healing of the Possessed by the Devil. Enlarged Detail of Canon Table. Bible of Mainerus of Canterbury. 530 × 365 mm. SENS or SAINT-BERTIN, c. 1180. *Paris, Bibliothèque Sainte Geneviève MS. 10, fol. 127ᵛ, 277.* Fig. 508: Initial D to Psalm 93. Lion devouring Lamb. H. 65 mm. YORK (?), c. 1170. *Copenhagen, MS. Thotts Saml. 143, fol. 116ᵛ.* Fig. 509: Initial R with two naked men wrestling. H. 160 mm. Bible of Saint-André-au-Bois. SAINT-BERTIN (?), end XII century. *Boulogne, MS. 2, vol. 2, fol. 81ᵛ.*

217. Fig. 510: Hercules wrestling with the Lion. H. 130 mm. Bronze cast. Perhaps from a Fountain. ENGLAND (?), late XII century (?). *New York, Untermyr Collection.* Fig. 511: Journey of the Magi. Detail of a Ciborium. H. 213 mm. Silver gilt, embossed. ENGLAND (?), early XIII cent. *Saint-Maurice Abbey.* Fig. 512: Centaur Chiron and Achilles. H. 43 mm.

BIBLIOGRAPHY

related reliquary is in the Victoria and Albert Museum.

503–05. O. Homburger, *Der Trivulzio Kandelaber* (1949).—C. C. Oman, in *Apollo* (1952), pp. 53 ff.—Bloch (115–16), 153 ff.

506/07. E. G. Millar, *English Illuminated MSS.* (1926), p. 86, Pl. 49.—R. Dodwell (278). —A twin Bible in Paris, Bibliothèque Nationale, MS. lat. 11534/5. A. Haseloff, in A. Michel, *Histoire de l'art*, II, 2 (1906), p. 320 f.—A. Boinet, in *Bulletin de la Société francaise de Réproduction des MSS.* (1921), pp. 21 ff., Pl. VII f.

508. As 316, Pl. 57.

509. A. Boutémy, in *Scriptorium*, 5 (1951), pp. 67 ff., Pls. 1–8.—A number of initials from the Bible in the Ecole des Beaux Arts, Paris.

510. Y. Hackenbroch, *Bronzes . . . and Sculpture in the Irwin Untermyr Collection* (1962), IXf. Pl. 2, 3.

511/12. E. Aubert, *Trésor de Saint-Maurice* (1872), p. 172.—J.-J. Berthier, *Coupe dite de Charlemagne*, Fribourg (1896).—The attribution to England is based on a stylistic comparison with contemporary English MSS.—O. Homburger,

Notes on the Plates

CATALOGUE

Diam. 49 mm. Bronze cast, gilt. Finial of Ciborium of Saint-Maurice.

218. Fig. 513: Samson wrestling with the Lion. Fig. 514: Isaac sacrificed. Fig. 515: The Molten Sea carried by 12 Oxen. Fig. 516: Moses crossing the Red Sea. H. 140 mm. Champlevé enamel. Plaques from the Altar of Klosterneuburg, originally an Ambo. Dedicated by Provost Wernher in 1181. By Nicholas of Verdun. LORRAINE, 1181. *Klosterneuburg Abbey*.

219. Fig. 517: The Three Marys at the Tomb. Rejected sketch on the reverse of the plaque depicting the Harrowing of Hell. Copper gilt, engraved. As Pl. 218. Fig. 518: The Three Marys at the Tomb. The Crucifixion. Eagle of John. Detail of the roof of the Shrine of the Virgin. 90 × 126 × 70 cm. Silver gilt, embossed. Champlevé and cloisonné enamel. Filigree. Precious Stones. By Nicholas of Verdun. LORRAINE, 1205. *Tournai Cathedral*.

220. Fig. 519: The Flight into Egypt. Considerably restored. As fig. 518. Fig. 520: Moses Return from Egypt. As Pl. 218.

221. Fig. 521: Bishop with Model of his Church. Perhaps Bruno or Anno of Cologne. H. 150 mm. Champlevé enamel. Workshop of Nicholas of Verdun in COLOGNE, early XIII cent. *Chicago, Museum*. Fig. 522: Daniel. H. 271 mm. Silver gilt, embossed. From the Shrine of the Three Kings. Champlevé and cloisonné enamel. Email brun. Filigree. Precious Stones. Workshop of Nicholas of Verdun in COLOGNE, 1190–1230. *Cologne Cathedral*.

222. Fig. 523: Musicians among scrolls. W. 35 mm. Copper gilt, engraved on blue champlevé enamel. Figs. 524–526: Inhabited scrolls. Dragons, Man fighting Centaur, Samson on the Lion, Knights on horseback, Lion. H. 48 mm.

BIBLIOGRAPHY

in *Akten zum III, Internationalen Kongress für Frühmittelalter Forschung* (1954), 352 f.

513–20. K. Drexler, *Der Verduner Altar im Stifte Klosterneuburg* (1903).—O. Demus, in *Oesterreichische Zeitschrift für Denkmalpflege*, V (1951), pp. 13 ff., figs. 26, 28.—J. Warichez, *Cathédrale de Tournay* in *Ars Belgica* (1935), Pls. 68–73.—M. Creutz (424/5), pp. 135 ff., Pls. XVI. XVII.—P. Metz (359–61), pp. 313 ff. —Collon-Gevaert (226), pp. 190 ff.—See also 522–6.—F. Roehrig, *Verduner Altar* (1959).

521. H. Schnitzler, in *Wallraf Richartz Jahrbuch*, XI (1939), pp. 56 ff.

522–26. O. v. Falke, *Dreikönigsschrein* (1911).—J. Braun, in *Stimmen der Zeit*, 115 (1928), pp. 130 ff., and *Kunstwissenschaftliches Jahrbuch der Görres-Gesellschaft*, I (1928).—P. Clemen, *Dom zu Köln. Kunstdenkmäler der Rheinprovinz* (1937), pp. 330 ff.—E. Hübinger, in *Annalen des Historischen Vereins f. d. Niederrhein*, 129 (1936), pp. 79 ff.—A. Weissgerber, *Studien zu N. v. Verdun* (1940).—Mutherich (421), pp. 39 ff., 53 ff.—J. Hoster, H. Schnitzler, *Der Meister des Dreikönigenschreins*. Catalogue (1964). Schramm-Mütherich (7), 191, 192.

Notes on the Plates

CATALOGUE

Silver gilt, *ajouré*. From Shrine of the Three Kings. As fig. 522. Fig. 527: Inhabited Scroll. Men and Dragon. H. 80 mm. Bronze cast, gilt. Fragment of Crest of a Shrine. COLOGNE (?), c. 1200. *London, Victoria and Albert Museum.* Fig. 528: Crest of the Shrine of St. Albinus. H. 51 mm. Detail. Copper cast, gilt. COLOGNE, end XII century. *Cologne, St. Pantaleon.*

223. Fig. 529: Peter. Fig. 530: Bartholomew. H. 75 mm. Fig. 531: Monkey between Dragons. Detail of Crest, enlarged. H. 65 mm. Silver gilt, embossed. Copper cast, gilt. Champlevé enamel. From the Shrine of St. Anno. 0.78 × 0.46 × 1.77 m. COLOGNE, c. 1183. *Siegburg Abbey.*

224. Fig. 532: Peter and Paul. H. 45 mm. Silver gilt, embossed. Mounted on a bookcover. TRÈVES, first quarter XIII century. *Manchester, Rylands Library.* Fig. 533: The Crucifixion, Peter, Paul. Niello plaques on the base of a Chalice. Diam. 154 mm. Signed. By Hugo of Oignies. MOSAN. c. 1220. *Namur, Notre Dame.*

225. Fig. 534: One of a Group of four Jews stoning St. Stephen. Applied to a Byzantine silver bowl brought in 1208 by Bishop Konrad of Krosigk from the Holy Land to his See. H. 130 mm. Bronze gilt, cast. HALBERSTADT, c. 1208. *Halberstadt Cathedral.* Fig. 535: Buckle. Mounted knight and lady (Entry into Jerusalem?). Seated Couple. 50 × 95 mm. Silver gilt, *ajouré*. Dug out in Dune, Gotland. See Pl. 198, figs. 458/59. LORRAINE or ENGLAND, early XIII century. *Stockholm Museum.* Fig. 536: Buckle. Solomon and Queen of Sheba (?). Two attendants. Dragon and Lion. 54 × 76 mm. Bronze gilt, *ajouré*. LORRAINE, early XIII century, *New York, Metropolitan Museum.*

BIBLIOGRAPHY

528. As 521. Falke, Frauberger (366), pp. 51 ff., Pls. 53/4.—Mütherich (421), pp. 65 ff.—C. Kesseler, in *Rheinische Kirchen im Wiederaufbau* (1951), pp. 41 ff.

529–31.—H. Peters (438), p. 18 ff., Pls. 25–38. Mütherich (421), pp. 56 ff.

532. M. R. James, *Descriptive Catalogue of the Latin MSS. in the John Rylands Library* (1921), pp. 310 ff., Pls. 186/87.—H. Swarzenski, in *Art Bulletin*, 24 (1942), p. 302 f.

533. F. Courtoy, J. Schmitz, *Mémorial de l'Exposition des Trésors d'Art.* Namur (1931), p. 18, Pl. VII.—Collon-Gevaert (226), pp. 204 ff.

534. E. Meyer, *Dommuseum Halberstadt* (1935), p. 27.—O. v. Falke, in *Pantheon*, 18 (1936), p. 268 f.

535. As 458/9, p. 20, Pl. XXI.

536. Rorimer (457).

Notes on the Plates

CATALOGUE

226/27. Figs. 537/38: Moses with the Tablets of the Law. H. 234 mm. Bronze cast. LORRAINE, end XII century. *Oxford, Ashmolean Museum.*

228. Fig. 539: Prophet. H. 219 mm. As Pls. 226/27. Fig. 540. Christ in Mandorla. The Four Beasts. H. 241 mm. Missal of ANCHIN, end XII century. *Douai, MS. 90, fol. 100ᵛ.*

229. Fig. 541: Pentecost. Psalter of Queen Ingebourge (d. 1236). H. 217 mm. ANCHIN (?), c. 1200. *Chantilly, MS. 1695, fol. 32ᵛ.*

230. Fig. 542: The Flagellation. Detail. *As Pl. 229, fol. 26ᵛ.* Fig. 543: The Crucifixion. *As Pl. 228, fig. 540, fol. 98ᵛ.*

231. Fig. 544: Christ on the Cross. H. 71 cm. Ivory. ENGLAND or DENMARK, early XIII century. *Herfursholm Abbey.*

232. Fig. 545: The Angel heals the blind Tobias. H. 185 mm. SAINT ALBAN'S (?), early XIII century. *Cambridge, University Library, MS. Kk.4.25, fol. 45.*

233. Fig. 546: St. Martin's Companions on the Falcon Hunt. H. 150 mm. TOURNAI, early XIII century. *British Museum, MS. Add. 15216, fol. 11.* Fig. 547: Sleeping Apostle from a Gethsemane group. H. 120 mm. Sketchbook of Villard de Honnecourt. NORTH-EASTERN FRANCE, c. 1240. *Paris, Bibliothèque Nationale, MS. français 19093, fol. 23ᵛ.* Fig. 548: Sleeping Apostle. H. 38 mm. Bronze cast, gilt. NORTHERN FRANCE, c. 1240. *London, Collection Peter Wilson.*

234. Figs. 549/50; Angel. Baptism of Christ. H. c. 260 mm. Details. Baptismal Font. Bronze cast. Gift of Wilbernus (= Wilbrandus) of Oldenburg. Signed Gerard. LOWER SAXONY (HILDESHEIM?), c. 1226. *Osnabrück Cathedral.* Fig. 551: Snake. Detail in original size of the Hildesheim Font. As Pl. 235.

235. Figs. 552/53: Rivers of Paradise, carrying the Baptismal Font. H. 450 mm. Bronze Cast.

BIBLIOGRAPHY

537–39. H. P. Mitchell, in *Burlington Magazine,* 38 (1921), pp. 157 ff.—O. v. Falke, in *Jahrbuch der Preussischen Kunstsammlungen,* 43 (1922), pp. 47 ff.—O. Homburger, in *Oberrheinische Kunst,* I (1925/6), pp. 5 ff.

540. V. Leroquais, *Les Sacramentaires des Bibliothèques de France,* I (1924), pp. 350 ff.

541/42. V. Leroquais, *Les Psautiers* (1940/41), p. 138.—L. Grodecki, in *Acts of the 20th International Congress of the History of Art I* (1963), p. 130. Porcher (187–89) 47, 90.

543. As 540.

544. A. Goldschmidt, *Elfenbeinsculpturen,* III (1923), 126.—L. Grodecki, *Ivoires Français* (1947), p. 81 f., Pl. XX.

546. H. Swarzenski, in *Festschrijt zum 70. Geburtstag von A. Goldschmidt* (1935), pp. 40 ff.

547. H. R. Hahnloser, *Villard de Honnecourt* (1935), pp. 79 ff., 198.

548. Hoster-Schnitzler (522–26), no. 29.

549–53. O. Dolfen, in *Jahresbericht des Diöcesan Museums Osnabrück* (1924/25), and *Osnabrücker Tageblatt, Beilage,* 17, IX, 1927.—Algermissen, in *Katholisches Kirchenblatt Bistum Hildesheim,* July 1949.

Notes on the Plates

CATALOGUE

Gift of Wilbernus, Provost of Hildesheim 1216–1220. HILDESHEIM, c. 1220. *Hildesheim Cathedral.*

236/37 Figs. 554–56: Samson Aquamanile. H. 330 mm. Bronze cast. From Ober-Achern (Baden). WEST GERMANY or LORRAINE, second quarter XIII century. *Boston, Museum.*

238. Fig. 557: Aquamanile. Lion sitting on Dragons. H. 250 mm. Bronze cast. LOWER SAXONY, second quarter XIII century. *Hamburg, Museum.*

BIBLIOGRAPHY

554–56. O. v. Falke, E. Meyer, *Bronzegeräte des Mittelalters*, I (1935), 453.—G. Swarzenski, in *Bulletin of the Museum of Fine Arts*, Boston, XXXVIII (1940), pp. 67 ff.

557. Falke-Meyer (as 554–56), 372. Two closely related casts in the Robert Lehman Collection, New York, and the Victoria and Albert Museum.

Index of Iconography

Aaron: Pl. 137, fig. 309; Pl. 155, fig. 344; Pl. 179, fig. 398.

Abimelech: Pl. 190; Pl. 192, fig. 436.

Abraham: Pl. 127, fig. 290; Pl. 155, fig. 343; Pl. 187, fig. 424; Pl. 192, fig. 436; Pl. 218, fig. 514.

Abraham (caster): Pl. 201, fig. 467.

Achilles: Pl. 189, figs. 429, 430; Pl. 217, fig. 512.

St. Adalbert: Pls. 116, 117.

Adam and Eve: Pls. 46, 47; Pl. 51, figs. 113–4; Pl. 96, fig. 222; Pl. 207, fig. 479.

Adam rising from the Tomb: Pl. 91, fig. 210; Pl. 205, fig. 240.

Adelheit: Pl. 36, fig. 85.

Adoration of the Magi: *see* Magi.

Air: Pl. 210, fig. 492.

Alexander: Pl. 163, fig. 359.

Almod of Mont-Saint-Michel: Pl. 130, fig. 294.

St. Amand: Pl. 77, figs. 178, 179; Pl. 128, fig. 292.

Amos: Pl. 162, fig. 357; Pl. 184, fig. 413.

St. Andrew: Pl. 66, fig. 152; Pl. 70, fig. 165; Pl. 153, fig. 339; Pl. 169, fig. 374.

Andromeda: Pl. 68, figs. 156–7.

Angels: Pl. 9, fig. 18; Pl. 11, fig. 22; Pl. 35; Pl. 36, fig. 84; Pl. 43; Pl. 49, fig. 110; Pl. 56, fig. 128; Pl. 66, fig. 151; Pl. 67, fig. 155; Pl. 75; Pl. 85; Pl. 87; Pl. 91, fig. 210; Pl. 100, fig. 231; Pl. 128, fig. 291; Pl. 146; Pl. 165, fig. 363; Pl. 167; Pls. 170–2; Pl. 174, fig. 383; Pl. 184, fig. 415; Pl. 192, fig. 437; Pl. 207, fig. 410; Pl. 212, fig. 499; Pl. 230, fig. 530; Pl. 234, fig. 549.

St. Anne: Pl. 66, fig. 153.

Annunciation: Pl. 20, fig. 45; Pl. 106, fig. 241; Pl. 187, fig. 425; Pl. 191.

Annunciation to the Shepherds: Pl. 193, fig. 438.

Apes: Pl. 200, fig. 465; Pl. 223, fig. 531.

Apocalyptic Elder: Pl. 67, fig. 154.

Apostles: Pl. 56, fig. 126; Pl. 102, fig. 234; Pl. 106, fig. 241; Pl. 108, fig. 248; Pl. 153, fig. 339; Pl. 155, fig. 344; Pl. 170, fig. 375; Pl. 212, figs. 496–8; Pl. 213.

Arion: Pl. 210, fig. 492.

Arithmetic: Pl. 209, fig. 488.

Ascension: Pls. 15, 20; Pl. 36, fig. 84; Pl. 56, fig. 127, Pl. 66, fig. 151; Pl. 69, fig. 160; Pl. 106, fig. 241; Pl. 180, fig. 400.

Assumption of the Virgin: Pl. 75.

Astronomy: Pl. 209, fig. 488.

St. Augustine: Pl. 80, fig. 185.

St. Augustine, illustrations to the *Civitas Dei*: Pl. 87, fig. 201; Pl. 128, fig. 291.

Bacchus: Pl. 163, fig. 358.

Baptism: Pl. 20; Pl. 54, fig. 121; Pl. 55, figs. 124–5; Pl. 113; Pl. 209, fig. 491; Pl. 234, figs. 549–50.

St. Bartholomew: Pl. 106, fig. 244; Pl. 223, fig. 530.

Battle with the King of Syria: Pl. 73, fig. 169.

Bear: Pl. 84, fig. 194; Pl. 126, fig. 288; Pl. 196, figs. 450, 452.

Beasts of the Evangelists: *see* Symbols of the Evangelists.

Beatitudes: Pl. 188, fig. 427; Pl. 191.

St. Benedict: Pl. 42; Pl. 159, fig. 352.

St. Bertin: Pl. 70, fig. 162; Pl. 83, fig. 193.

Bishops of Tongern: Pl. 187, fig. 424.

St. Blaise: Pl. 101, fig. 232.

Blind healed: Pl. 10, fig. 20.

Boethius: Pl. 70, fig. 164; Pl. 131, fig. 296.

Brazen Serpent: *see* Moses.

St. Bruno of Cologne (?): Pl. 221, fig. 521.

Index of Iconography

Cain and Abel: Pl. 48; Pl. 127, fig. 290; Pl. 207, fig. 479.

Camel: Pl. 180, figs. 402, 404.

Centaurs: Pl. 121, fig. 277; Pl. 150, fig. 332; Pl. 222, fig. 524.

Charity: Pl. 127, fig. 289; Pl. 182, fig. 408; Pl. 188, fig. 426.

Chartres Cathedral: Pl. 76.

Chasing from the Temple: Pl. 10, fig. 20.

Cherubim: Pl. 192, fig. 437; Pl. 207, fig. 479.

Chiron: Pl. 189, figs. 429, 430; Pl. 217, fig. 512.

Chosroes: Pl. 187, fig. 424.

Christ: Pl. 10, fig. 20; Pls. 20, 31; Pl. 36, fig. 85; Pl. 54, figs. 122-3; Pl. 62, figs. 138, 140; Pl. 64; Pl. 65, fig. 148; Pl. 66, fig. 151; Pl. 67, fig. 155; Pl. 73, fig. 170; Pl. 85, fig. 198; Pl. 97; Pl. 98, fig. 226; Pl. 100, fig. 230; Pl. 101, fig. 231; Pl. 106, fig. 241; Pl. 107, fig. 246; Pl. 119, fig. 273; Pl. 127; Pl. 128, fig. 291; Pl. 128, fig. 292; Pl. 132, fig. 299; Pl. 136, fig. 306; Pls. 146, 170; Pl. 172, fig. 378; Pl. 174, fig. 384; Pl. 176; Pl. 187, fig. 425; Pl. 193, fig. 438; Pl. 195, fig. 447; Pl. 207, fig. 479; Pl. 208, figs. 481, 482; Pl. 228, fig. 540.

Christ calling Peter: Pl. 8, fig. 15; Pl. 70, fig. 165.

Christ led to Herod: Pl. 45, fig. 102.

Christ's Mission to Paul and Peter: Pl. 193, fig. 438.

Christ on the Cross: Pl. 11, fig. 22; Pl. 18; Pl. 19, fig. 43; Pl. 22, fig. 50; Pl. 23, fig. 51; Pl. 28, fig. 67; Pl. 29, fig. 71; Pl. 30, figs. 72, 73; Pl. 34, fig. 82; Pl. 35; Pl. 36, fig. 85; Pl. 63, fig. 142; Pl. 64, fig. 146; Pl. 65, fig. 150; Pl. 69, fig. 161; Pls. 94, 95, 104; Pl. 105, fig. 239; Pl. 106, fig. 241; Pl. 109, fig. 249; Pls. 122, 140, 141; Pl. 144, fig. 405; Pl. 186, fig. 423; Pl. 192, fig. 437; Pl. 193; Pl. 197, fig. 453; Pl. 219, fig. 518; Pl. 224, fig. 533; Pls. 230, 231.

Christ Stoned: Pl. 123.

Circumcision: Pl. 196, fig. 448.

Church: Pl. 73, fig. 170.

Church and Synagogue: Pl. 36, fig. 84; Pl. 69, fig. 160; Pl. 187, fig. 425; Pl. 192, fig. 436; Pl. 193, fig. 438.

Column of Christ: Pl. 91, fig. 210.

Concord: Pl. 78, fig. 180.

St. Constantine: Pl. 36, fig. 85; Pl. 166; Pl. 187, fig. 424.

Continents: Pl. 175, fig. 388.

St. Cosmas: Pl. 35; Pl. 36, fig. 84.

Creation: Pl. 207, fig. 479.

Creation of Eve: Pl. 96, fig. 221; Pl. 201, fig. 466; Pl. 207, fig. 479; Pl. 209, fig. 486.

Crucifixion: *see* Christ on the Cross.

Cyrus: Pl. 98, fig. 225.

St. Damian: Pl. 35; Pl. 36, fig. 84.

Daniel: Pl. 106, fig. 242; Pl. 221, fig. 522.

David: Pls. 2-4; Pl. 67, fig. 154; Pl. 106, fig. 242; Pl. 126, fig. 288; Pl. 149, fig. 316; Pl. 190; Pl. 207, fig. 479.

David rescuing the Lamb: Pl. 60, fig. 133; Pl. 93, fig. 216; Pl. 145, fig. 323; Pl. 196, figs. 450, 452.

Deborah: Pl. 110, fig. 252.

Deposition: Pl. 154.

Destruction of the Temple: Pl. 8, fig. 14.

Devils: Pl. 87; Pl. 128, fig. 291; Pl. 146; Pl. 159, fig. 352; Pl. 207, fig. 480.

Dialectic: Pl. 209, fig. 488.

Disk of Heaven: Pl. 9, fig. 18.

Dodolinus: Pl. 70, fig. 162.

Doeg: Pl. 137, fig. 308.

Eagle: Pl. 25, fig. 56; Pl. 152; Pl. 198, fig. 455; Pl. 206.

Earth: Pl. 5, figs. 8, 9; Pl. 22, fig. 50; Pl. 69, fig. 161; Pl. 72, fig. 168; Pl. 96, fig. 222; Pl. 157; Pl. 177, figs. 391, 392; Pl. 178; Pl. 186, fig. 423.

St. Edmund: Pl. 120.

Elemosina: *see* Charity.

Elijah: Pl. 73, fig. 169; Pl. 135, fig. 304; Pl. 187, fig. 424; Pl. 190; Pl. 192, fig. 436; Pl. 190, fig. 449.

Eliphaz: Pl. 211, fig. 494.

Elkanah's Sacrifice: Pl. 110, fig. 251.

Entombment: Pl. 206.

Index of Iconography

Index of Iconography

Joshua: Pl. 135, fig. 305.

Justice: Pl. 170, fig. 376; Pl. 186, fig. 423; Pl. 191.

St. Kilian: Pl. 102, fig. 233.

Lamb of God: Pl. 8, fig. 14; Pl. 29, fig. 70; Pl. 32, fig. 77; Pl. 83, fig. 192; Pl. 186, fig. 422.

Lambert of St. Bertin: Pl. 127, fig. 289.

Last Judgement: Pls. 172, 173.

Last Supper: Pl. 30, fig. 74; Pls. 71, 191.

Lazarus: Pl. 8, fig. 14; Pl. 52, fig. 117; Pl. 128, fig. 291.

Leper healed: Pl. 9, fig. 17; Pl. 10, fig. 20.

Levi's Tribe: Pl. 187, fig. 424.

Liberal Arts: Pl. 209, fig. 488.

St. Liborius: Pl. 102, fig. 233.

Lion: Pl. 60; Pl. 84, figs. 194, 195; Pl. 93, fig. 216; Pl. 98, fig. 226; Pl. 103, fig. 236; Pl. 114, fig. 260; Pl. 117, fig. 270; Pl. 118, fig. 272; Pl. 126, fig. 287; Pls. 144, 145, 147; Pl. 180, fig. 103; Pl. 198, fig. 459; Pl. 200, fig. 465; Pls. 203–6; Pl. 216, fig. 508; Pl. 217, fig. 510; Pl. 218, fig. 513; Pl. 222, fig. 525; Pls. 236–8.

St. Livin: Pl. 78, fig. 181.

Lothair I: Pl. 100, fig. 229.

Lothair II (?): Pl. 28, fig. 68.

Lovers: Pl. 202, fig. 469.

St. Luke: Pl. 7, fig. 13; Pl. 10, fig. 20; Pl. 23, fig. 52; Pl. 36, fig. 84; Pl. 57, fig. 130; Pl. 80, fig. 186; Pl. 81, fig. 189; Pl. 124; Pl. 175, fig. 385.

Luna: Pl. 68, fig. 158—see also: Sun and Moon.

St. Magdalen: Pl. 108, fig. 247.

Magi: Pl. 125, fig. 286; Pl. 214; Pl. 217, fig. 511.

Malachi: Pl. 106, fig. 242.

Mambres: Pl. 61, fig. 136.

Manger of Avranches: Pl. 130, fig. 294.

Marys at the Tomb: Pl. 20; Pl. 49, fig. 109; Pl. 69, fig. 161; Pl. 79, fig. 183; Pl. 103, fig. 235; Pl. 106, fig. 241; Pls. 144, 206, 219.

Marys before Christ: Pl. 20; Pl. 174, fig. 384.

St. Mark: Pl. 6; Pl. 10, fig. 20; Pl. 23, fig. 52; Pl. 32, fig. 76; Pl. 36, fig. 84; Pl. 72, fig. 167; Pl. 81, fig. 187; Pl. 162, fig. 356.

St. Martin: Pl. 233, fig. 546.

Martin of St. Bertin: Pl. 127, fig. 289.

St. Mary: see Virgin Mary.

Massacre of the Innocents: Pls. 16, 17.

Mathilda: Pl. 28, fig. 69.

St. Matthew: Pl. 1, fig. 1; Pl. 10, fig. 20; Pl. 23, fig. 52; Pl. 36, fig. 84; Pl. 57, fig. 129; Pl. 81, fig. 188; Pl. 82, fig. 189; Pl. 125, fig. 285.

St. Maurice: Pl. 78, fig. 182; Pl. 79, fig. 184.

Maurus: Pl. 159, fig. 352.

St. Maxentius: Pl. 166.

Melchisedek: Pl. 106, fig. 242; Pl. 155, fig. 344.

St. Michael: Pl. 41, fig. 93; Pls. 42, 85; Pl. 130, fig. 295; Pl. 136, fig. 306; Pl. 175, fig. 387; Pl. 207, fig. 480.

Michal: Pl. 190

Milo: Pl. 70, fig. 163.

Molten Sea: Pl. 110, fig. 253; Pl. 218, fig. 515.

Monsters: Pl. 61, fig. 137; Pl. 189, fig. 431.

Moses: Pl. 155, fig. 344; Pls. 226, 227.

Moses and Aaron: Pl. 117, fig. 309.

Moses addressing the Israelites: Pl. 134, fig. 302.

Moses and the Brazen Serpent: Pl. 178; Pl. 187, fig. 424; Pl. 192, fig. 436; Pl. 197, fig. 453.

Moses at the Burning Bush: Pl. 191.

Moses crossing the Red Sea: Pl. 218, fig. 516.

Moses' Death: Pls. 58, 59.

Moses marking the 'T': Pl. 179, fig. 398; Pl. 187, fig. 424.

Moses receiving the Law: Pl. 21, fig. 47.

Moses' return from Egypt: Pl. 220, fig. 520.

Moses striking the Rock: Pl. 179, fig. 399; Pl. 192, fig. 436.

Mouth of Hell, see Hell.

Muses: Pl. 210, fig. 492.

Musicians: Pl. 86, fig. 199; Pl. 126, fig. 288; Pl. 131, fig. 296; Pl. 222, fig. 523.

Nathan reproaching David and Bathsheba: Pl. 149, fig. 316.

Nativity: Pl. 20; Pl. 36, fig. 84; Pl. 106, fig. 241; Pl. 193, fig. 438.

Index of Iconography

St. Nicholas' Birth: Pl. 139, figs. 312, 313.

Nichomachus: Pl. 131, fig. 296.

Noli me Tangere: Pl. 193, fig. 438.

Nudes: Pl. 198, figs. 456, 457; Pl. 199, fig. 462; Pls. 216, 217; Pl. 218, fig. 516.

Odbert of St. Bertin: Pl. 70, fig. 162.

Orpheus: Pl. 210, fig. 492.

Otto of Kappenberg: note to fig. 363; Pl. 188, fig. 428.

Otto of Swabia: Pl. 28, fig. 69.

Oxen, symbolising the Molten Sea: Pl. 110, fig. 253; Pl. 113, fig. 258; Pl. 218, fig. 515.

St. Pantaleon: Pl. 99, fig. 228.

Parable of the Wicked Husbandman: Pl. 168, fig. 370.

Paradise: Pl. 192, fig. 437.

St. Paul: Pl. 35; Pl. 36, fig. 84; Pl. 53, fig. 120; Pl. 56, fig. 126; Pl. 77, fig. 177; Pl. 193, fig. 438; Pl. 194, figs. 443–5; Pl. 216, fig. 506; Pl. 224.

Pelican: Pl. 206.

Pentecost: Pl. 20; Pl. 180, fig. 401; Pl. 195, fig. 440; Pl. 229.

Perfection: Pl. 163, fig. 359.

St. Peter: Pl. 35; Pl. 36, fig. 84; Pl. 70, fig. 165; Pl. 107, figs. 243, 245; Pl. 193, fig. 438; Pl. 223, fig. 529; Pl. 224.

St. Philip: Pl. 169, fig. 374.

Philosophy: Pl. 70, fig. 164; Pl. 119, fig. 274.

Phlebotomy: Pl. 210, fig. 493.

Phoenix: Pl. 206.

Piety: Pl. 170, fig. 376.

St. Pinnosa: Pl. 36, fig. 84.

Plato: Pl. 131, fig. 296.

Pliny: Pl. 129.

Porcupine: Pl. 114, fig. 260.

Portraits: Pl. 28, fig. 69; Pl. 36, fig. 84; Pl. 41, fig. 94; Pl. 45, fig. 101; Pl. 70, figs. 162, 163; Pl. 76; Pl. 99, fig. 227; Pl. 128, fig. 292; Pls. 129, 130; Pl. 131, fig. 296; Pl. 132; Pl. 143, fig. 319; Pls. 163, 165; Pl. 187, fig. 424; Pl. 188, fig. 428; Pl. 195, fig. 446; Pl. 200, fig.

464; Pl. 201, fig. 467; Pl. 208, figs. 483, 484; Pl. 210, fig. 492; Pl. 221, fig. 521.

Presentation: Pl. 106, fig. 241.

Prophets: Pl. 155, fig. 344; Pl. 185, fig. 421; Pl. 194, fig. 441; Pl. 213; Pl. 228, fig. 539.

Prudence: Pl. 174, fig. 382; Pl. 185, fig. 418.

Psalm 22: Pl. 118, fig. 272.

Psalm 26: Pl. 4.

Psalm 43: Pls. 2, 3.

Psalm 85: Pl. 83, fig. 192.

Psalm 103: Pl. 119, fig. 273.

Pythagoras: Pl. 131, fig. 296; Pl. 210, fig. 492.

St. Quentin: Pl. 82, fig. 191.

Resurrection: Pl. 144; Pl. 181, fig. 406.

Resurrection of the Dead: Pl. 5, fig. 8; Pl. 36, fig. 84; Pls. 172, 173.

Revelation XII, 14: Pl. 157.

Richard II of Normandy: Pl. 130.

Rivers of Paradise: Pl. 51, figs. 113, 114; Pl. 69, fig. 161; Pl. 103, fig. 236; Pl. 168, fig. 369; Pl. 169, figs. 372, 373; Pl. 186, fig. 422; Pl. 191; Pl. 209, fig. 485; Pls. 213, 235.

Robert le Diable: Pl. 130, fig. 295; Pl. 143, fig. 320.

Roma: Pl. 5, fig. 8.

Rudolf of Swabia: Pl. 99, fig. 227.

Ruth and Boaz: Pl. 133, fig. 300.

Salamander: Pl. 198, fig. 456; Pl. 199, fig. 463 (?).

Salome: Pl. 52, fig. 118.

Samson and the Lion: Pl. 60, fig. 134; Pl. 180, fig. 403; Pl. 203, fig. 471; Pl. 217, fig. 510 (?); Pl. 218, fig. 513; Pl. 222, fig. 525; Pls. 236, 237.

Samuel: Pl. 190.

Samuel (Annunciation of his birth): Pl. 192, fig. 436.

Satan: Pl. 118, fig. 271; Pl. 160, fig. 354; Pl. 161, fig. 355.

Saul's death: Pl. 133, fig. 301.

Sea: Pl. 5, fig. 8; Pl. 69, fig. 161; Pl. 96, fig. 222; Pl. 177, figs. 394, 395; Pl. 186, fig. 423.

Index of Iconography

Seraphim: Pl. 192, fig. 437.

Serpent: Pl. 28, figs. 68, 69; Pl. 29, fig. 71; Pl. 69, fig. 161; Pl. 121, fig. 278; Pl. 157; Pl. 174, fig. 382; Pl. 177, fig. 193; Pl. 185, fig. 418.

St. Sigismund: Pl. 36, fig. 85; Pl. 208, fig. 484.

Sisera: Pl. 110, fig. 252.

Solomon: Pl. 190.

Solomon and the Queen of Sheba (?): Pl. 225, fig. 536.

Solomon's Temple: Pl. 155, figs. 343, 344.

Spies returning with the Grape: Pl. 178; Pl. 185, fig. 420; Pl. 187, fig. 424; Pl. 192, fig. 436.

Spinario: Pl. 91, fig. 211.

St. Stephen: Pls. 225, fig. 534.

Sun and Moon: Pl. 11, fig. 22; Pl. 13, fig. 28; Pl. 18, figs. 41, 42; Pl. 19, fig. 43; Pl. 22, fig. 50; Pl. 29, fig. 71; Pl. 192, fig. 436; Pl. 193.

Susanna: Pl. 13, figs. 29, 30.

St. Sylvester: Pl. 166.

Symbols of the Evangelists: Pl. 26; Pl. 27, figs. 63–5; Pls. 29, 32; Pl. 34, fig. 82; Pl. 36, fig. 84; Pl. 54, fig. 122; Pl. 81; Pl. 82, fig. 190; Pl. 84, fig. 196; Pl. 86, fig. 200; Pl. 89, fig. 206; Pl. 97, fig. 224; Pl. 100, fig. 230; Pl. 124; Pl. 132, fig. 298; Pl. 186, fig. 422; Pl. 187, fig. 425; Pl. 191; Pl. 192, fig. 437; Pl. 193, fig. 438; Pl. 208, fig. 482; Pl. 219, fig. 518; Pl. 228, fig. 540.

Synagogue, see also Church and Synagogue: Pl. 192, fig. 437.

Temperance: Pl. 185, fig. 420; Pl. 191.

Temptation: see Adam and Eve.

Terence illustration: Pl. 13, fig. 31; Pl. 131, fig. 297.

St. Theodolus: Pl. 163, fig. 359.

St. Thomas: see Incredulity of Thomas.

St. Thomas à Becket: Pl. 209, fig. 490.

Three Worthies in the Fiery Furnace: Pl. 155, fig. 346; Pl. 167, fig. 368.

Tobias: Pl. 232.

Transfiguration: Pl. 176.

Trinity: Pl. 128, fig. 291.

Trinity in the guise of the Second Person: Pl. 62, fig. 140.

Tristan and Iseult: Pl. 202, fig. 469.

Truth: Pl. 83, fig. 192; Pls. 170, 171.

Typological Scenes: Pl. 145, fig. 322; Pls. 178, 179; Pl. 185, figs. 418, 420; Pls. 190–2; Pl. 196, figs. 448, 449; Pl. 197, fig. 453; Pls. 218, 220.

Uriah stoned: Pl. 140, fig. 316.

Vespasian: Pl. 129.

Virgin and Child: see Virgin Mary.

Virgin Mary: Pl. 11, fig. 22; Pl. 12, figs. 24, 26; Pl. 13, fig. 28; Pls. 18, 19; Pl. 23, fig. 52; Pl. 35; Pl. 36, fig. 85; Pls. 38, 39; Pl. 62, figs. 139, 141; Pl. 63, fig. 143; Pl. 64, fig. 146; Pl. 66, fig. 153; Pl. 69, fig. 161; Pl. 74, fig. 172; Pl. 75; Pl. 109, fig. 250; Pl. 122, fig. 279; Pl. 127, fig. 289; Pl. 128, fig. 291; Pl. 136, fig. 307; Pl. 187, fig. 425; Pl. 193; Pl. 224, fig. 533.

Virtues: Pl. 68, fig. 159; Pl. 127, fig. 290; Pl. 163, fig. 359; Pl. 188, fig. 426; Pl. 191; Pl. 208, fig. 482.

Virtues overcoming Vices: Pl. 183, fig. 411; Pl. 196, fig. 451; Pl. 197, fig. 454.

Visitation: Pl. 106, fig. 241.

St. Waldpurgis: Pl. 36, fig. 84.

Wedding at Cana: Pl. 14.

Wedricus of Liessies: Pl. 132.

Wheel of the Universe: Pl. 188, fig. 426; Pl. 207, fig. 479.

Widow of Sarepta: Pl. 122, fig. 279; Pl. 187, fig. 424; Pl. 192, fig. 436.

Winds: Pl. 51, figs. 115, 116; Pl. 119, fig. 273; Pl. 185, fig. 419.

Wolfram: Pl. 200, fig. 464.

Woman in Adultery: Pl. 10, fig. 20; Pl. 132, fig. 299.

Youth of Naim: Pl. 8, fig. 15.

Zechariah: Pl. 185, fig. 421.

Zephaniah: Pl. 185, fig. 421.

Zodiac: Pl. 73, fig. 170.

Index of Names

Index of Names

Irene (Empress): 68, fig. 366.

Johannes of Liessies: 62, Pl. 132.
John of Salisbury: 80, fig. 490.
Judith Guelph: 49, Pl. 64.

Konrad II: 43, figs. 73, 75.
Konrad III of Burgundy: 43, Pl. 31.
Konrad of Krosigk: 83, fig. 534.
Kunigunde: 45, Pls. 41, 42, fig. 101.

Lambert of St. Omer: 58 f., figs. 260, 263; 66, fig. 348.
Liuthar: 38 f., Pl. 10, fig. 32.
Lothair I: 56, fig. 229.
Lothair II: 39, figs. 29, 30; 42, figs. 68, 70.

Mainerus of Canterbury: 81, figs. 506, 507.
Martianus Capella: 80, fig. 492.
Mathilda of Essen: 42, fig. 69; 43, fig. 80; 45, Pl. 39; 47, figs. 115, 116.
Maurilius of Fécamp: 51, note to fig. 174.

Nicholas of Verdun: 82, figs. 513–26.
Nortpertus: 54, note to figs. 209, 210.

Odbert of St. Bertin: 50, figs. 160–3.
St. Oswald: 79, figs. 484, 485.
Otto I: 38, fig. 12; 47, fig. 121.
Otto III: 41, fig. 55; 43 f., Pls. 34, 37.
Otto of Kappenberg: 68, fig. 363; 74, fig. 428.

Peter of Gloucester: 54, figs. 205–8.
Philibert: 51, note to fig. 174.

Rainer of Huy: 58, Pls. 111–3; 66, fig. 346.
Reiner: 66, fig. 346.
Rogerus: 56 f., figs. 232–4, 239.
Ruoprecht of Prüm: 52, fig. 177.

Simon II of Saint-Bertin: 71, figs. 396–9.
Snello *auctor*: 56, fig. 236.
Solinus Polyhistor: 73, fig. 431.
Statius: 74, figs. 429, 430.
Suger: 65, figs. 336, 337.

Theophanu (Empress): 40, fig. 50.
Theophanu of Essen: 43, fig. 80; 44, fig. 84; 56, fig. 230.
St. Thomas à Becket: 80, fig. 490.
Tostig of Northumbria: 49, Pl. 64.

Villard d'Honnecourt: 84, fig. 547.

Wedricus of Liessiés: 62, Pl. 132.
Welandus: 75, fig. 439.
Wernher of Klosterneuburg: 82, Pl. 218.
Wibald of Stavelot: 67, figs. 359–61; 68, figs. 364–6.
Wibertus of Aachen: 74, figs. 427, 428.
Wichman of Magdeburg: 78, Pl. 201.
Wilbernus: 84 f., Pls. 234, 235.
Wilbrandus: 84, Pl. 234.
Willelmus frater: 76, figs. 451, 452.
St. Winnoc: 53, note to fig. 192.
Wladimir II of Bohemia: 65, Pl. 151.
Wolfram: 77, Pl. 200.
Wolfranus Scultexus: 78, Pl. 200.
Wolpero: 75, note to fig. 438.

Index of Places of Origin

Index of Places of Origin

Gloucester: 54, figs. 205–8.
Gnesen: 59, Pls. 116, 117.
Goslar: 54, fig. 214.
Gotland: 76, figs. 458, 459; 83, fig. 535.

Halberstadt: 83, fig. 534.
Helmarshausen: 56 f., figs. 232–4, 237–9; 78, figs. 474, 478.
Helmstedt: 55, figs. 218–20.
Hereford: 49, figs. 152, 153; 59, fig. 274.
Hildesheim: 42 f., figs. 67, 74, Pl. 34; 46, figs. 102–4, 107, Pls. 50–3; 57, fig. 239; 76, figs. 441, 442; 77 f., figs. 475, 479, 480, 482; 84, figs. 549–53.

Jumièges: 53, fig. 195.

Komburg: 57 f., Pls. 107, 108.

Le Mans: 54, figs. 204–8; 61, fig. 293.
Liége: 38, figs. 11, 13; 44, fig. 84; 52 f., figs. 180, Pl. 80, fig. 192; 56, figs. 231, 235; 58, Pls. 111–3; 59, Pls. 116, 117; 66 f., Pls. 158, 159; 69, fig. 367; 69, figs. 369, 375; 72, figs. 409–11; 73, figs. 424–6; 79 f., figs. 483, 493.
Liesborn: 44, Pl. 35.
Liessiés Abbey: 62, Pl. 132.
Lindau: 39, figs. 22–5.
Lobbes: 38, fig. 12.
Lorraine: 39, Pl. 13; 40 f., Pls. 17, 23, 24; 43, Pl. 31; 46, fig. 110; 48, fig. 127; 53, fig. 202; 54, fig. 212; 59, figs. 261, 262; 65, Pl. 151; 65, figs. 341, 342; 66, fig. 347; 71, figs. 391–3; 79, fig. 481; 80 f., figs. 499, 503–5; 82, figs. 513–20; 83 f., figs. 535–9; 85, figs. 554–6.
Lorsch: 38, fig. 18; 40, Pl. 19.
Lower Saxony: 41, fig. 55; 54 f., figs. 214, 218–20, 227; 57, fig. 240; 68, Pl. 165; 74 f., Pls. 191–4; 77, fig. 461; 78, fig. 471; 84 f., figs. 549, 550, 557.
Lüneburg: 46, fig. 108; 54, figs. 209, 210.

Maastricht: 41, figs. 51, 57, 58; 65, note to figs. 341, 342; 69 f., figs. 376, 377, 379–81; 78, fig. 470.
Magdeburg: 52, fig. 182; 54, note to figs. 209, 210; 78, Pl. 201.
Mainz: 41, fig. 56; 42 f., figs. 72, 73, Pls. 31–3, fig. 79; 44 f., figs. 87, 88, 93–5, 96, 98, 99, 101; 52, fig. 184; 55, fig. 221; 56, fig. 236.
Malines: 72, figs. 416, 417.
Malmesbury: 76, fig. 453.
Manassès Abbey: 53, note to fig. 192.
Marburg: 78, fig. 468.
Marchiennes: 47, fig. 122.
Maroilles: 63, Pl. 141.
Metz: 37, fig. 1; 40, Pl. 16; 47, fig. 121.
Milan: 65, Pl. 151; 80 f., figs. 503–5.
Minden: 78, figs. 473, 476.
Mont-Saint-Michel: 51, fig. 174; 61, Pl. 130.
Mosan: 66, fig. 346; 67, fig. 358; 69, figs. 372, 373; 70 ff., figs. 378, 382, 383, Pl. 175, figs. 394–405; 73, Pl. 186; 83, fig. 533.

Normandy: 53 f., figs. 195, 197, 198, 200, 204; 60, fig. 286.
North Eastern France: 84, figs. 547, 548.
Norway: 55, fig. 216; 64, fig. 329.

Old Malton: 49, fig. 150.

Park Abbey: 67, fig. 357.
Plozk: 78, Pl. 201.
Poland: 46, fig. 110.
Prüm: 52, fig. 177.

Ratisbon: 37 f., Pls. 8, 10.
Reims: 37 ff., figs. 2, 6–10, 14–7, 19, Pls. 10–12; 39, Pl. 13, fig. 31; 41, figs. 57, 58; 48, fig. 131; 49, fig. 148; 51, fig. 167; 60, fig. 288; 64, figs. 330–2; 80, fig. 492.
Rhineland: 78, fig. 469.

St. Alban's: 59, figs. 272, 273; 84, fig. 545.

Index of Places of Origin

Saint-Amand: 40, fig. 42; 52, fig. 178; 61, fig. 292; 63 f., figs. 315, 317–9.

Saint-André-au-Bois: 81, fig. 509.

Saint-Bertin: 37, fig. 5; 48, fig. 130; 49, figs. 143, 144; 50, figs. 154, 157, 158, 160–3; 53, fig. 193; 58 f., figs. 260, 263; 61, Pl. 127; 71, figs. 396–9; 80, Pl. 211, figs. 506, 507, 509.

Saint-Denis: 37, fig. 9; 38, Pls. 8, 10; 41, figs. 57, 58; 51, figs. 165, 175; 54, fig. 213; 64, figs. 326–9.

St. Gall: 39, Pl. 11.

St. Germer (Oise): fig. 337.

Saint-Germain-des-Prés: 51, fig. 166.

Saint-Hubert-d'Ardennes: 56, fig. 229.

Saint-Trond: 65, fig. 340; 70, fig. 378.

Saint-Vaast: *see* Arras.

Saint-Vinoc: 53, fig. 192.

Sandford: 49, fig. 148.

Sens: 81, figs. 506, 507.

Sherbourne: 62, fig. 303.

Stavelot: 45, fig. 97; 52, fig. 182; 55, figs. 222, 224, 225; 58, figs. 251, 252; 65, fig. 333; 67, figs. 356, 359–61; 68, figs. 264–6; 69, figs. 370 371, 374; 72, fig. 414.

Tirstrup: 58, fig. 249.

Tournay: 82, figs. 518, 519; 84, fig. 546.

Tremessen: 74 f., Pls. 191, 192.

Trèves: 40, Pls. 19–20; 41, Pl. 27; 51, fig. 168; 55, fig. 221; 65 f., figs. 343, 344; 83, fig. 532.

Troyes: 79, fig. 486.

Waulsort Abbey: 39, figs. 29, 30; 73, fig. 426.

Werden: 55, figs. 218–20; 66, fig. 345.

Wilten Abbey: 75, fig. 437.

Wladimir Cathedral: 72, Pl. 181.

Winchester: 46, fig. 105; 47 f., figs. 123, 124, 126, 128; 48 f., figs. 140, 141; 62 f., figs. 304, 308–11; 64, figs. 323, 324.

Worcester: 60, fig. 279.

York: 63, fig. 316; 81, fig. 508.

Index of Present Locations

Index of Present Locations

Index of Present Locations

Index of Present Locations

Index of Materials and Techniques

Index of Objects

PLATES

PLATE 1

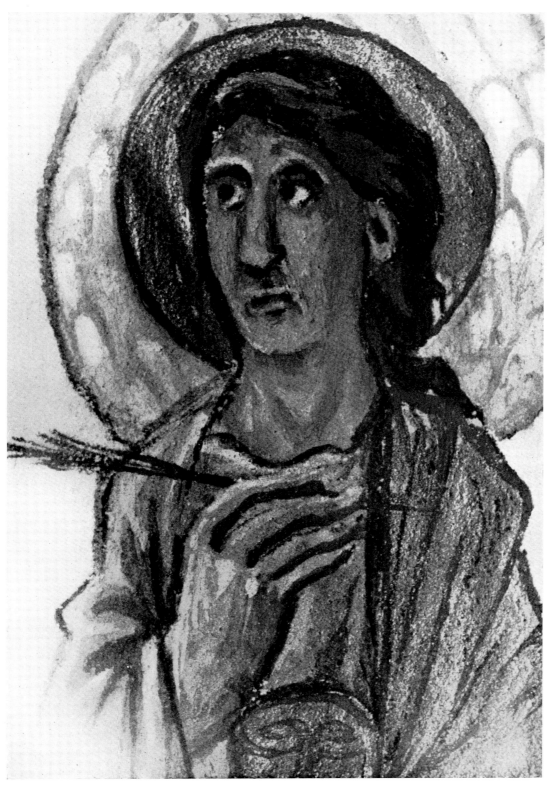

1. Angel of Matthew. Metz, c. 850

PLATE 2

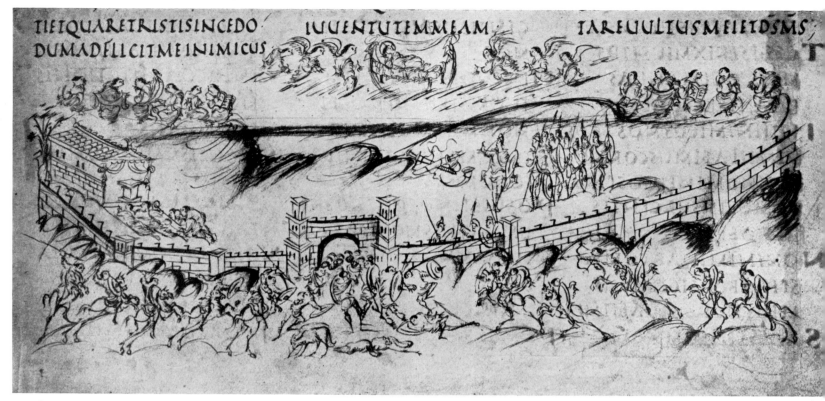

TIEIQUARETRISTISINCEDO IUUENTUTEMMEAM IAREUULTUSMEIETDSMS
DUMADFLICITMEINIMICUS

2. The Utrecht Psalter. Reims, *c.* 832

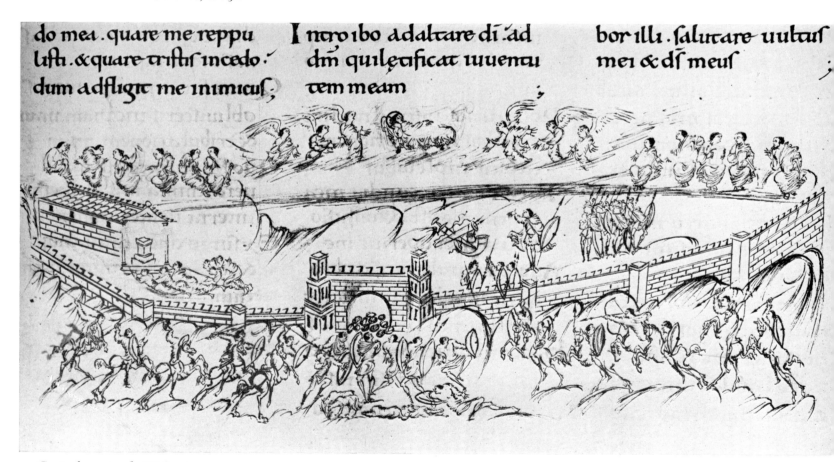

do mea . quare me reppu I ntroibo adaltare di ad bor illi . salutare uultus
listi . & quare tristis incedo · dm quiletificat iuuentu mei & ds meus
dum adfligit me inimicus ; tem meam

3. Canterbury, early XI Century

2—5. ILLUSTRATIONS TO PSALM 43 IN THE UTRECHT PSALTER
AND ITS THREE COPIES:

'Up Lord why sleepest Thou.' Our fathers who record the deeds of the Lord. Men crouching in the dust before the
Temple 'Our belly cleaveth unto the ground'. The Psalmist, armed, appealing to the Lord. David's people dispersed
and killed 'like sheep for the slaughter'

PLATE 3

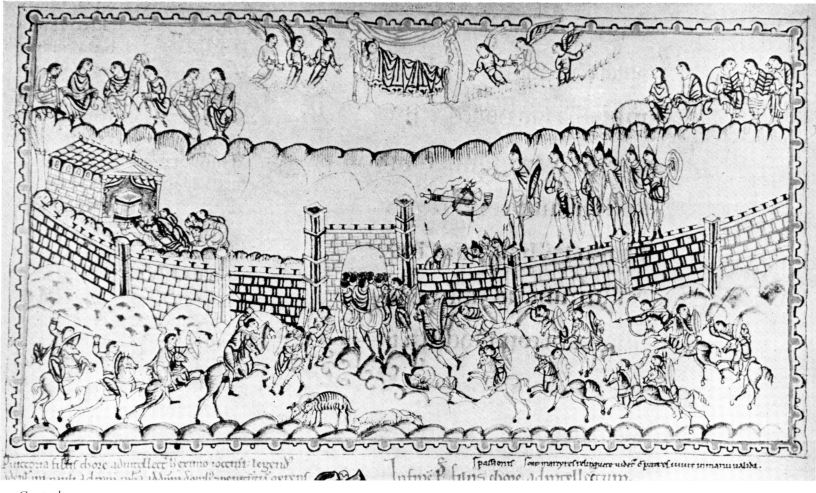

Puttona fulhf chore admrtlect b'ecnno rocennt legend
spaffionif ſoup martyrel relinquere udef ɛ parcf ununcre ın manu ualıda.
Infmc'b fluuf chore admrellettum.

4. Canterbury, c. 1150

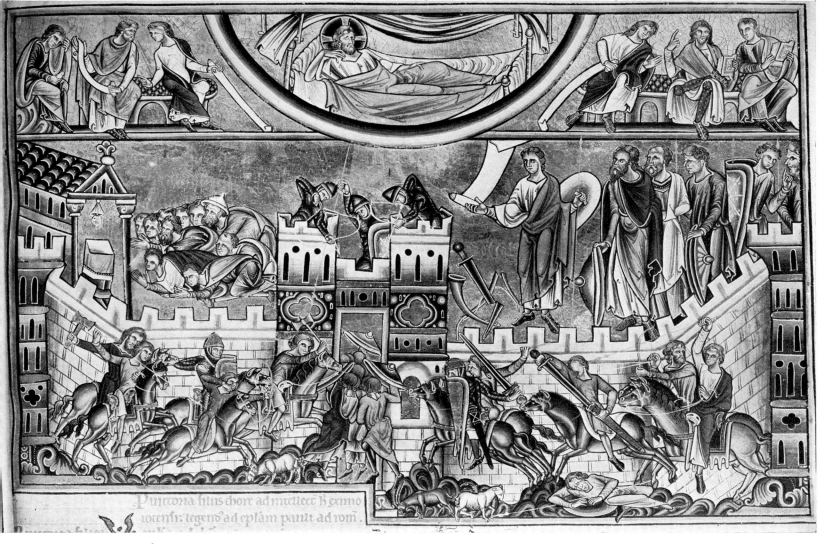

Puttona fluuf chore ad mtellect b ermo
iouenfr legend'ad eplam paui ad rom.

5. Saint—Bertin or Canterbury, c. 1200

PLATE 4

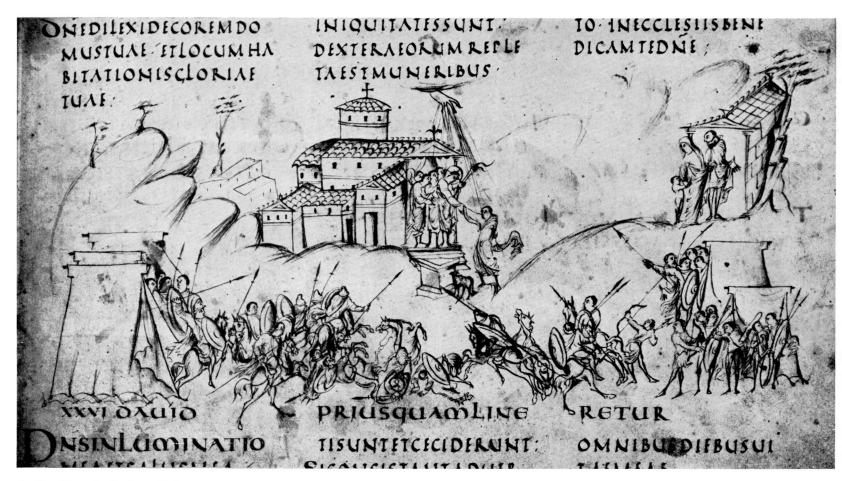

ONEDILEXIDECOREMDO
MUSTUAE ETLOCUMHA
BITATIONISCLORIAE
TUAE

INIQUITATESSUNT
DEXTERAEORUMREPLE
TAESTMUNERIBUS

TO INECCLESIISBENE
DICAMTEDNE

XXVI DAVID

PRIUSQUAMLINE

RETUR

DNSINLUMINATIO

TISUNTETCECIDERUNT

OMNIBUSDIEBUSUI

6. The Utrecht Psalter. Reims, c. 832

6–7. ILLUSTRATIONS TO PSALM 26:
The hosts who attack the Psalmist have fallen. The Lord in the Holy Temple, taking up the Psalmist by the hand. The Oblation. Mother and father forsaking the Psalmist

7. Reims (?), c. 860

PLATE 5

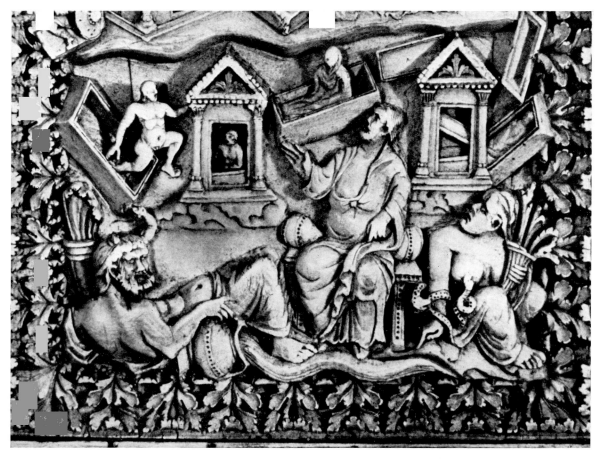

8. Resurrection of the Dead. Personifications of Rome, Sea and Earth. Reims (?), c. 860

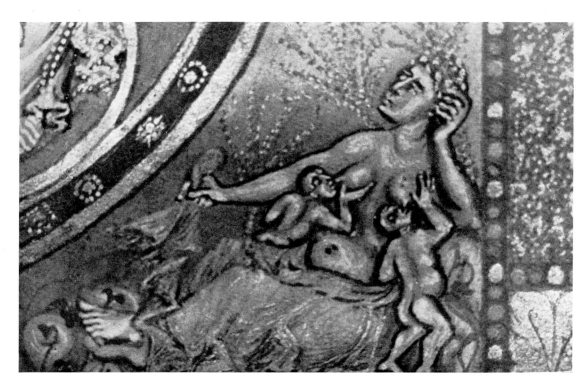

9. The Earth. Reims (?), c. 870

PLATE 6

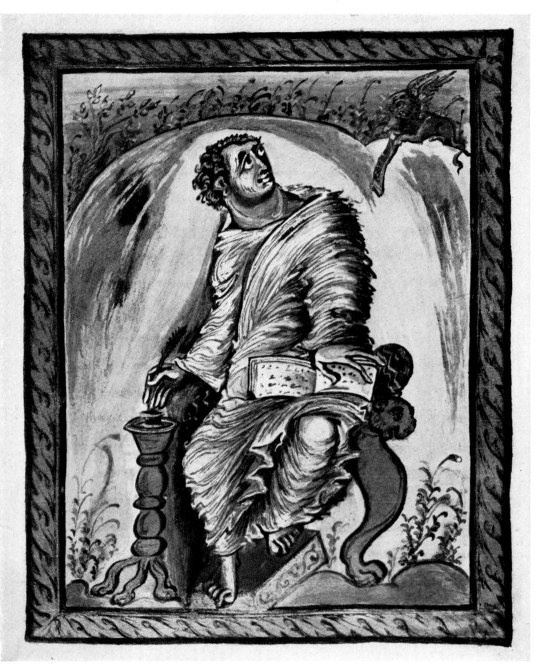

10. Mark. Gospels of Ebbo of Reims (816–35)

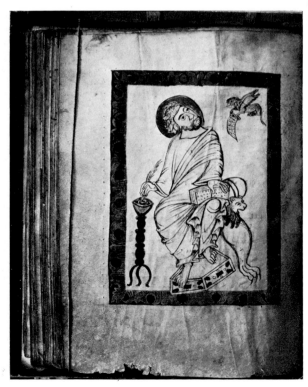

11. Copy of Fig. 10. Liége of Fleury (?),
end X Century

PLATE 7

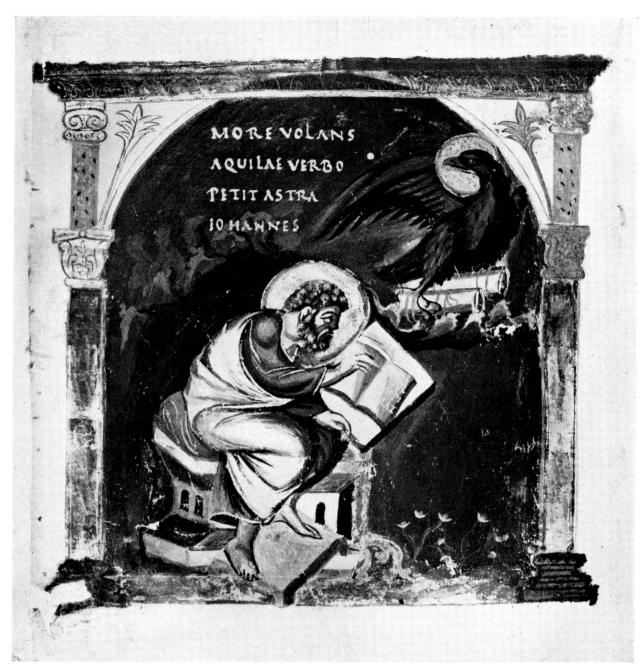

MORE VOLANS
AQUILAE VERBO
PETIT ASTRA
IOHANNES

12. John. Lobbes, *c.* 950

13. Luke. Liége, late X Century

PLATE 8

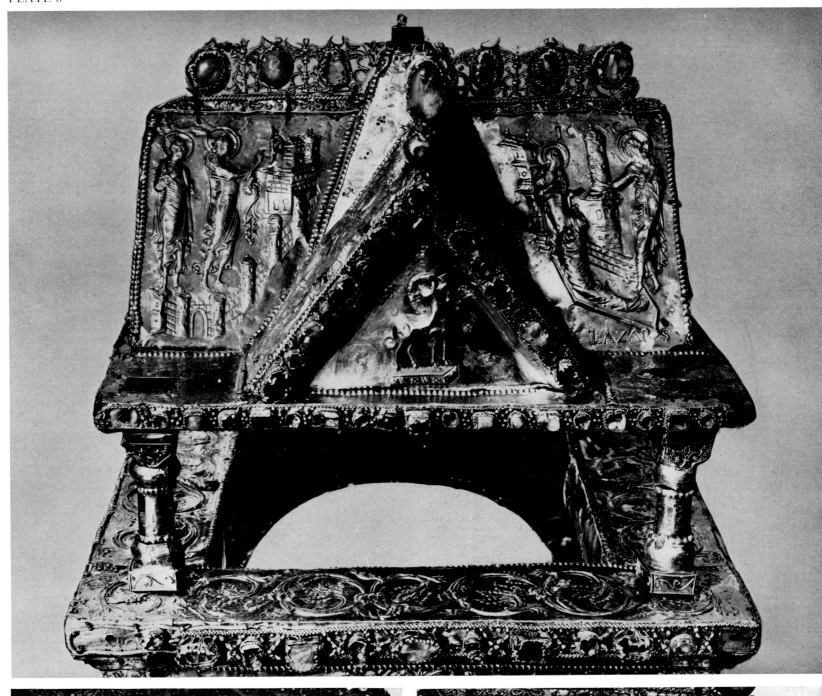

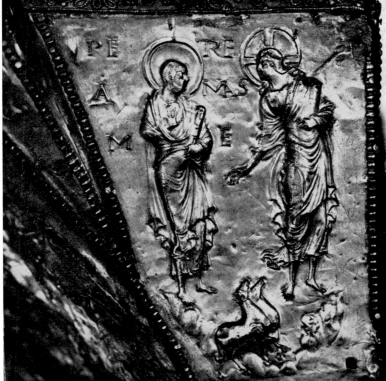

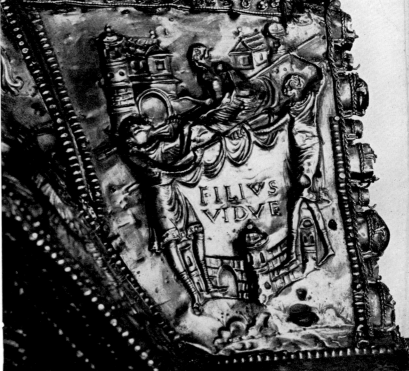

14–16. Portable Altar of King Arnulf. Scenes from the Gospels. Reims (?), *c.* 870

PLATE 9

17. Healing of the Leper. Reims, c. 830

18. Angel of the Lord. Lorsch, end X Century

19. Healing of the Leper. Details of Pl. 10

PLATE 10

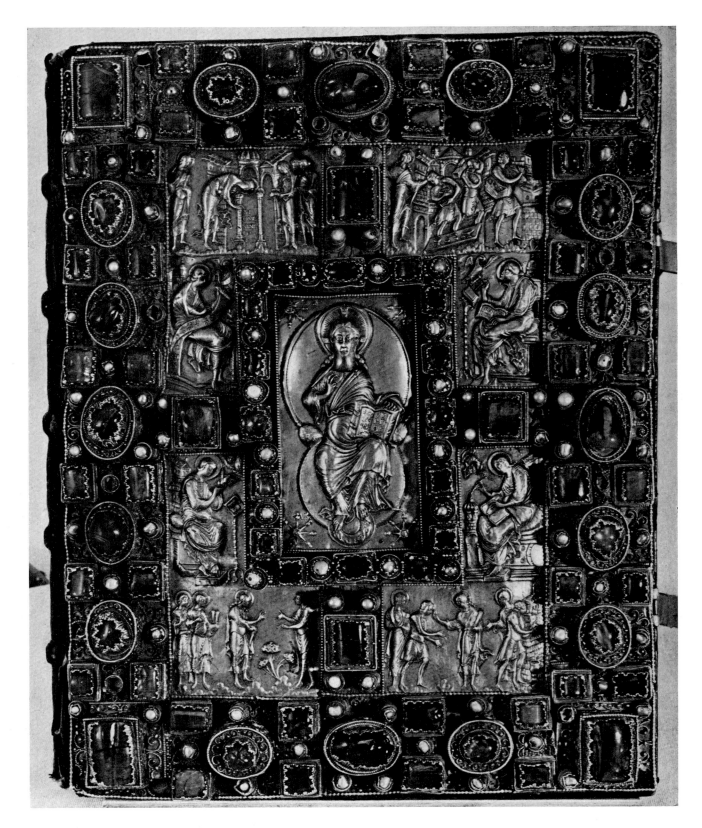

20–21. Codex Aureus of St. Emmeram's. Christ. The Evangelists. Scenes from the Gospels.
Reims (?), c. 870

PLATE 11

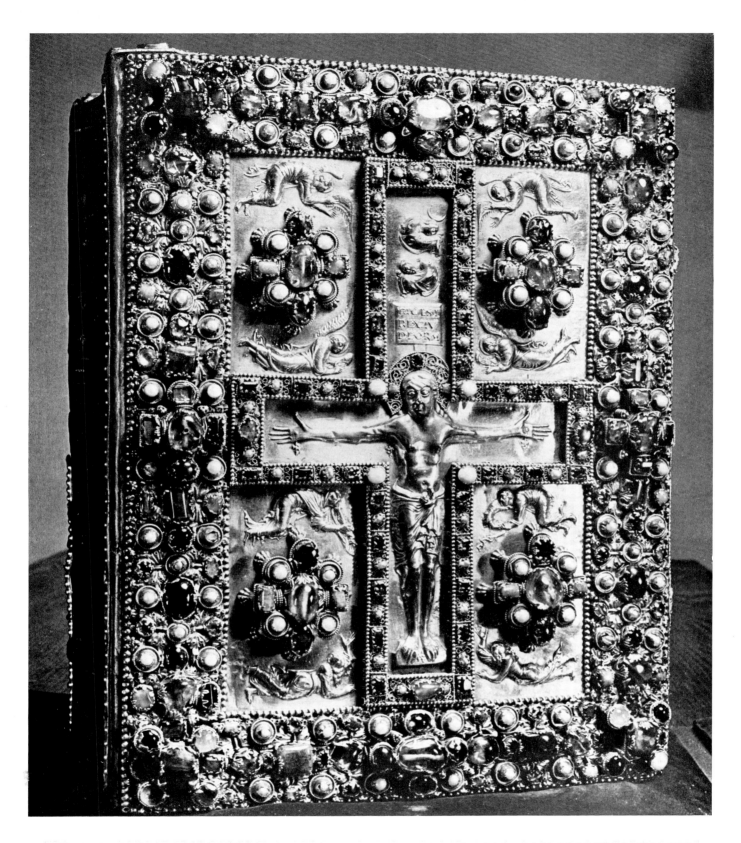

22–23. Codex Aureus of Lindau. Reims (?), c. 870

PLATE 12

24–25. Details of Pl. 11

26–27. Reims (?), end IX Century

MARY AND JOHN MOURNING

PLATE 13

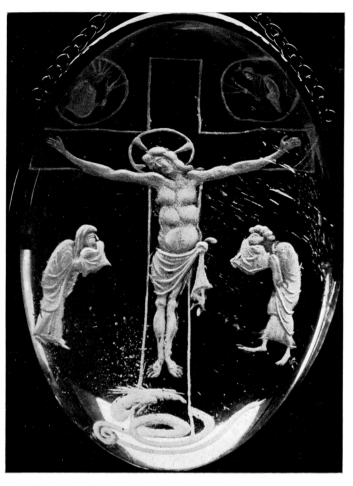

28. The Crucifixion. Lorraine (?), c. 870

29. The Chaste Susanna. Lorraine (?), c. 865

30. Detail of Fig. 29

31. Illustration to the *Eunuchus* of Terence.
Reims or Corbie (?), c. 850

PLATE 14

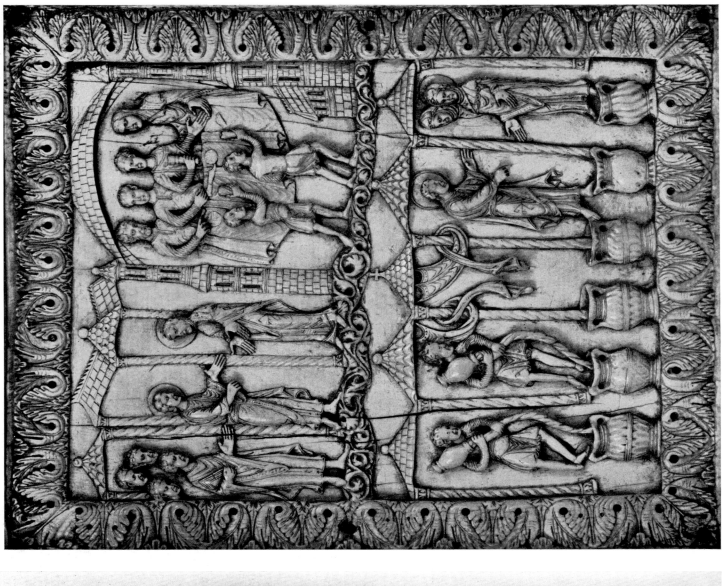

33. Copy of Fig. 32. Liége, end X Century

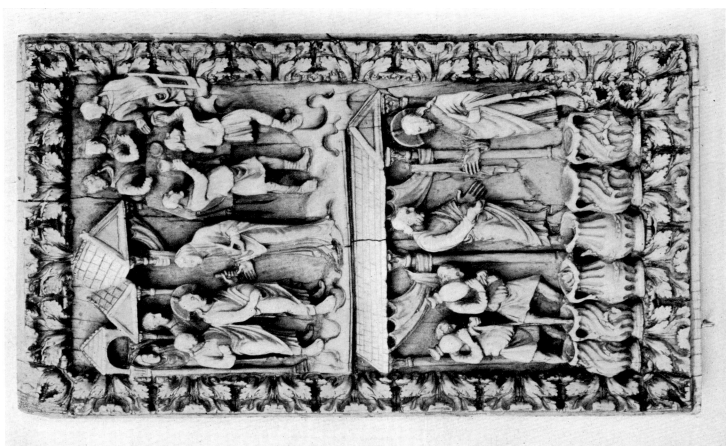

32. Reims (?), c. 870

THE WEDDING AT CANA

PLATE 15

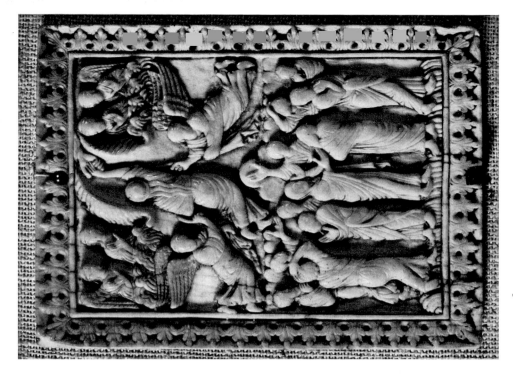

35. Copy of Fig. 34. Lorraine (?), c. 1000

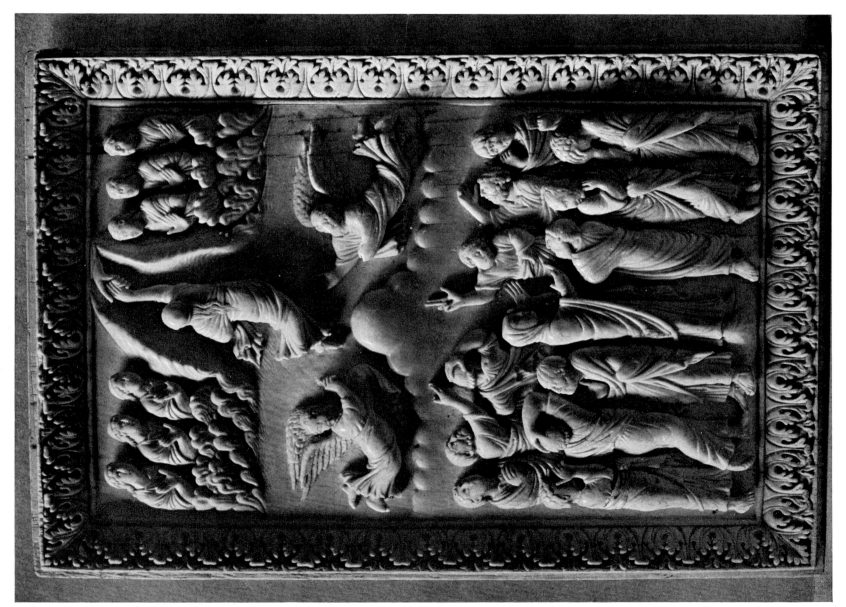

34. Lorraine (?), X Century

PLATE 16

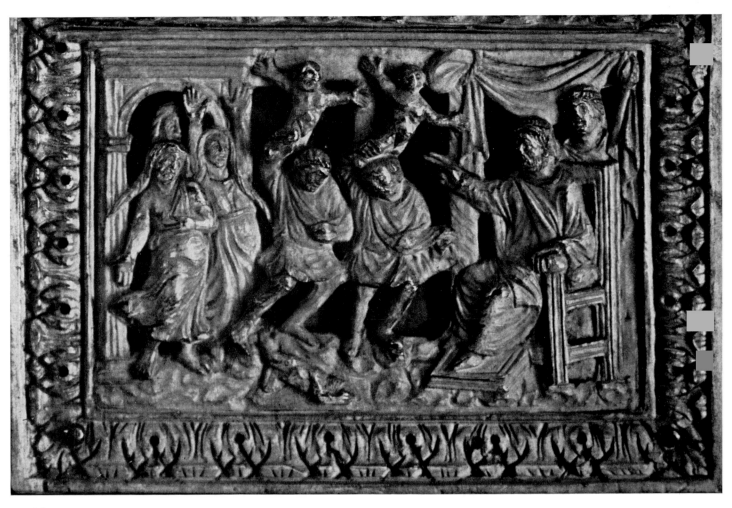

36. Metz, *c.* 850

37. Initial 'D'. Metz, *c.* 850

36–39. THE MASSACRE OF
THE INNOCENTS

PLATE 17

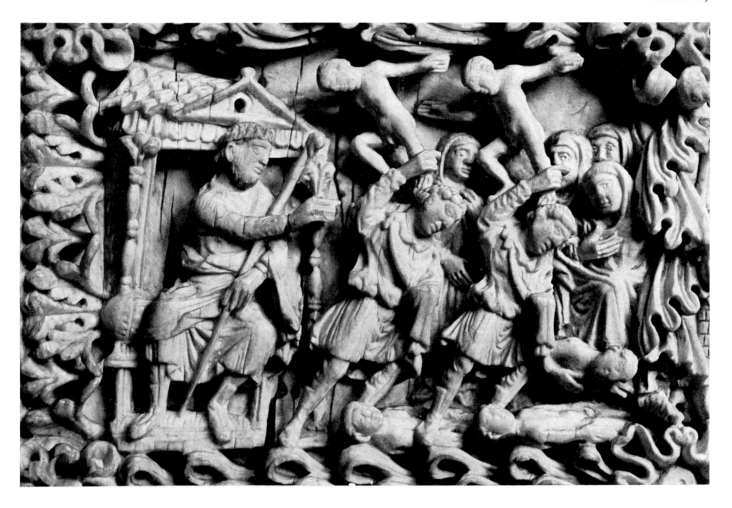

38–39. Lorraine or North-Eastern France, XI Century

PLATE 18

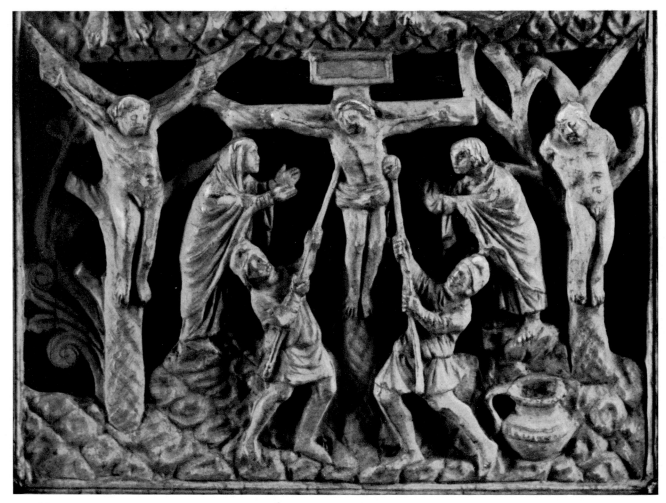

40. Metz *c.* 850

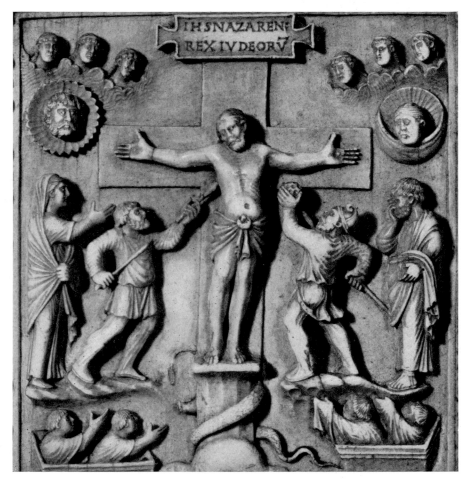

41. Lorraine (?), X Century

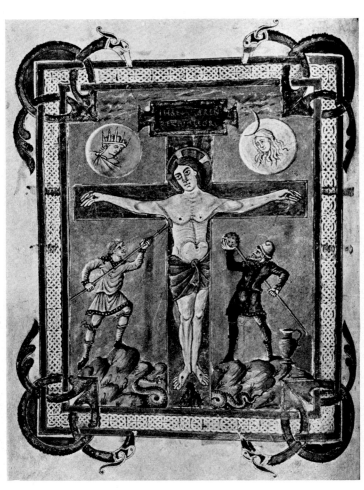

42. Saint-Amand, second half IX Century

40–42. THE CRUCIFIXION

PLATE 19

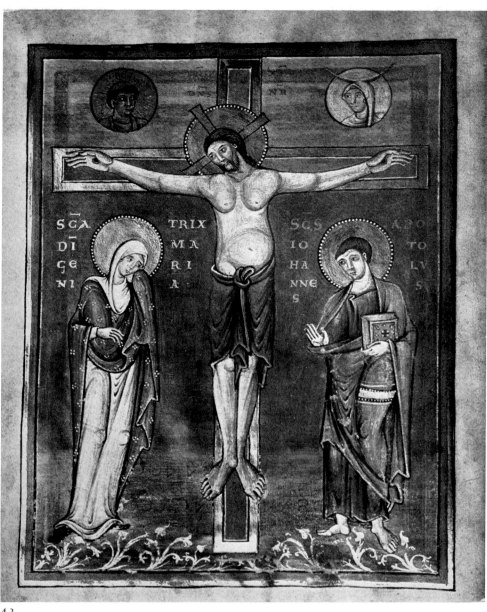

43

44

43–44. TRÈVES, LAST QUARTER
X CENTURY

43. The Crucifixion
44. The Virgin

PLATE 20

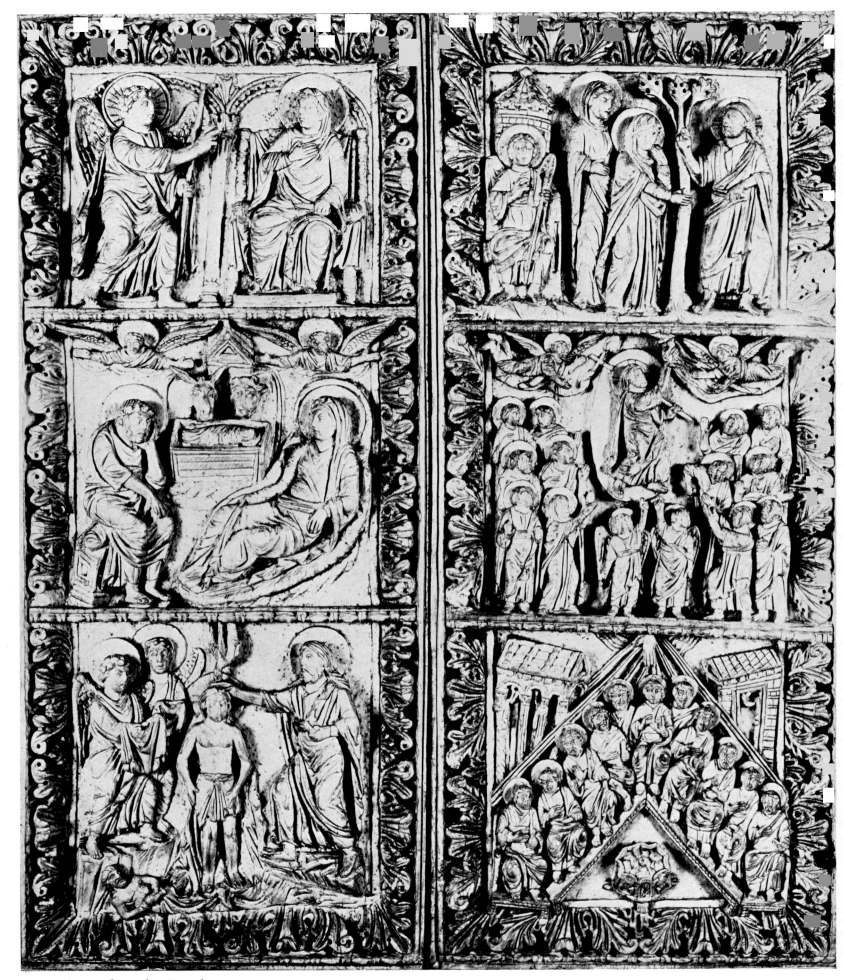

45–46. Scenes from the Gospels

TRÈVES, SECOND HALF X CENTURY

PLATE 21

47. Moses receiving the Law

48. Incredulity of St. Thomas

TRÈVES, c. 990

PLATE 22

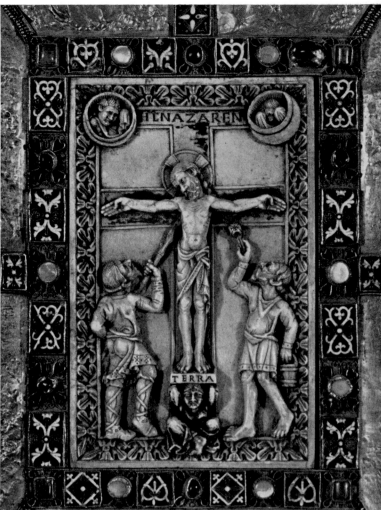

50. Book-cover. The Crucifixion. Trèves, *c.* 990

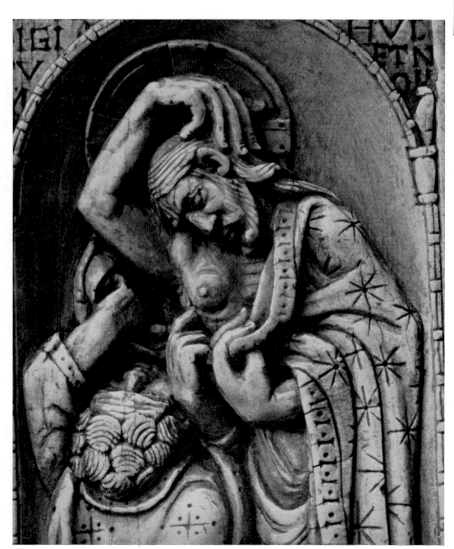

49. Enlarged detail of Fig. 48

PLATE 23

Christ on the Cross. Maastricht (?), late X Century

52. Book-cover. The Evangelists. The Virgin. Lorraine, end X Century

PLATE 24

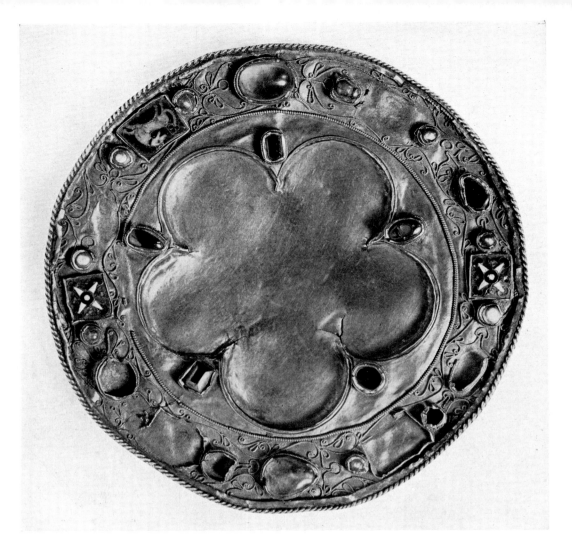

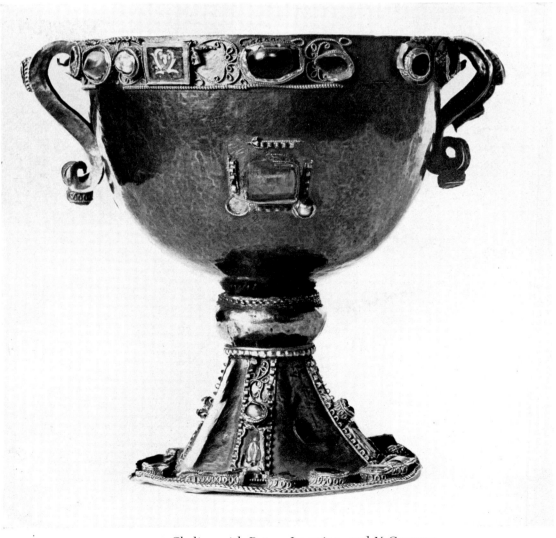

53–54. Chalice with Paten. Lorraine, end X Century

PLATE 25

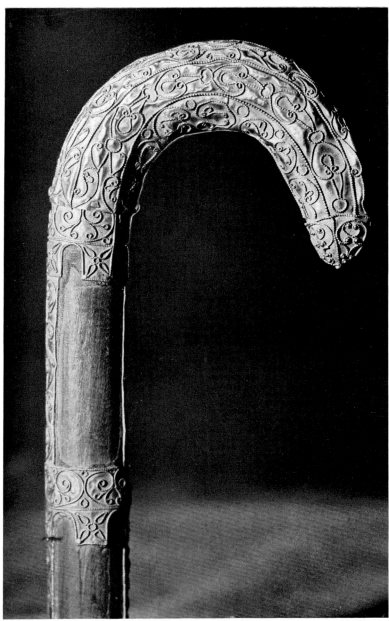

55. Crozier. Saxony (?), end X Century

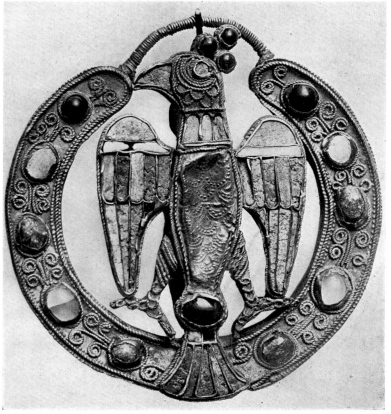

56. Eagle Brooch. Mainz, c. 1025

PLATE 26

57–60, 63–65. BEASTS OF THE
EVANGELISTS

57–58. Reims (?) or Maastricht (?), end X century
59–60. Champagne (?), end X century
63. Trèves, end X century. Details of Fig. 62
64–65. Essen, end X century

57

58

59–60

PLATE 27

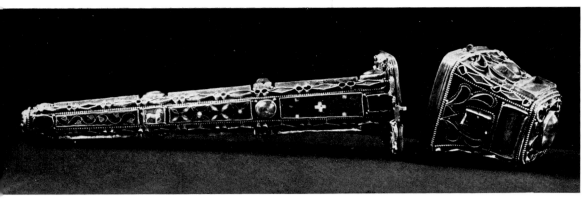

61. Reliquary of a Nail of the Holy Cross. Trèves, 977–93

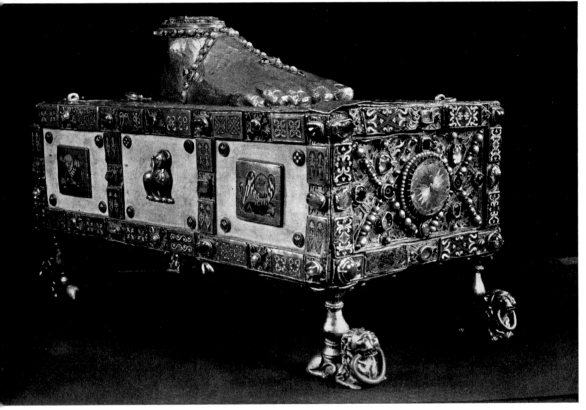

62. Reliquary of the Foot of Andrew. Trèves, 977–93

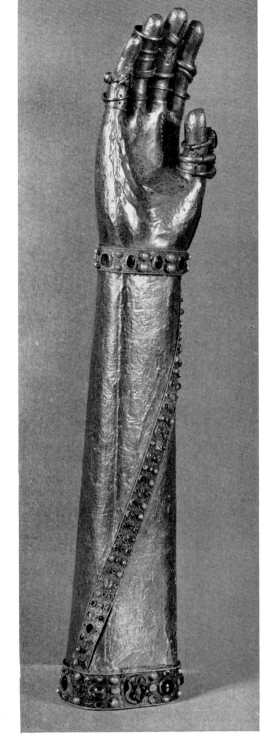

66. Arm Reliquary. Braunschweig, c. 1038

63 64 65

PLATE 28

67. Cross of Bernward of Hildesheim, *c.* 1000

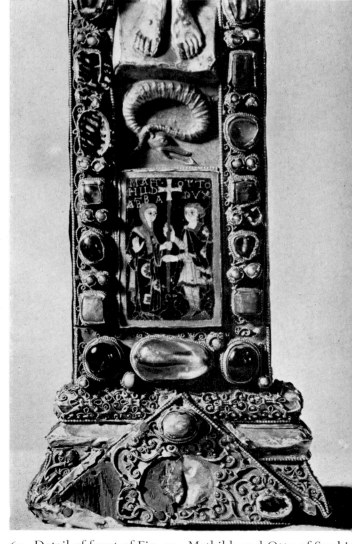

68. Detail of front of Fig. 71. Intaglio of Lothair II (?)

69. Detail of front of Fig. 70. Mathilda and Otto of Swabia

PLATE 29

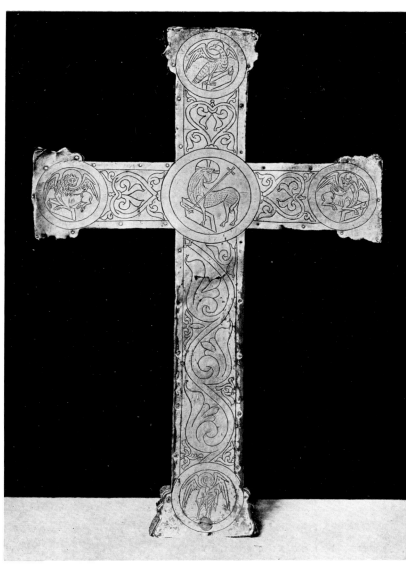

70. Cross of Mathilda. Reverse. Essen, c. 980

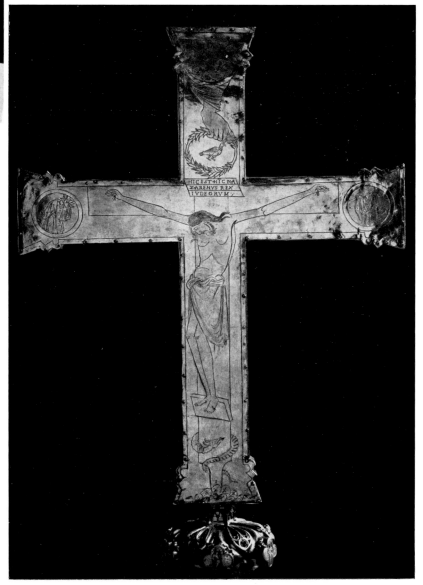

71. Cross of Lothair. Reverse. Aachen, end X Century

PLATE 30

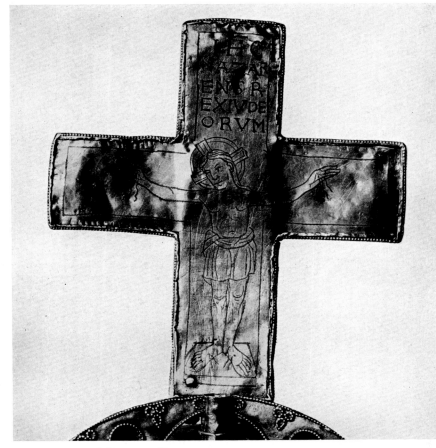

72. Book-Cover

73. Reverse of Cross on Fig. 75

72-73. CHRIST ON THE CROSS. MAINZ, EARLY XI CENTURY

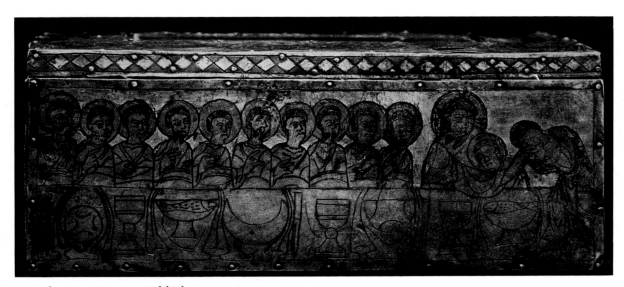

74. The Last Supper. Hildesheim, *c.* 1000

PLATE 31

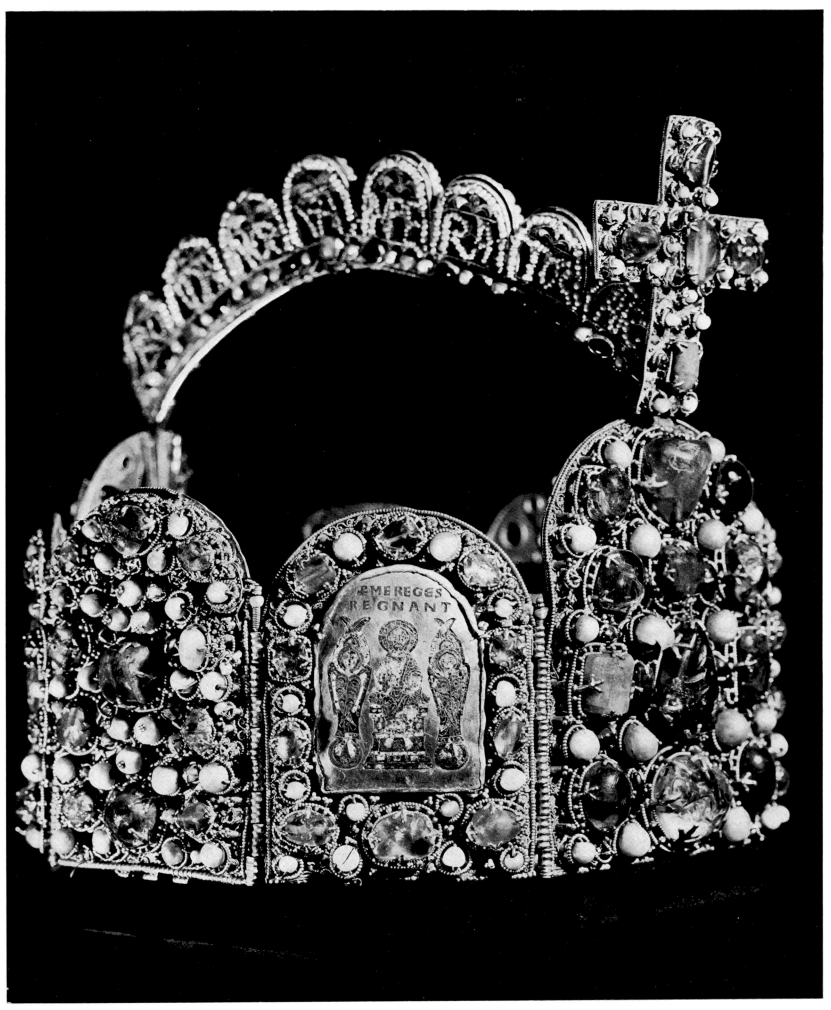

75. The Crown of the Holy Roman Empire. Lorraine and Mainz (?), X and XI Century

PLATE 32

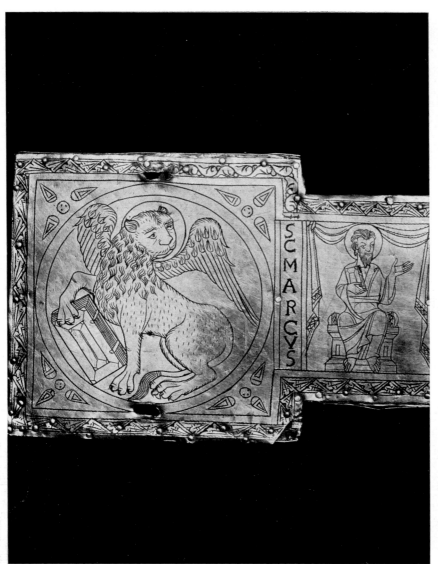

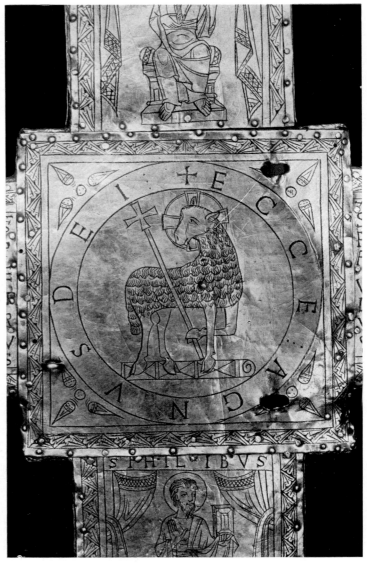

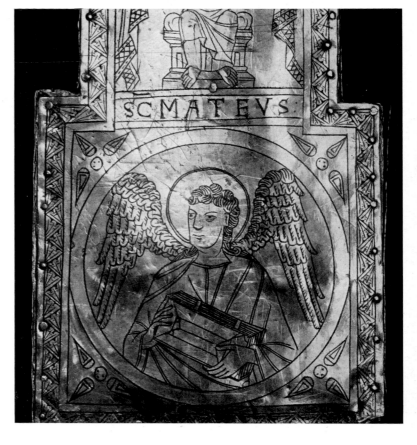

76–79. FROM THE CROSS OF THE HOLY ROMAN EMPIRE.
MAINZ (?), c. 1030

BEASTS OF THE EVANGELISTS. LAMB OF GOD. APOSTLES

PLATE 33

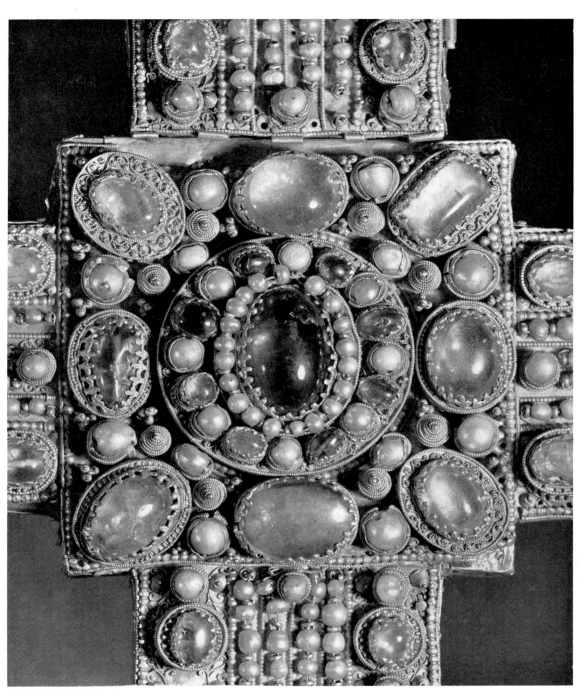

79

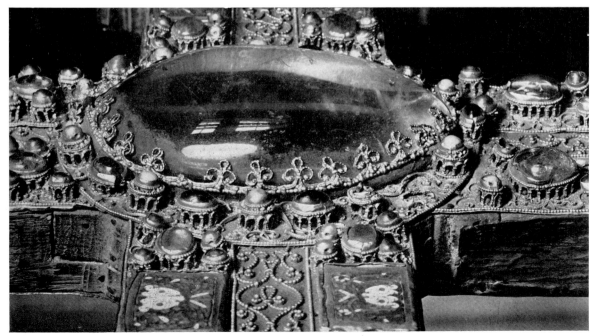

80. Detail of Cross of Theophanu.
Essen, c. 1050

PLATE 34

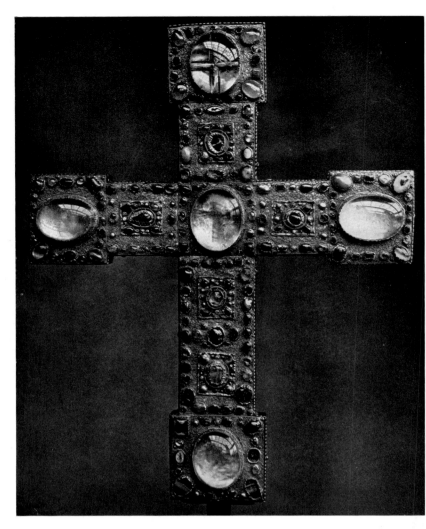

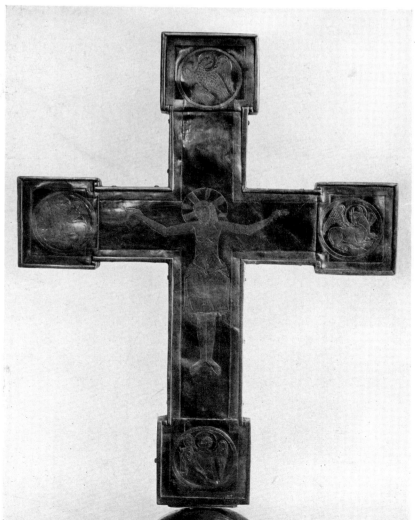

81–82. So-called Reliquary Cross of Bernward of
Hildesheim. Hildesheim, after 1100

PLATE 35

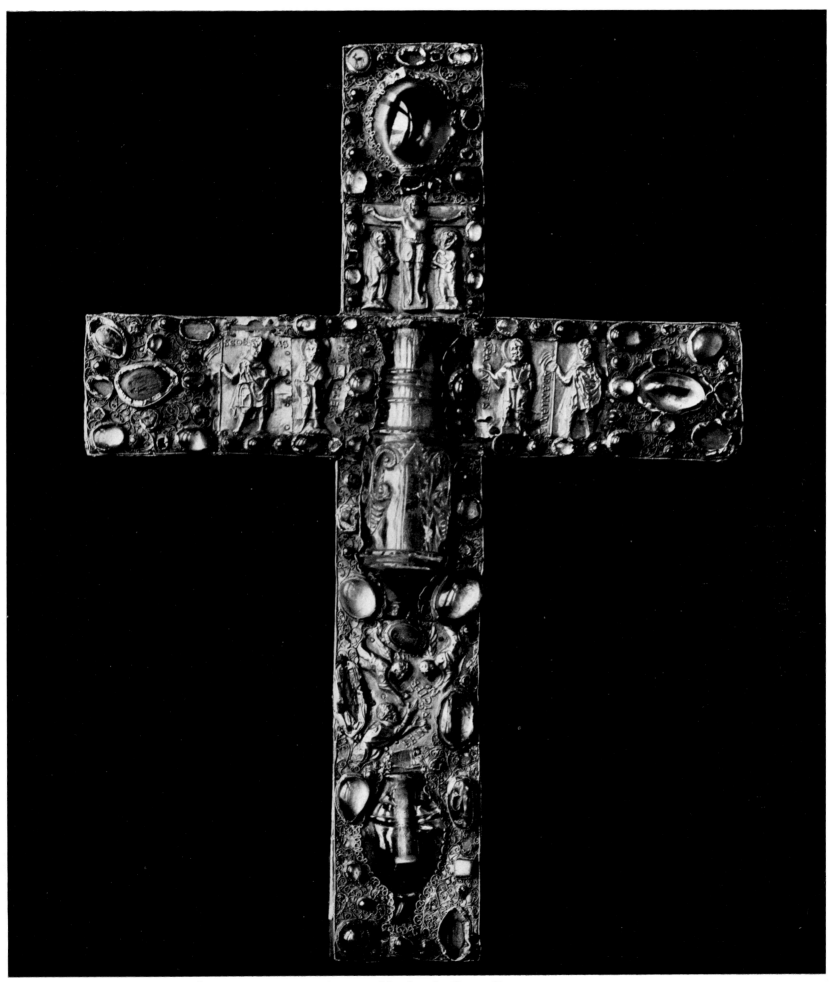

83. Reliquary Cross. The Crucifixion. Saints. Henry II received by Angels. Essen (?), *c.* 1024

PLATE 36

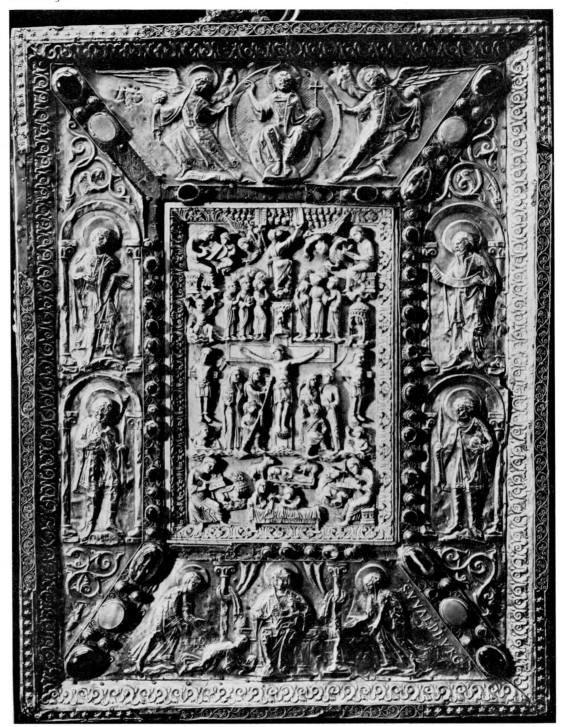

84. Book-cover of Theophanu. Essen, *c. 1050*

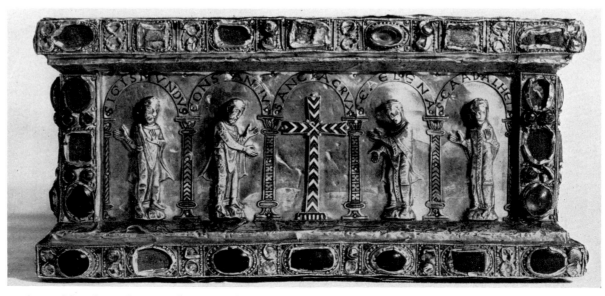

85. Portable Altar of Gertrud. Braunschweig, *c. 1038*

PLATE 37

86. Golden Altar. Detail. Entry into Jerusalem. Aachen (?), *c.* 1000

PLATE 38

87–88. Virgin and Child. Mainz, c. 1000

PLATE 39

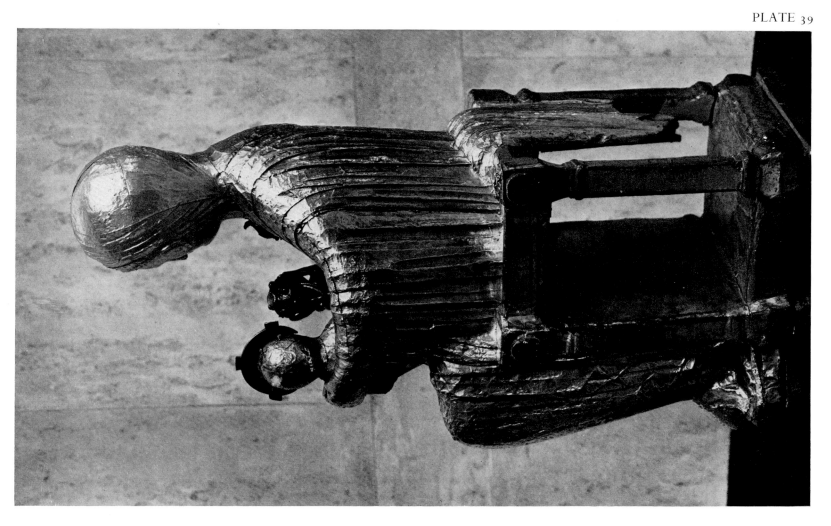

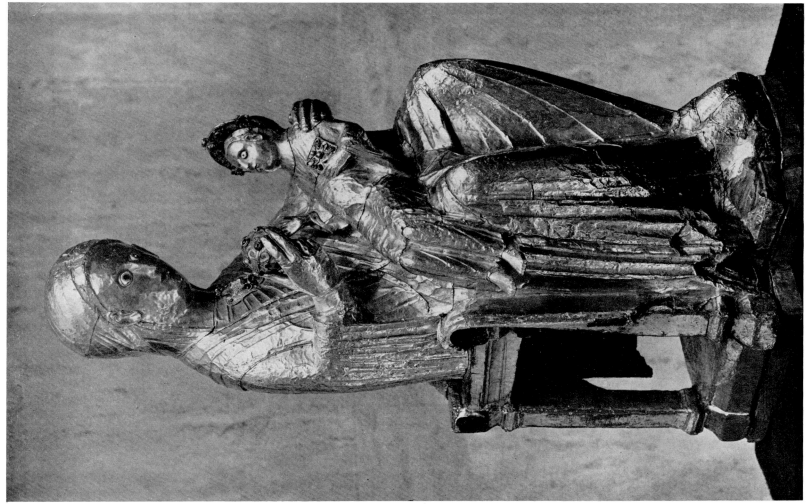

89–90. The Essen Madonna. Essen or Mainz (?), end X Century

PLATE 40

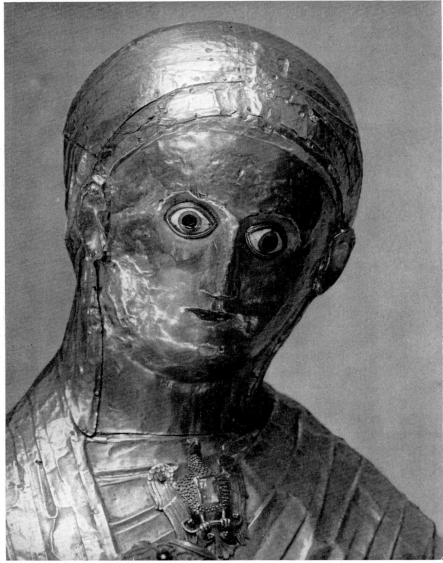

91. Detail of Fig. 89

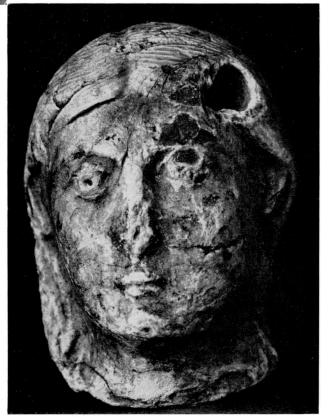

92. Wax impression or model of Fig. 93

PLATE 41

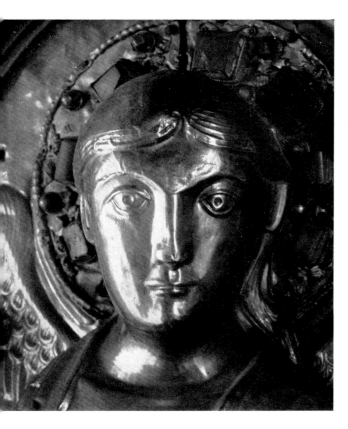

92–95. FROM THE GOLDEN ALTAR OF BÂLE.
MAINZ (?), BETWEEN 1002 AND 1019

93. St. Michael

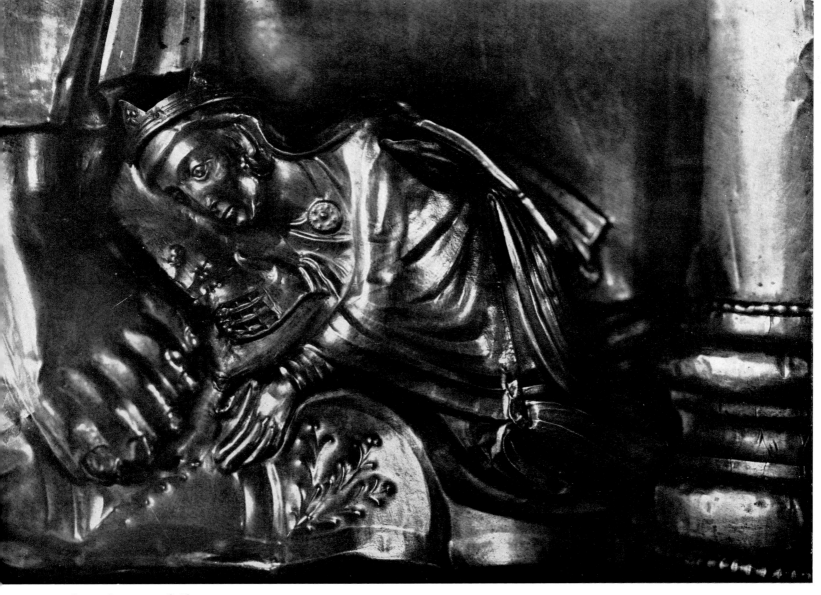

4. Kunigunde at the Feet of Christ

PLATE 42

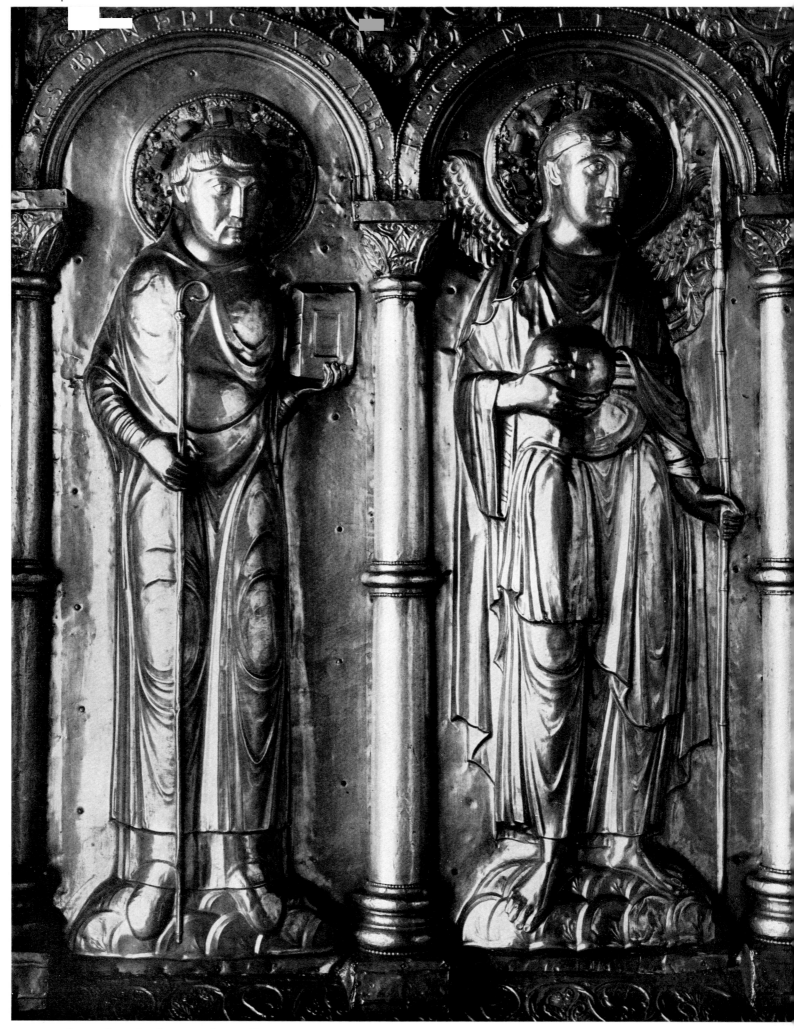

95. Benedict and Michael. From the Golden Altar of Bâle. [Pl. 41]

PLATE 43

96. Mainz (?), c. 1030

96–97. ANGELS HOLDING TABLETS WITH
THE INTRODUCTION TO THE GOSPELS

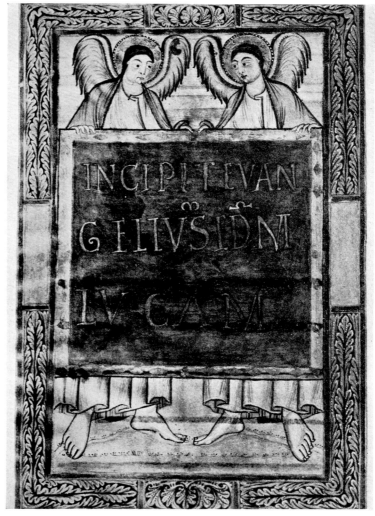

97. Stavelot, c. 1000

PLATE 44

99

98–100. INHABITED SCROLLS
98. Sketch. Mainz (?), end X century
99. From the Golden Altar of Bâle.
[Pls. 41, 42]
100. From the Sheath of the Essen
Sword, c. 1000

PLATE 45

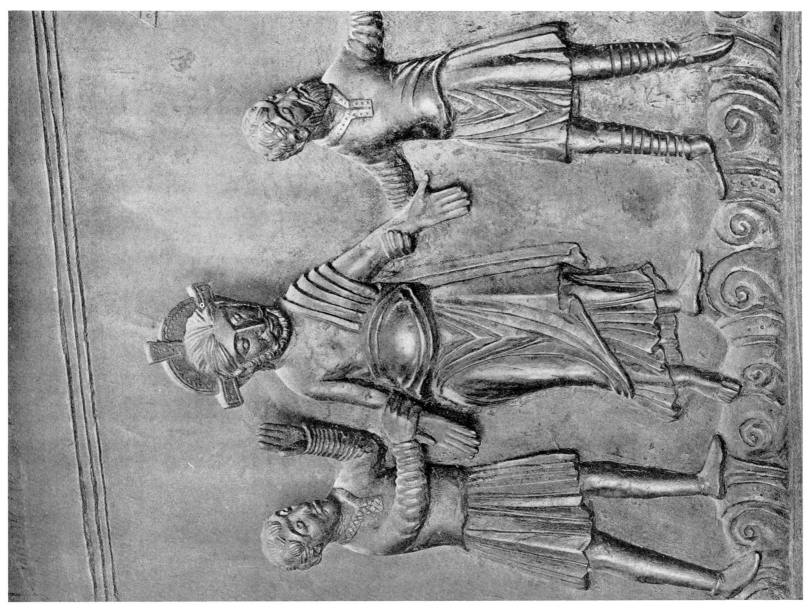

102. Christ led to Herod. From the Bronze Doors of Hildesheim [Pl. 46]

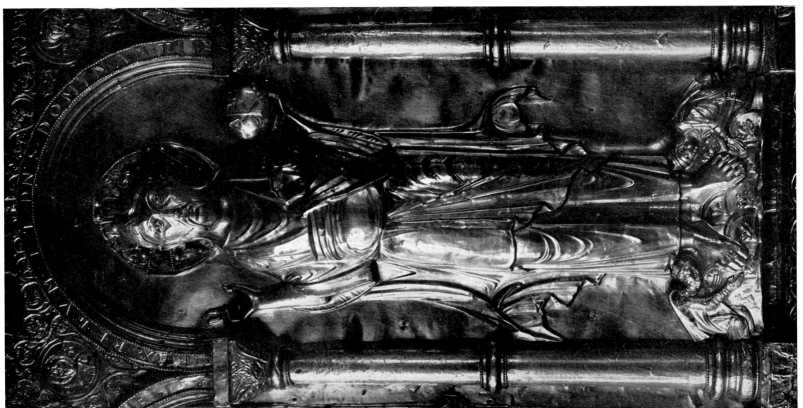

101. Christ. Henry II and Kunigunde. From the Golden Altar [Pls. 41, 42]

PLATE 46

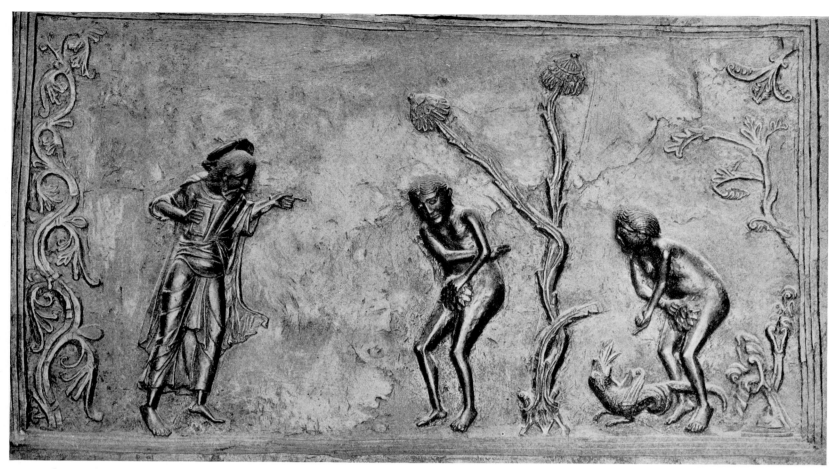

103. Adam and Eve before God

104. The Expulsion

103–104. FROM THE BRONZE DOORS
OF BERNWARD OF HILDESHEIM 1015

PLATE 47

105. The Temptation. Canterbury (?), early XI Century

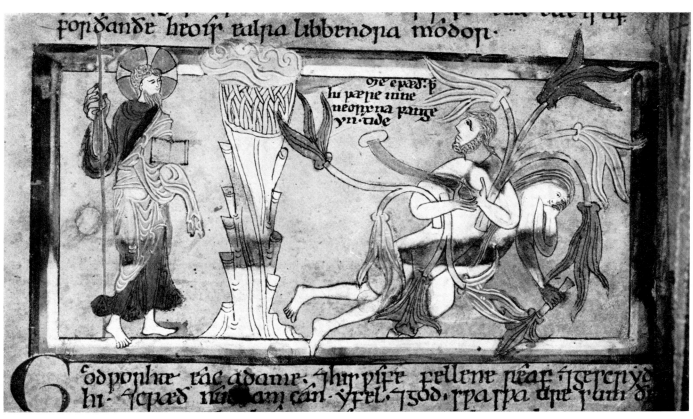

106. Adam and Eve hiding before God. Canterbury (?), c. 1025

PLATE 48

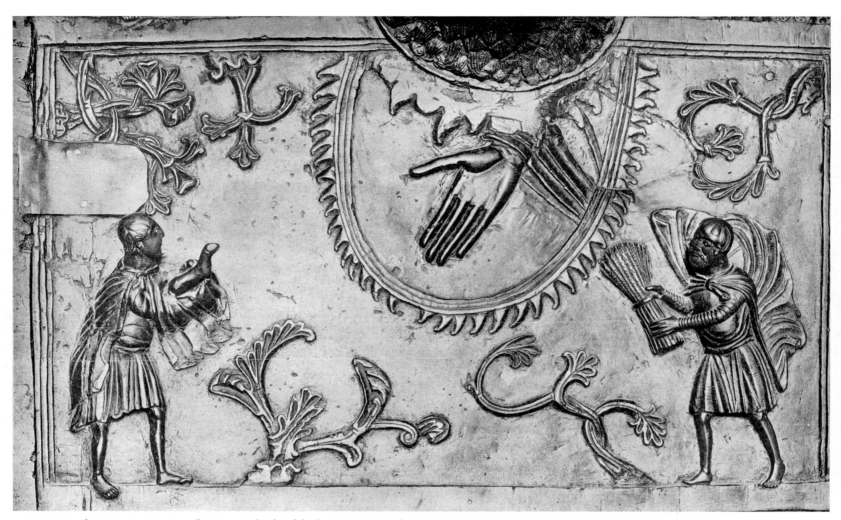

107. From the Bronze Doors of Bernward of Hildesheim, 1015 [Pl. 46]

107–108. THE SACRIFIC
OF CAIN AND ABEL

108. Lüneburg (?), XI Centur

PLATE 49

109. The Three Marys at the Tomb. Harrowing of Hell.
Abdinghof (?), end X Century

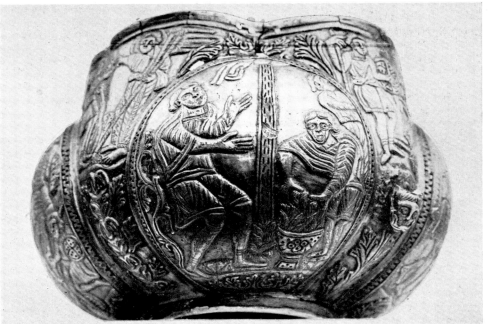

110. 'The Angel of the Lord put forth the staff and touched
the flesh and the unleavened cakes.' Belgium or Lower-
Saxony (?), late X Century

PLATE 50

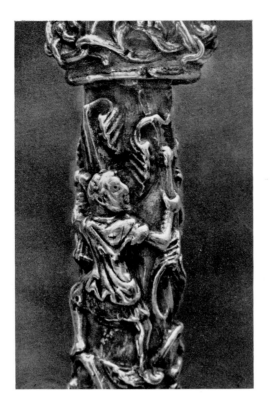

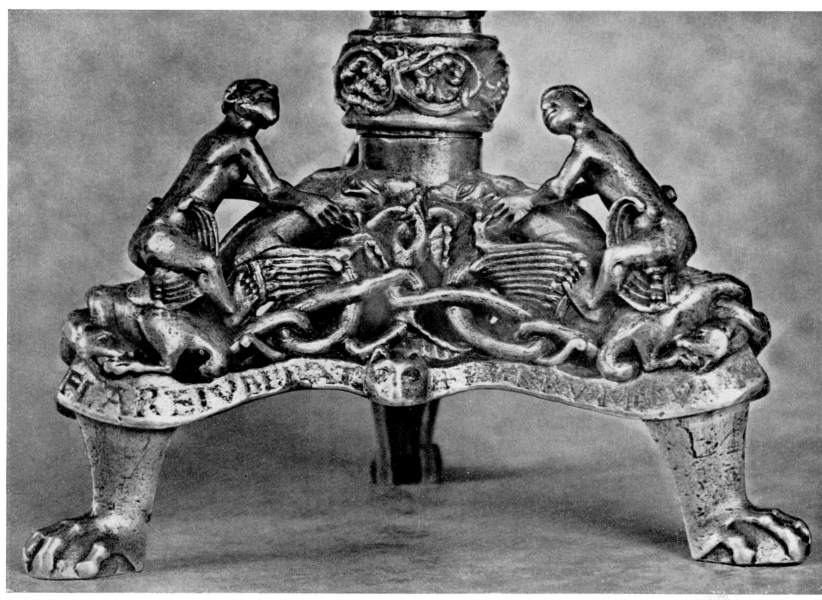

III–II2. MEN STRIVING FROM THE DARKNESS OF VICE TO THE LIGHT OF CHRIST

From the Candlestick of Bernward of Hildesheim, end X Century

PLATE 51

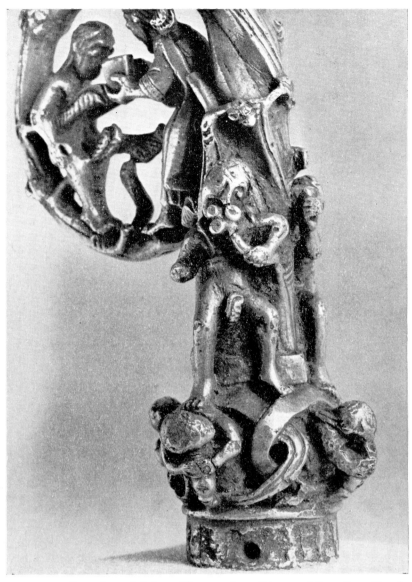

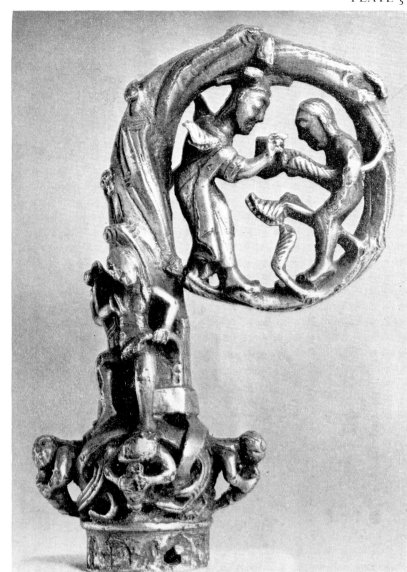

113–114. Creation of Adam. Temptation. Rivers of Paradise. Head of Crozier of Bernward of Hildesheim, end X Century

115–116. Personifications of Winds. From the Base of the Essen Candlestick, early XI Century

PLATE 52

117. Lazarus at the Table of Dives

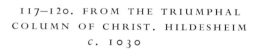

117–120. FROM THE TRIUMPHAL
COLUMN OF CHRIST. HILDESHEIM
c. 1030

118. Salome's Dance

PLATE 53

119. Detail of Fig. 117

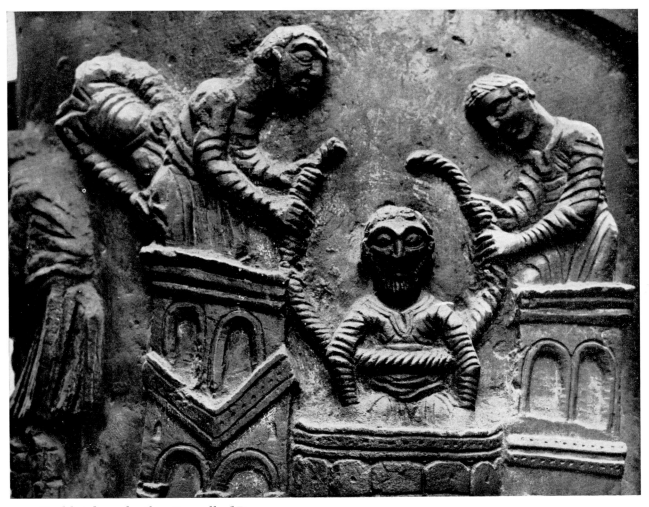

120. Paul let down by the city wall of Damascus

PLATE 54

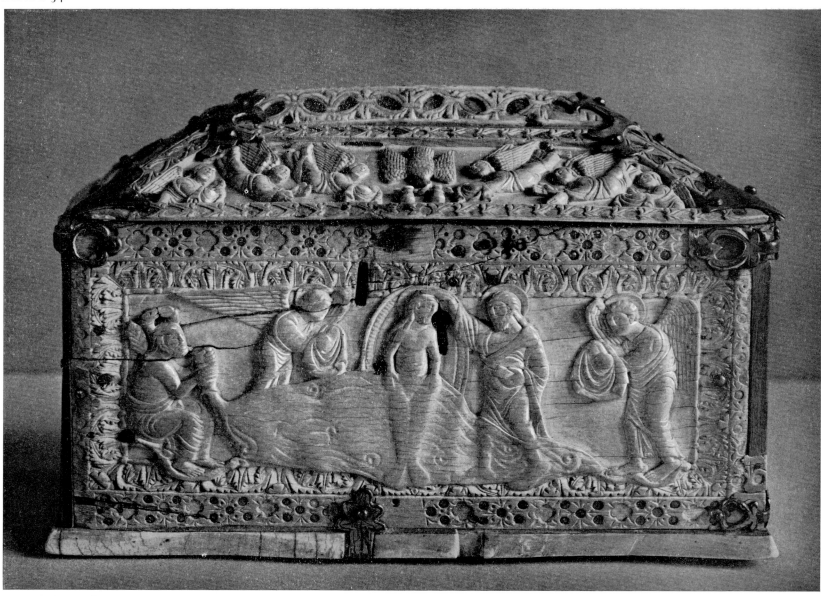

121. Baptism of Christ. Metz or Saxony, early X Century

122. Lorraine, end X Century

123. Winchester (?), 925–40

122–123. CHRIST IN MAJESTY

PLATE 55

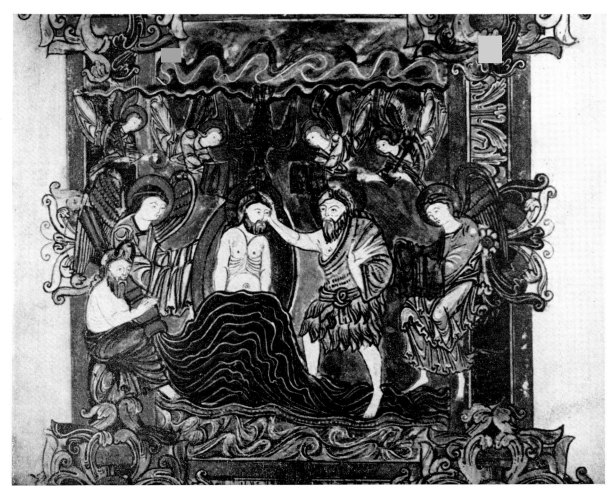

124. Benedictional of Aethelwold. Winchester, 963–84

124–125. THE BAPTISM OF CHRIST

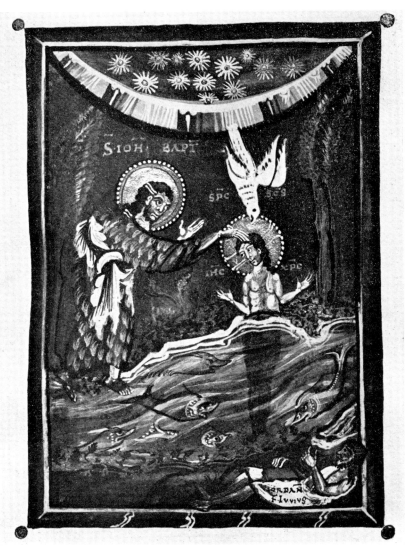

125. Cologne, early XI Century

PLATE 56

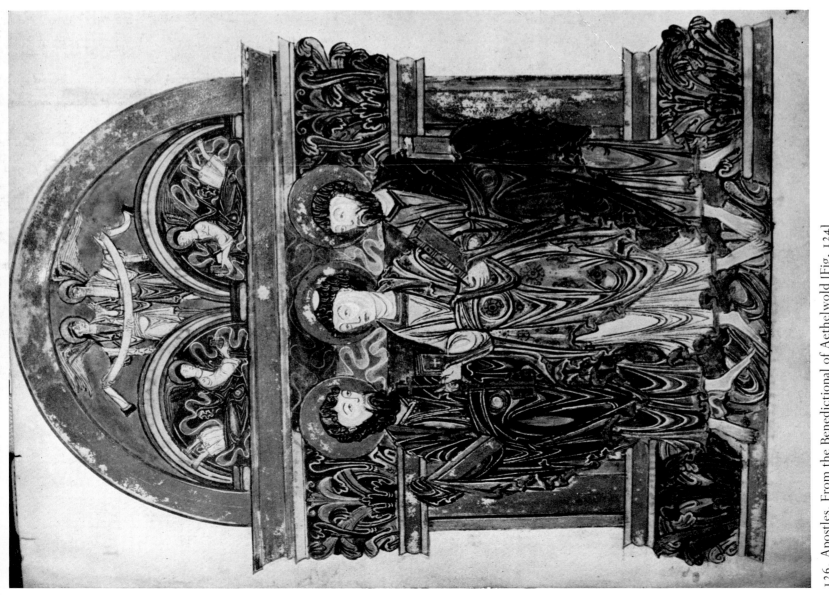

128. Angels.
Winchester,
end X Century

127. Mary and the
Apostles watching
the Ascension. Lor-

126. Apostles. From the Benedictional of Aethelwold [Fig. 124]

PLATE 57

130. Luke. Saint-Bertin (?), end X Century

129. Matthew. Anglo-Saxon, end X Century

PLATE 58

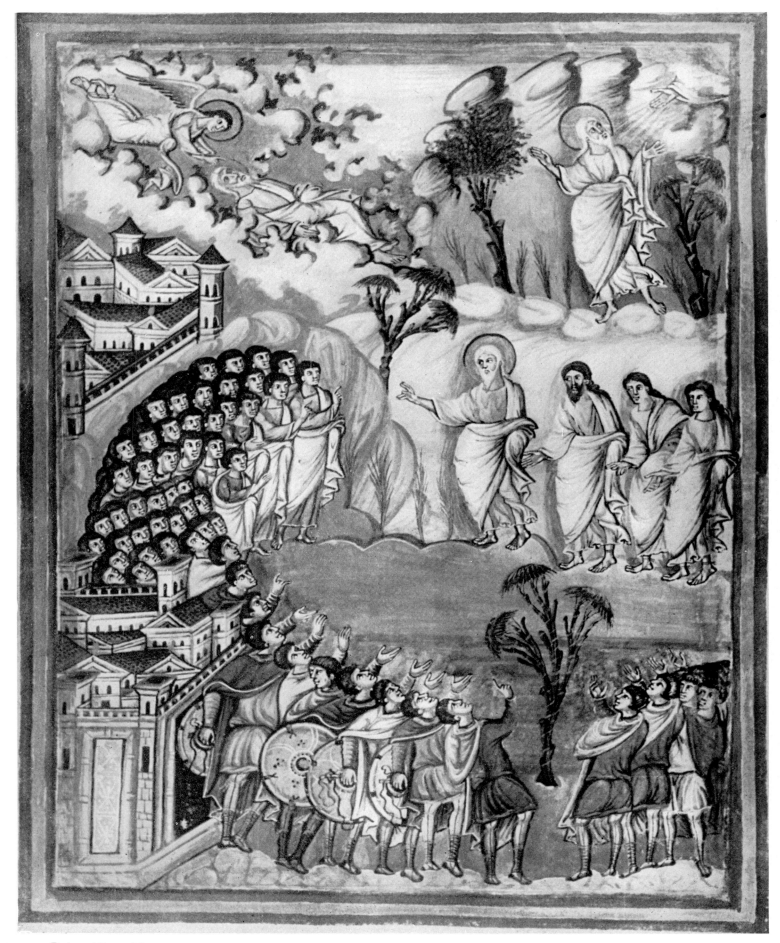

131. Reims (?), *c.* 880

131-132. BLESSING OF THE TRIBES AND DEATH OF MOSES

PLATE 59

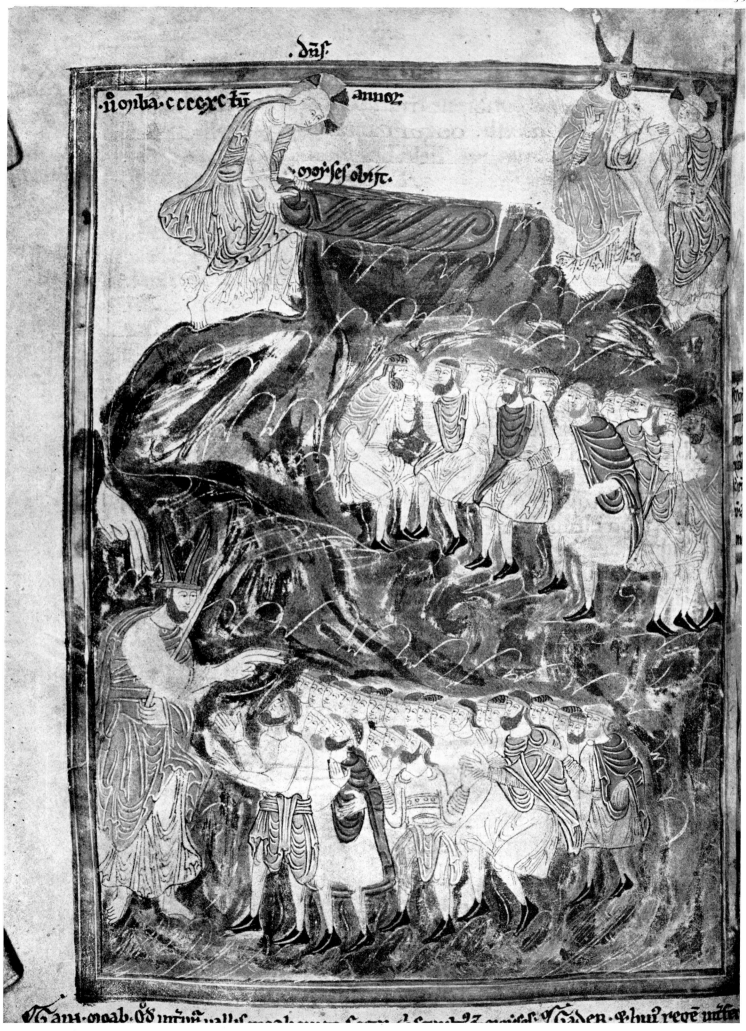

nonba ccccxc tu annoz

dns

moyses obiit

PLATE 60

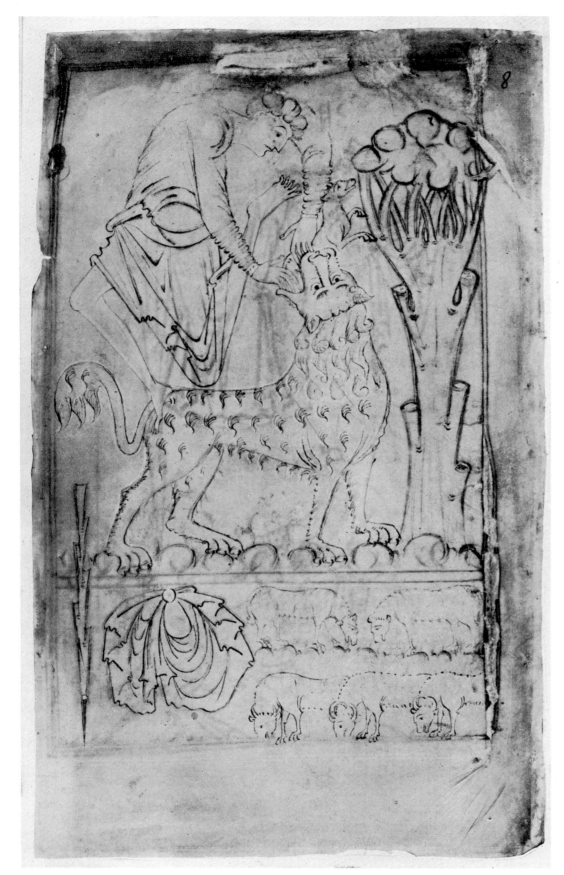

8

133. David rescuing the Lamb from the Lion. Anglo-Saxon, second quarter XI century

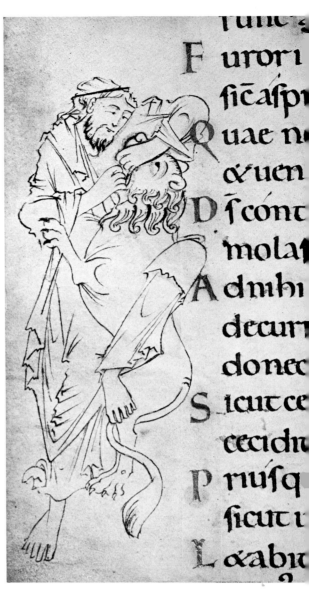

134. Samson and the Lion.
Bury St. Edmund's, second quarter XI Centur

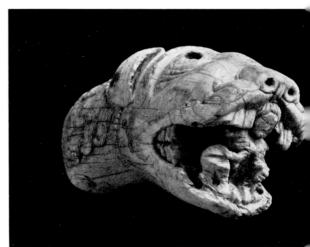

135. Lion devouring Man. Anglo-Saxon, early XI C

PLATE 61

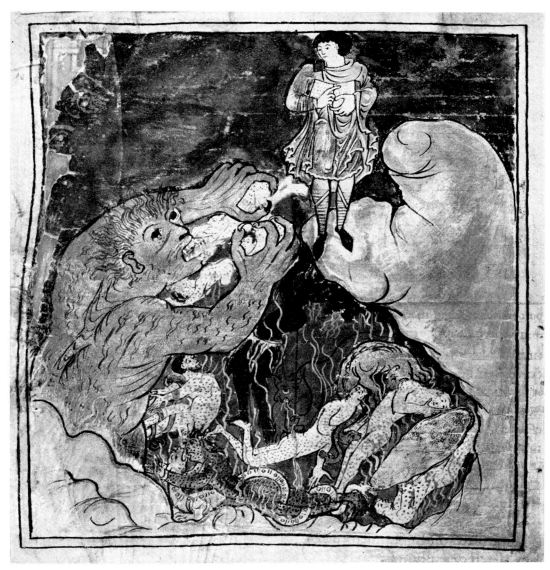

136. Mambres at the Mouth of Hell

136–137. FROM THE MARVELS OF
THE EAST. ANGLO-SAXON, c. 1025

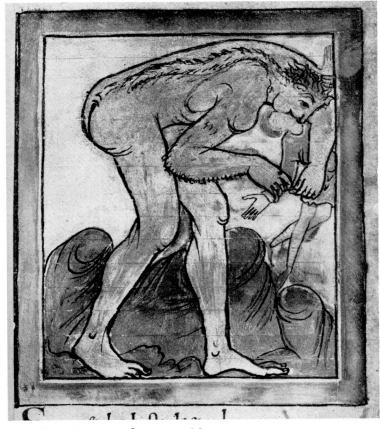

137. Huge Monster devouring Man

PLATE 62

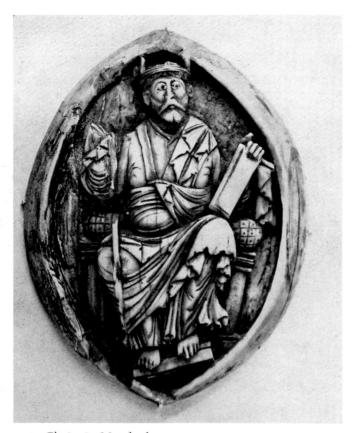

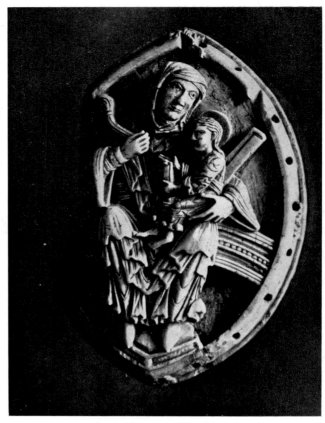

138. Christ in Mandorla

139. Virgin and Child in Mandorla

138–139. ANGLO-SAXON, FIRST HALF XI CENTURY

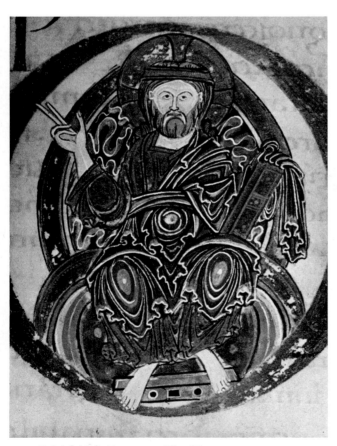

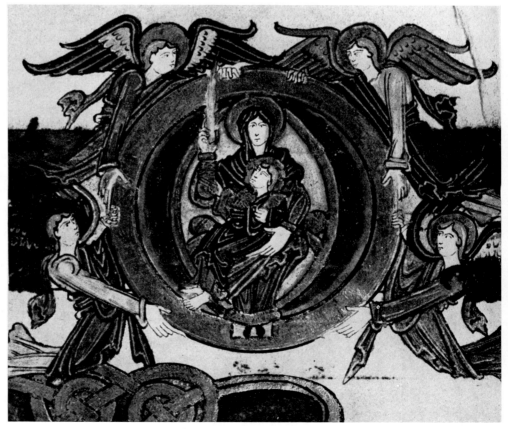

140. Initial 'O' [Fig. 124] The Trinity

141. Virgin and Child. Winchester (?), early XI Century

PLATE 63

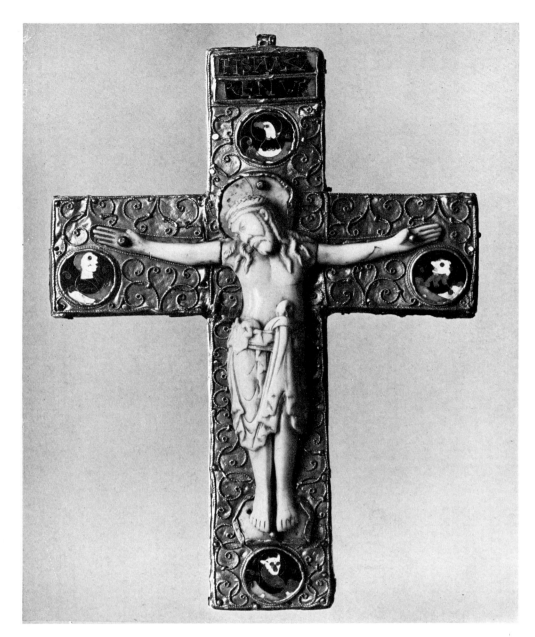

142. Christ on the Cross, Anglo-Saxon, *c.* 1000

143–144. Mary and John. Anglo-Saxon, *c.* 1000

PLATE 64

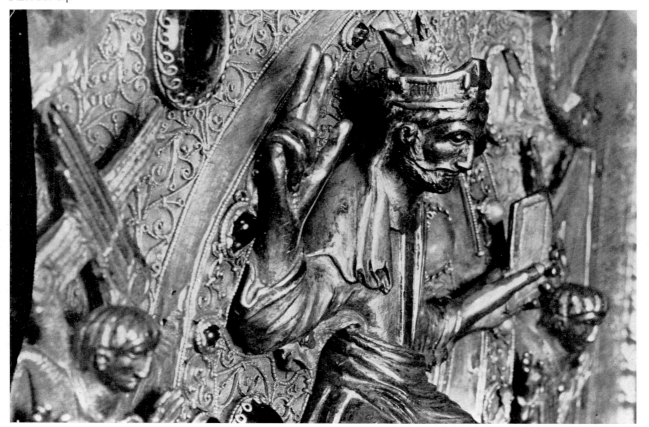

145–147. From the cover of the Gospels of Judith of Flanders. Christ in Mandorla. Mary at the Cross. Anglo-Saxon, *c.* 1040

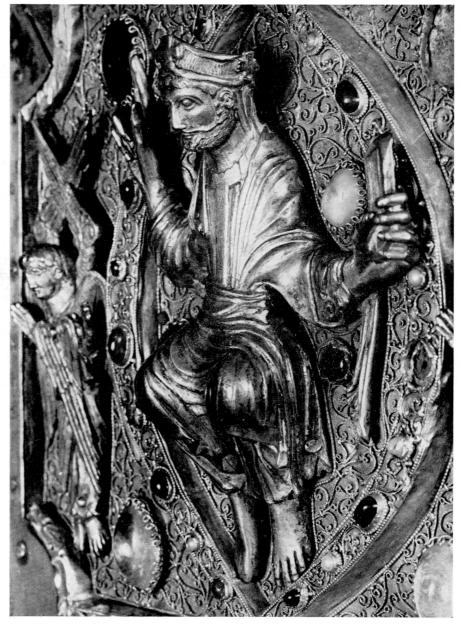

PLATE 65

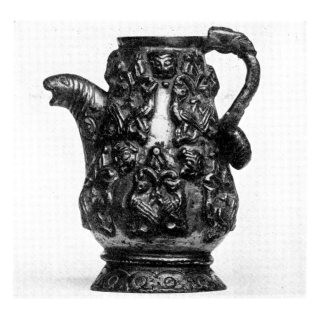

ANGLO-SAXON

148. Christ in Majesty.
End X Century
149. Cruet. Early XI Century
150. Christ from a Cross.
c. 1070

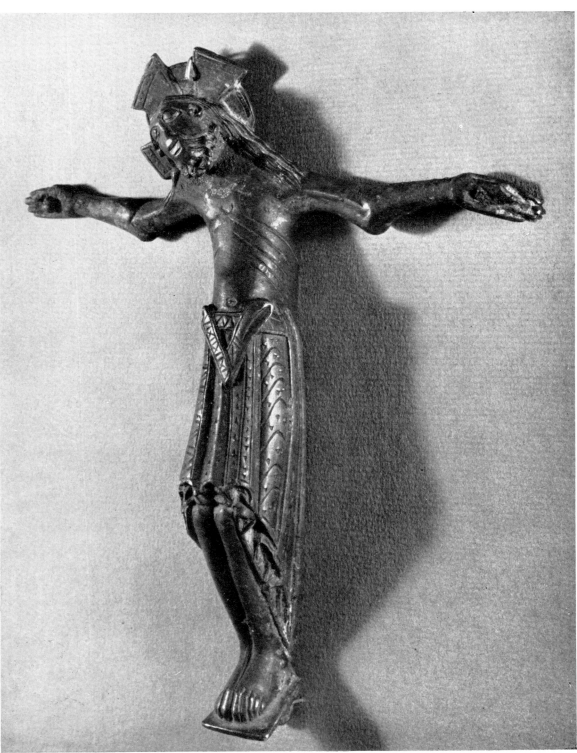

PLATE 66

151. Christ in Mandorla. The Ascension. Anglo-Saxon, late X Century

152. St. Andrew

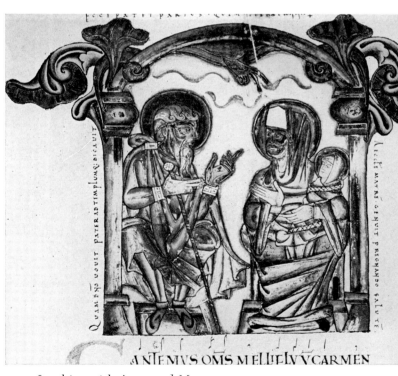

153. Joachim with Anne and Mary

152–153. HEREFORD, SECOND QUARTER XI CENTURY

PLATE 67

155. Christ in Mandorla.
Arras (?), first half XI Century

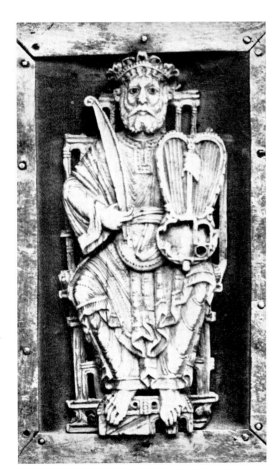

154. Apocalyptic Elder.
Saint-Bertin, c. 1050

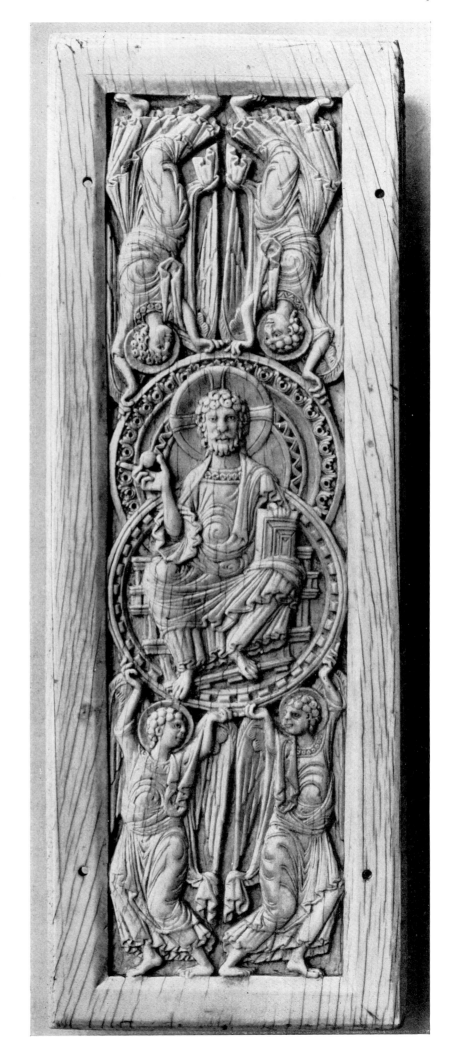

PLATE 68

156. Andromeda. Reims or Saint-Omer, early IX Century

157. Copy of Fig. 156. Saint-Bertin, early XI Century

158. Luna on Chariot. [Fig. 157]

159. Virtues. Inhabited Scroll. Fulda (?), early XI Century

PLATE 69

160–161. SAINT-BERTIN
c. 1000

160. Inhabited Scrolls
161. 'I'. Crucifixion with Church and Synagogue. Ascension. Rivers of Paradise. Harrowing of Hell. The Marys at the Tomb. Earth and Sea

161

160

PLATE 70

162. Dedication of the Gospels to St. Bertin

163. The Poet Milo thanking God

162–163. SAINT-BERTIN, c. 1000

164. Philosophy consoling Boethius. Fleury (?), early XI Century

165. Initial 'O'. Christ calling SS. Peter and Andrew. Saint-Denis, c. 1030

PLATE 71

166. The Last Supper. Saint Maur-de-Fossés, *c.* 1070

PLATE 72

167. Mark. Arles (?), first half XI Century

168. The Earth swallowing the Flood. Northern France, early IX Century

PLATE 73

169–170. ARRAS, c. 1030

169. Ascension of Elias. Battle with the King of Syria

170. Initial 'O'. Christ and the Church surrounded by the Zodiac

PLATE 74

171. Initial 'O'. Vision of Habakkuk [Figs. 169–70]

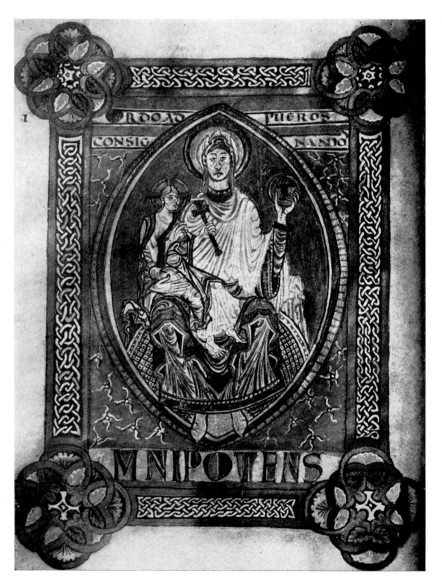

171–173. ARRAS, C. 1030

172. Virgin and Child in Mandorla

PLATE 75

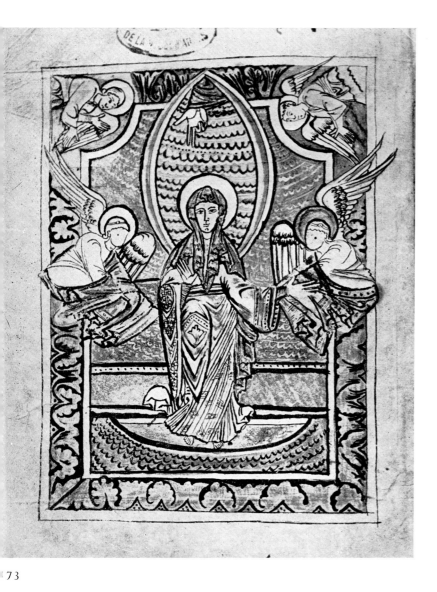

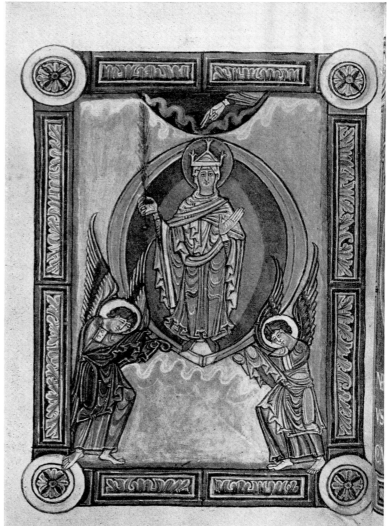

73

174. Mont-Saint-Michel, soon after 1067

3–175. THE ASSUMPTION
OF THE VIRGIN

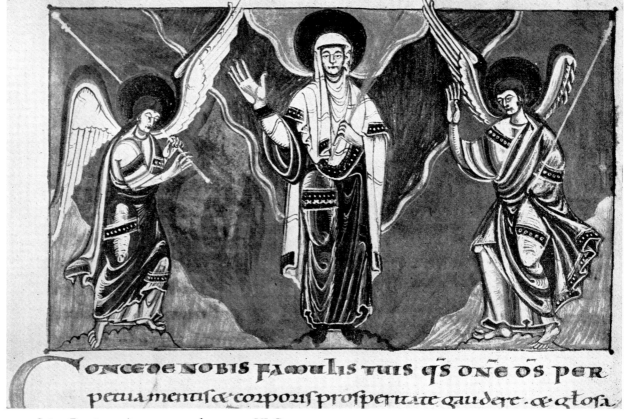

Conce de nobis famulis tuis qs dne ds per
petua mentis & corporis prosperitate gaudere. & gtosa

175. Saint-Denis or Arras, second quarter XI Century

PLATE 76

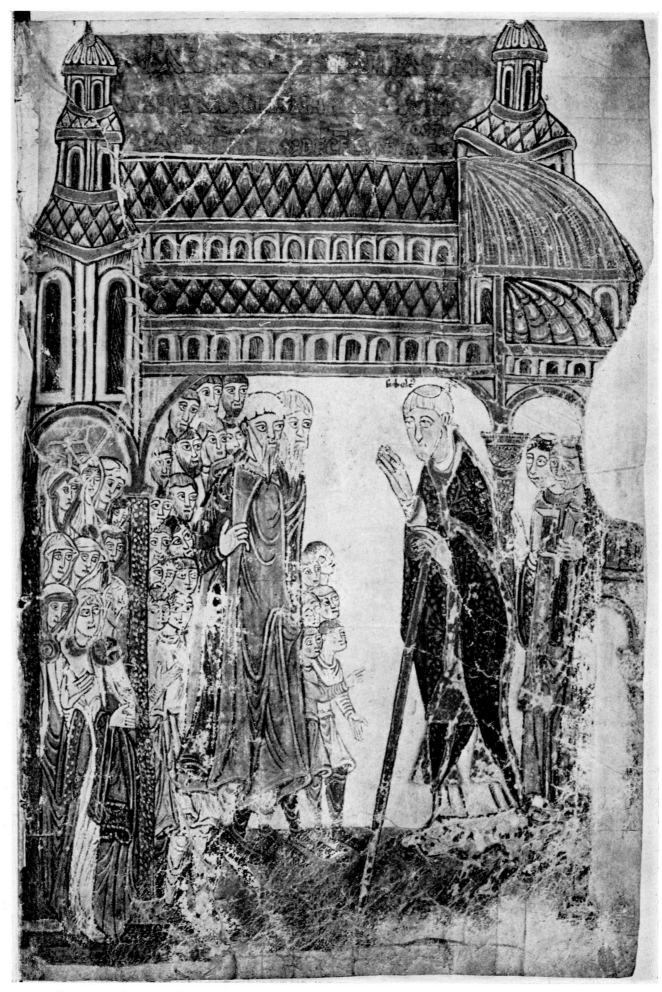

176. Fulbert preaching in Chartres Cathedral, 1006–28

PLATE 77

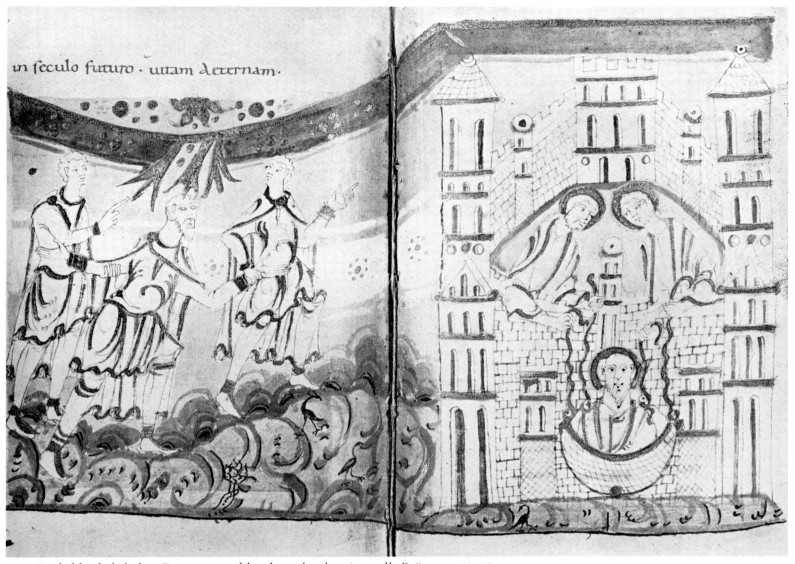

in feculo futuro · uitam deternam.

177. Paul, blinded, led to Damascus and let down by the city wall. Prüm, 1026–68

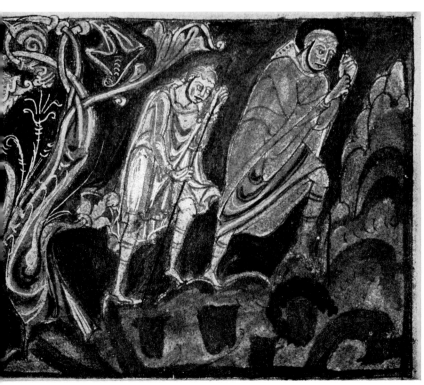

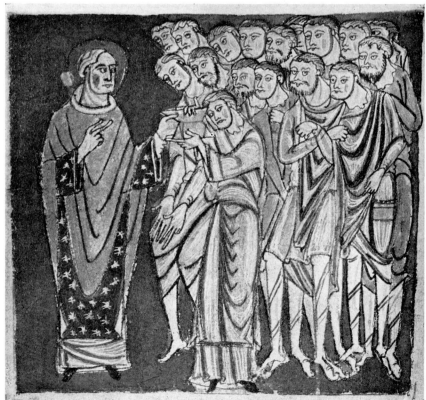

-179. From the Life of St. Amand. Saint-Amand, c. 1025

PLATE 78

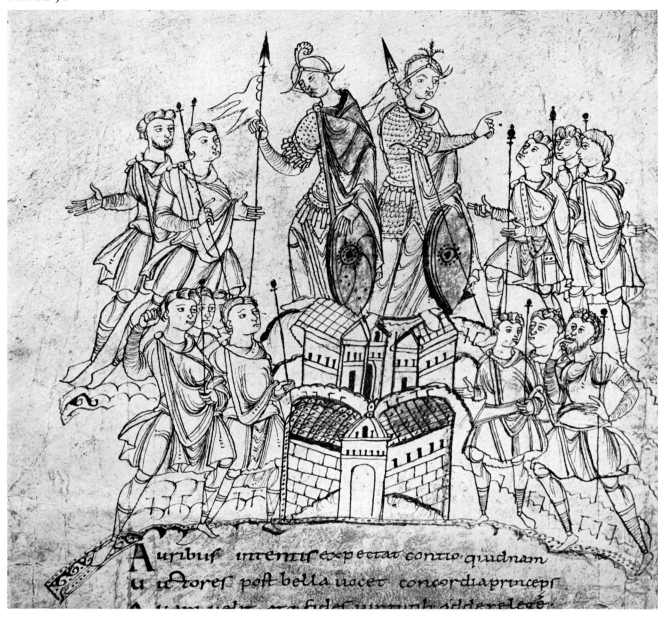

180. Triumph of Faith and Concord. Liége, second quarter XI Century

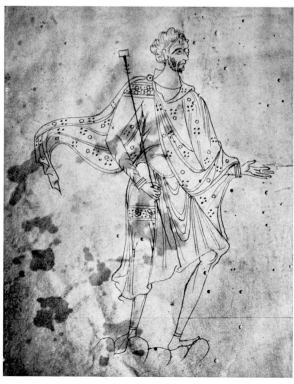

181. St. Livin. Ghent, c. 1054

182. St. Maurice (?). Stavelot (?),
early XI Century

PLATE 79

183. The Three Marys at the Tomb.
Gembloux or Liége (?), *c.* 1025

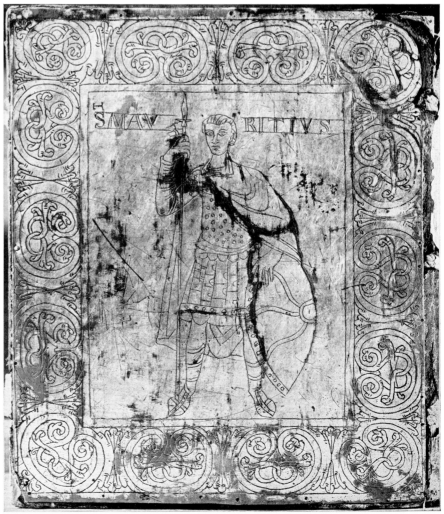

184. St. Maurice. Book-cover. Mainz, XI Century

PLATE 80

185–186. LIÉGE, SECOND QUARTER
XI CENTURY

185. St. Augustine

186. Luke

PLATE 81

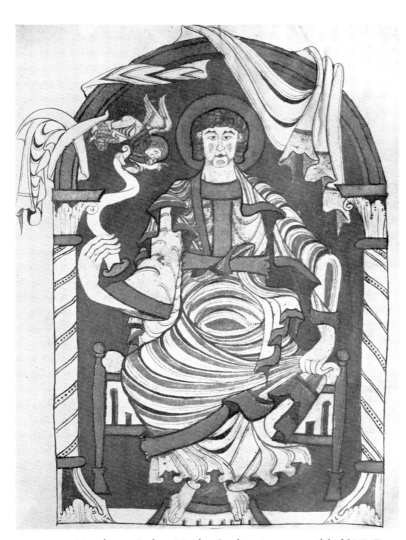

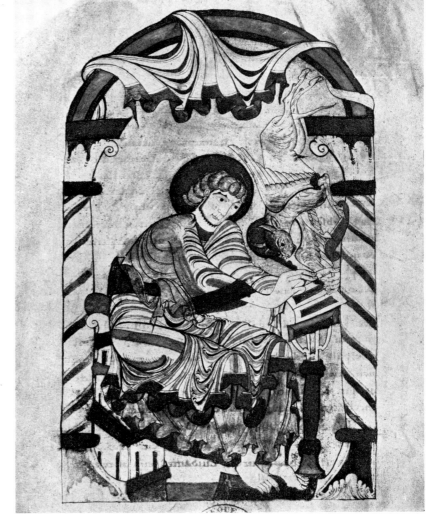

187–189. Matthew, Luke, Mark. Corbie (?), second half XI Century

PLATE 82

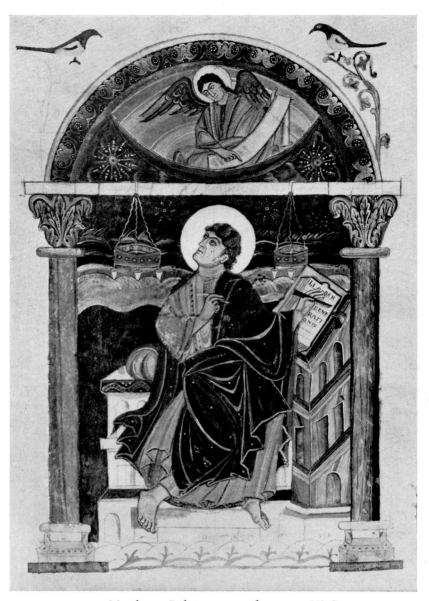

190. Matthew. Belgian, second quarter XI Century

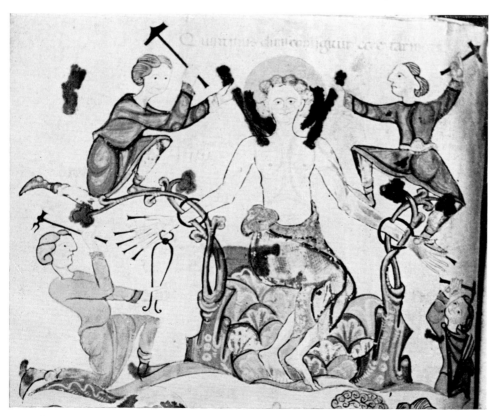

191. St. Quentin tortured. Saint-Quentin, c. 1050

PLATE 83

192. Lamb of God. 'Truth shall spring out of the Earth and Righteousness shall look down from Heaven.' Liége, after 1025

193. St. Bertin crossing the Sea. Saint-Omer, end XI Century

PLATE 84

194. Lion attacking Bear. Detail of Pl. 125, Fig. 286

195. Lion. Jumièges, *c.* 1050

196. John. Cysoing (?), *c.* 1050

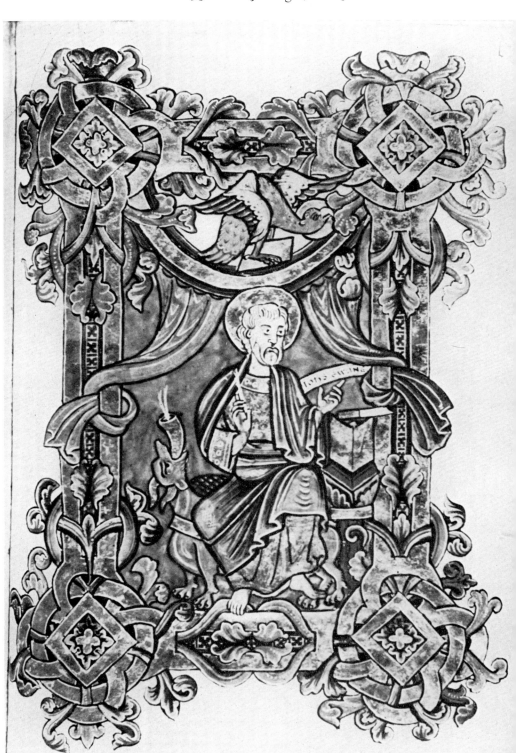

PLATE 85

197. St. Michael and the Dragon

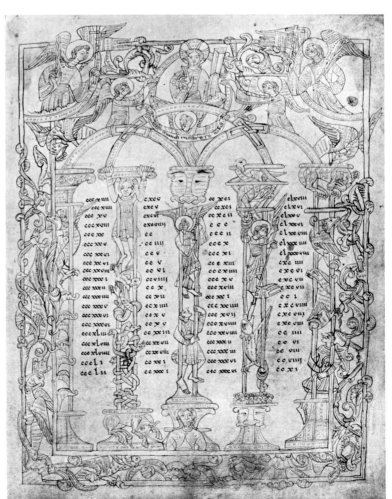

198. Canon Table. Christ. Angels. Inhabited scrolls and columns

PLATE 86

HI. CASTORIS. SIMPLICII. VI. IDVS
NOVEMBRIS.

TEMPO
RIBVS
QVIBVS
DIOCLI
TIANVS

PERREXIT PANNONIS ꝫ admetalla
diuersa sua presencia demontib' absci
denda. factū est dum oms artifices
metallicos congregaret inuenit int

199. Initial 'Y'. Musicians. Canterbury, c. 1100

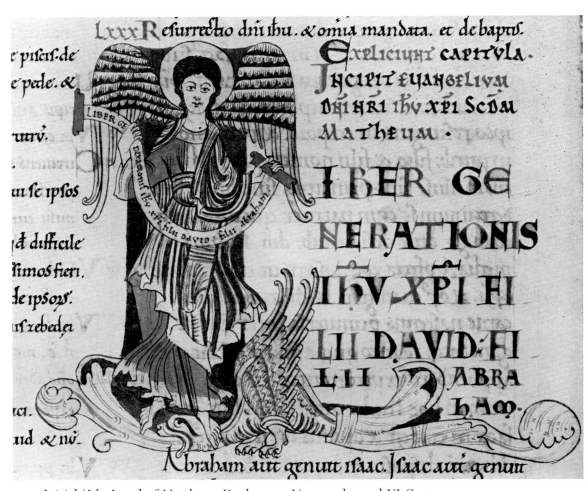

200. Initial 'L'. Angel of Matthew. Durham or Normandy, end XI Century

PLATE 87

201. The Bad and the Good Regiment. Canterbury (?), early XII Century

PLATE 88

202–204. INHABITED SCROLLS

202. Lorraine or England, late XI Century
203. Initial 'G'. As Pl. 87
204. From a Tau Cross. English (?), early XII Century

PLATE 89

206. Eagle of John

205. Man striving to the Light of Christ, fighting Dragons (symbol of Vice)

205–206. FROM THE GLOUCESTER CANDLESTICK, 1104–1113

PLATE 90

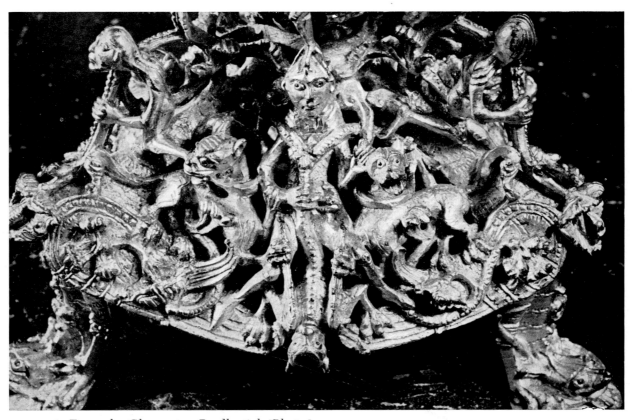

207–208. From the Gloucester Candlestick [Pl. 89]

PLATE 91

209. Evangelist astride River of Paradise

210. Angels lifting the Column of Christ over Adam rising from his Tomb

209–210. FROM THE CROSS-FOOT OF LÜNEBURG, LAST QUARTER XI CENTURY

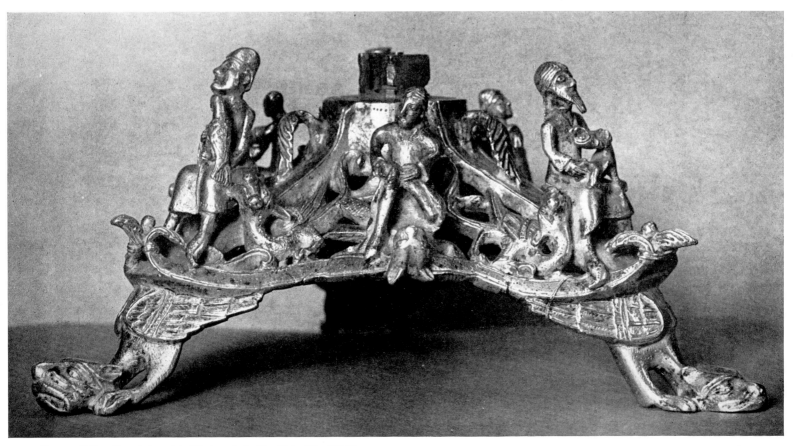

211. Foot of Candlestick with 'Spinario'. English (?), XI Century

PLATE 92

212. Key of St. Servatius. Lorraine, late IX Century

213. Throne of Dagobert. Armrest. Saint-Denis (?), late IX Century

PLATE 93

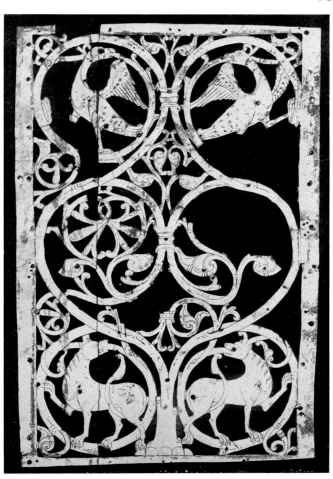

214. From the Imperial Throne of Goslar. Last quarter XI Century

215. Inhabited scrolls. Fritzlar (?), second half XI Century

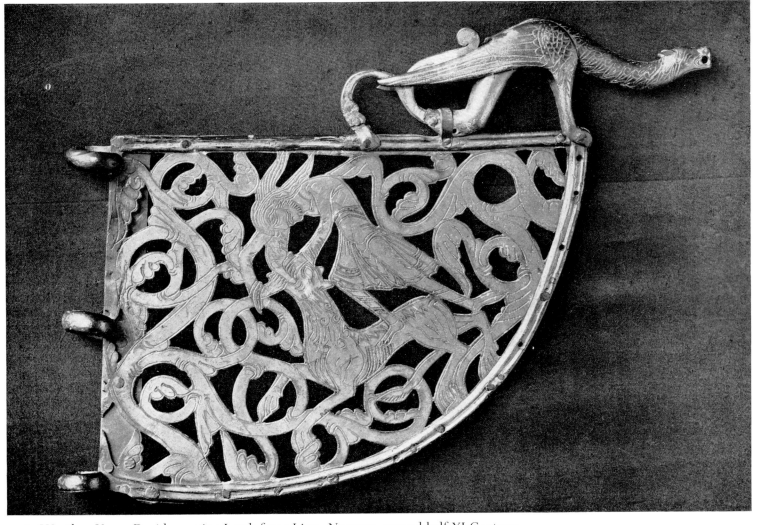

216. Weather Vane. David rescuing Lamb from Lion. Norway, second half XI Century

PLATE 94

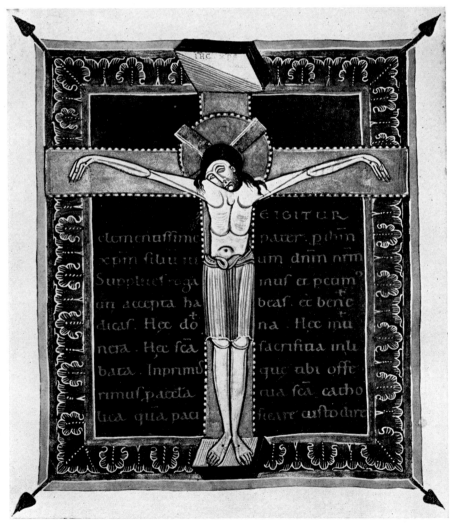

217. Initial 'T'. Cologne, c. 1060

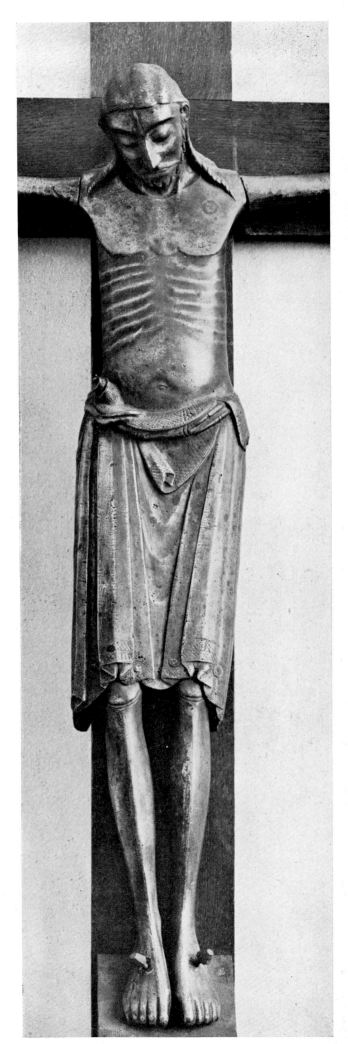

218

PLATE 95

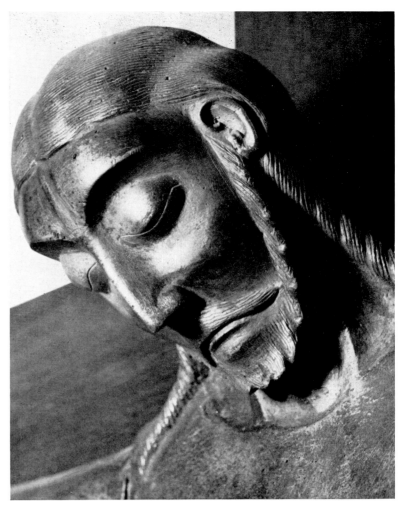

220

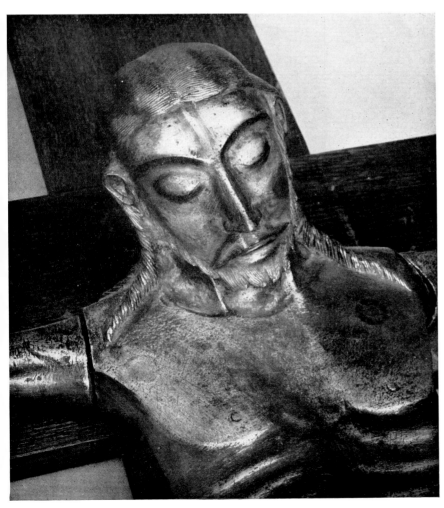

218–220. The Werden Cross. Lower-Saxony (?),
last quarter XI Century

PLATE 96

222. Initial 'T'. Adam and Eve before God

221. Creation of Eve. Mainz (?), 1067–77

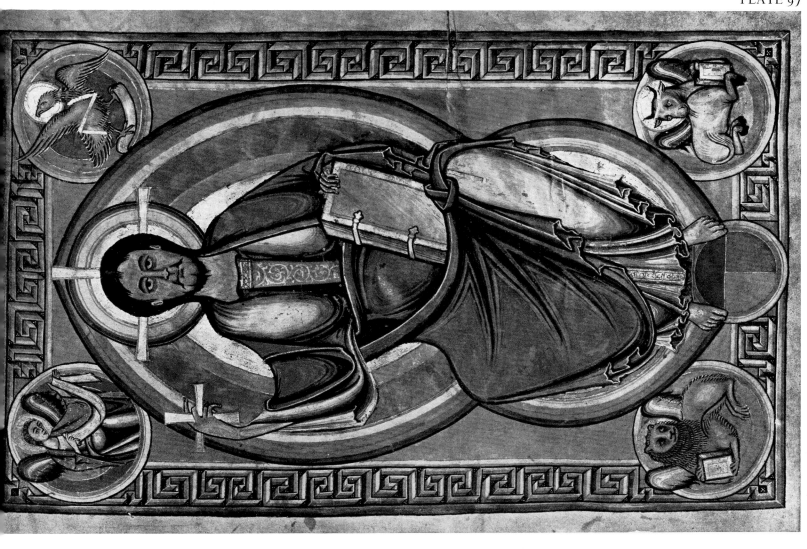

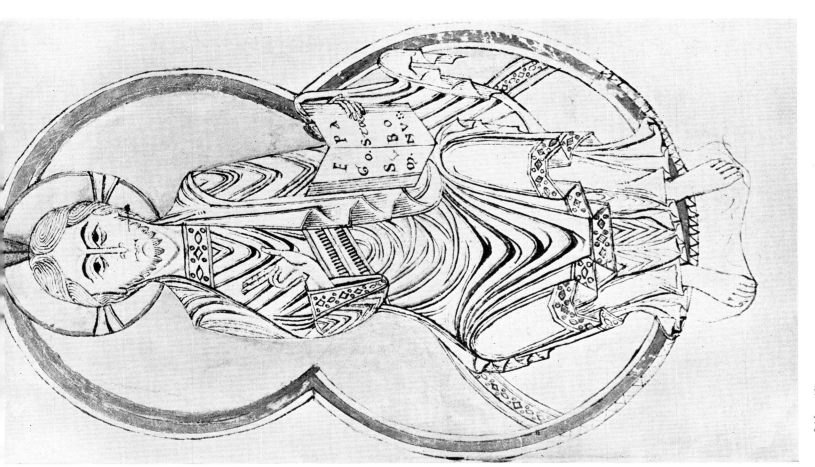

PLATE 97

224. Stavelot Bible, 1097

223–224. CHRIST IN MANDORLA

223. Liége (?), c. 1100

PLATE 98

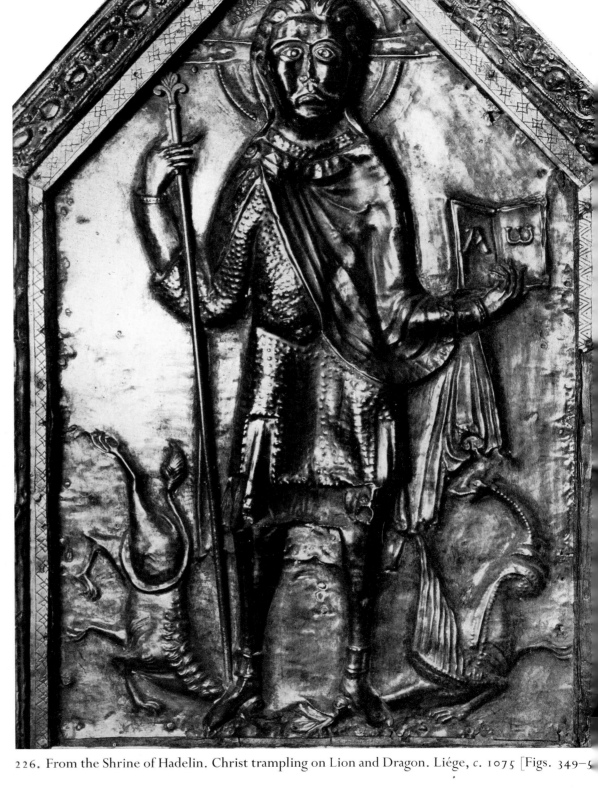

226. From the Shrine of Hadelin. Christ trampling on Lion and Dragon. Liége, c. 1075 [Figs. 349-5

225. Initial 'I'. Cyrus.
Stavelot Bible, 1097

PLATE 99

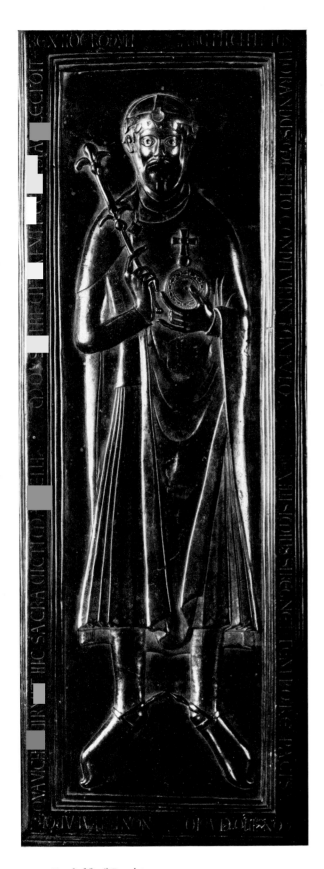

227. Rudolf of Swabia.
Merseburg (?), soon after 1080

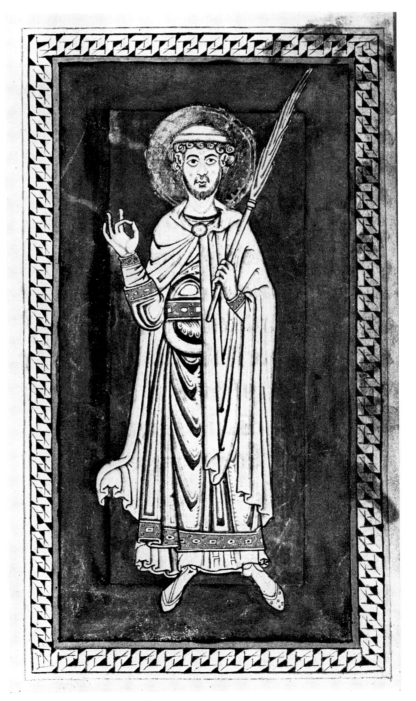

228. St. Pantaleon. Cologne, c. 1130

PLATE 100

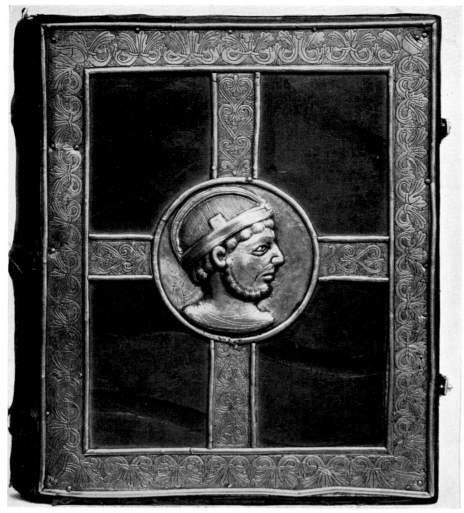

229. Book-cover. Lothair I. Liége (?), second quarter XI Century

230. Cross of Theophanu. Reverse. Christ. The Beasts.
Essen, after 1100

PLATE 101

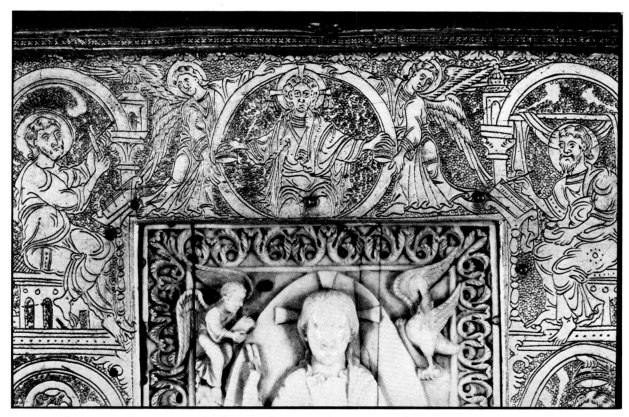

231. Book-cover. Christ in Mandorla. Angels. Evangelists. Liége, first quarter XI Century

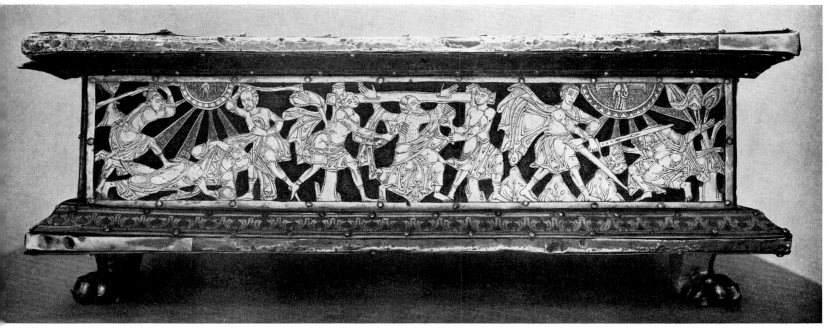

232. Martyrdom of St. Blaise. Portable Altar. Helmarshausen, *c.* 1100

PLATE 102

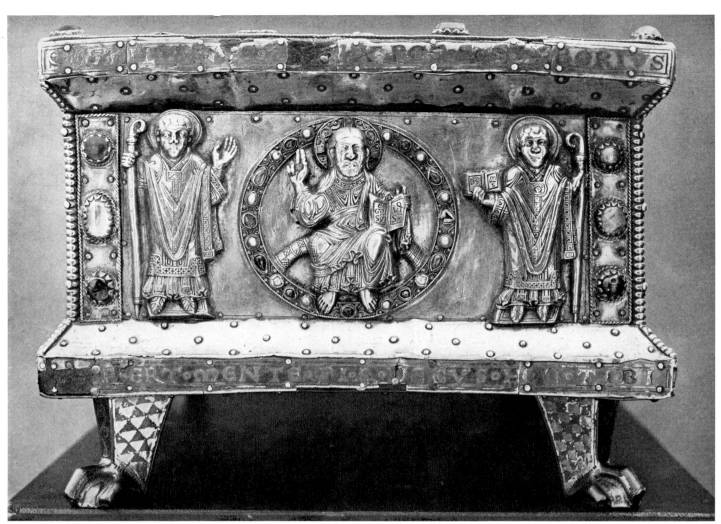

233. Christ in Majesty. SS. Kilian and Liborius

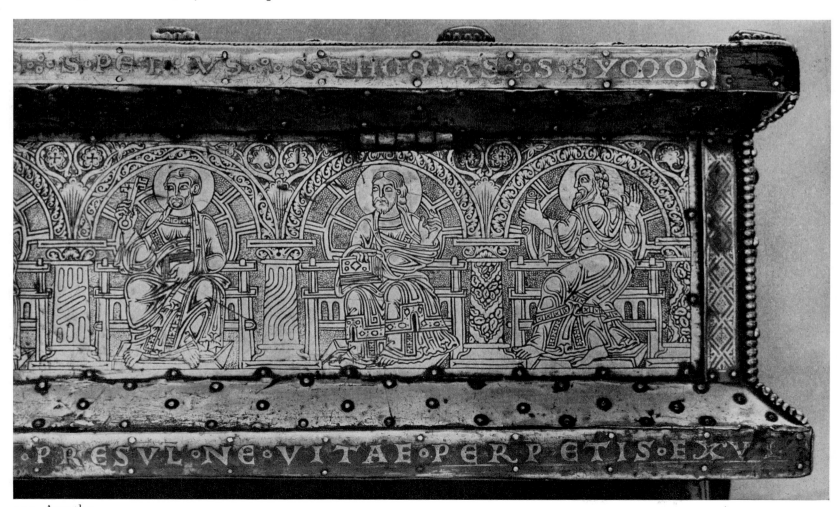

234. Apostles

233–234. PORTABLE ALTAR OF ROGERUS OF HELMARSHAUSEN, 1100

PLATE 103

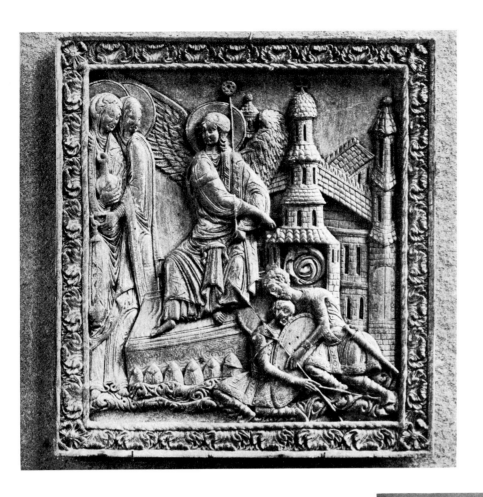

235. The Marys at the Tomb. Liége (?), early XII Century

236. Ewer for Holy Water. Rivers of Paradise.
Anthropomorphic Beasts. Knights on horseback.
Mainz, 1116–19

PLATE 104

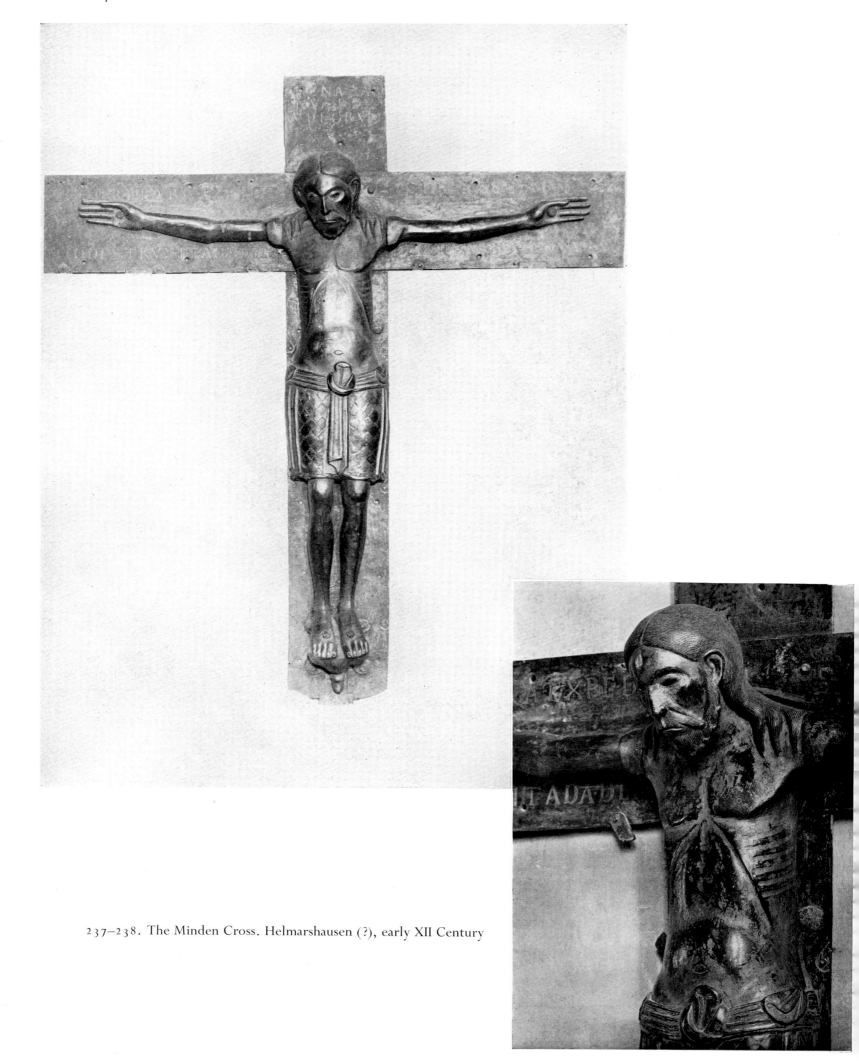

237–238. The Minden Cross. Helmarshausen (?), early XII Century

PLATE 105

239. Christ from a Cross. Hildesheim (?), c. 1130

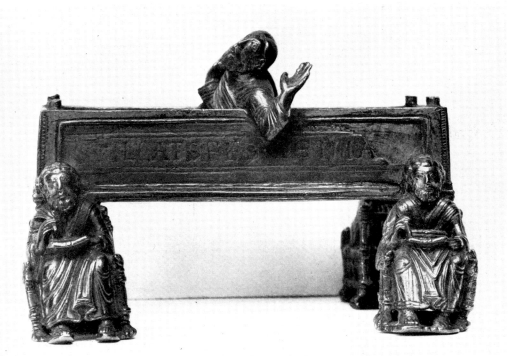

o. Base of a Cross. Adam rising from the
mb. The Evangelists. Lower Saxony, c. 1130

PLATE 106

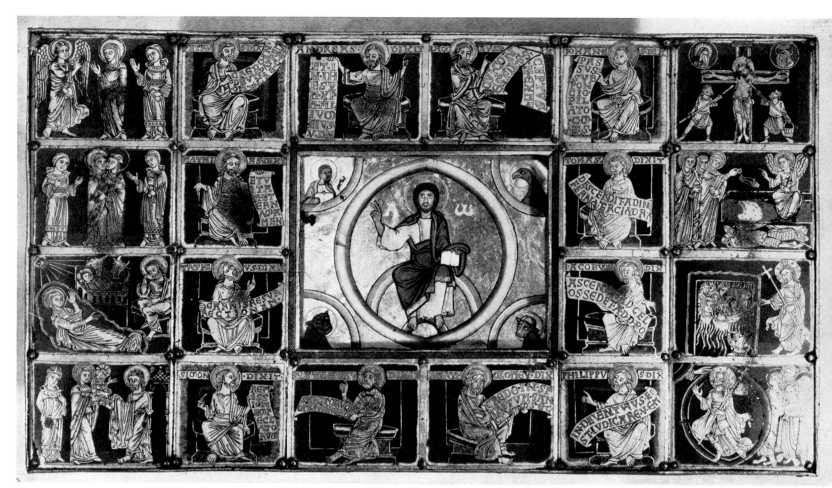

241. Christ in Majesty. The Apostles. Scenes from the Gospels

242. Prophets

241–242. PORTABLE ALTAR OF EILBERTUS. COLOGNE, SECOND THIRD XII CENTURY

PLATE 107

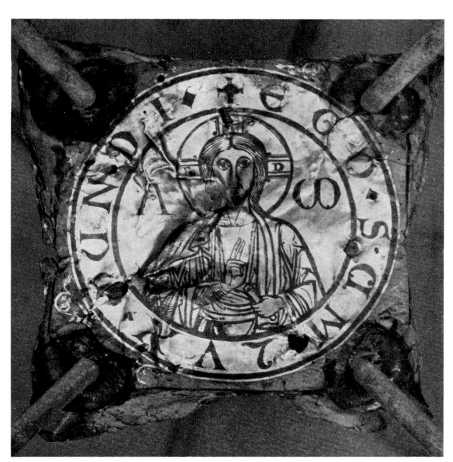

3. St. Peter. Westphalia (?), c. 1130

246. Christ [Pl. 108]

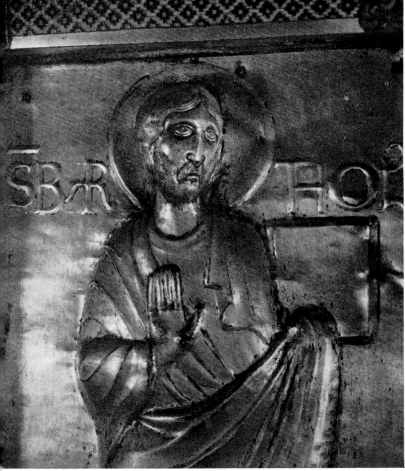

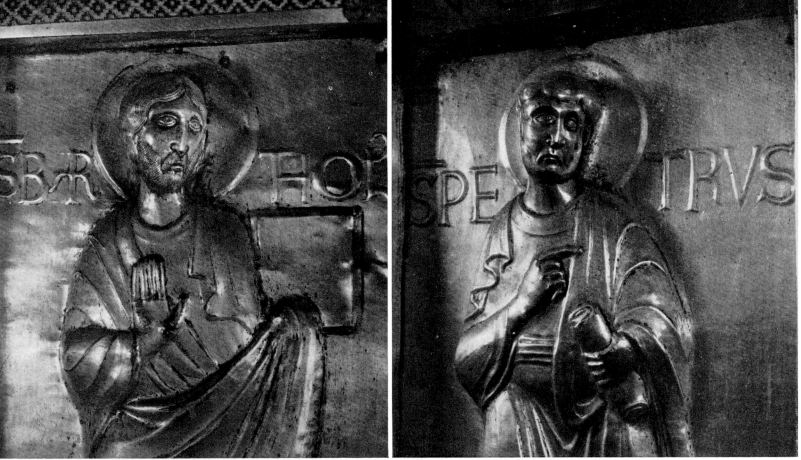

44. St. Bartholomew

245. St. Peter

244–246. KOMBURG OR CORVEY, c. 1130

PLATE 108

247–248. FROM THE KOMBURG CHANDELIER,
c. 1130

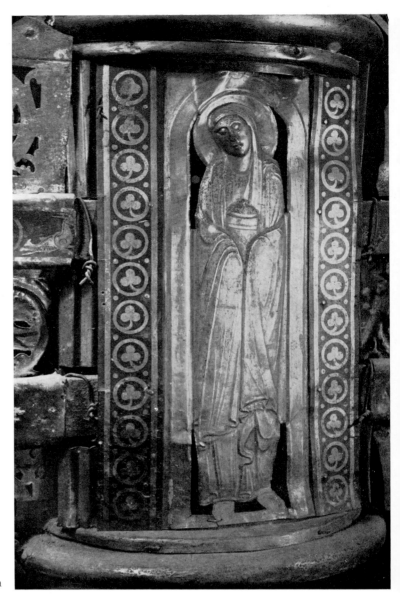

247. St. Magdalen

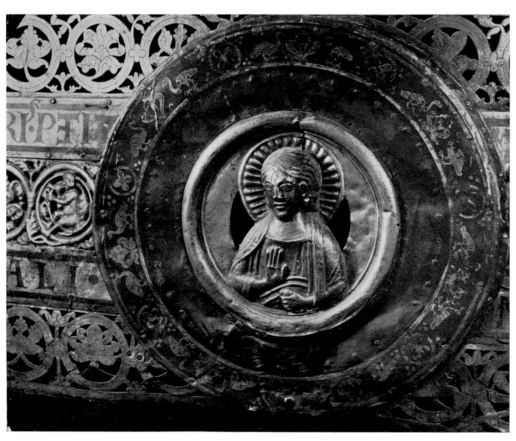

248. Apostle

PLATE 109

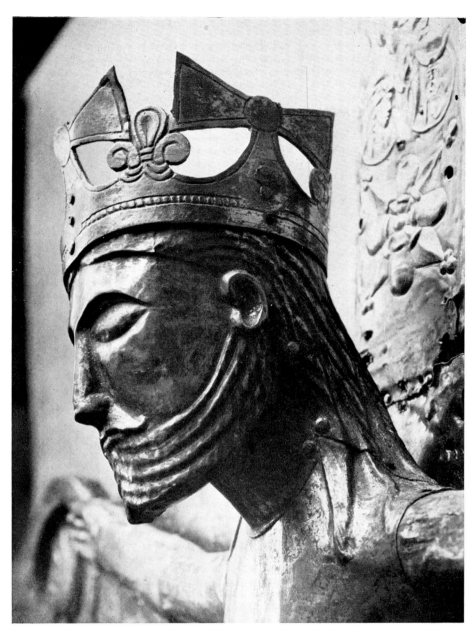

249. Christ

249–250. DENMARK, c. 1140

250. The Virgin Mary

PLATE 110

251. Elkanah's Sacrifice

252. Deborah killing Sisera with the Nail

251–252. BIBLE OF STAVELOT, 1097 [Fig. 224]

253. The Font carried by Oxen, symbolizing the Molten Sea

PLATE 111

254. John preaching

253–258.
FROM THE FONT OF REINER OF HUY, 1107–18

255. John baptizing

PLATE 112

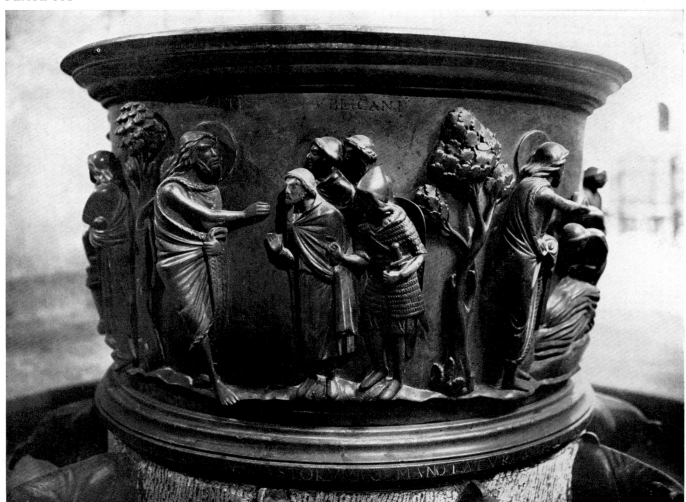

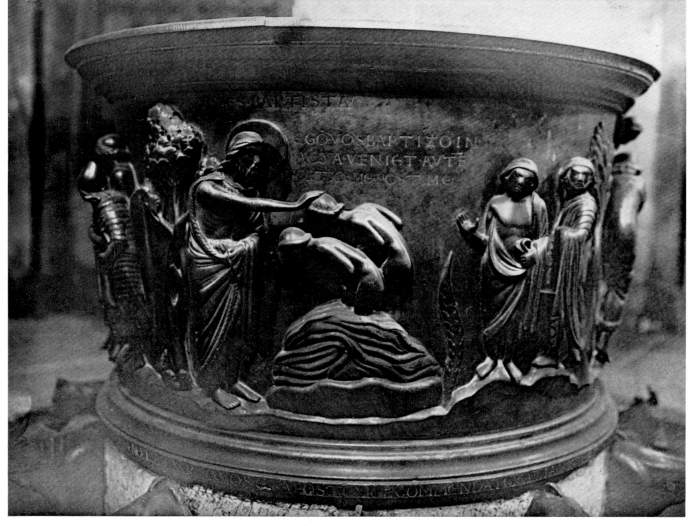

256–258. FONT OF REINER OF HUY, 1107–18

PLATE 113

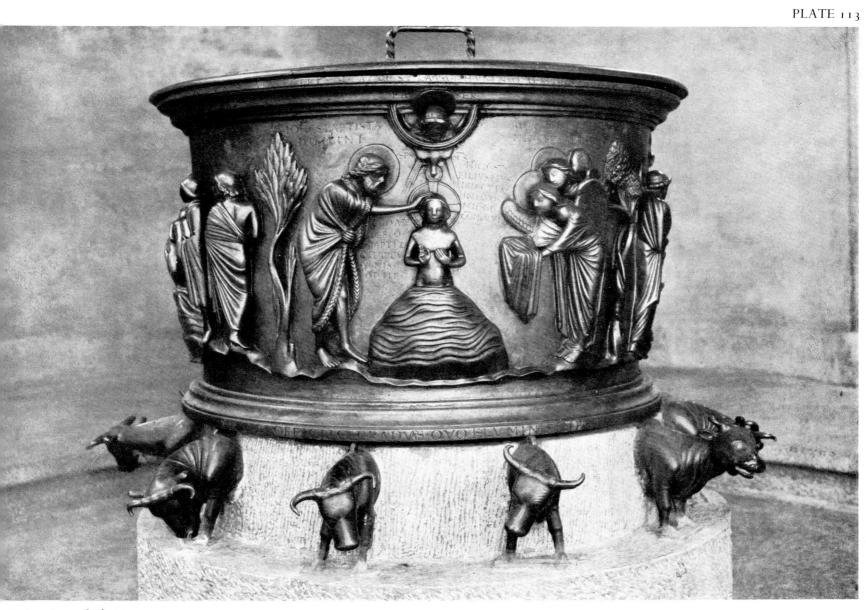

58. Baptism of Christ

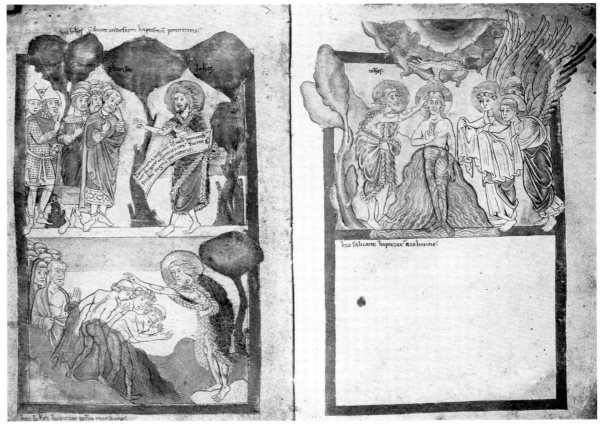

259. John preaching and baptizing. Liége, c. 1160

PLATE 114

260. Lion and Porcupine. Saint-Bertin, *c.* 1120

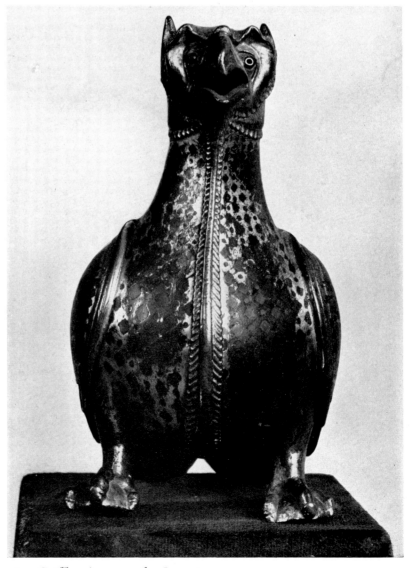

261. Griffin. Aquamanile. Lorraine, *c.* 1130

PLATE 115

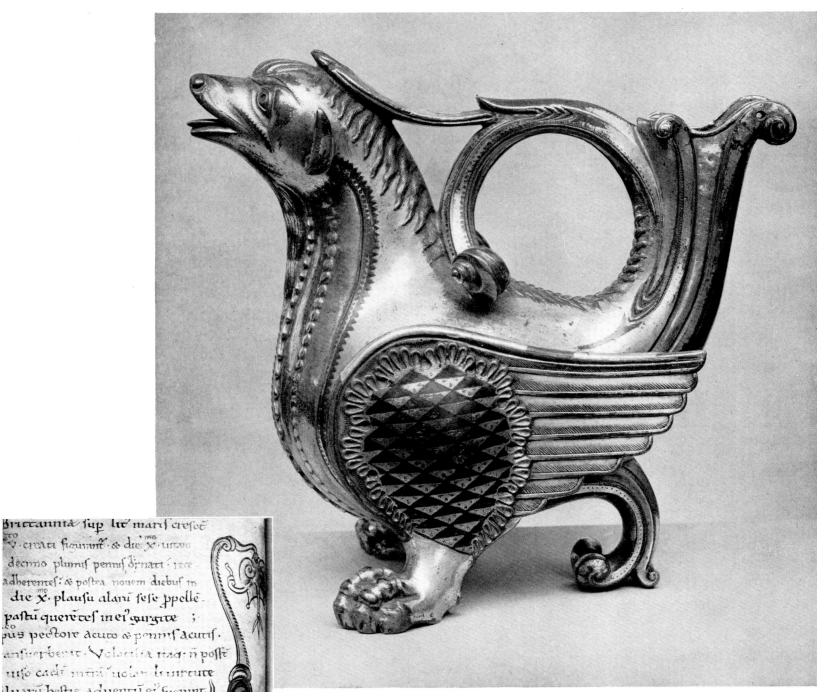

262. Griffin. Aquamanile. Lorraine, c. 1130

263. Griffin. [Fig. 260]

PLATE 116

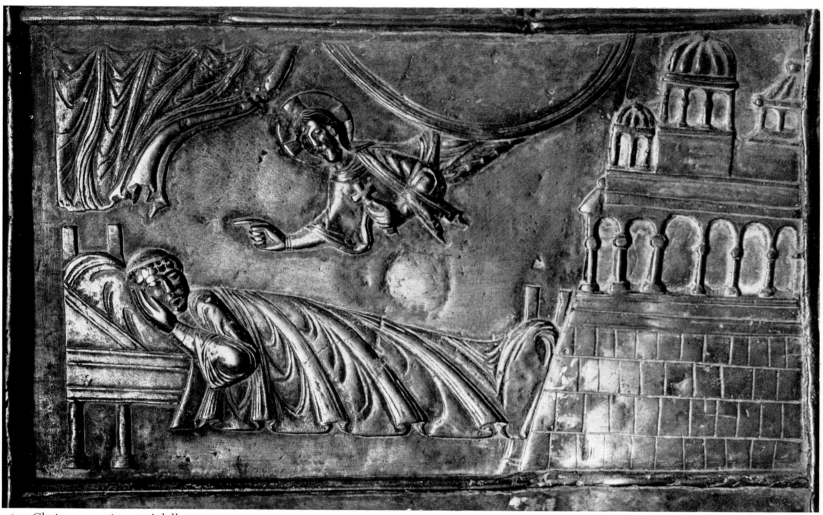

264. Christ appearing to Adalbert

265. The fleeing Companions

266–267. Inhabited scrolls

264–268. FROM THE BRONZE
DOORS OF GNESEN. LIÉGE (?),
SOON AFTER 1127

PLATE 117

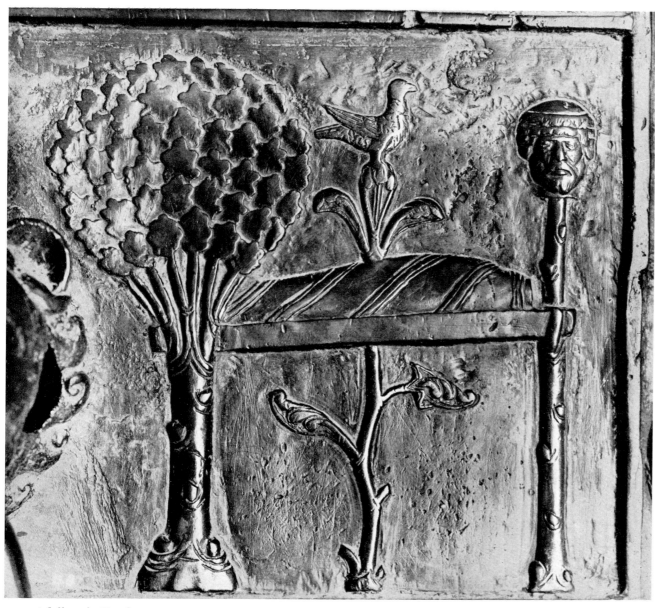

268. Adalbert's Tomb

269–270. Pyx. Liége (?), first quarter XII Century

PLATE 118

271. Initial 'V'. Job's Soul struggling with Satan and Beasts. Winchester (?), c. 1150

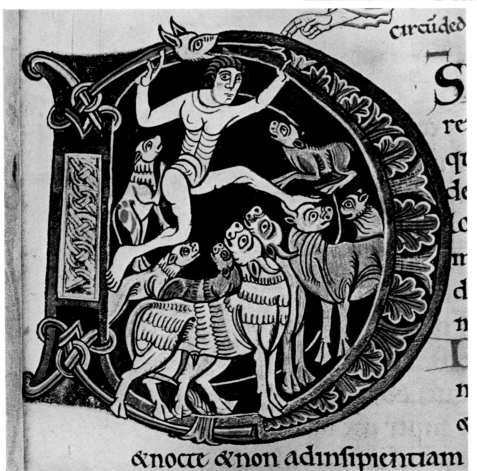

272. Initial 'D'. The Psalmist threatened by Bulls and Lions. The Rescuing Hand of God

272–273. ST. ALBAN'S PSALTER, c. 1123

PLATE 119

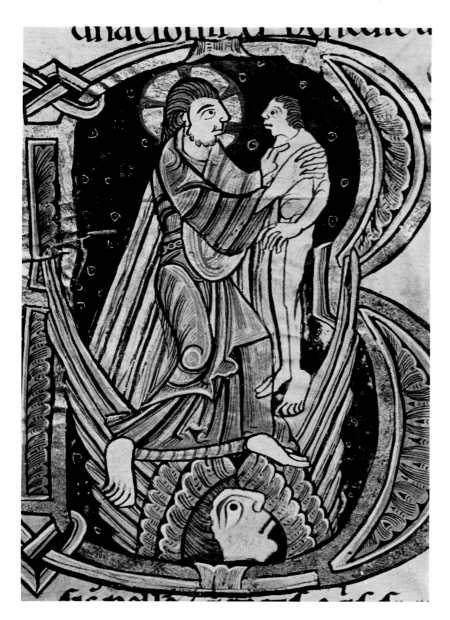

273. Initial 'B'. The Lord walking upon the Wings of the Wind breathes the Spirit into his Angels

274. Philosophy consoling Boethius. Hereford, c. 1140

PLATE 120

276. Hanging of the Thieves. Bury St. Edmond's, c. 1140

275. The Flagellation. St. Alban's Psalter (Figs. 272-3) between 1131 and 1145

PLATE 121

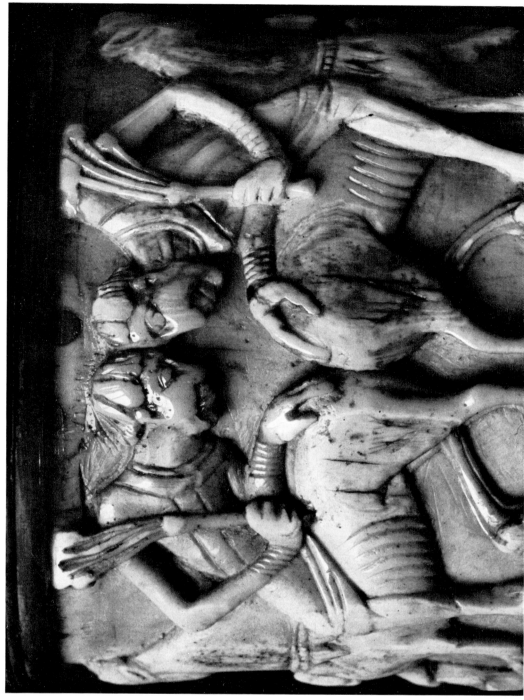

277. Box. Centaurs. English, c. 1130

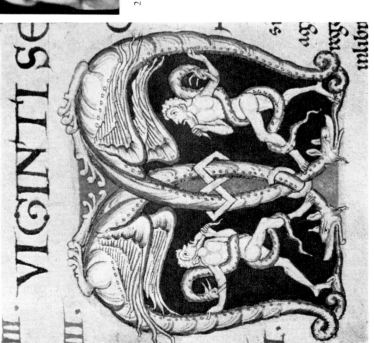

278. Initial 'M'. Nudes bitten by Serpents. Canterbury, c. 1150

PLATE 122

279. The Crucifixion. Worcester (?), c. 1150

280. Christ of a Cross. English, c. 1150

PLATE 123

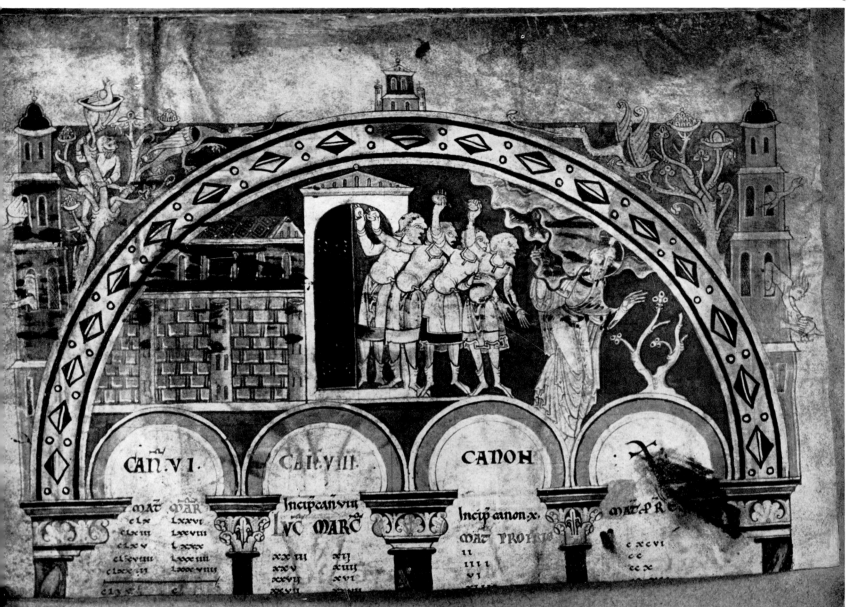

81. English, c. 1140

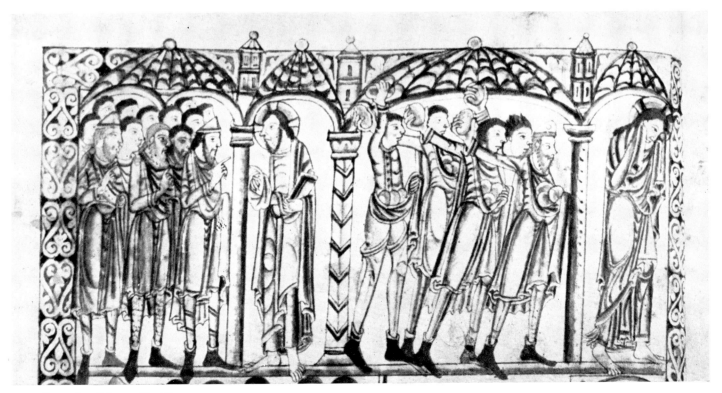

282. Bury St. Edmund's (?), c. 1140

281—282. THE STONING OF CHRIST

PLATE 124

283. Luke riding on his Bull. Canterbury (?), c. 1130

284. Initial 'Q'. Luke slaughtering his Bull. Canterbury, c. 1150

PLATE 125

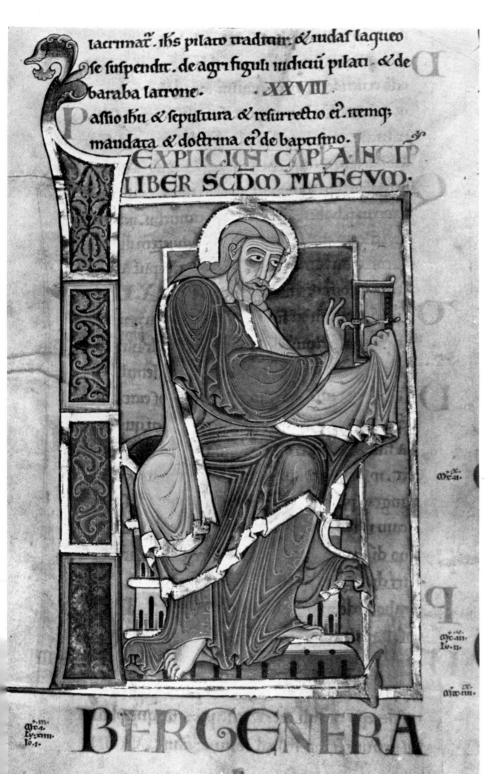

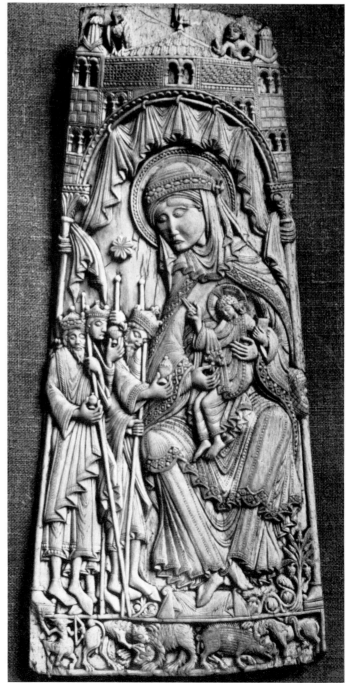

285. Initial 'L'. Matthew. [Fig. 284]

286. Adoration of the Magi. English or Norman, *c.* 1140

PLATE 126

287. Lions. English, *c.* 1150

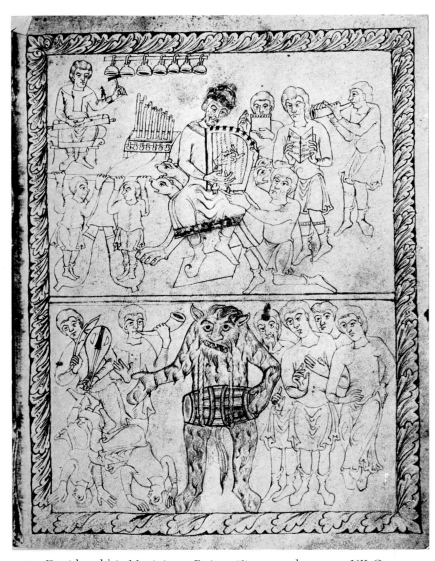

288. David and his Musicians. Reims (?), second quarter XII Century

PLATE 127

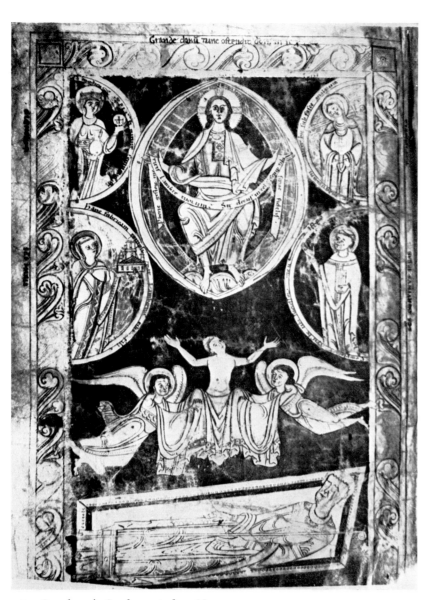

289. Lambert's Soul carried to Heaven

289–290. SAINT-BERTIN,
SECOND QUARTER XII CENTURY

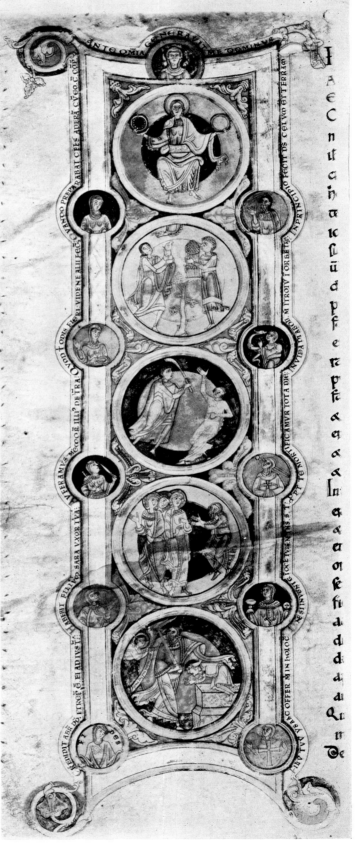

290. Initial 'I'. Christ. Cain and Abel. Abraham visited,
Isaac sacrificed

PLATE 128

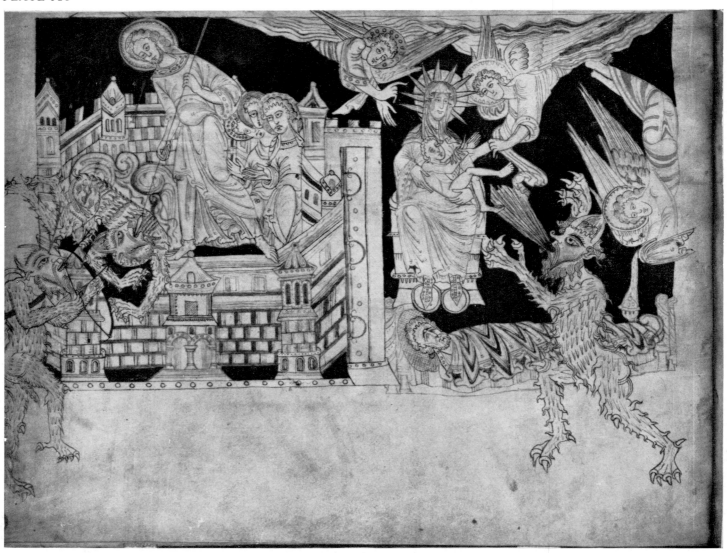

291. Christ defending the City of God. Adaptation of Revelation XII. English, *c.* 1140

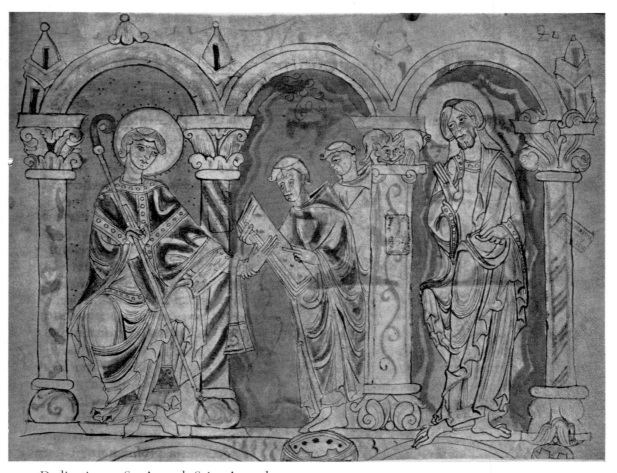

292. Dedication to St. Amand. Saint-Amand, *c.* 1140

PLATE 129

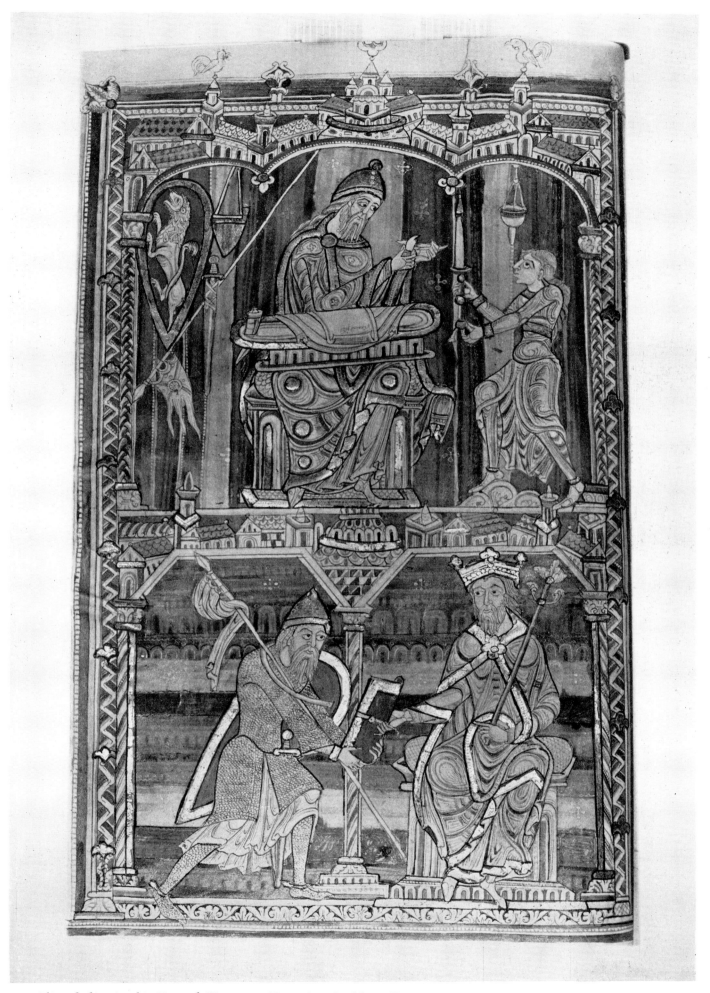

293. Pliny dedicating his Natural History to Vespasian. Le Mans (?), *c.* 1150

PLATE 130

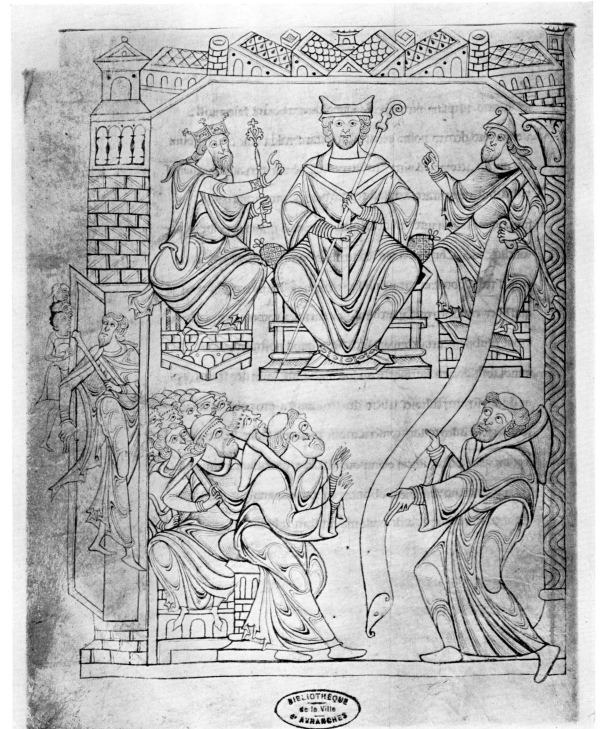

294. The Donation of Richard of
Normandy

294–295. MONT-SAINT-MICHEL,
c. 1160

295. Robert le Diable offering his Glove to St. Michael

PLATE 131

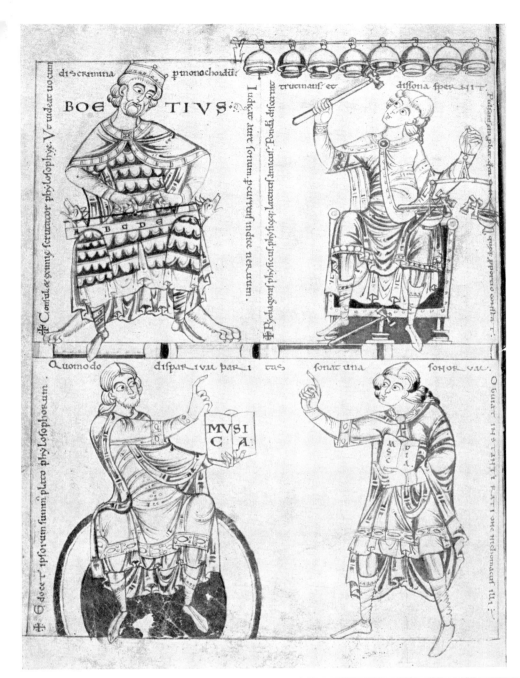

296. Boethius. Pythagoras. Plato and Nicho-machus discussing Music. Canterbury, *c.* 1150

297. Illustration to the ''Andria'' of Terence. St. Alban's, *c.* 1150

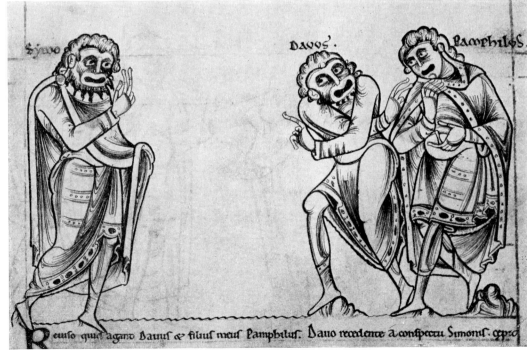

PLATE 132

299. Initial 'I'. Wedricus dedicating his Gospels to Christ

298–299. CAMBRAY OR CANTERBURY (?), 1147

298. St. John and Abbot Wedricus of Liessies

PLATE 133

301. Initial 'F'. Battle of Gilboa. Saul's Death

300–301. LAMBETH BIBLE, C. 1150

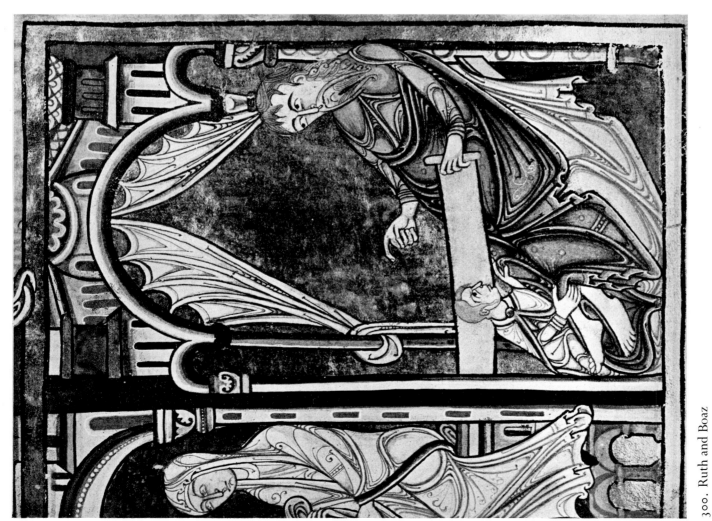

300. Ruth and Boaz

PLATE 134

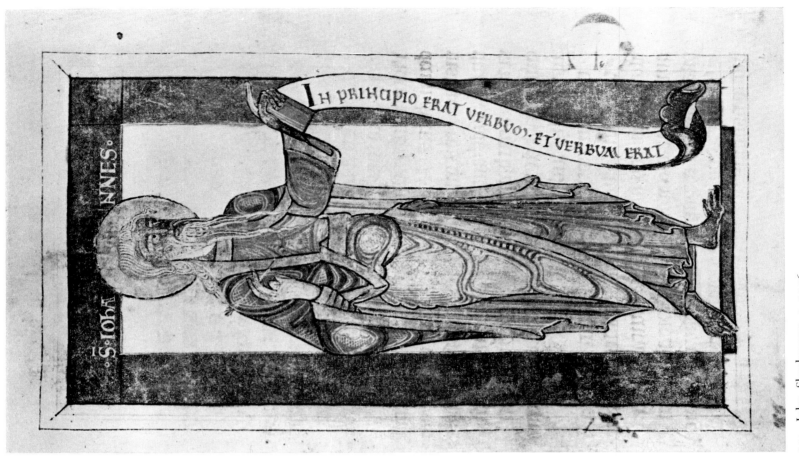

303. John. Sherbourne, c. 1146

302. Moses. Bury St. Edmunds, c. 1148

PLATE 135

305. Initial 'E'. God calling Joshua. Fécamp (?), c. 1150

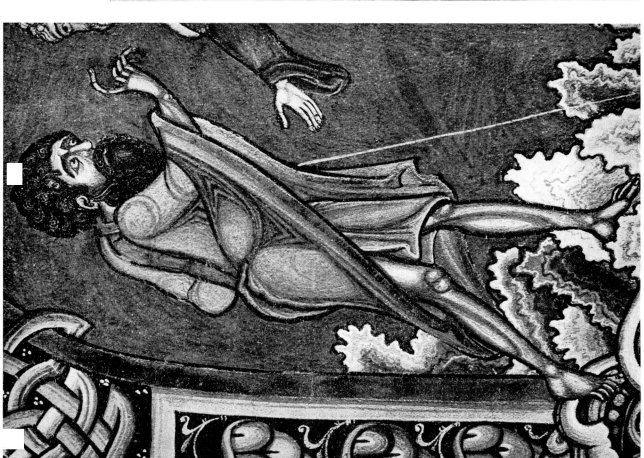

304. Elijah. Winchester Bible, c. 1150–60

PLATE 136

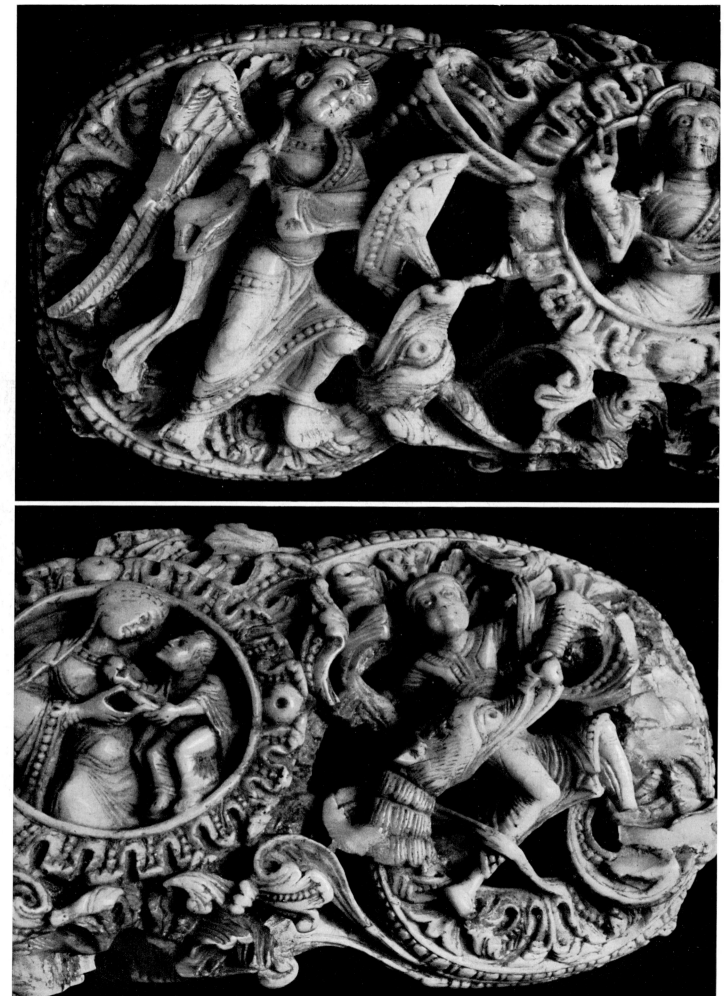

306–307. From a Tau Cross. St. Michael and a Man fighting Dragons. Christ. Virgin and Child. English, c. 1145

PLATE 137

nsidianf cogitat lingua sua quasi nouacula

308. Initial 'Q'. Doeg slaying the Priests

308–309. WINCHESTER BIBLE, *c.* 1150–60

309. Initial 'I'. Moses and Aaron

PLATE 138

310. Burial of Judas Maccabeus

311. Initial 'P'. Inhabited scroll

310–311.
WINCHESTER BIBLE,
c. 1150–60

PLATE 139

312–313. From a Crozier Head. Nativity and Miraculous Birth of St. Nicholas of Bari

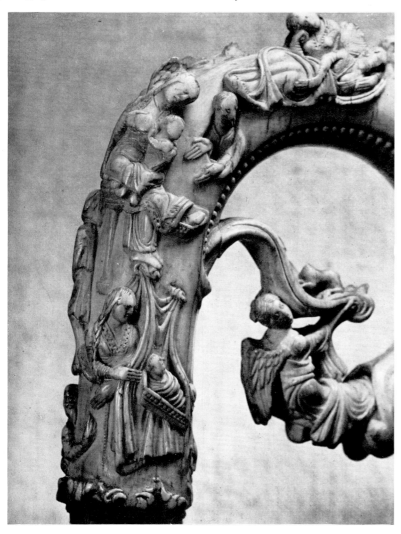

313

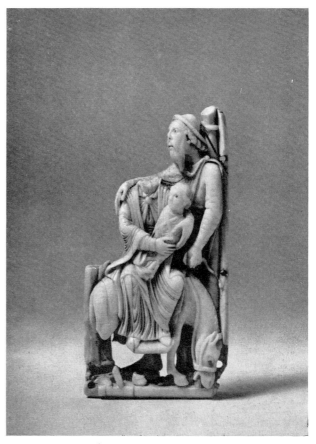

314. Flight into Egypt

312–314. ENGLISH, C. 1150

PLATE 140

315. The Crucifixion. Saint-Amand, *c.* 1150

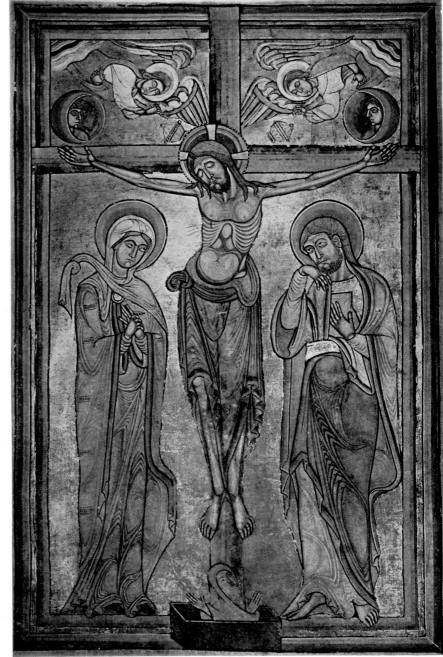

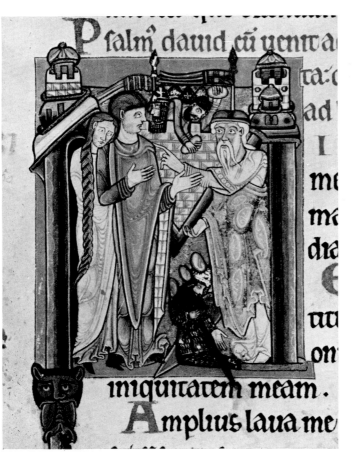

316. Initial 'M'. Stoning of Uriah. Nathan reproaching David and Bathshe[?]
York (?), *c.* 1170

PLATE 141

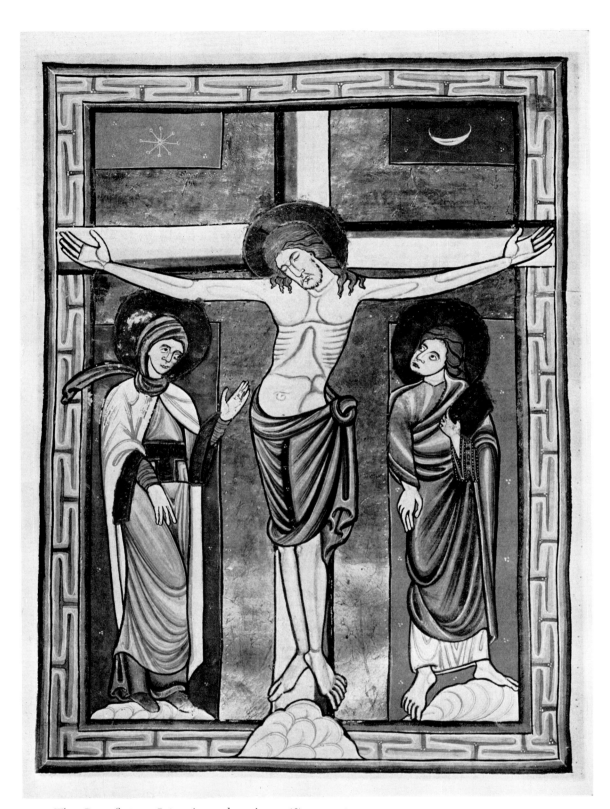

317. The Crucifixion. Saint-Amand or Arras (?), *c.* 1160

PLATE 142

318. St. Gregory. Saint-Amand, *c.* 1160

PLATE 143

319. Guilbert de la Poirée, Boethius and Scribe.
Saint-Amand, c. 1170

320. Robert Le Diable. Bec, c. 1150

PLATE 144

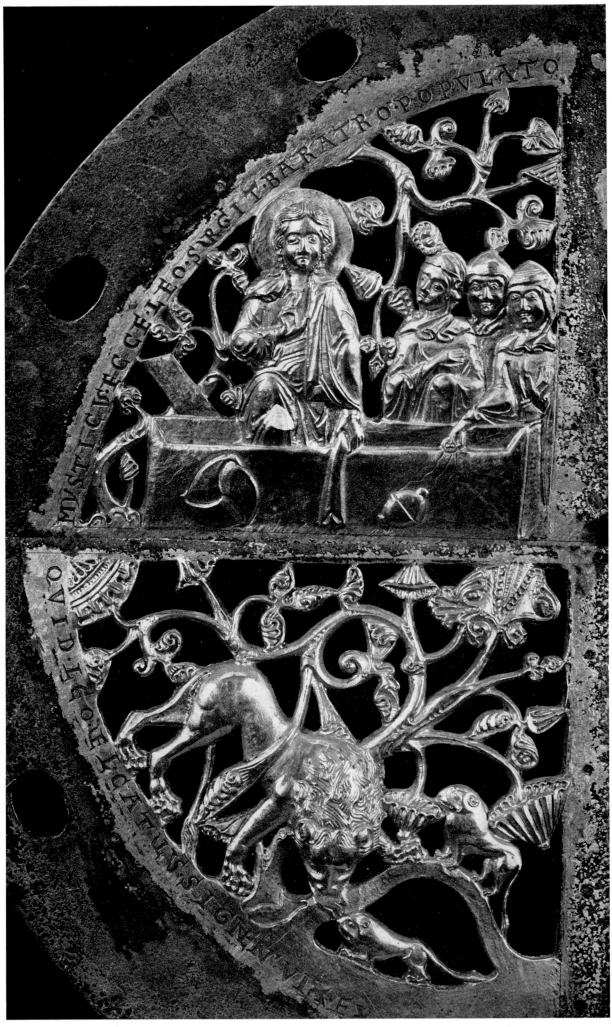

321. From a Flabellum. The Resurrection with the Three Marys.
The Lioness vivifying her Whelps. English (?), c. 1150

PLATE 145

322. The Lioness vivifying her Whelps. Averboden (?), *c.* 1150

323. David rescuing the Lamb from the Lion. Winchester, *c.* 1150

PLATE 146

324. The Angel closing the Mouth of Hell. [Fig. 323]

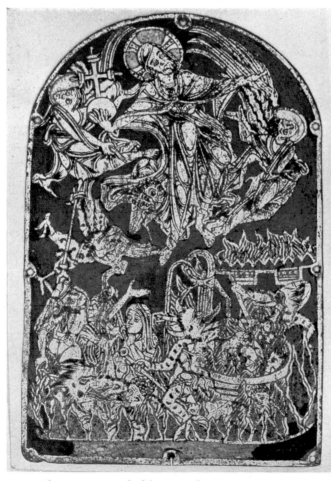

325. Christ surrounded by Angels
above the Damned in Hell. England, c. 1150

PLATE 147

326–327. Doorknocker. Lion as Mouth of Hell.
Durham (?), c. 1140

PLATE 148

328. Ring of the Durham Doorknocker. [Pl. 147]

329. Candle-Bearer.
Anglo-Norwegian,
second quarter XII Century

PLATE 149

330

330–332. DETAILS OF THE REIMS
CANDLESTICK. REIMS OR ENGLAND,
SECOND QUARTER XII CENTURY

331

PLATE 150

332 [Pl. 149]

333. Initial 'L'. Inhabited scrolls. Stavelot Bible, 1097
[Fig. 224]

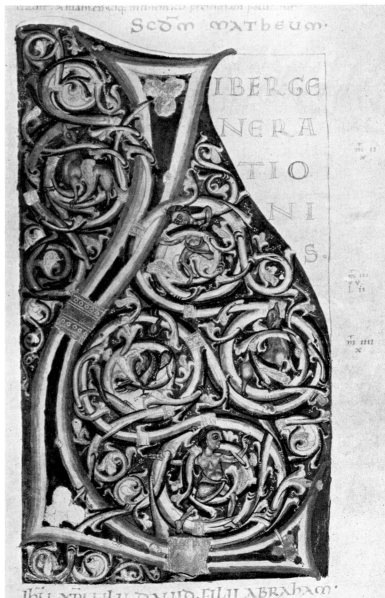

PLATE 151

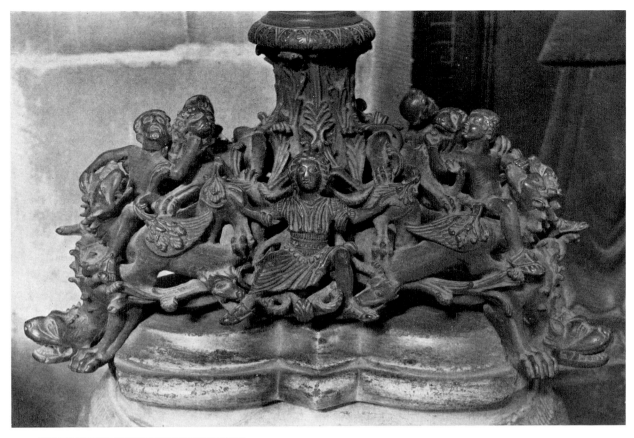

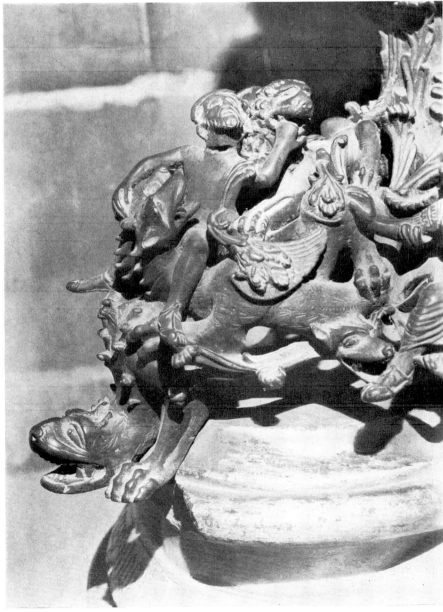

334–335. Base of the Prague Candlestick.
Lorraine or Milan (?), c. 1140

PLATE 152

336. Eagle Vase of Suger of Saint-Denis, 1122–51

PLATE 153

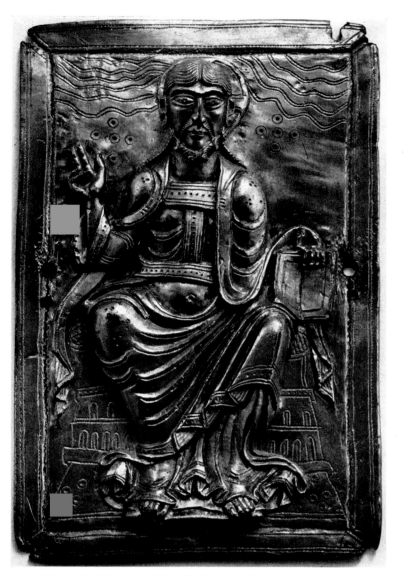

337. Christ in Majesty. North Eastern France, c. 1140

338. The Two Marys at the Tomb.
From the Cross of Bury St. Edmunds, second half 12th century

339. Apostles. From a shrine or portable altar, Saint-Denis (?), second quarter XII Century

PLATE 154

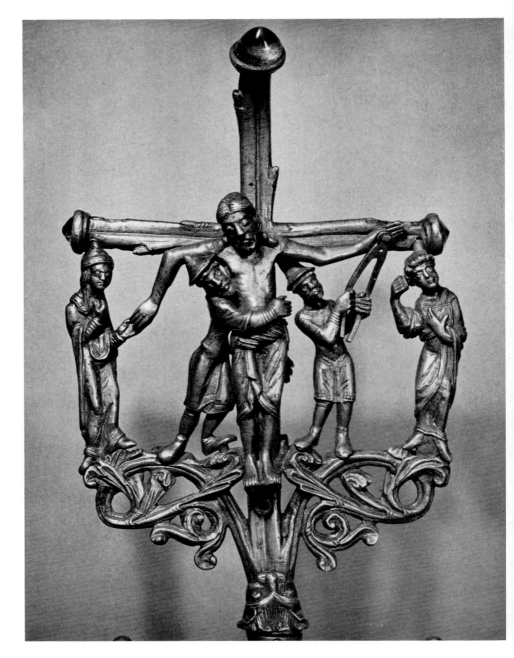

340–342. THE DEPOSITION

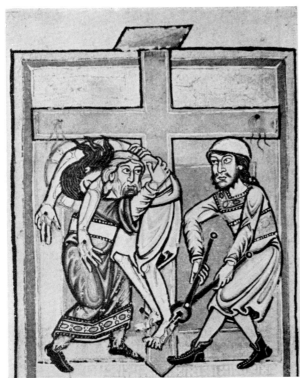

340. Saint-Trond (?), c. 1140

341–342. Lorraine, c. 1130

PLATE 155

343–344. Censer, symbolizing the Temple of Solomon.
Trèves, c. 1000 (?)

Top of Holy Water Sprinkler (?). Werden (?), c. 1130

346. Censer. The Angel and the Three Worthies in the Fiery Furnace.
Mosan, second quarter XII Century

PLATE 156

347. Aquamanile. Man wrestling with Dragon. Lorraine, third quarter XII Century

PLATE 157

348. The Woman given Wings that she might escape from the Serpent, casting out Water as a Flood which is swallowed by the Earth. Ghent (?), c. 1150

PLATE 158

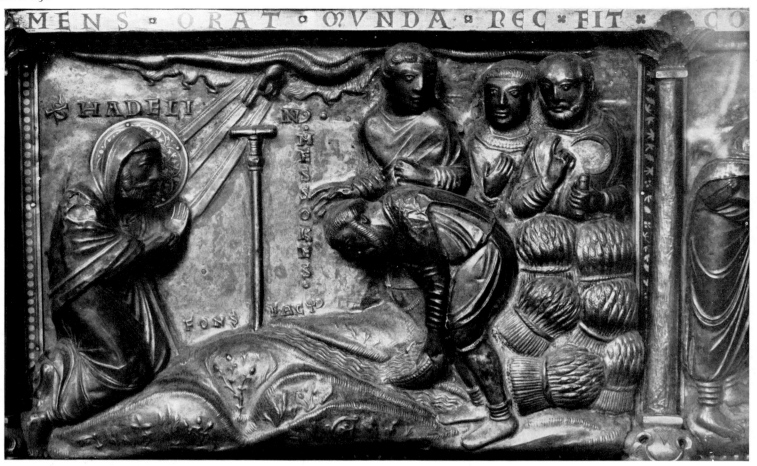

349. The Miracle of the Spring

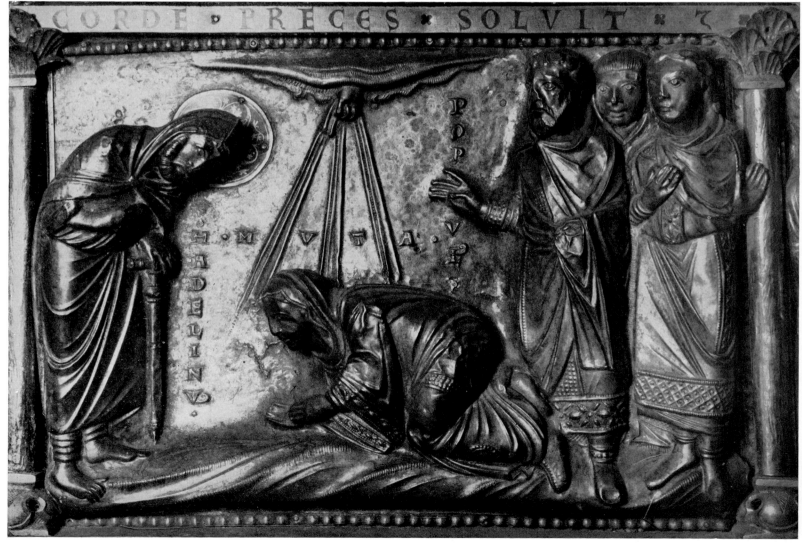

350. Hadelin healing a mute woman

349–351. FROM THE SHRINE OF HADELIN, LIÉGE, c. 1140

PLATE 159

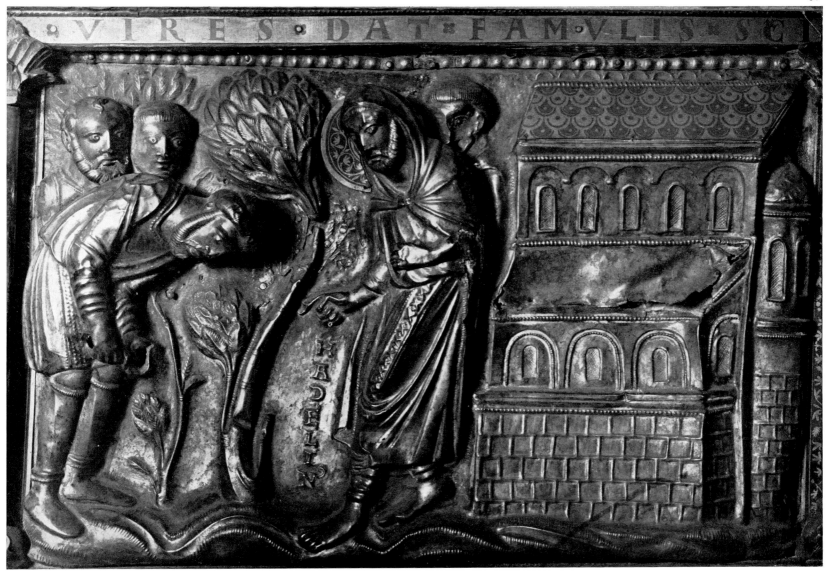

351. Hadelin receiving pupils at Celles Abbey

352. SS. Benedict and Maurus taming Devil. Liége, c. 1150

PLATE 160

353. Job scraping his boils, tried by his wife and his friends. Champagne (?) c. 1140

354. Job scraping his boils inflicted by Satan. Franco-Flemish, c. 1150

PLATE 161

Vt satane tota cum magno turbine mota. Flamma coruscauit. æ oues pueros q; cremauit.

Vnue oserore veniene cumulando prior e
Cuo gemitu tristi tao tristia nunciat ut i.

355. The Fire of Heaven burning up the sheep and the servants of Job. [Fig. 354]

353–355. THE STORY OF JOB

PLATE 162

357. Initial 'V'. Amos as Shepherd. Park's Abbey, 1148

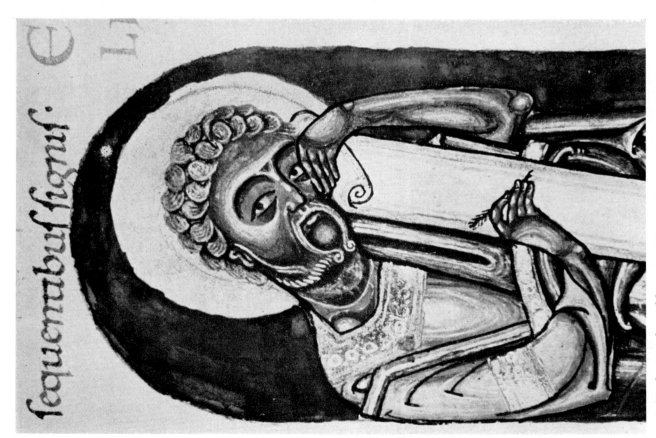

356. Mark. Stavelot Bible, 1097 [Fig. 224]

PLATE 163

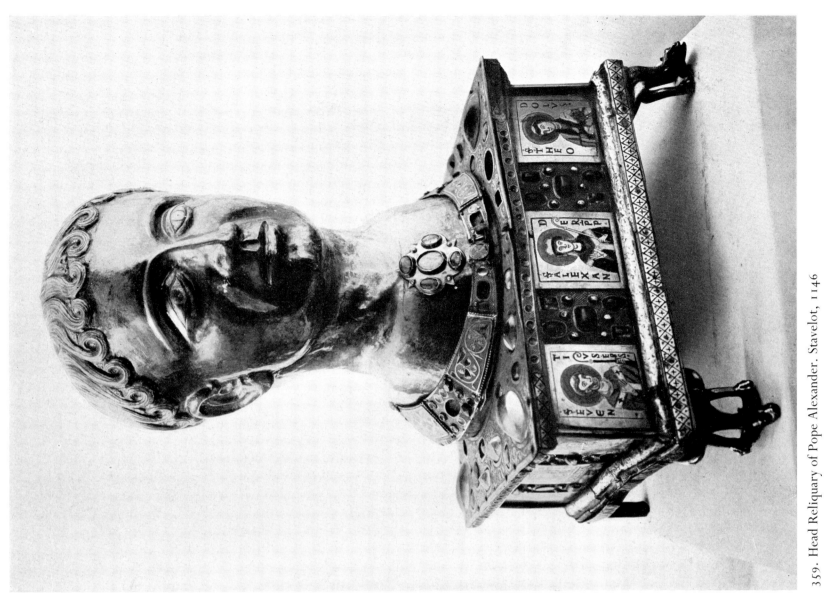

359. Head Reliquary of Pope Alexander. Stavelot, 1146

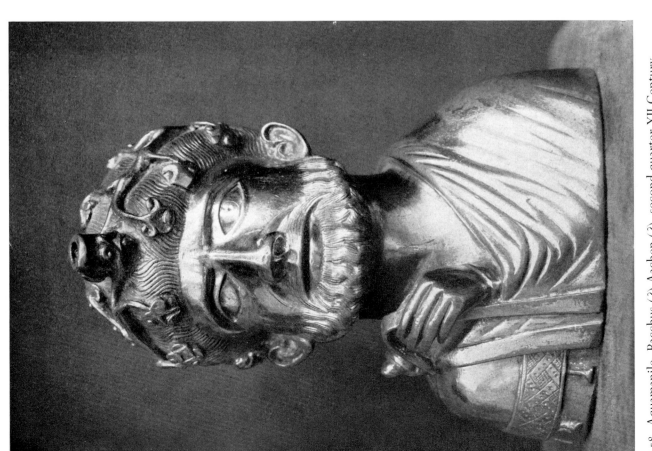

358. Aquamanile. Bacchus (?) Aachen (?), second quarter XII Century, or early XIII Century

PLATE 164

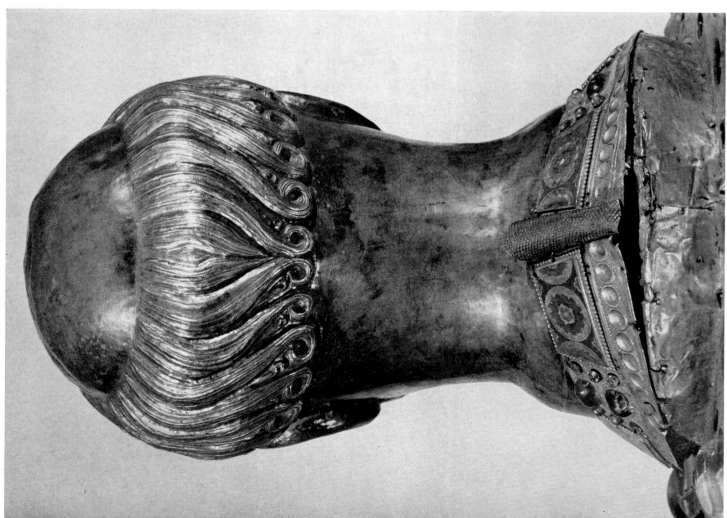

360–361. Head Reliquary of Pope Alexander [Fig. 359]

PLATE 165

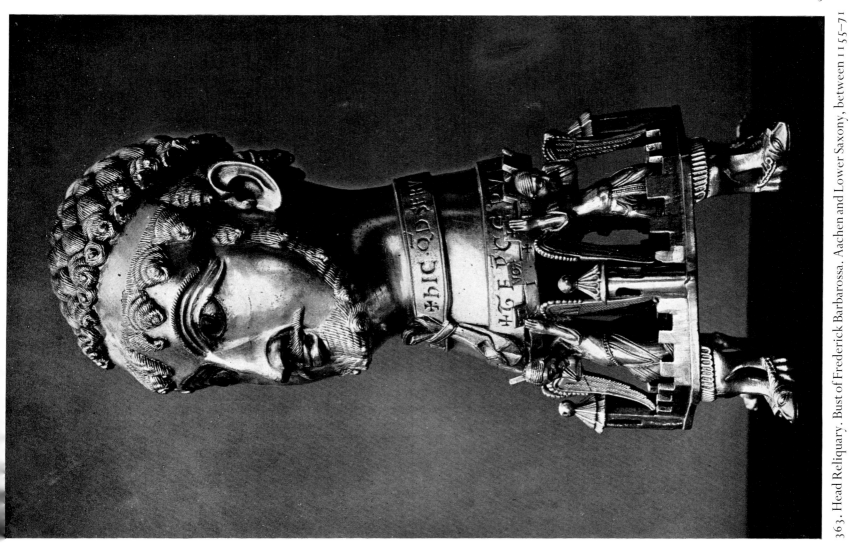

363. Head Reliquary. Bust of Frederick Barbarossa. Aachen and Lower Saxony, between 1155–71

362. Head Reliquary. Lower Saxony, c. 1150

PLATE 166

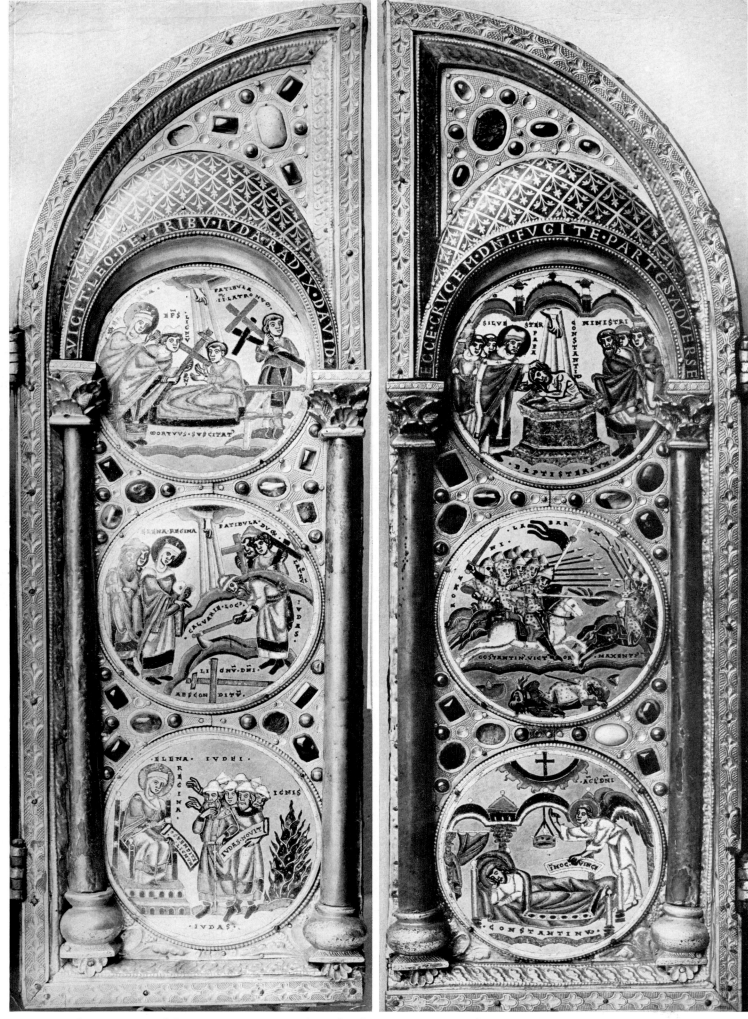

364–365. The Invention of the True Cross. From the Life of Constantine. Stavelot, c. 1150

PLATE 167

366. Faith with Baptismal Font. Stavelot, c. 1156

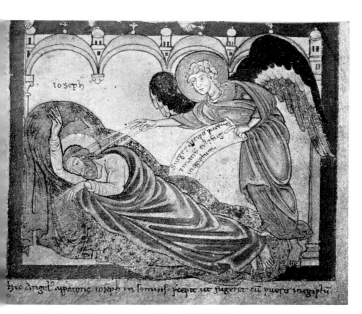

367. The Angel appears to Joseph. Liége, c. 1160

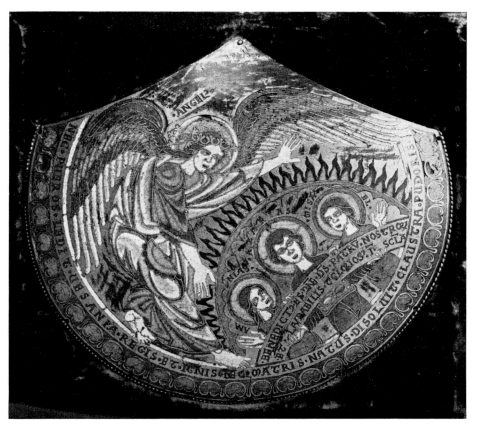

368. The Angel appears to the three Worthies in the Fiery Furnace. Maastricht (?), c. 1160

PLATE 168

369. Rivers of Paradise. Liége, *c.* 1150

370. The Killing of the Servants in the Vineyard

371. Underside of Portable Altar.

370–371. FROM A PORTABLE ALTAR. STAVELOT, *c.* 1160

PLATE 169

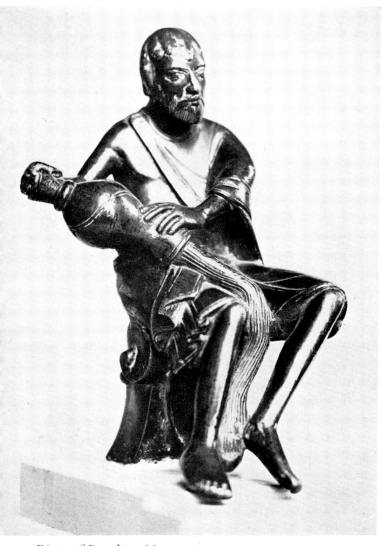

373. River of Paradise. Mosan, c. 1150

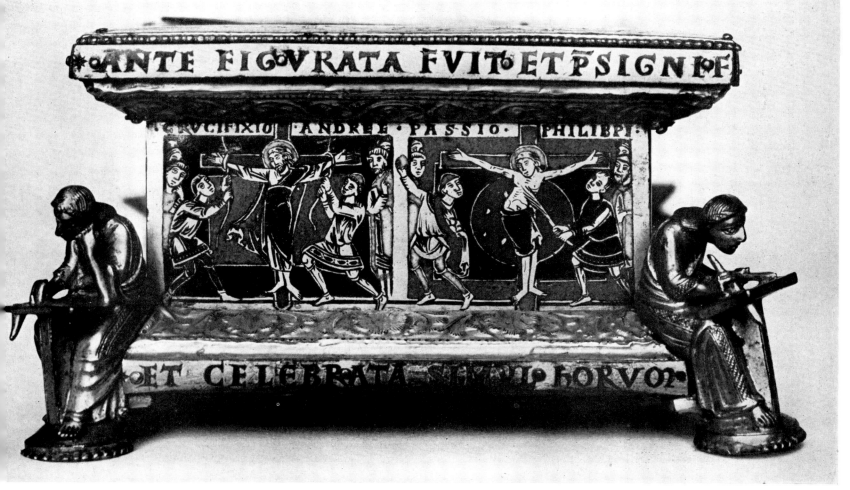

Martyrdom of SS. Andrew and Philip. The Evangelists. Portable Altar of Stavelot, c. 1150

PLATE 170

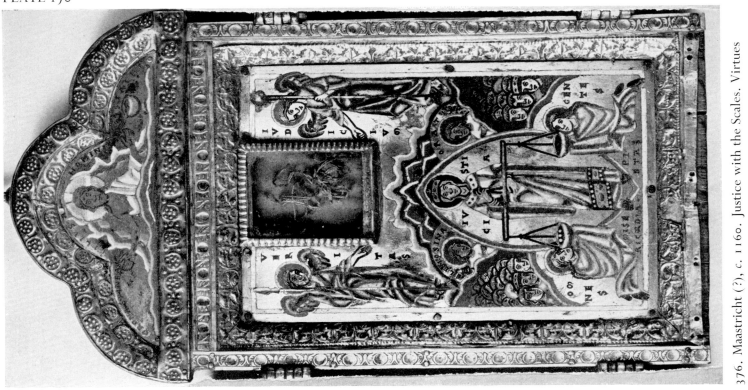

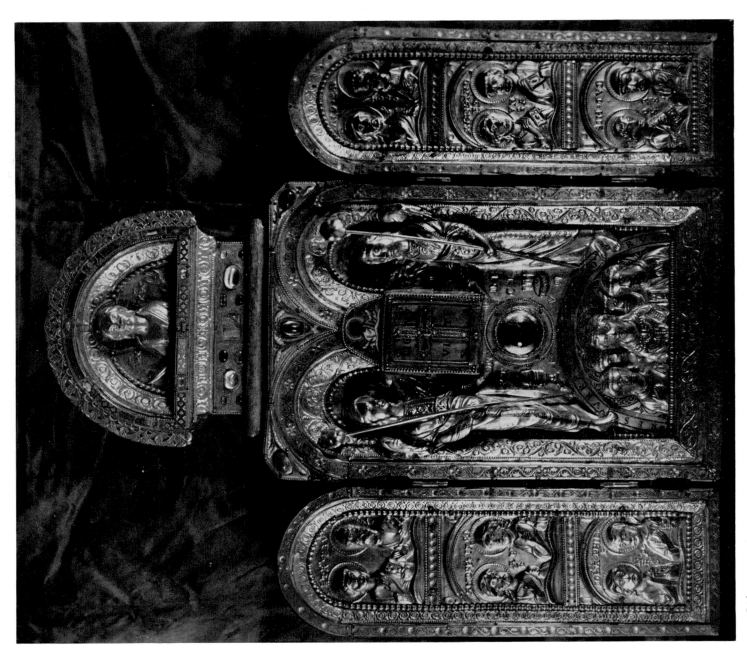

376. Maastricht (?), c. 1160. Justice with the Scales. Virtues

375–376. RELIQUARY TRIPTYCHS OF THE HOLY CROSS. ANGELS HOLDING THE RELIC. CHRIST

375. Liège, c. 1160

PLATE 171

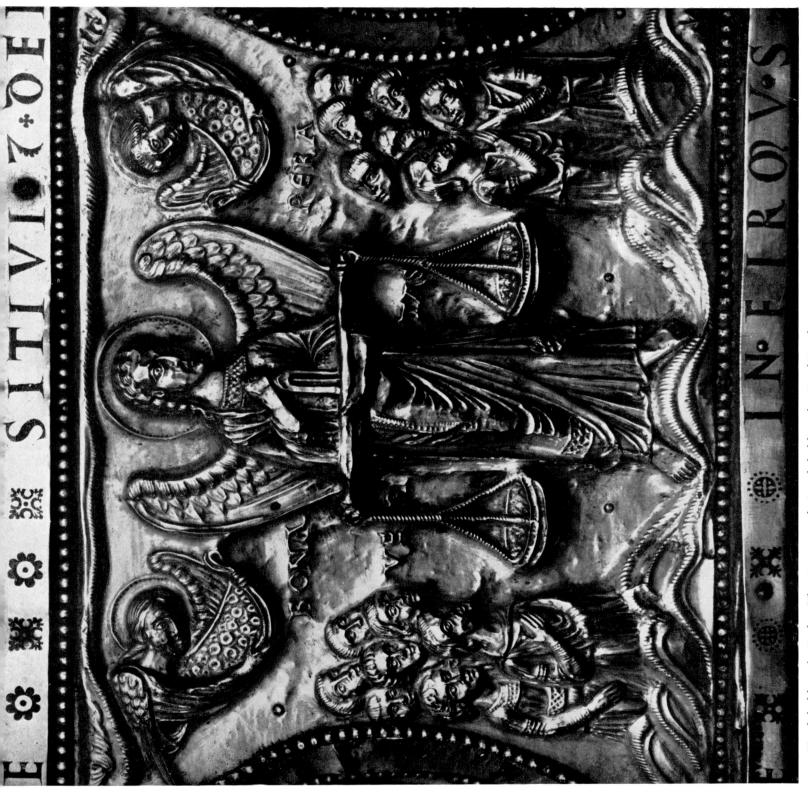

377. Truth holding the Scales. The Resurrected. Angels holding the Good Deeds

FROM THE SHRINE OF ST. SERVATIUS, MAASTRICHT, THIRD QUARTER XII CENTURY

PLATE 172

379. Wings of Triptych [Fig. 376]

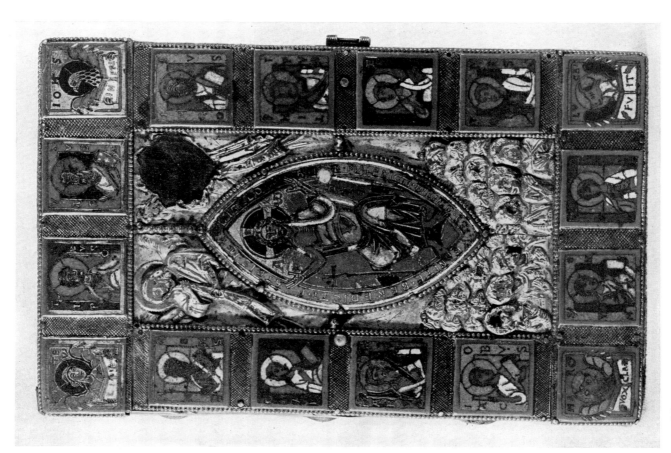

378. Mosan, c. 1160

PLATE 173

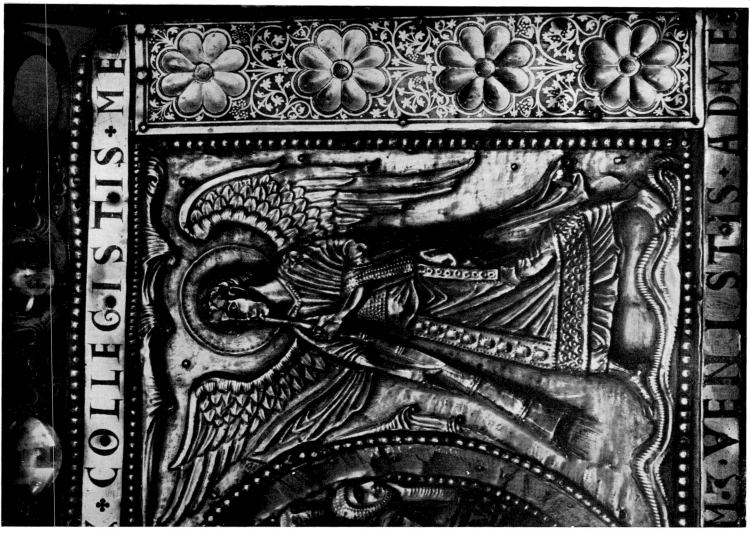

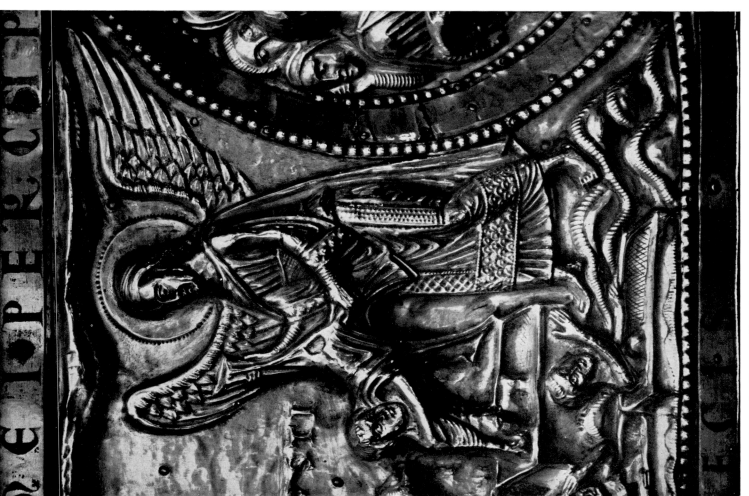

380–381. From the Shrine of St. Servatius [Pl. 171]

378–381. THE LAST JUDGEMENT

PLATE 174

382. Prudence. Mosan, *c.* 1160

383. Angel. Mosan, *c.* 1170

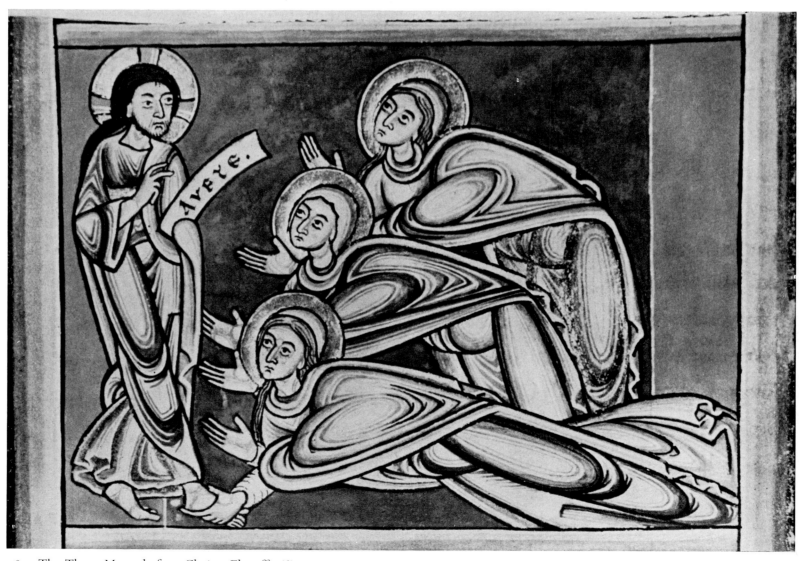

384. The Three Marys before Christ. Floreffe (?), *c.* 1155

PLATE 175

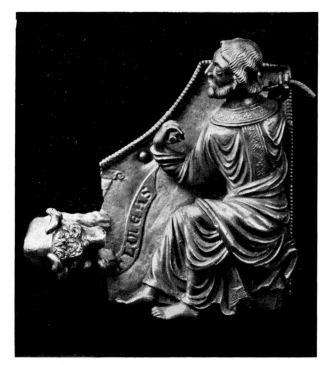

385. Luke

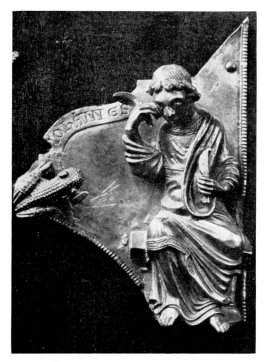

386. John

387. Base of a Cross. Michael

388. Candlestick. The three Continents

385–388 MOSAN, c. 1170

PLATE 176

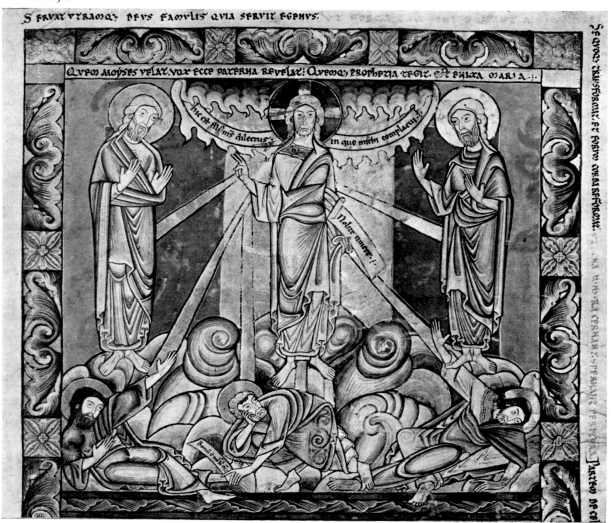

389. Floreffe (?), c. 1155 [Fig. 384]

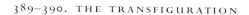

389–390. THE TRANSFIGURATION

390, Belgium, c. 1170

PLATE 177

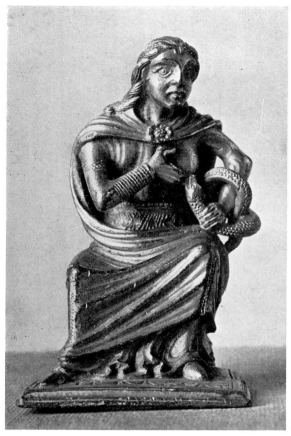

391–393. Earth and Fire. Lorraine, *c.* 1180

394–395. The Sea. Mosan, *c.* 1180

396. St. John [Pls. 178–179]

PLATE 178

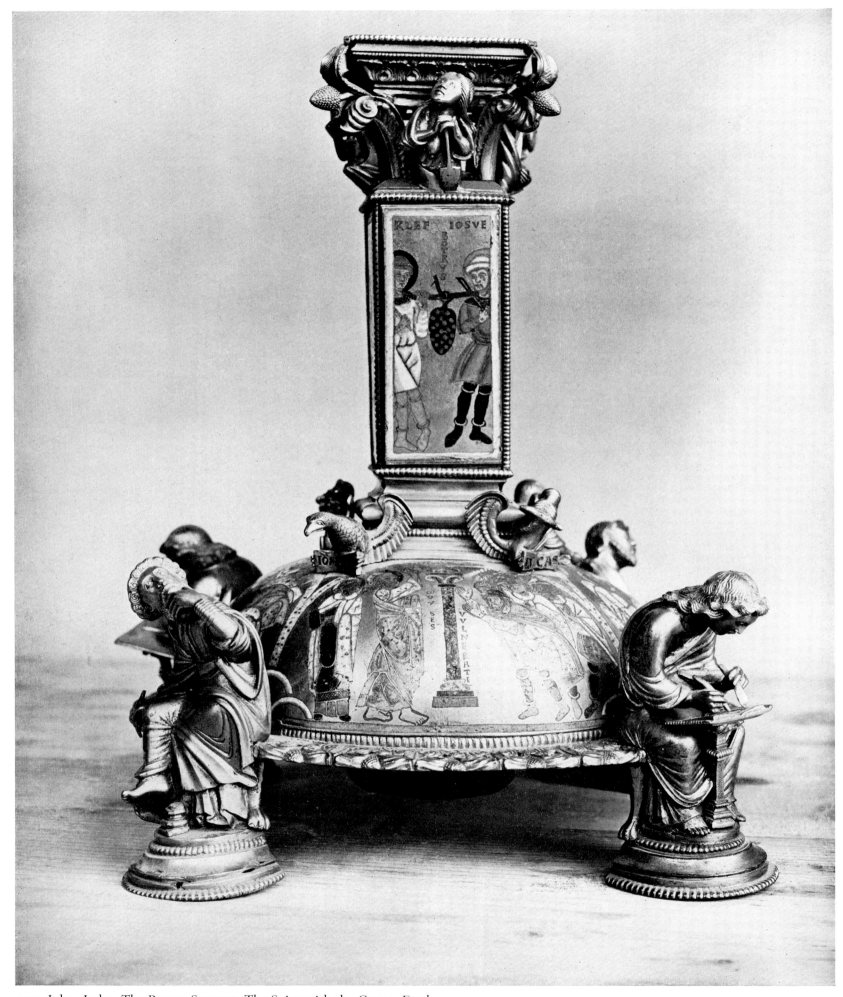

397. John. Luke. The Brazen Serpent. The Spies with the Grape. Earth

PLATE 179

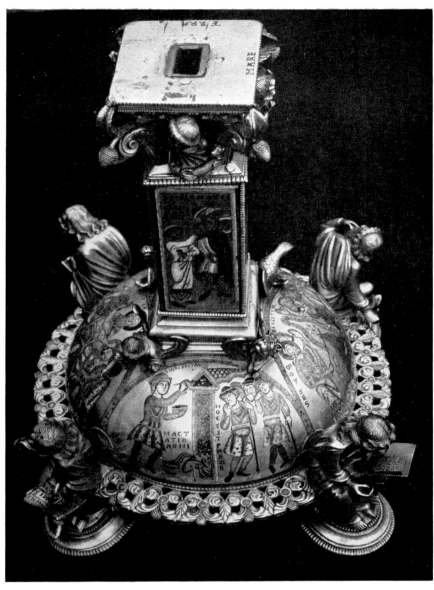

398. Marking the 'T'

396–399. FOOT OF THE CROSS OF
SAINT-BERTIN. MOSAN, c. 1170

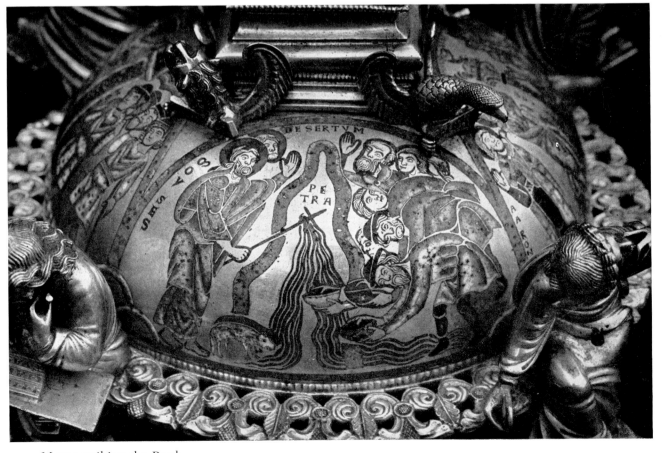

399. Moses striking the Rock

PLATE 180

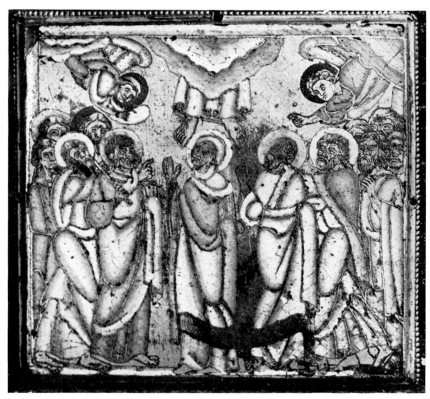

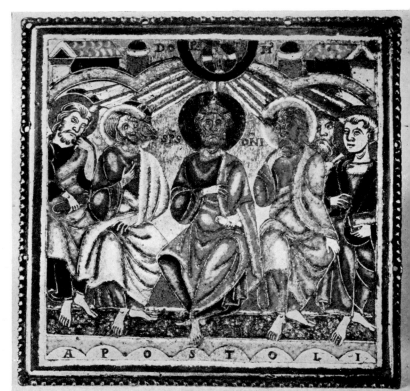

400–401. Ascension. Pentecost. Mosan, *c.* 1160

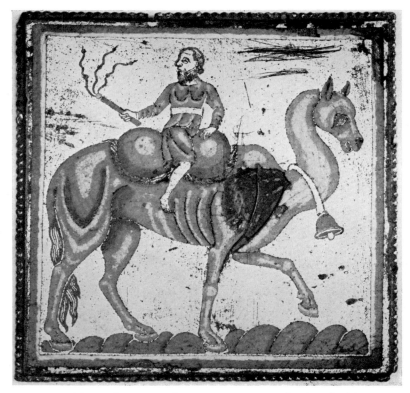

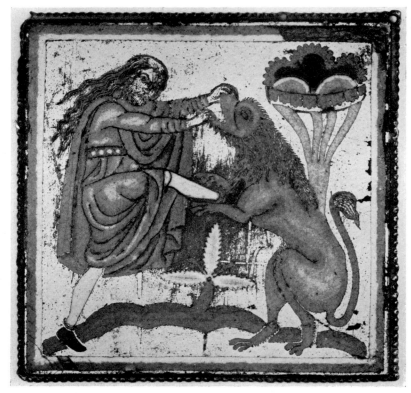

402–403. Man riding Camel. Samson (?) wrestling with the Lion. Mosan or English, *c.* 1160

404. Initial 'I'. Man riding Camel. English, last quarter XII Century

PLATE 181

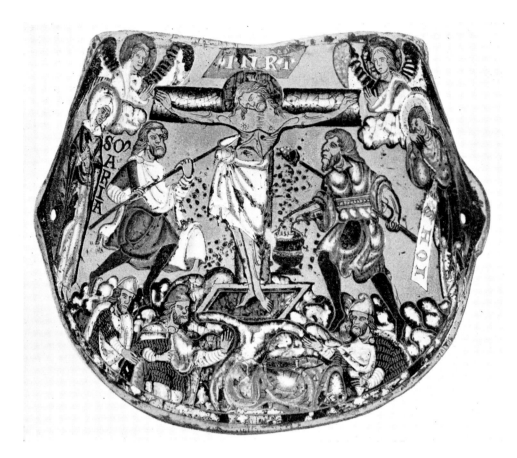

A PAIR OF IMPERIAL BRACELETS.
MOSAN OR COLOGNE, *c.* 1165

405. The Crucifixion

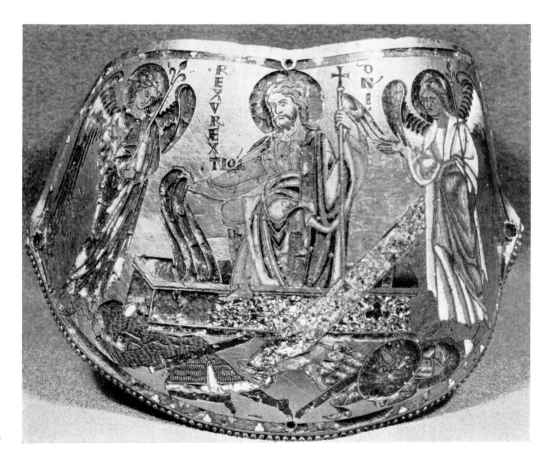

406. The Resurrection

PLATE 182

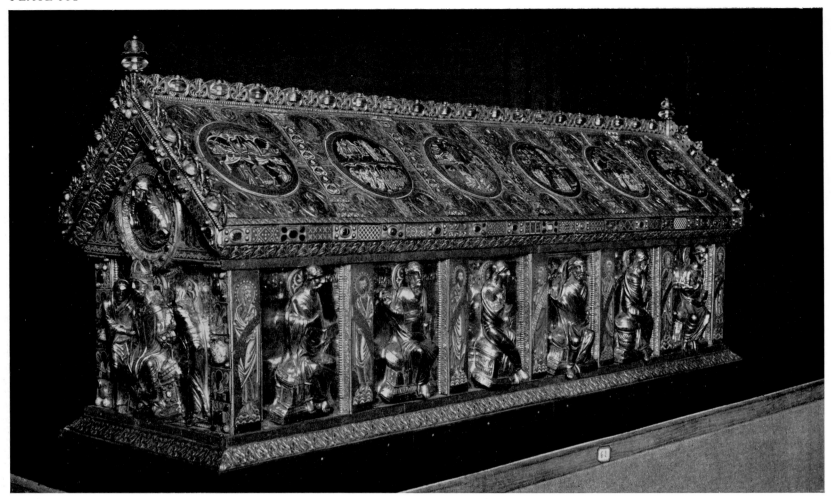

407

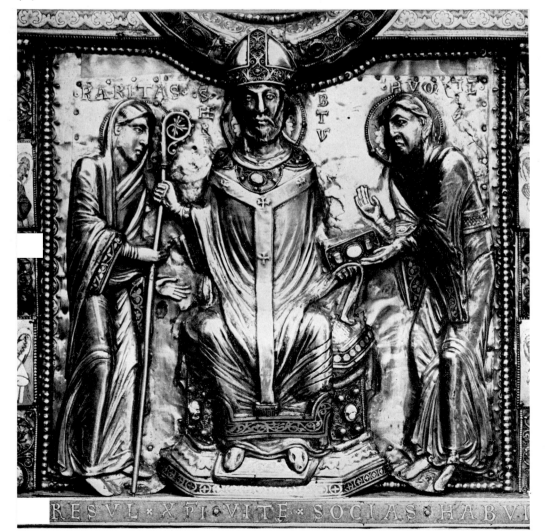

407–413. SHRINE OF HERIBERT.
COLOGNE AND LIÉGE,
SOON AFTER 1165

408. Charity and Humility bestowing Crozier and Book on Heribert

PLATE 183

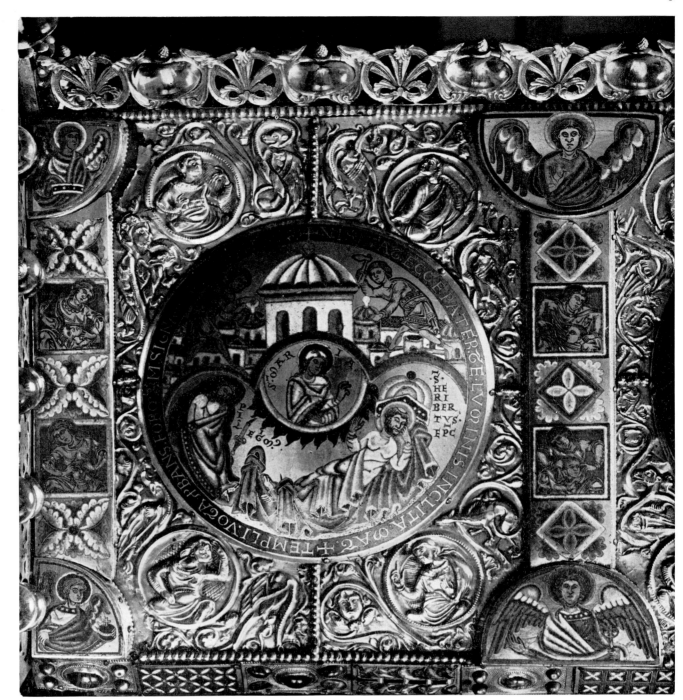

409. Heribert begged by the Virgin to build the Abbey

o Building Deutz Abbey

411. Virtue overcoming Vice

PLATE 184

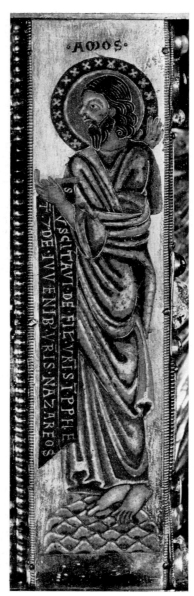

412-3. Ezekiel. Amos. [Fig. 407]

414. Initial 'I'. James. Stavelot, 1097 (Figs. 223-4, 251-2)

415. Gabriel. Cologne, c. 1180

416-417. BIBLE OF MALINES, c. 1160

416. Initial 'I'. Ezekiel

417. Initial 'T'. Inhabited Scrolls

PLATE 185

418–420. Jacob's Blessing, Prudence. South Wind. The Spies with the Grape, Temperance. Cologne, c. 1170

421. Tower Reliquary. Prophets. Cologne, c. 1160

PLATE 186

422–423. MOSAN (?), c. 1150

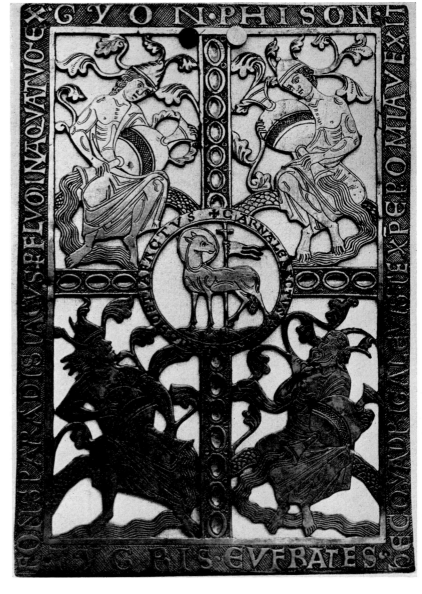

422. Rivers of Paradise. Lamb of God

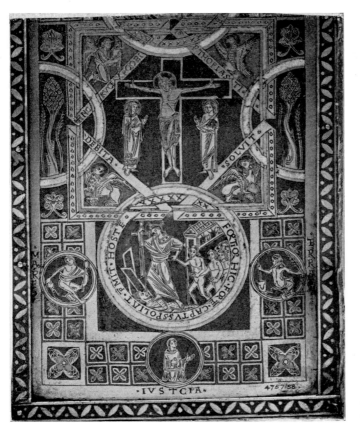

423. Centre of Reliquary Triptych. Crucifixion. The Beasts. Harrowing of Hell. Elements. Justice

PLATE 187

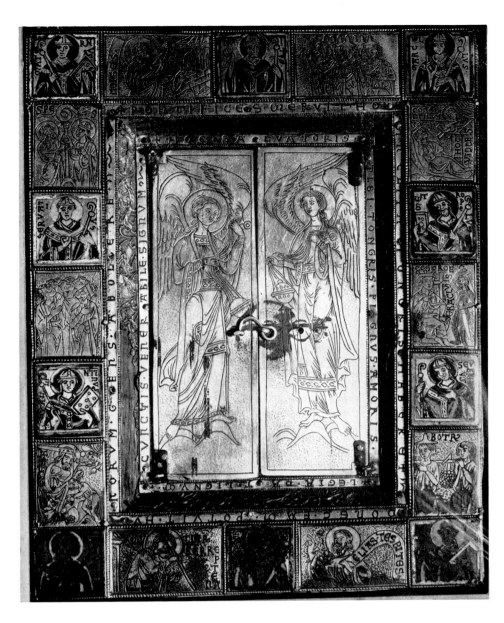

424–425. RELIQUARY TRIPTYCH OF
THE HOLY CROSS. LIÉGE, c. 1170

424. The Annunciation. Prefigurations of the Sacrifice
of Christ. Legend of Constantine. Bishops of Tongern

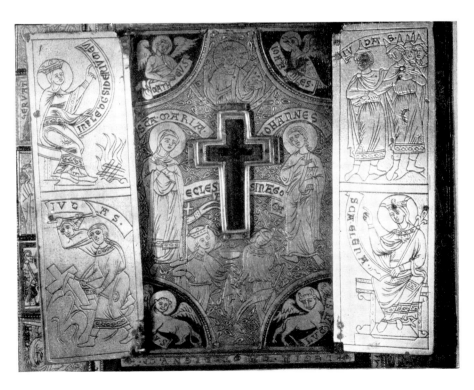

425. Christ. Mary and John. Church and Synagogue.
The Beasts. The Invention of the True Cross

PLATE 188

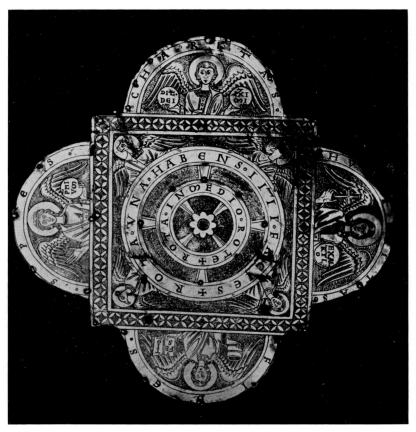

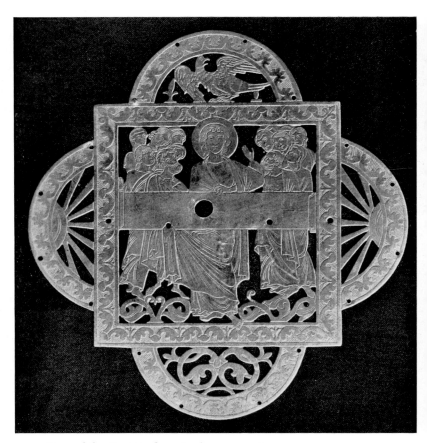

426. The Cardinal Virtues. The Beasts holding the Wheel of Universe. Liége, c. 1160

427. One of the Beatitudes. Aachen, c. 1165

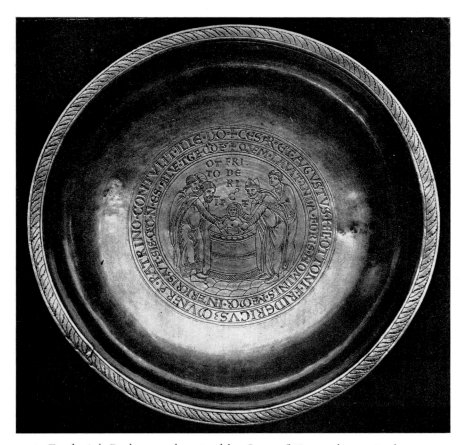

428. Frederick Barbarossa baptized by Otto of Kappenberg. Aachen, 1155–71

PLATE 189

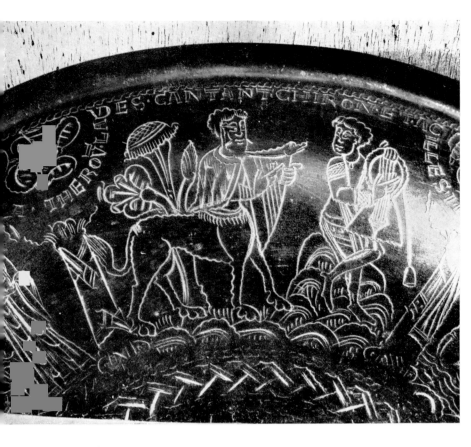

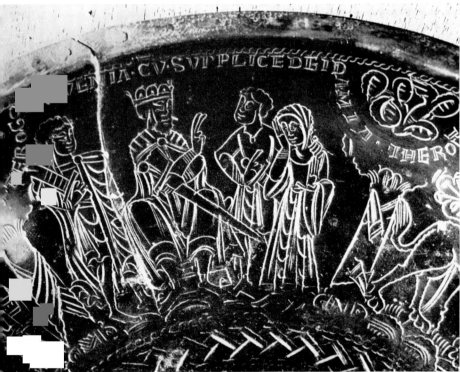

429–430. From a Bowl. Scenes from the Youth of Achilles. Cologne (?), c. 1150

431. The Monstrous Races. Arnstein, second half XII Century

PLATE 190

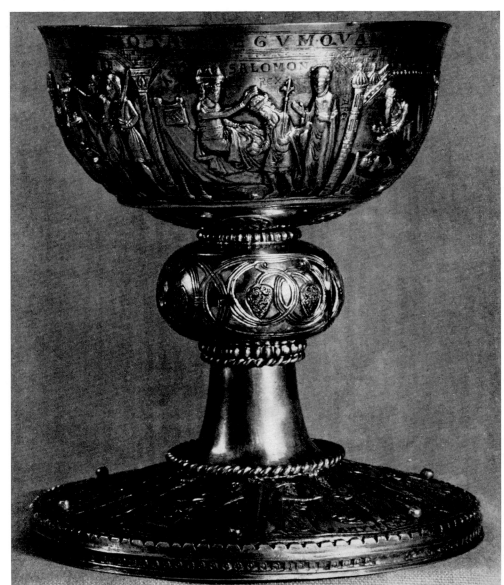

432–433. Chalice. Scenes from the
Life of David. England (?), c. 1160

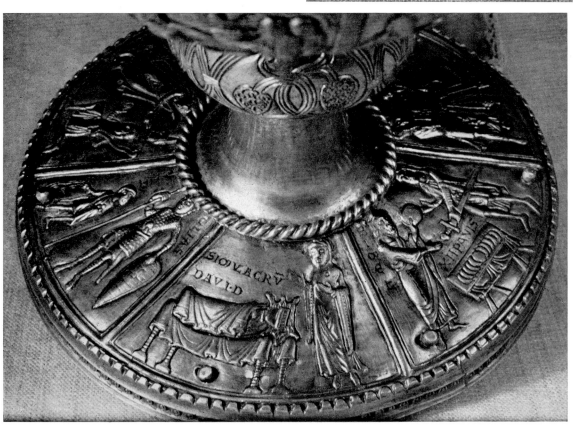

PLATE 191

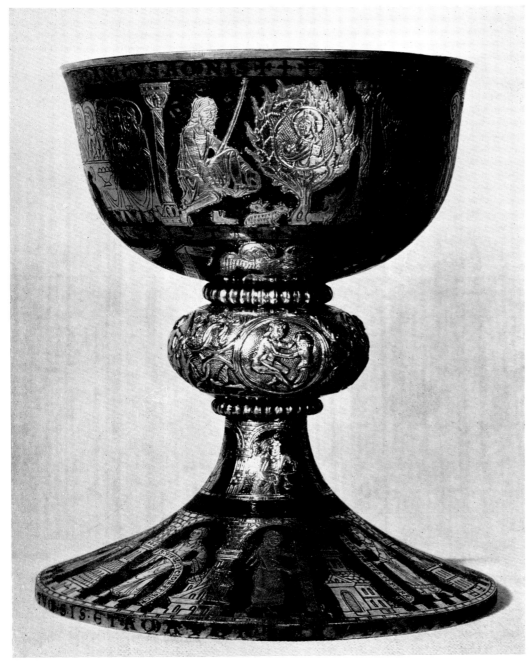

434–435. Chalice. Moses at the Burning Bush. The Beasts. The Cardinal Virtues. The Beatitudes. Lower Saxony, *c.* 1170

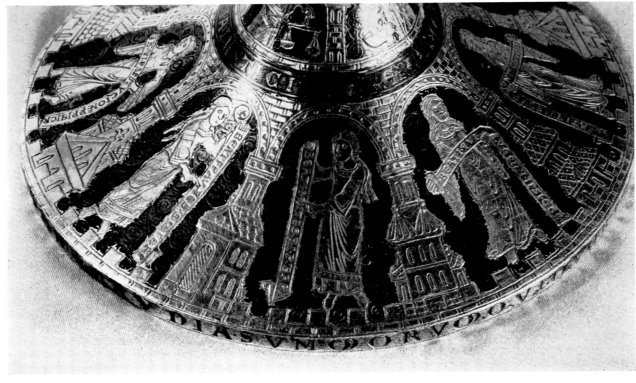

PLATE 192

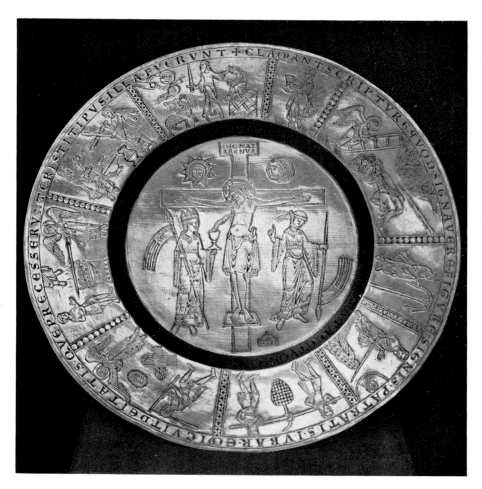

436. Paten. Christ on the Cross. Church and Synagogue. Prefigurations of the New Testament. [Pl. 191]

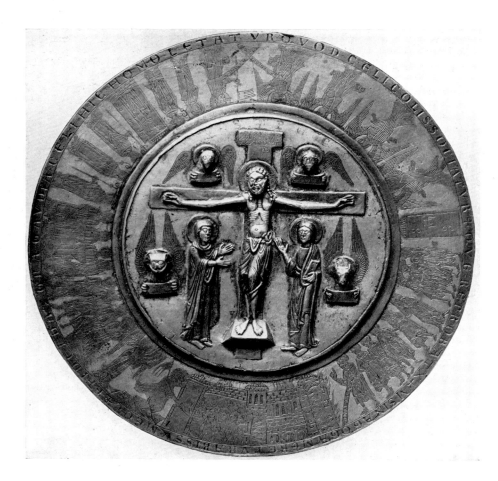

437. Paten of the Wilten Chalice. The Crucifixion. The Beasts. Harrowing of Hell. The Elected. The Damned. Lower Saxony, c. 1160–70

PLATE 193

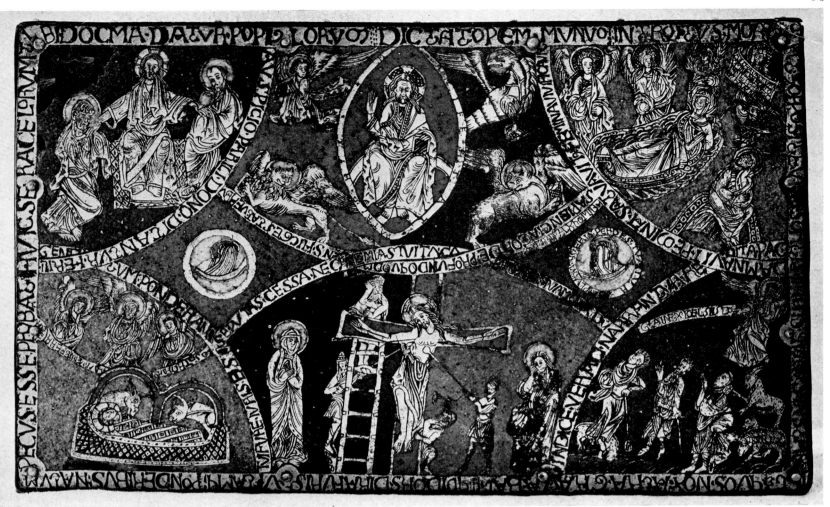

438. Christ in Majesty. Scenes from the Gospels

438–439. LOWER SAXONY, C. 1170

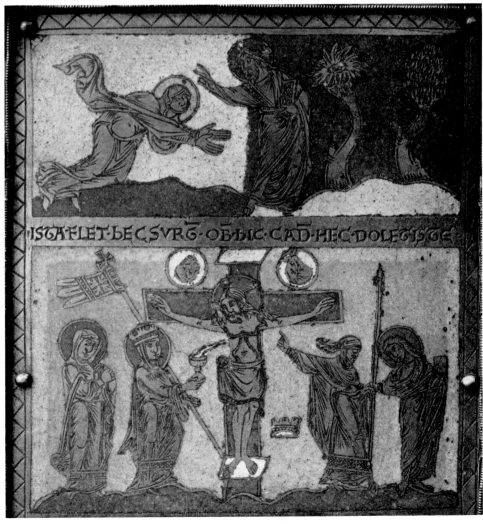

439. Noli me Tangere. Crucifixion. Church and Synagogue

PLATE 194

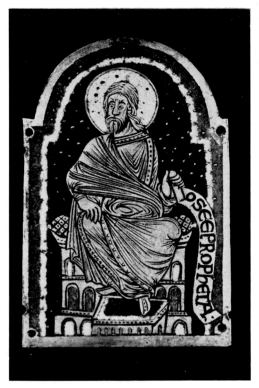

440. Hosea. Lower Saxony, *c.* 1170

441. Sketch. On reverse of Fig. 442

442. Pentecost. Hildesheim (?), *c.* 1160

443

444

445

443–445. Scenes from the Life of St. Paul. England, *c.* 1160

PLATE 195

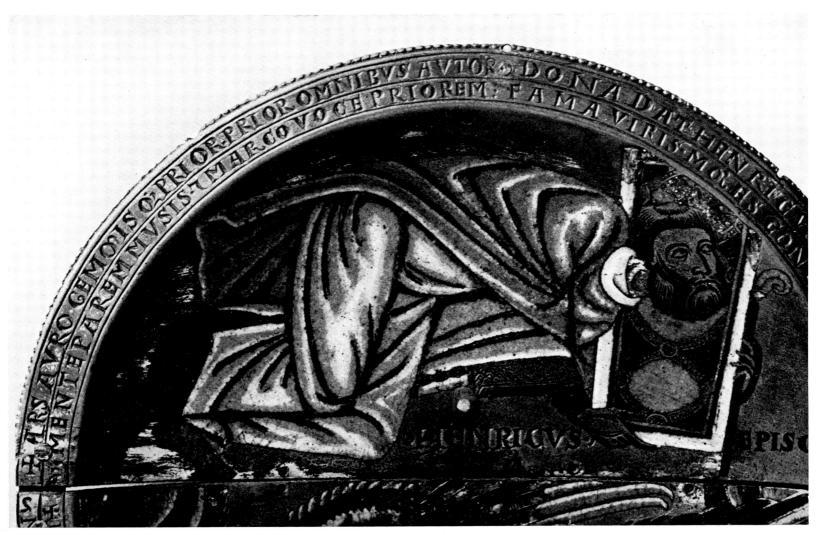

446. Henry of Blois offering a Shrine. England, *c.* 1150

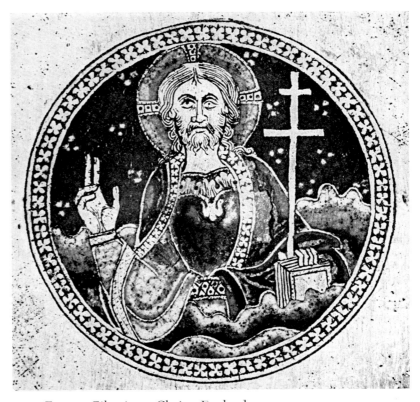

447. From a Ciborium. Christ. England, *c.* 1175

PLATE 196

448. Circumcision of Isaac. [Fig. 447]

449–450. Ascension of Elijah. David rescuing Lamb from Bear. Details from a Ciborium.

451–452. Virtues overcoming Vices. David rescuing Lamb. From a Crozier

PLATE 197

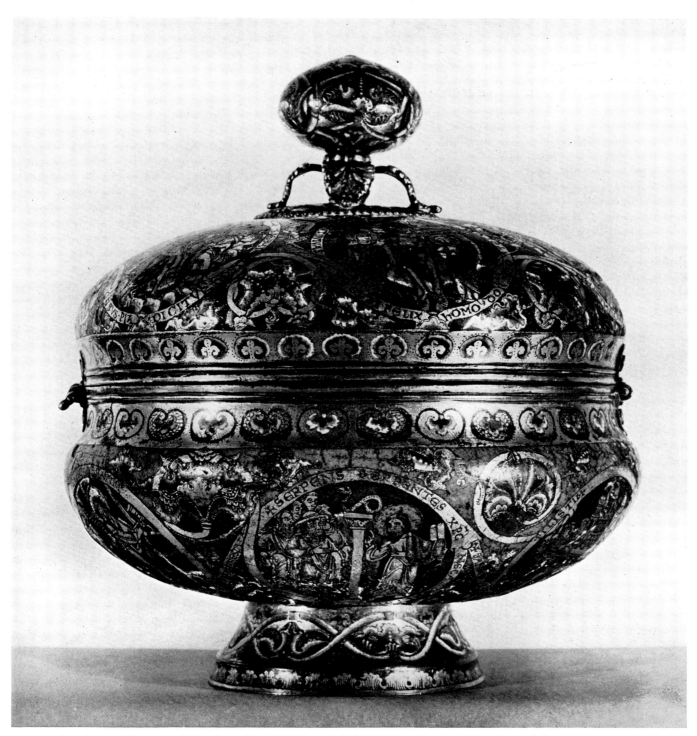

453. Malmesbury Ciborium. The Crucifixion. Moses and the Brazen Serpent. Typological Scenes

447–454. ENGLAND, c. 1175

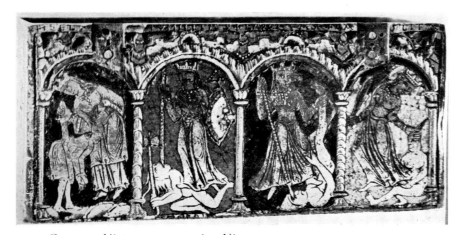

454. Casquet. Virtues overcoming Vices

PLATE 198

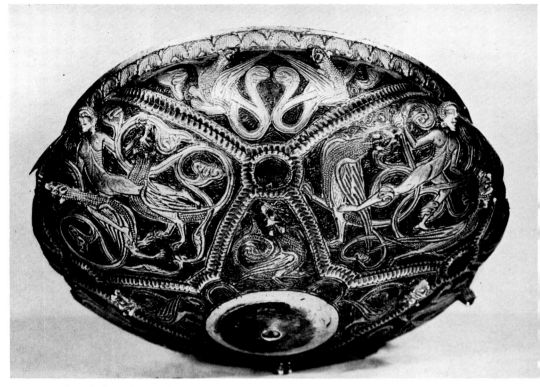

457. Bowl. Inhabited Scrolls

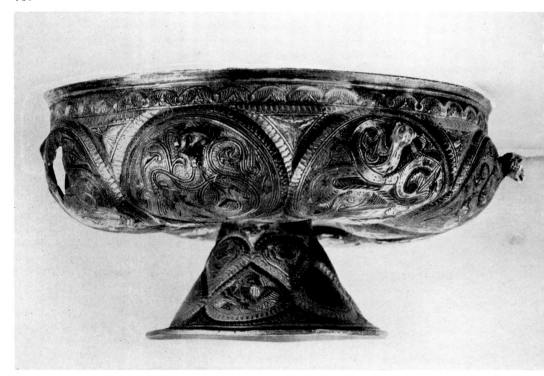

458–459. Bowl.
Inhabited Scrolls

455. Precentor's Staff

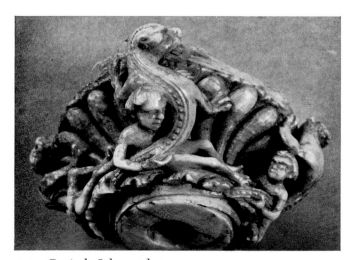

456. Capital. Salamander

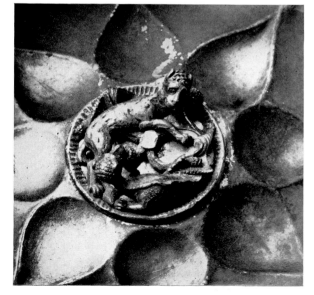

455–460.
ENGLAND, c. 1175

PLATE 199

460. Mirror Case. England, *c.* 1175

461. Ostrich Egg. Reliquary. Mounts. Lower Saxony, *c.* 1200

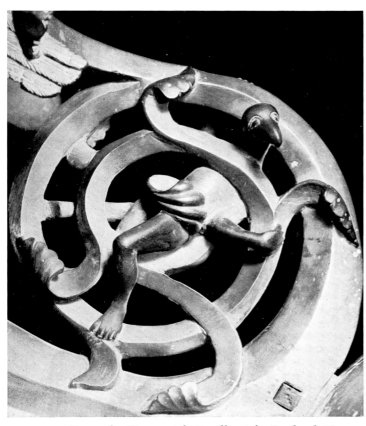

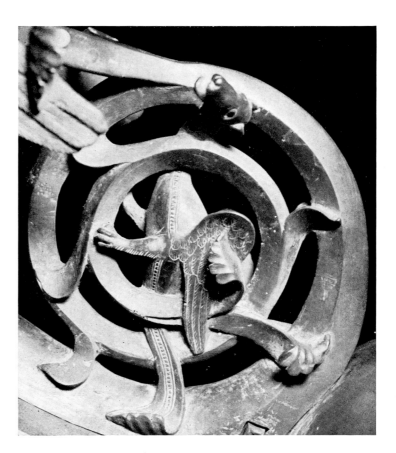

462–463. From the Brunswick Candlestick. England (?), *c.* 1170

PLATE 200

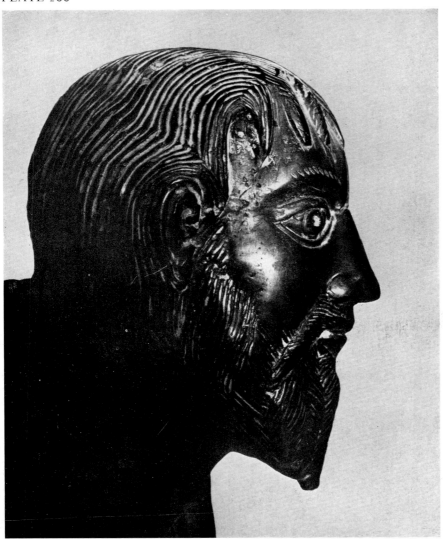

464–465. FROM THE ERFURT
CANDLESTICK, 1157 (?)

464. Wolfram or Jesse

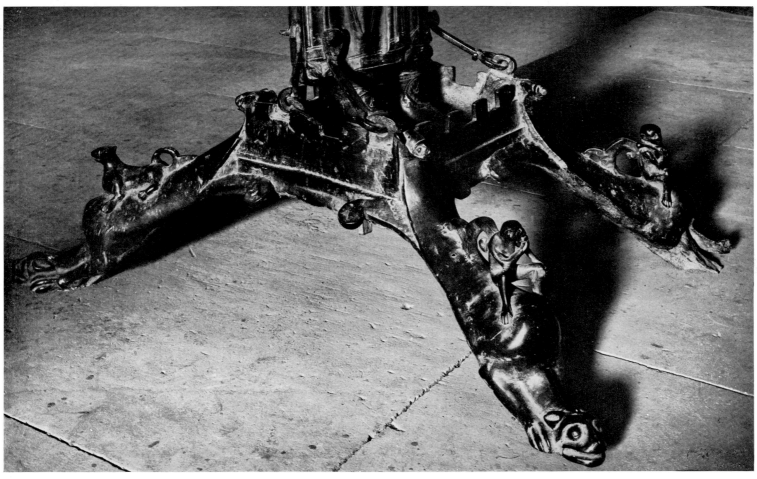

465. Lions and Apes

PLATE 201

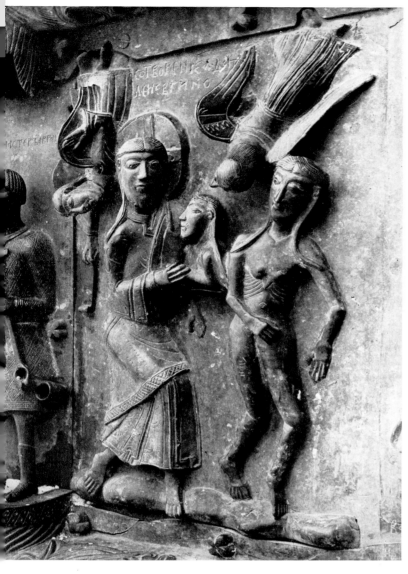

466. Creation of Eve

466-467. FROM THE BRONZE DOORS OF PLOCK.
MAGDEBURG, 1152-54

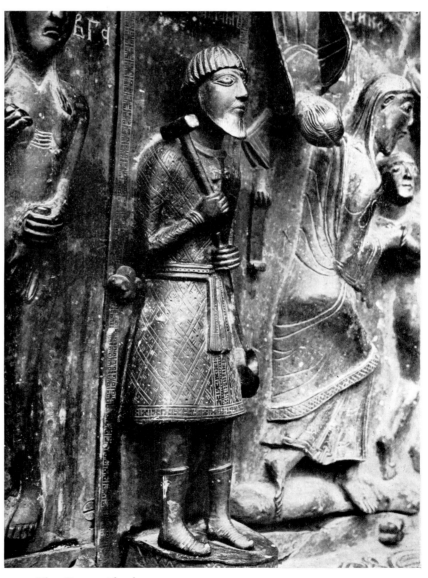

467. The Caster Abraham

PLATE 202

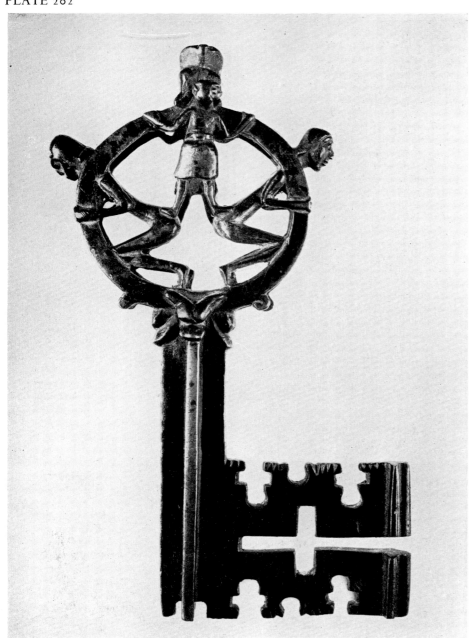

468. Key of St. Elisabeth's. Marburg, second quarter XIII Century

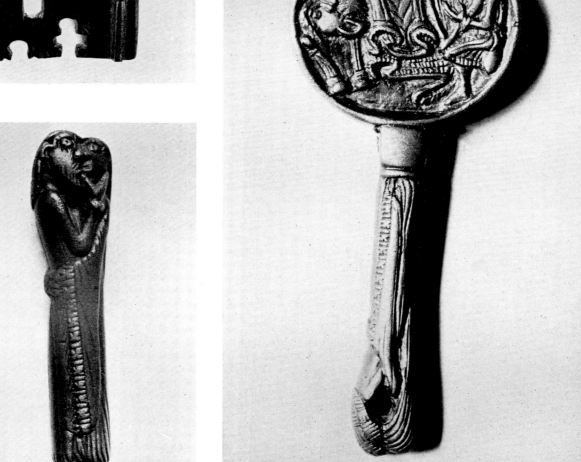

469a, b. Mirror Case with Handle.
Lovers. Tristan and Iseult or
Sponsus and Sponsa according to
the Song of Solomon. Upper Rhine,
late XII Century.

PLATE 203

470. Aquamanile. Maastricht (?), c. 1150

471. Samson Aquamanile. Lower Saxony, second quarter XII Century

PLATE 204

472. Monument of Henry the Lion. Braunschweig, 1166

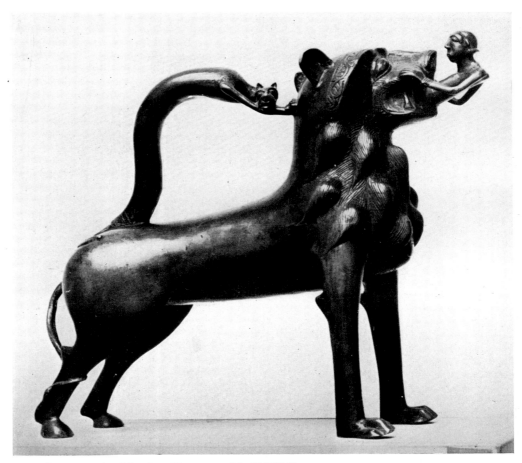

473. Aquamanile. Minden (?), second half XII Century

PLATE 205

475. Initial 'O'. Lion of Judah. Hildesheim, *c.* 1159

474. Initial 'I'. Lion blowing Horn. Helmarshausen, *c.* 1175

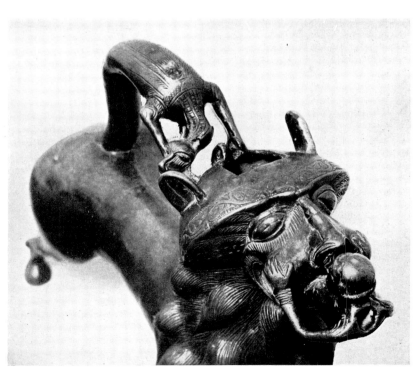

476. Detail of Fig. 473

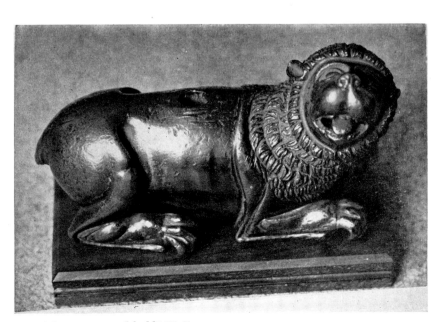

477. Mosan, second half XII Century

PLATE 206

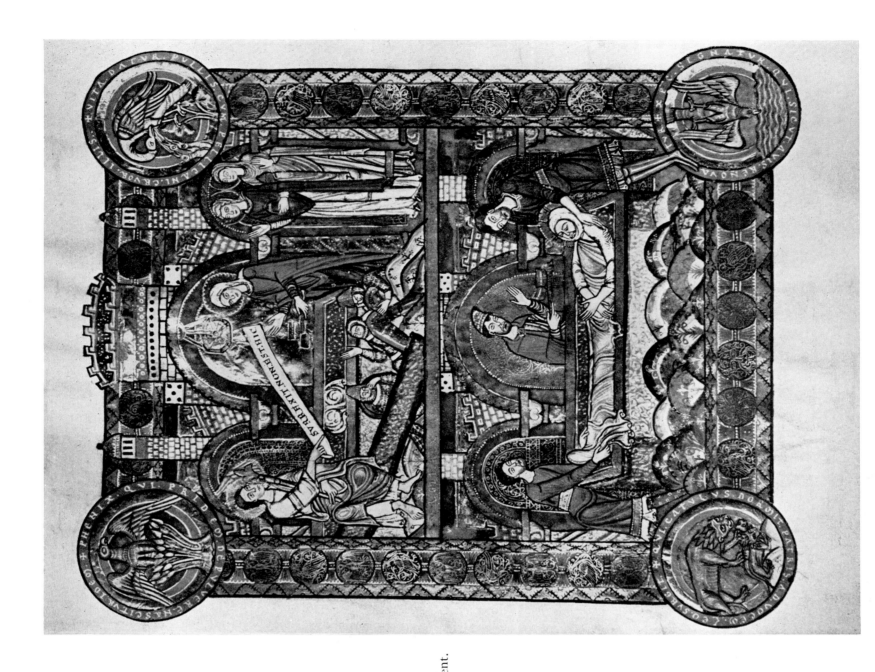

478. The Three Marys at the Tomb. The Entombment.
Symbols of the Resurrection. Helmarshausen, c. 1171

PLATE 207

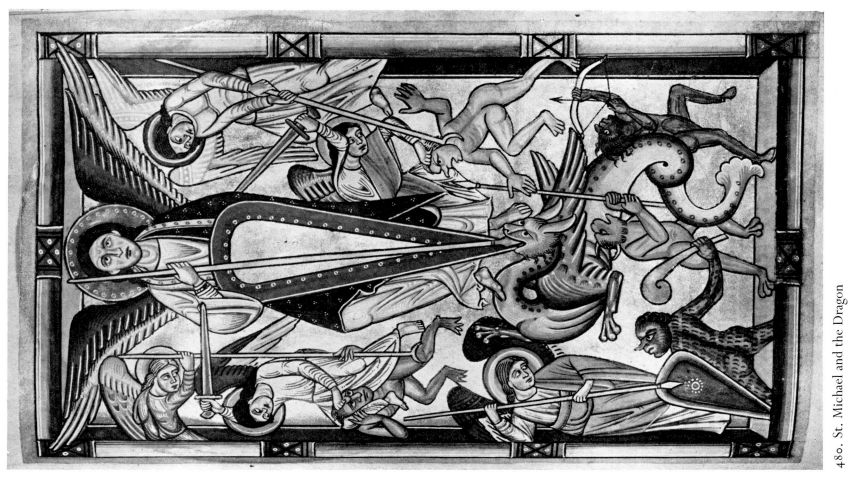

480. St. Michael and the Dragon

479-480. HILDESHEIM, C. 1159

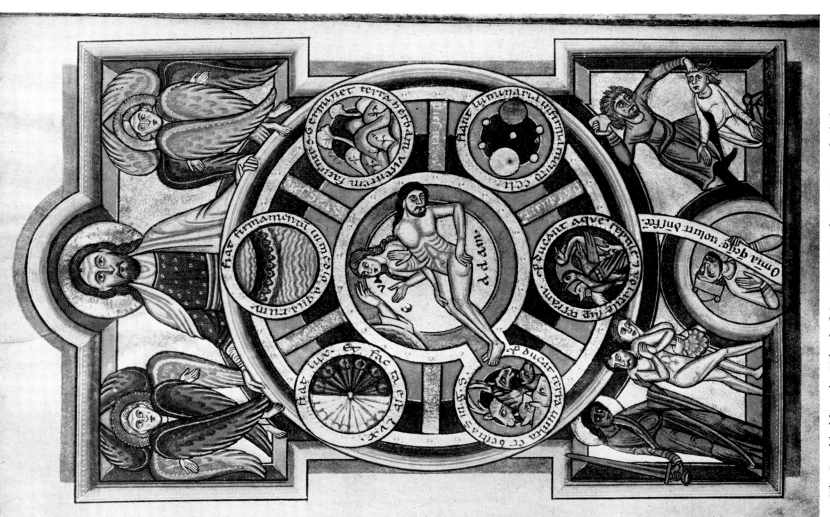

479. The Lord holding the Wheel of Creation. Expulsion. Cain and Abel

PLATE 208

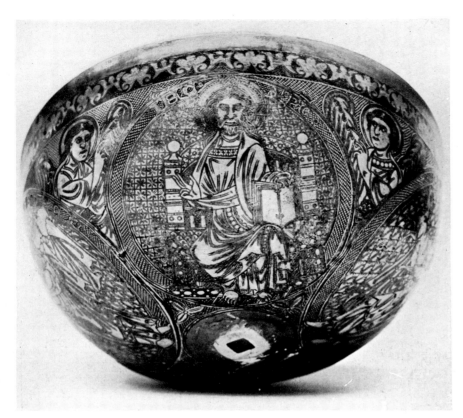

481. Bowl of Chalice. Christ. Lorraine (?), c. 1175

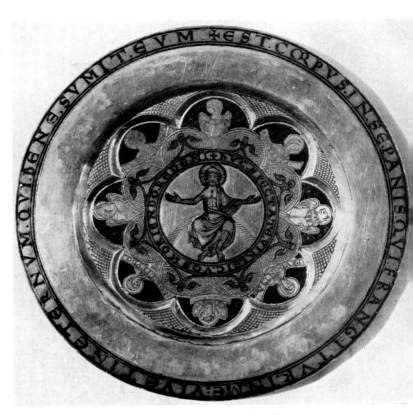

482. Paten. Christ. The Beasts. The Cardinal Virtues. Braunschweig, c. 1175

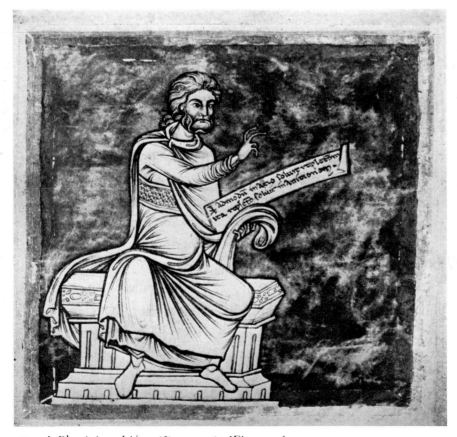

483. A Physician. Liége (?), c. 1160 [Fig. 493]

484. St. Sigismund. England (?), c. 1170

PLATE 209

485. River of Paradise. England (?), c. 1170 [Fig. 484]

486. Creation of Eve. Troyes (?), c. 1160

487. Book clasp. Durham (?), end XII Century

488. The Four Liberal Arts, c. 1200

489. Inhabited Scrolls, c. 1200

490. Thomas Becket slain, c. 1175

491. The Baptism, c. 1200

488–491. ENGLISH CASKETS

PLATE 210

492. The Harmony of the Spheres. Air and the Winds. Arion. Pythagoras. Orpheus. The nine Muses. Reims, c. 1170

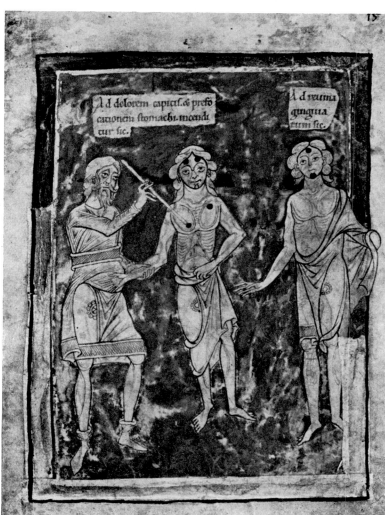

493. Phlebotomy. Liége (?), c. 1160

PLATE 211

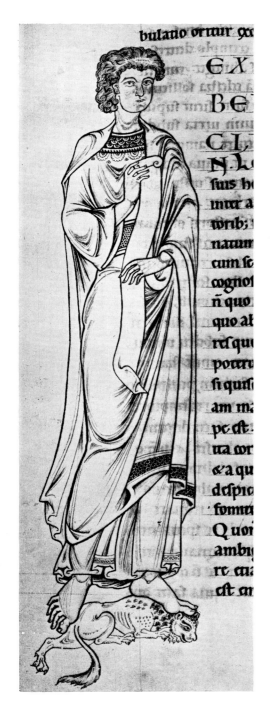

494–495. SAINT-BERTIN,
END OF XII CENTURY

494. Eliphaz, Job's arrogant Friend

495. Job smitten by Satan,
tried by his Wife and
Friends

PLATE 212

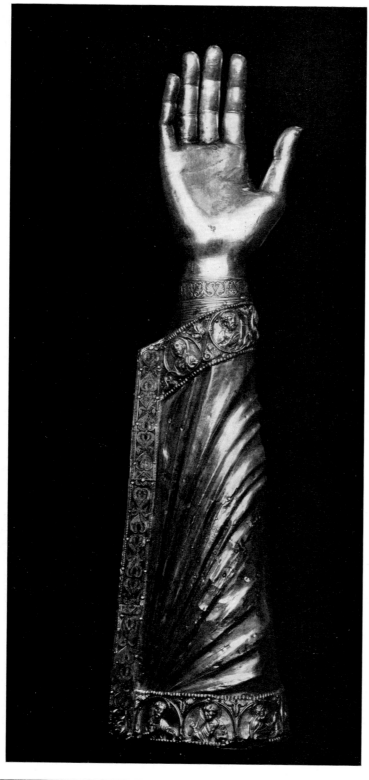

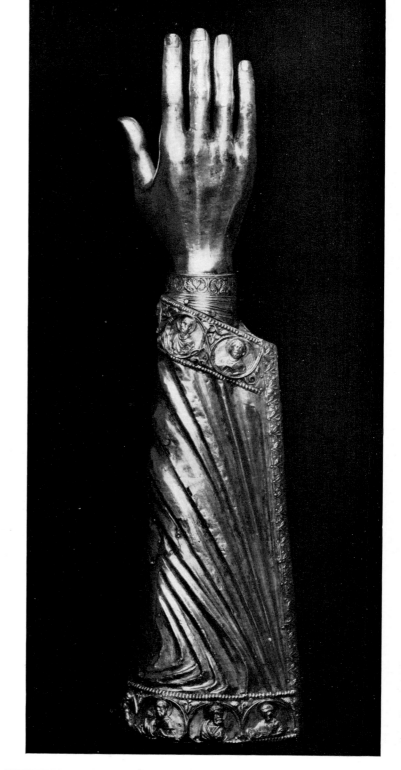

496–498. Arm Reliquary. Apostles. Braunschweig (?), c. 1175 499. Casket. Lorraine (?), c. 1175

PLATE 213

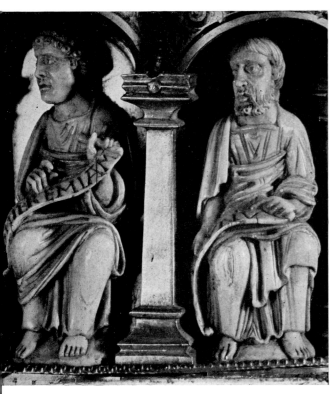

500–502. Dome Reliquary. Prophets. Apostles. Scenes from the Gospels. Cologne, *c.* 1180

PLATE 214

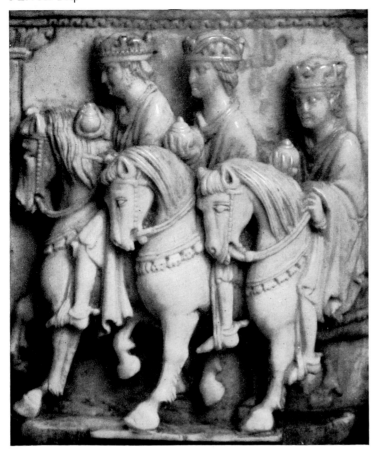

502–503. JOURNEY OF THE MAGI

502. Detail of Fig. 500

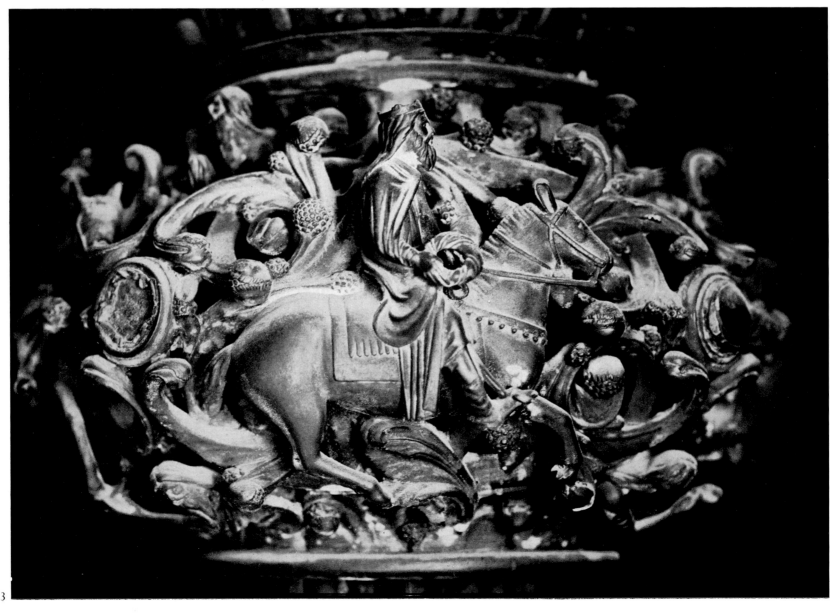

503

PLATE 215

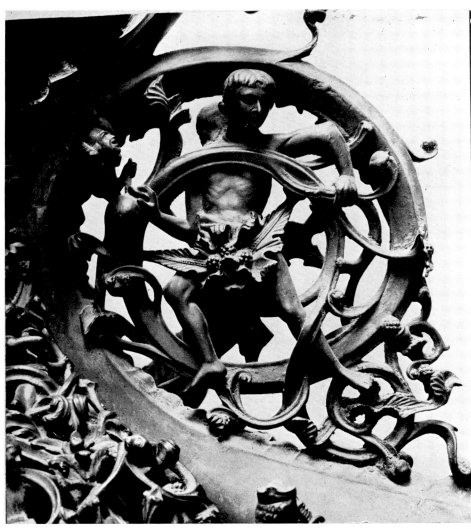

504

504–505. RIVERS OF PARADISE

503–505. From the Milan Candlestick.
Milan (?) or England (?), c. 1200

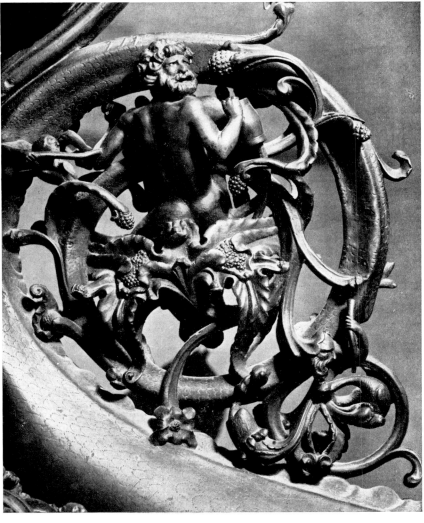

505

PLATE 216

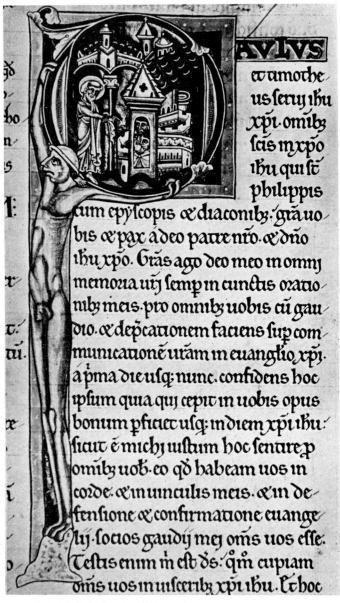

Initial 'P'. St. Paul Preaching:

AVLVS
er tunoche
us seruy ihu
xpi omibz
scis in xpo
ihu qui st
philippis
cum epyscopis œ diaconibz: grā uo
bis œ pax à deo patre nro. œ dño
ihu xpo. Grās ago deo meo in omni
memoria uri semp in cunctis oratio
nibz meis. pro omnibz uobis cū gau
dio. œ depcationem faciens sup com
municatonē uram in euanglio xpi.
à pma die usq; nunc. confidens hoc
ipsum quia qui cepit in uobis opus
bonum pficiet usq; in diem xpi ihu:
sicut ē michi iustum hoc sentire p
omibz uob. eo qd habeam uos in
corde. œ in uinculis meis. œ in de
fensione œ confirmatione euange
lij. socios gaudij mei oms uos esse.
Testis enim in est ds: qm cupiam
oms uos in uisceribz xpi ihu. Et hoc

506. Initial 'P'. St. Paul Preaching

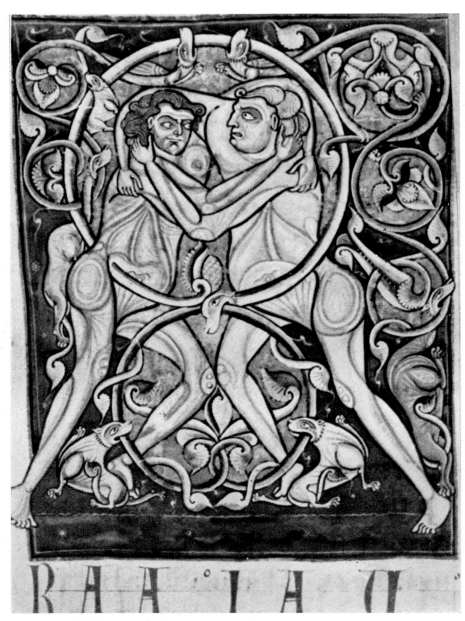

509. Initial 'R'. Wrestlers. Saint-Bertin (?), end XII Century

507. The Possessed by the Devil

506–507. SENS OR SAINT-BERTIN, c. 1180

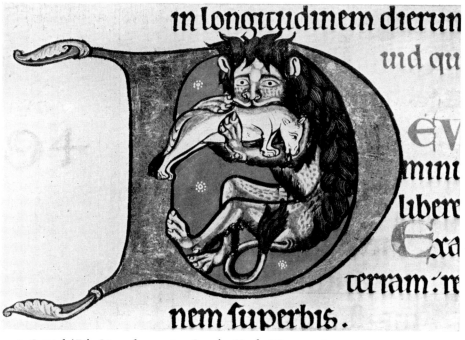

508. Initial 'D'. Lion devouring Lamb. York (?), c. 1180

PLATE 217

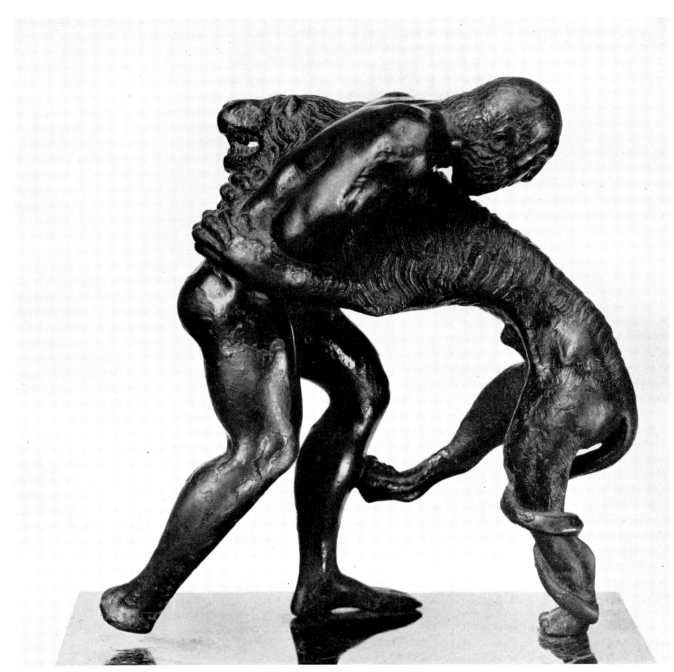

510. Hercules or Samson wrestling with the Lion. England (?), late XII Century (?)

511. Journey of the Magi

512. Chiron and Achilles

511-512. FROM A CIBORIUM. ENGLAND, c. 1200

PLATE 218

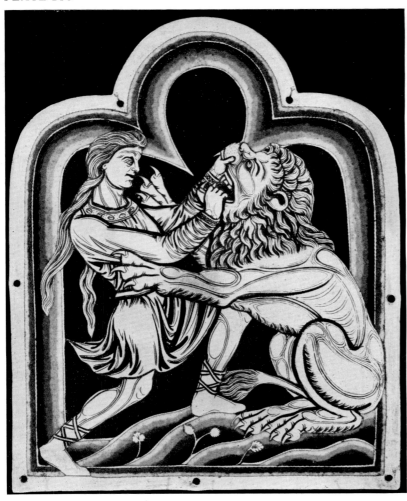

513. Samson and the Lion

514. Sacrifice of Isaac

515. The Molten Sea carried by twelve Oxen

516. Moses Crossing the Red Sea

PLATE 219

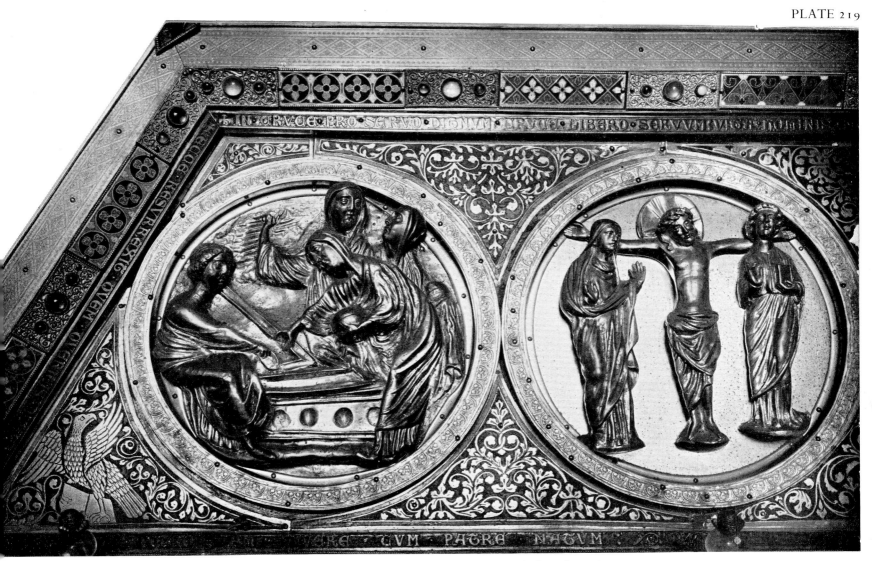

518. The Three Marys at the Tomb. The Crucifixion. From the Shrine of the Virgin. Nicholas of Verdun, 1205

513–517. FROM THE KLOSTERNEUBURG ALTAR.
NICHOLAS OF VERDUN, 1181

517. The Three Marys at the Tomb

PLATE 220

519. The Flight into Egypt. [Fig. 518]

520. Moses' Return from Egypt. [Figs. 513–517]

PLATE 221

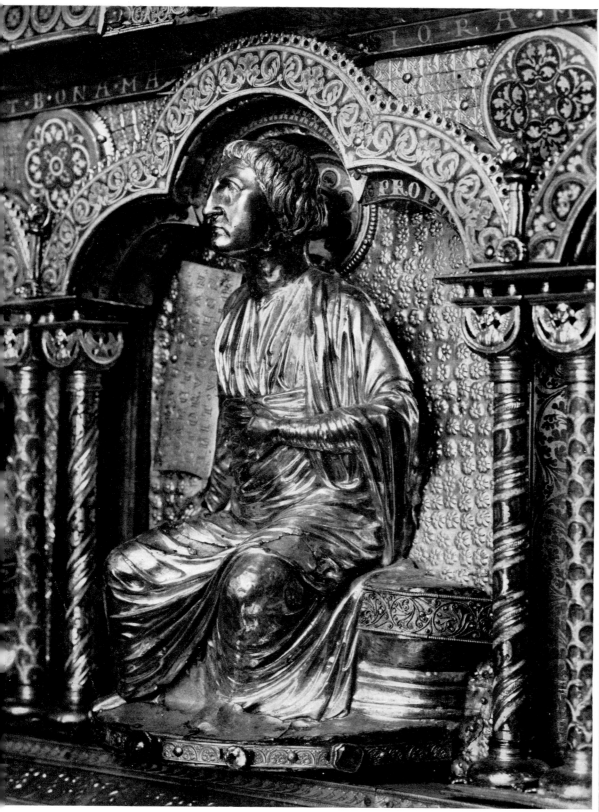

. Daniel. From the Shrine of the Three Kings

521. St. Bruno with Model of St. Pantaleon (?)

521–522. COLOGNE WORKSHOP OF NICHOLAS OF VERDUN, c. 1200

PLATE 222

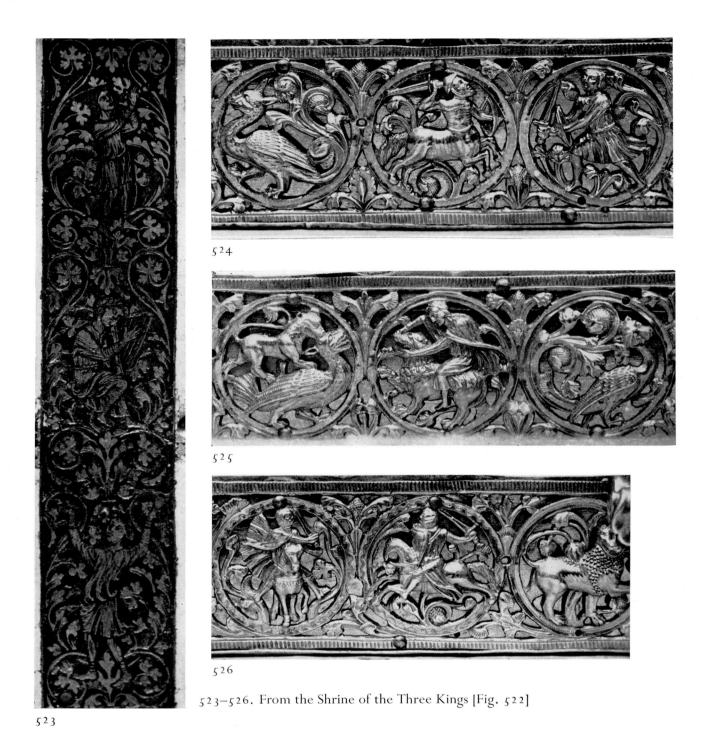

523–526. From the Shrine of the Three Kings [Fig. 522]

523

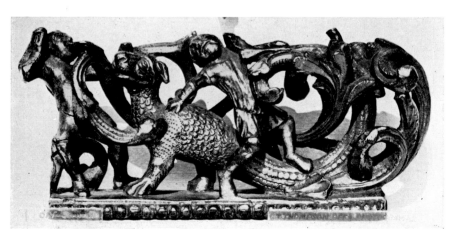

527. Cologne (?), c. 1200

528. Cologne, end XII Century

523–528. INHABITED SCROLLS

PLATE 223

529. St. Peter

530. St. Bartholomew

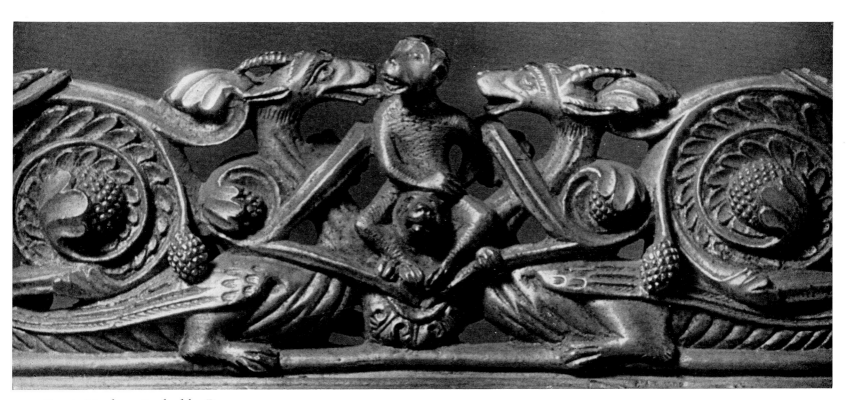

531. Crest. Monkey attacked by Dragons

529–531. FROM THE SHRINE OF ANNO. COLOGNE, c. 1183

PLATE 224

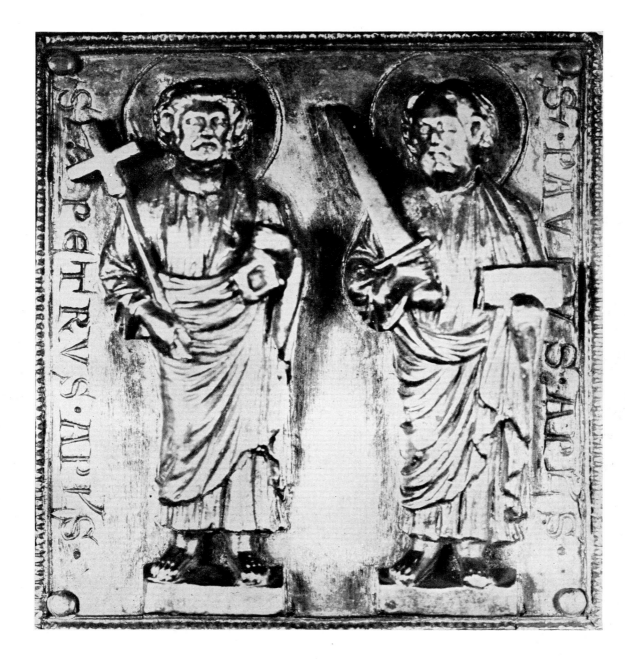

532. From a Book-cover.
St. Peter. St. Paul.
Tréves, c. 1220

533. Foot of Chalice.
St. Peter. St. Paul. Crucifixion.
Hugo of Oignies, c. 1220

PLATE 225

534. Jew stoning Stephen. Halberstadt, *c.* 1208

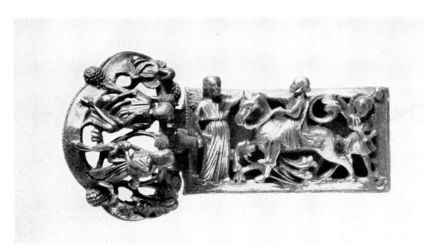

535. Buckle. Lady and Mounted Knight. Seated Couple.
Lorraine or England, early XIII Century

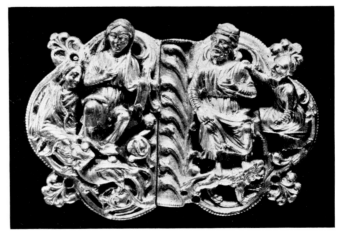

536. Buckle. Solomon and Queen of Sheba (?)
Lorraine, early XIII Century

PLATE 226

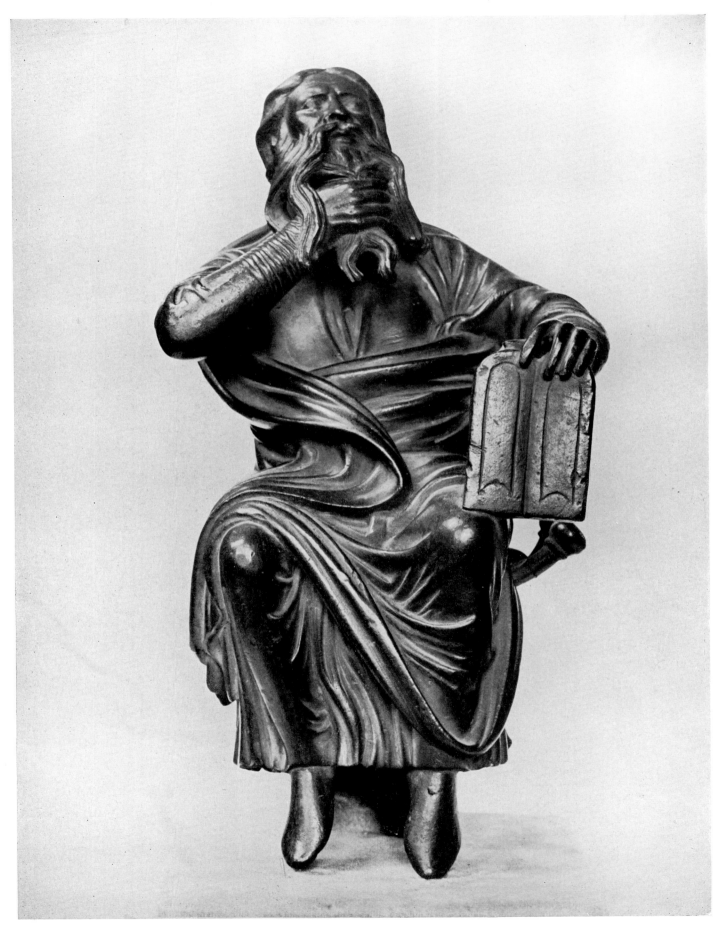

PLATE 227

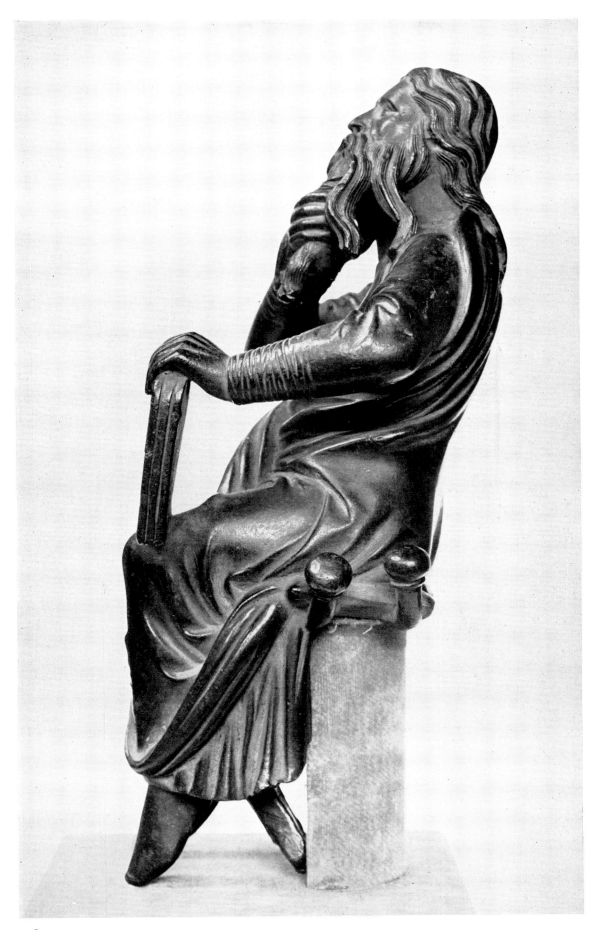

537–538. MOSES. LORRAINE, END XII CENTURY

PLATE 228

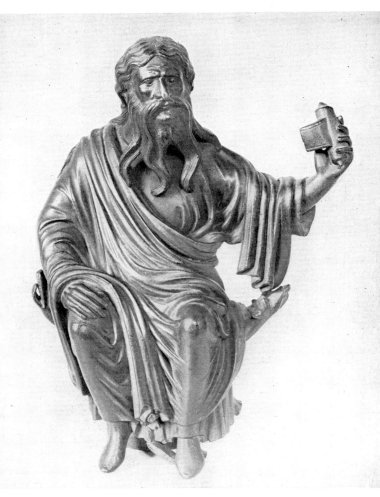

539. Prophet. [Pls. 226–27]

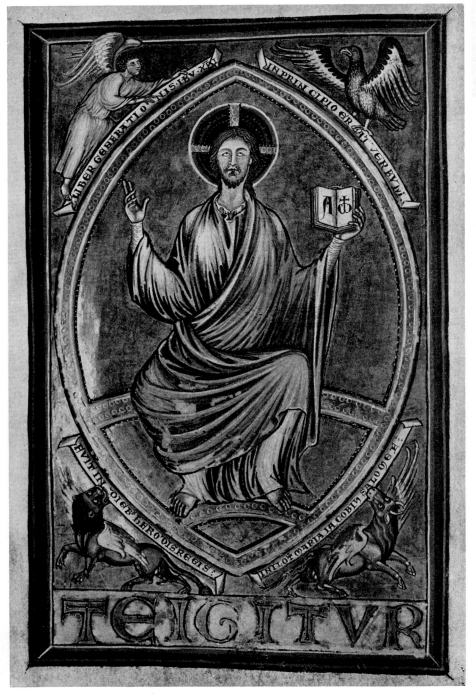

540. Christ in Mandorla.
Anchin, end XII Century

PLATE 229

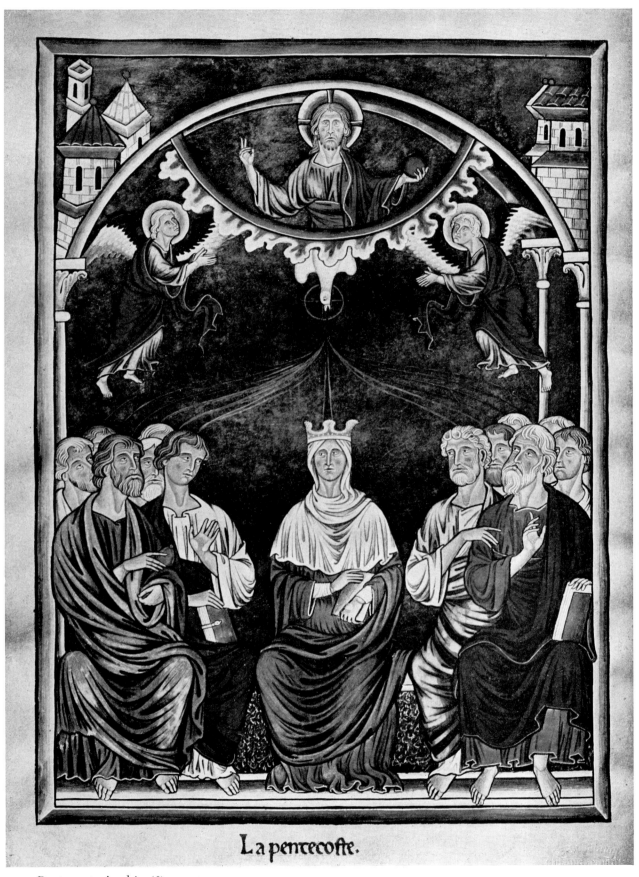

541. Pentecost. Anchin (?), c. 1200

PLATE 230

542. The Flagellation. [Pl. 229]

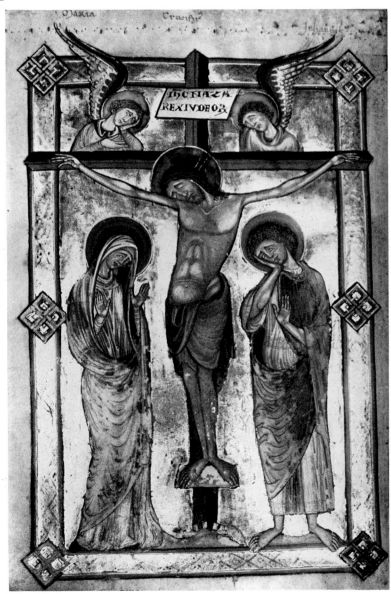

543. The Crucifixion. [Fig. 540]

PLATE 231

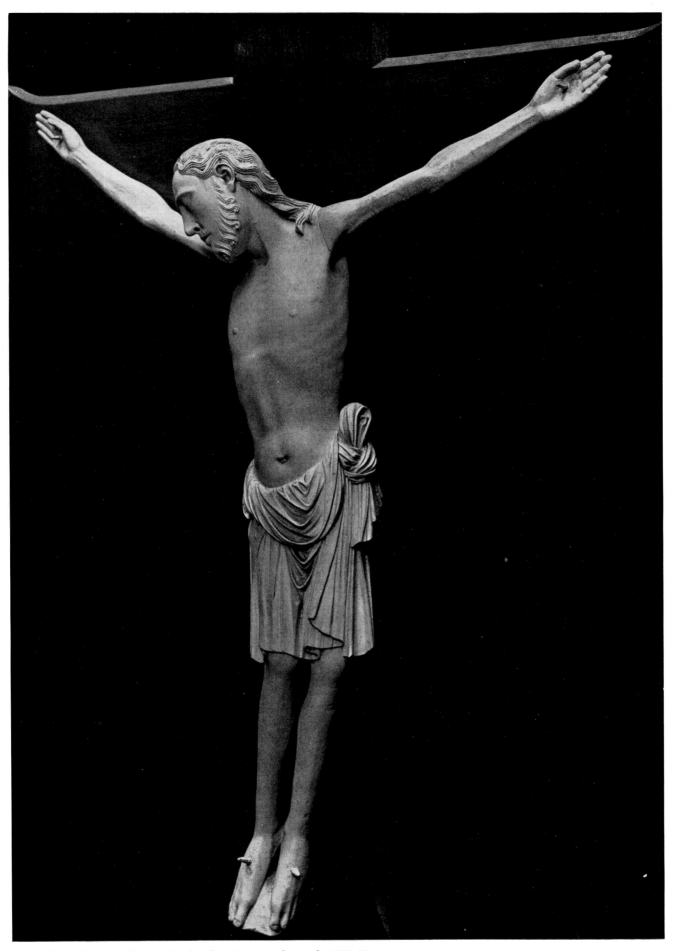

544. Christ from a Cross. England or Denmark, early XIII Century

PLATE 232

545. The Angel healing the blind Tobias. St. Alban's, early XIII Century

PLATE 233

546. Martin's Companions at the Falcon Hunt. Tournay, early XIII Century

547. Villard de'Honnecourt, c. 1240

548. Sleeping Apostle, Northern France, c. 1240

PLATE 234

549–550. From the Osnabrück Font. Baptism of Christ. Lower Saxony, *c.* 1226

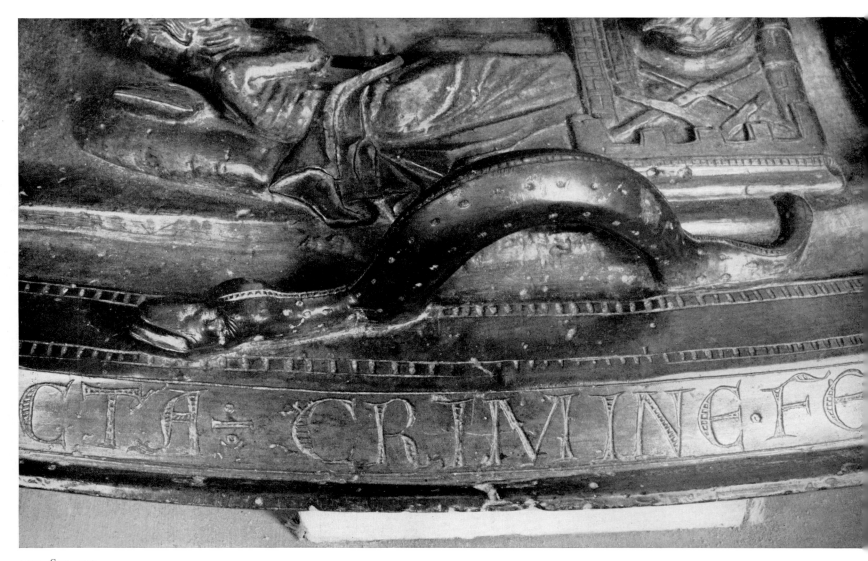

551. Serpent

PLATE 235

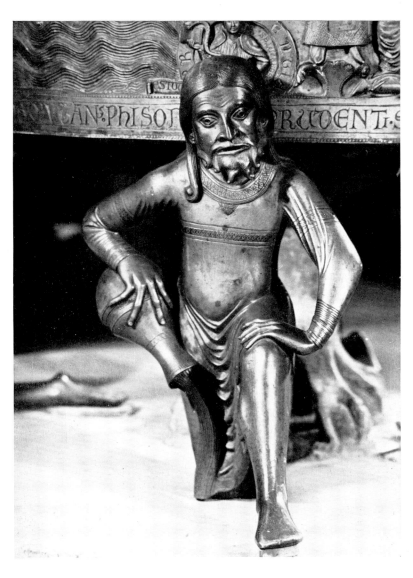

552–553. Rivers of Paradise

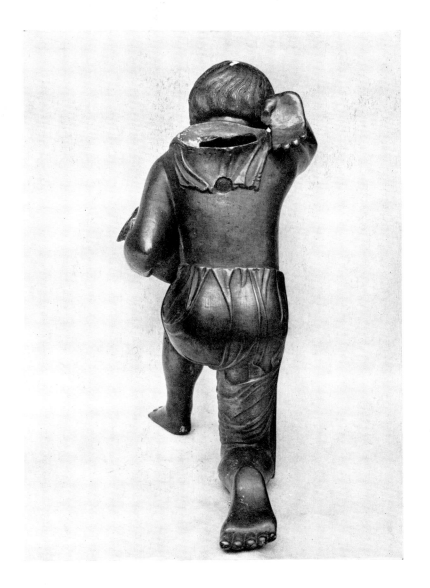

551–553. FROM THE HILDESHEIM FONT.
HILDESHEIM, C. 1220

PLATE 236

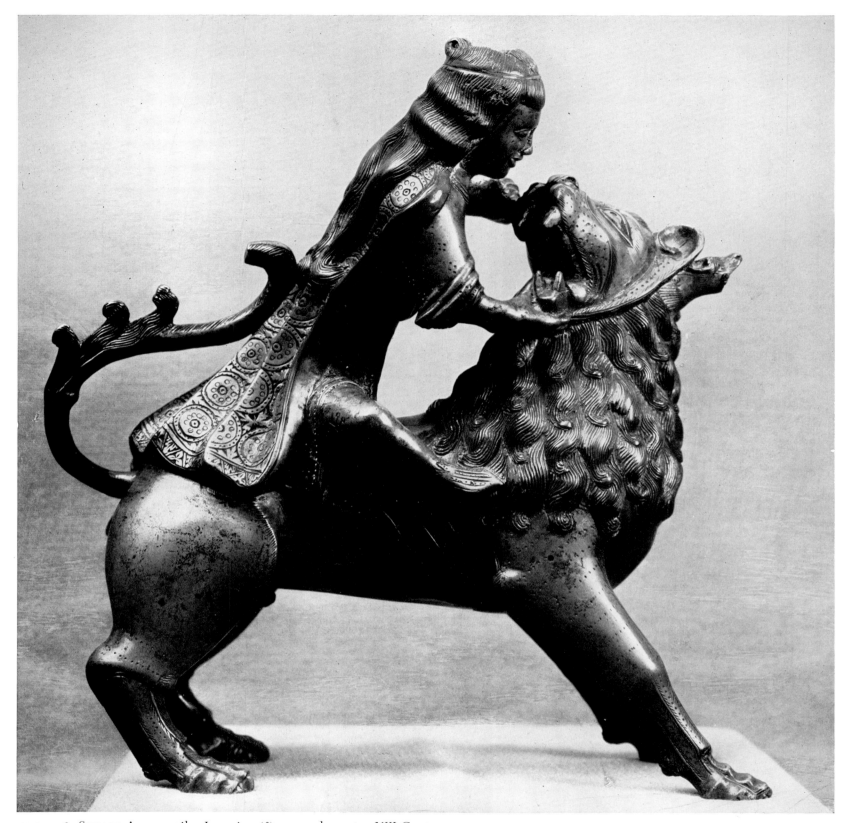

554–556. Samson Aquamanile. Lorraine (?), second quarter XIII Century

PLATE 237

555

PLATE 238

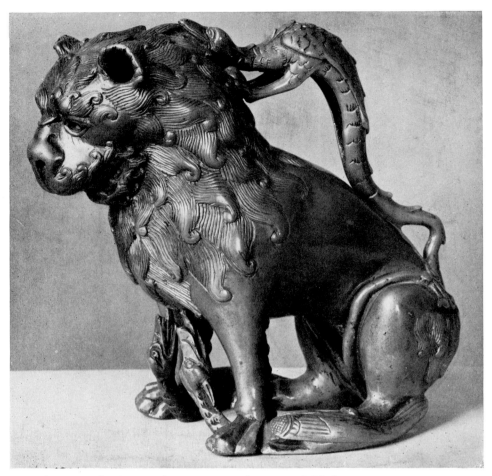

557. Aquamanile. Lower Saxony, second quarter XIII Century

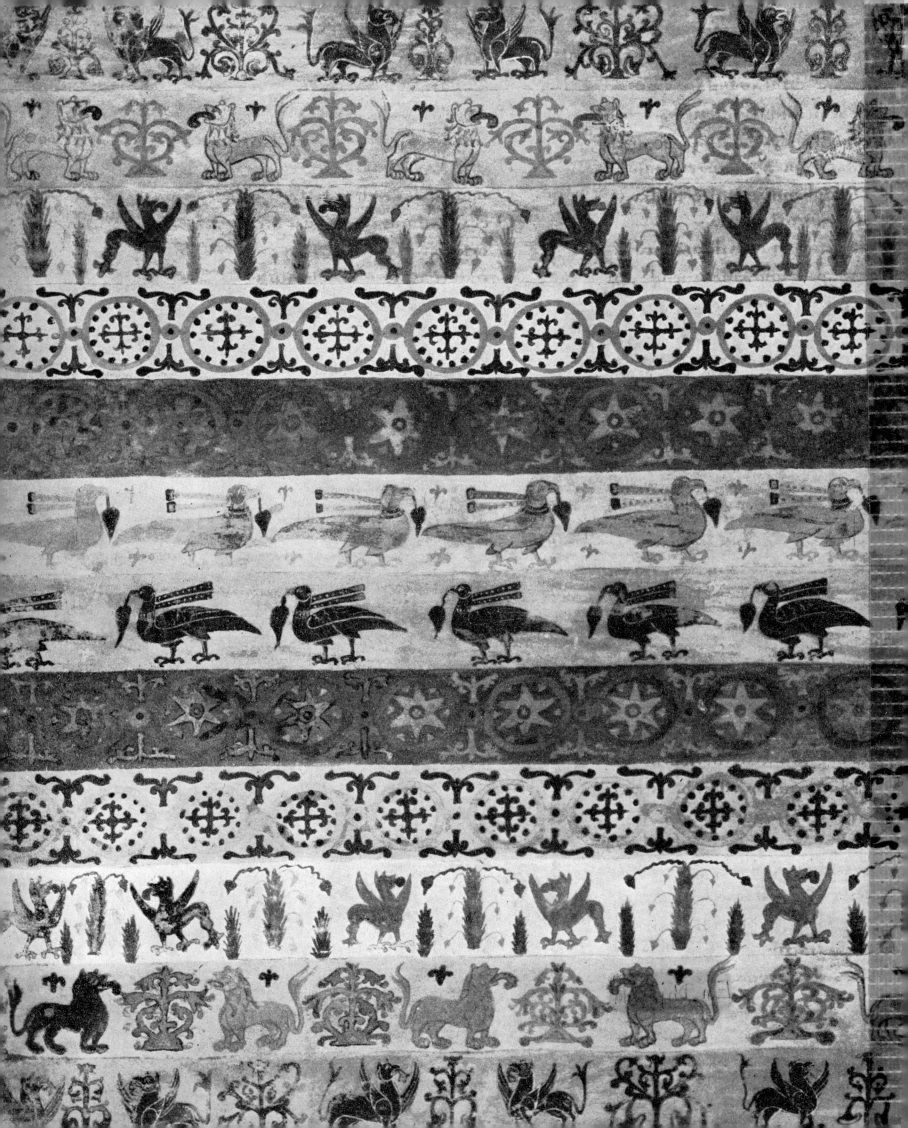